I listen to Istanbul, my eyes closed.
The cool bazaar,
Mahmutpasha, the courtyards,
Filled with warbling pigeons,
Hammer sounds from the docks,
The smell of sweat in the spring wind;
I listen to Istanbul, my eyes closed.

Extract from *I Listen To Istanbul,* by Orhan Veli, Turkish poet

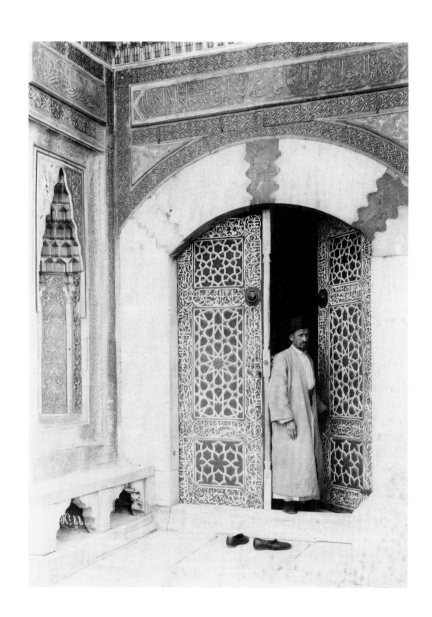

THE BAZAARS OF ISTANBUL

Isabel Böcking
Laura Salm-Reifferscheidt
Moritz Stipsicz

Thames & Hudson

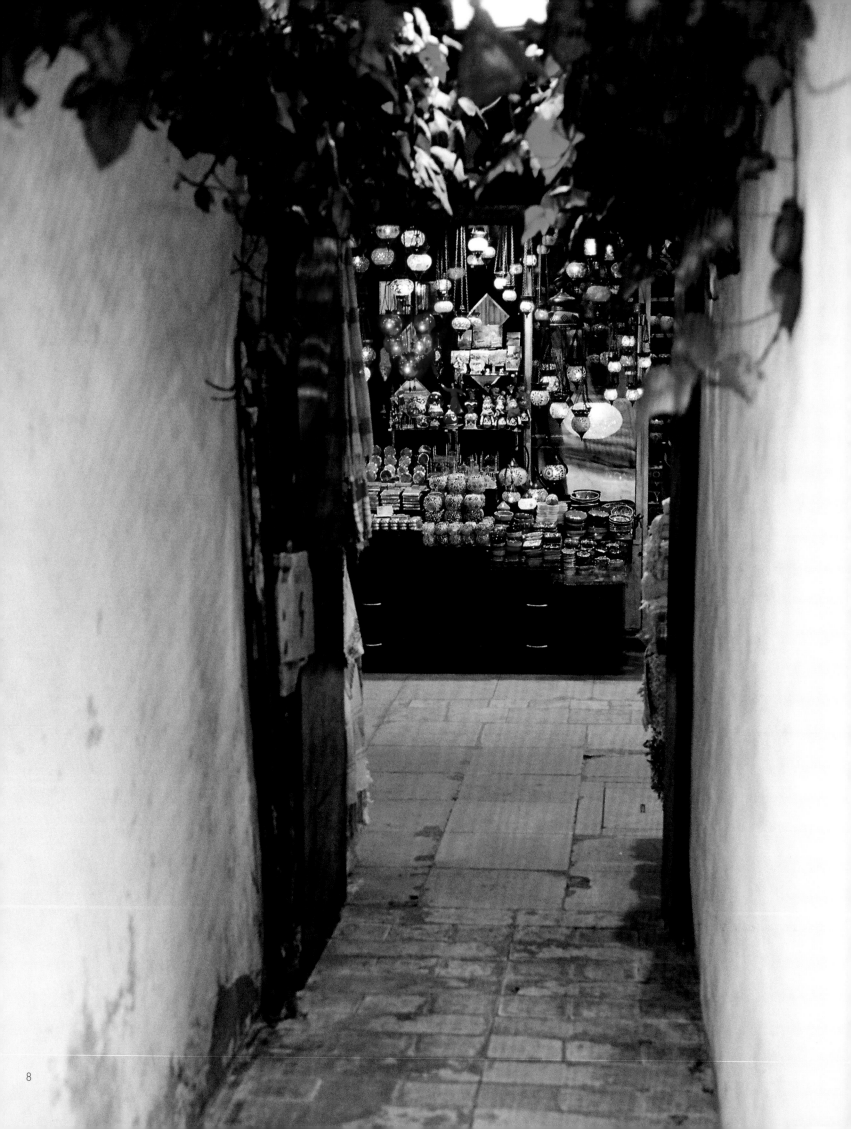

CONTENTS

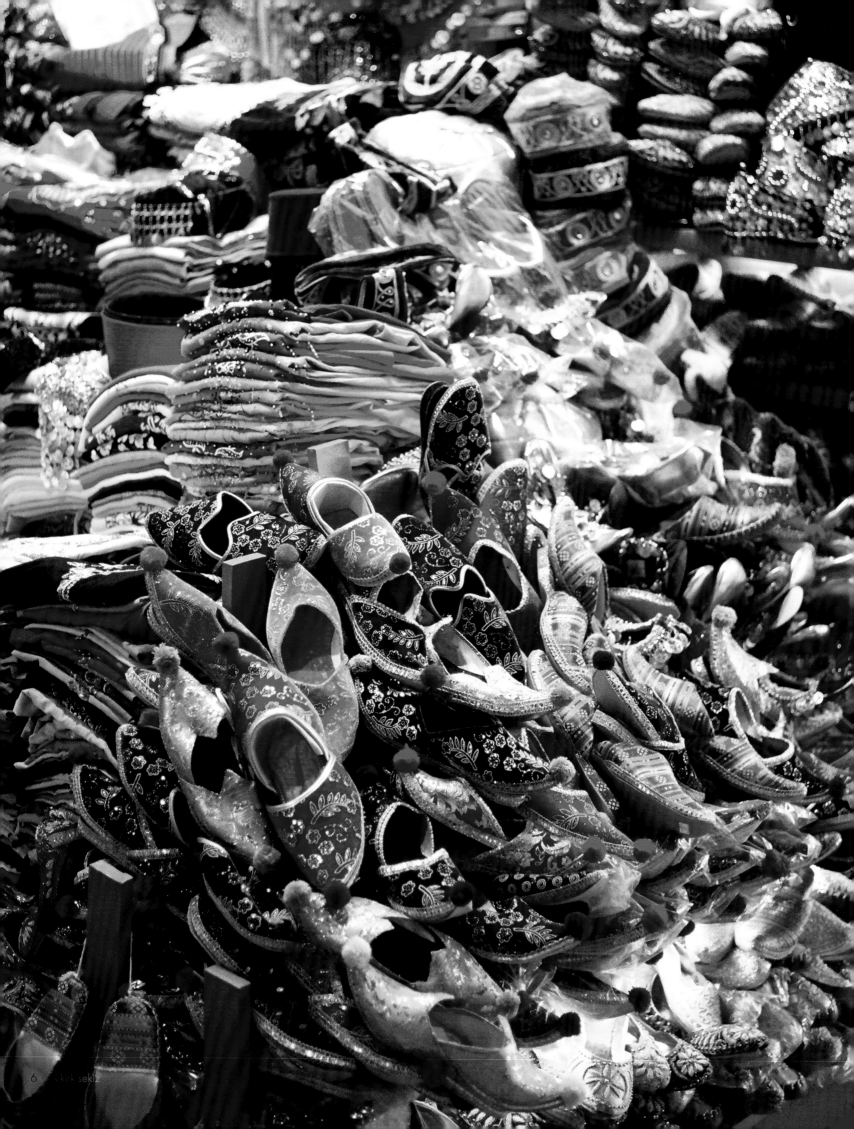

INTRODUCTION

With its infinite variety and its colourful hustle and bustle, Istanbul itself resembles a huge bazaar, and the bazaars in turn are a microcosm of the city. On the historic peninsula, centuries-old covered markets, mosques and storehouses compete with new concrete buildings and shabby booths for the precious space available. Spacious offices with brightly lit windows vie with dusty little shops in dark alleyways. Elderly traders look back nostalgically on the good old days as they surf the Internet for new products. Their sons listen to them indulgently but dress in the latest fashions, although many of their wives and daughters still wear veils when they leave the house. Istanbul is like its people, and its people are like Istanbul – holding onto the traditions of the East while fixing their eyes firmly on the West.

It is not just the buildings and people but also the goods on sale that reflect both the past and the present of the metropolis on the Bosporus. Next door to a trader selling old, handwoven kilims, you will find another offering fake designer sunglasses and watches, made in China. The bazaars of Istanbul are a mixture of globalization and Ottoman handicrafts, East and West, past and present, romance and practicality, tasteless tat and the very latest in style. These glorious opposites cast the spell of the bazaar.

Now may well be the right time to go there, while the old and the new are still balancing each other out. With every day, every week that passes, something is lost, and if you talk to the traders and craftsmen in the bazaars, you will soon learn that the knowledge, skills and traditions of the past are rapidly fading away. Men who, with endless patience, sit for hours fashioning candleholders or mouthpieces for hookah pipes will soon become flotsam in the tide of globalization. The bazaars have lived through many crises, but their crafts have never been under such threat as they are today.

The politicians are anxious to cater for the tastes of the tourists who come flocking here every year in their millions, and they are planning major reforms: if they have their way, the workshops and countless cars that cram the narrow lanes will disappear, as will the wholesalers and their warehouses. Illegally constructed buildings are to be demolished. Some dealers fear for their livelihood, while others believe the district will lose its character. What will remain will be a mask concealing a variety of sins. But for the moment, this quarter of the city remains a true reflection of the life within it – sometimes beautiful, sometimes ugly, but never less than fascinating.

No matter how much time you may spend within the ancient walls of the Grand Bazaar or in the narrow alleyways around it, and no matter how often you wander among mosques, workshops and warehouses, and listen over a glass of tea to the tales of the traders, you will never be able to encompass the whole world of the marketplace, bustling and deserted, laughing and melancholy, grey and multicoloured. Doubt can turn to certainty, certainty to doubt, and that is the way it is meant to be, for what use is a bazaar if it is not a constant source of surprises?

Since 1845 the Galata Bridge has linked the old Istanbul of palaces, bazaars and mosques to the modern part of the city, which in the days of the Ottomans housed European diplomats and merchants. Before the bridge was built, people and their goods were transported across the Golden Horn in rowing boats. It has been renovated many times, the last occasion being in 1992. Until 1930, all pedestrians and vehicles had to pay a toll in order to cross it.

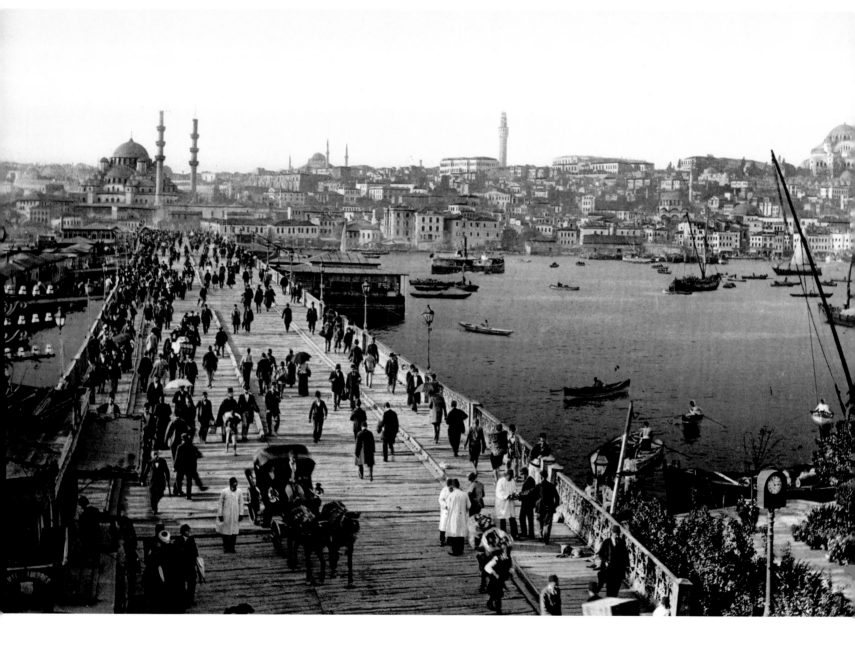

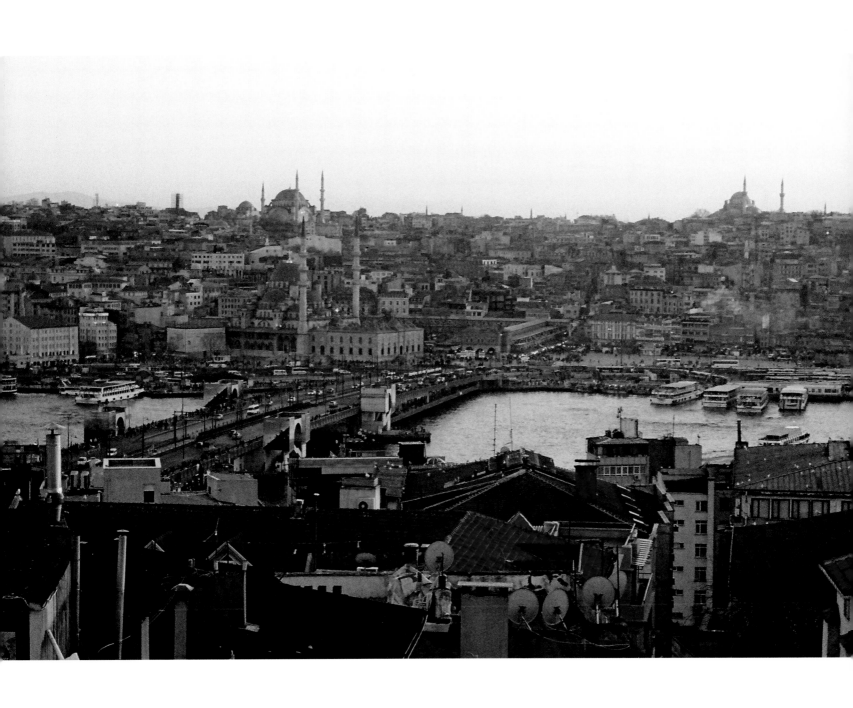

Commerce and faith are closely connected in Istanbul. The income from the bazaars and shops often went towards the upkeep of the mosque complexes, such as the New Mosque on the Golden Horn (below), or the Sultan Ahmed Mosque, also known as the Blue Mosque (opposite).

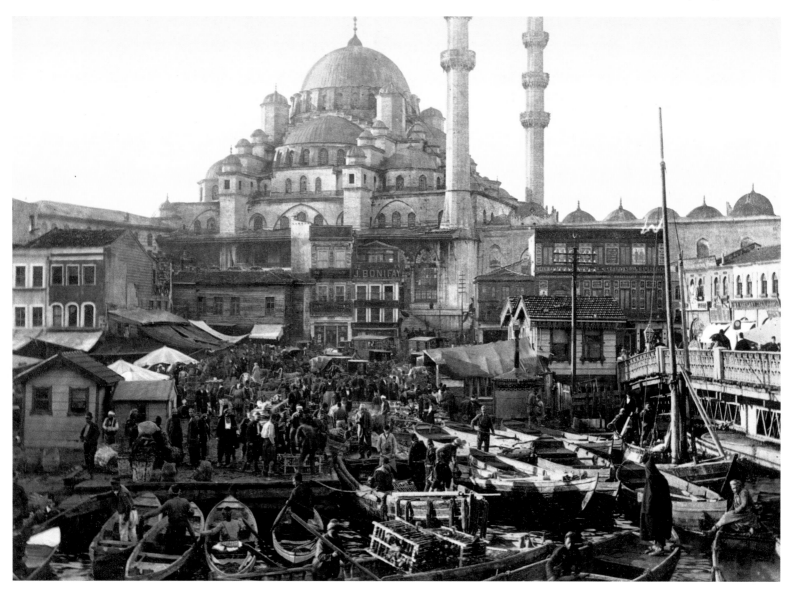

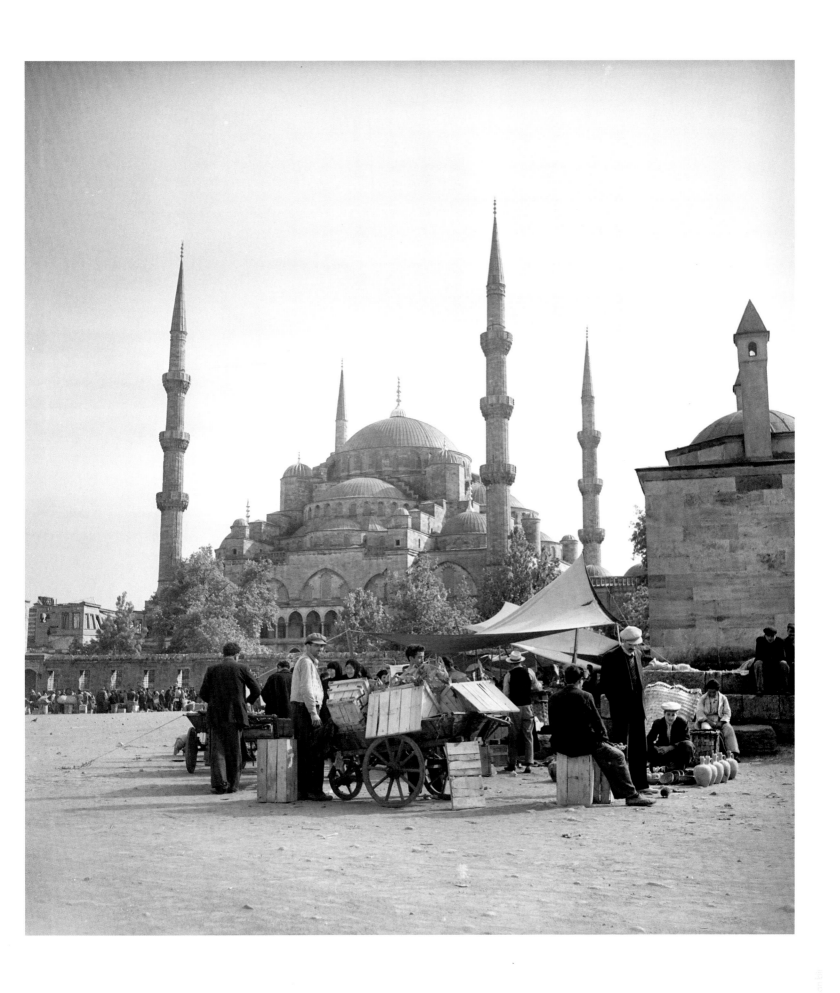

THE BAZAAR DISTRICT
OF ISTANBUL

The colourful bazaar district on the peninsula of Istanbul, once the site of Byzantium and of Constantinople, is a paradise for shopaholics, browsers and daydreamers. Inside this labyrinth of lanes and alleyways, you will find the three largest and oldest bazaars of the great city. The Grand Bazaar itself begins on the other side of the Egyptian Bazaar, where spices, dried fruits, all kinds of food and perfumes are on sale, and beyond the Rüstem Pasha Mosque with its rich decorations of Iznik tiles on the shore of the Golden Horn, where you can now board the pleasure boats and ferries that cross the Bosporus. In the days of the Ottoman Empire, ships would dock in the harbour, bearing exotic goods from distant lands to be taken to the city's bazaars, workshops and warehouses. Today, from dawn till dusk, you will see crowds of people heading towards the Grand Bazaar, which stands at the top of the hill between Bayezid Square and the Nuruosmaniye Mosque. Life is teeming in this, Istanbul's largest bazaar, which for over five hundred years has been the commercial hub and home of countless thousands of traders and craftsmen. But if you are looking for some peace and quiet, you will find it in the nearby Book Bazaar – an idyllic little square covered with vines and surrounded by tiny shops selling Korans, prayer beads and illustrated books.

However, if you are hoping to catch a glimpse of the Golden Horn, the Bosporus or the Sea of Marmara, all of which surround the promontory, you will be disappointed. The Grand Bazaar is hemmed in by old warehouses, booths built without planning permission, and densely packed shops which sell every conceivable product from East and West. You will gaze in amazement at the stands and their displays, and be mesmerized by the ocean of goods on offer: plastic eyes for dolls and stuffed animals, piles of gold and silver thread, plastic mats in bright pinks and purples, towels, underwear, kitchen utensils, shoes, buttons, belly-dancers' costumes – all attractively laid out in front of the shops. One boy sells single cigarettes, while another fascinates the children with his glove puppets. Cars inch their way through the crowds, with their drivers hooting and swearing because no one wants to give way. Porters – known as *hamallar* – are bent double under their heavy loads as they struggle up the steep alleys.

The Istanbul bazaars also look after your taste buds: a vendor of freshly baked sesame rolls carefully manoeuvres his way around the potholes, and the scent of grilled meat and exotic spices comes wafting round every corner. Tea kitchens are constantly brewing their strong tea, while young waiters balance trays of full or empty glasses on their heads as they replenish supplies for the traders and their customers. The whole area is a teeming throng of shouting stallholders, friendly sellers, gawping tourists, young men in the latest garb, veiled women and noisy children. It is the beating heart of Istanbul. Here you can go with the crowd and breathe in the magical atmosphere that makes the city so special.

THE GRAND BAZAAR: SOMETHING FOR EVERYONE

For 550 years, traders have been selling their wares in the Grand Bazaar, the Kapalı Çarşı. It has defied fires and earthquakes, survived the fall of the Sultans, and flourished in the Republic, and even now it draws in up to half a million visitors every day.

The conquest of Constantinople

Sultan Mehmed II had at last fulfilled his dream: on 29 May 1453, after a siege lasting two months followed by a decisive battle, he rode triumphantly into the holy city of Constantinople, the last Christian stronghold in the mighty Ottoman Empire. But the moment he saw the fallen city, his heart sank. He had conquered a ghost town. Even before it had been besieged and plundered by the Turks, this once flourishing metropolis had lost its lustre as well as its pre-eminence as a trade centre. Mehmed's top priority therefore became the rebuilding of Constantinople, already known unofficially by the name of Istanbul. After that, the most urgent need was to repopulate the abandoned town, and so some of the prisoners were made to settle on the Golden Horn, while whole families were brought in from the provinces. To ensure that trade started up again, Mehmed allowed the expelled Armenians and Greeks to return, and he also granted non-Muslims the right to practise their faith unmolested. Between 1455 and 1461, a covered market called a Bedesten was built on the site of an old Byzantine market on Theodosius Square, and this became the nucleus of the present Grand Bazaar.

The Bedestens: the beginnings of the bazaar

The Bedestens were the economic centres of Ottoman towns – the prototypes of our modern department stores. There were already similar indoor markets in the centres of former capital cities like Bursa and Edirne. In Istanbul's gigantic new Cevahir Bedesteni, today called the Old Bedesten, the wares on offer included fine cloths, precious jewels, leather goods and ornate weapons. The building itself extended over 3,400 square metres (36,500 sq. ft) and stood on eight massive pillars supporting a roof with fifteen domes. Clearly impressed by this covered market, an envoy from the Habsburgs wrote during the 16th century: 'There is also a magnificent store in Constantinople, where one finds all kinds of splendid wares brought from far-away places... In short, this Bedesten or store contains so many goods that they may be worth several princedoms.'

Such valuable commodities naturally needed to be protected, and the Bedesten offered maximum security. Thanks to its thick iron gates, barred shop windows, walls 1.5 metres (5 feet) thick, and fireproof vaults, even travelling merchants used to entrust their cash and documents to the safekeeping of the traders. However, these items were handed over in accordance with a strict procedure: if someone wanted his valuables to be locked away, he would be accompanied by an officer of the law, who would then stand discreetly in the background. As soon as the valuables had been deposited in a box, the owner would close it with a seal which the officer would check for himself. Traders in the Old Bedesten also used to lend out money at low rates of interest. Of course the market was guarded day and night, and the watchmen were the only people with keys to the heavy iron gates.

Not far from the first Bedesten, Sultan Mehmed had a second market hall constructed, smaller and less striking, but enough to make Istanbul unique in having two Bedesten. This new building was named the Sandal Bedesteni, after a particular kind of silk from Bursa, because initially silk was the main commodity sold here, along with other valuable fabrics and robes. But even two Bedesten were not enough. The Sultan was determined to return Istanbul to its former prominence as a trade centre, and so he

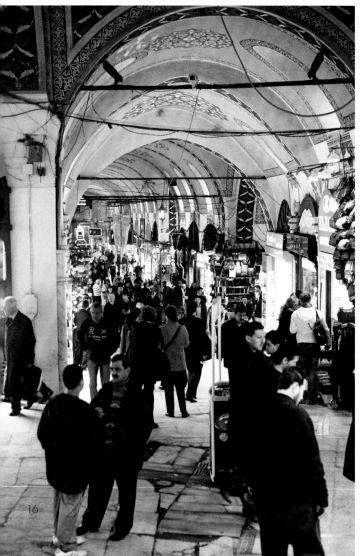

encouraged the richer citizens to build new premises. As a result, the two Bedesten were gradually surrounded by wooden booths and row upon row of shops. The alleys were covered with canvas canopies, and vines grew up over the walls to form a natural canopy. However, the majority of these buildings were destroyed by fire in 1701, and so in order to reduce the risk of a recurrence, it was decided during reconstruction to replace wooden buildings with masonry and to provide the passages with roofs – hence the Turkish name for the Grand Bazaar, *Kapalı Çarşı*, meaning 'Covered Bazaar'.

A place of wealth and luxury

The high roofs and impressive variety of goods brought an enthusiastic response, especially from foreign visitors. 'The Exchanges are all noble buildings, full of fine alleys, the greatest part supported with pillars, and kept wonderfully neat. ...The *besisten* or jeweller's quarter, shews so much riches, such a vast quantity of diamonds, and all kinds of precious stones, that they dazzle the sight. ...People walk here as much for diversion as business,' wrote Lady Mary Wortley Montagu, wife of the British ambassador, in the early 18th century. And the Danish writer Hans Christian Andersen remarked: 'By comparison with the bazaars of Constantinople, the fine shops of the Palais Royal are merely a well-groomed grisette competing with this daughter of the Orient in her splendid fabrics, her hair scented with attar of roses and myrrh.'

But it was the wares on display that gave the buildings their real beauty and glamour. The walls and roofs were simply whitewashed, and the columns were plain stone – there was no decoration of any

More than sixty lanes and passageways branch off from the Kalpakçılar Caddesi and the Yağlıkçılar Caddesi, the two main streets of the Grand Bazaar. Some lead into tiny courtyards.

...that dark, hidden city full of wonders, treasures and memories.

Edmondo de Amicis, an Italian travel writer, describing the Grand Bazaar, 19th century

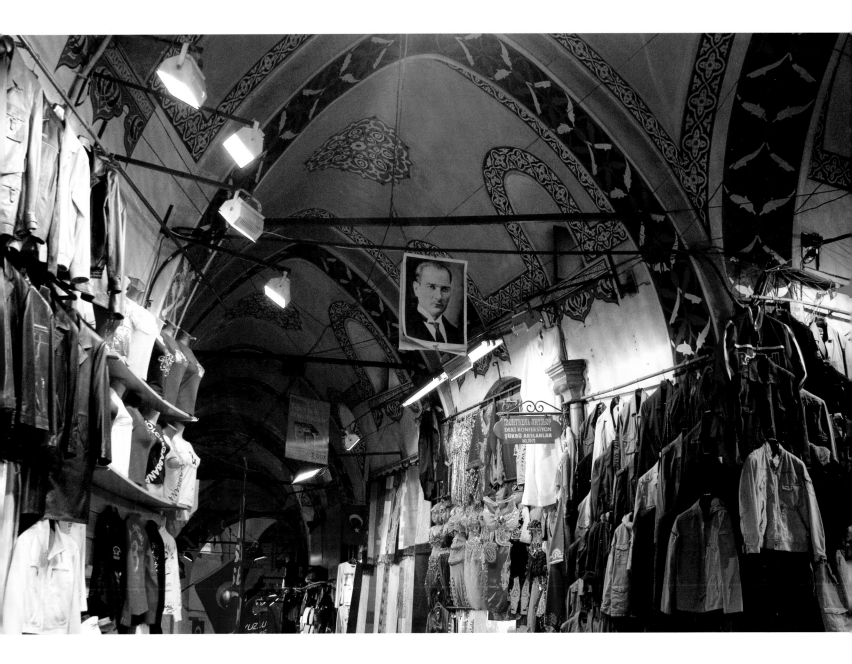

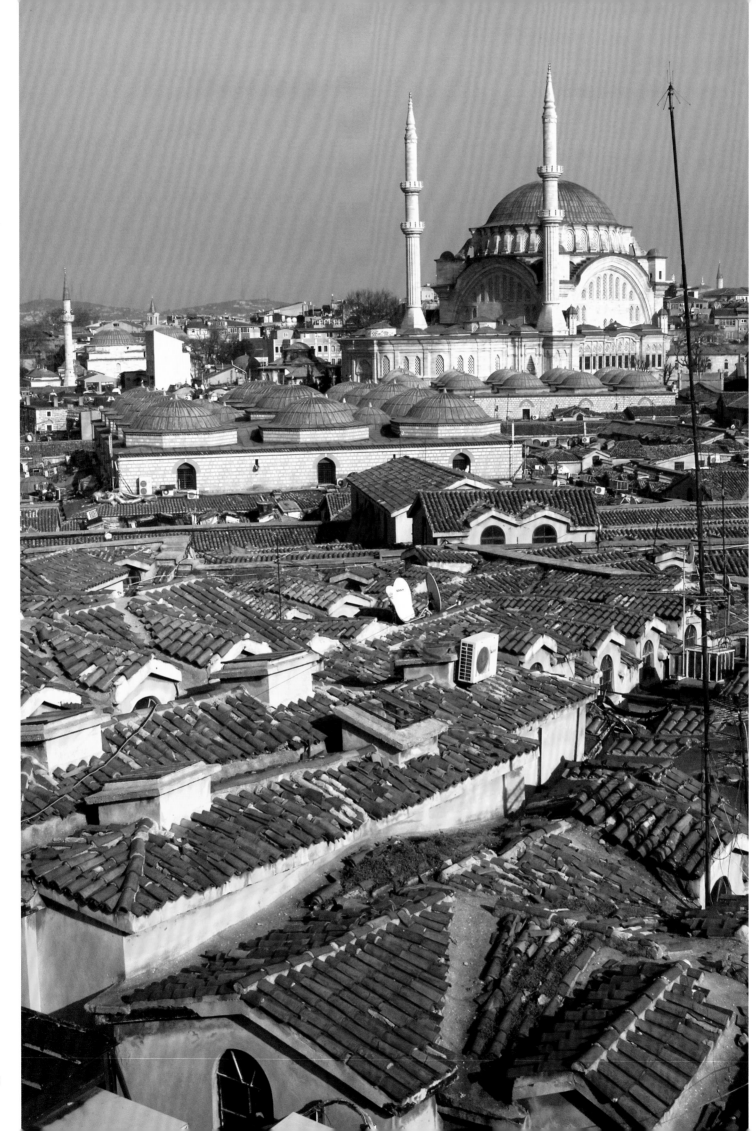

The Grand Bazaar extends between the Nuruosmaniye and Bayezid Mosques. Almost half a million people pass through its twenty or so gates every day.

kind. The people of the East did not judge the beauty of a house by its exterior, but by what lay inside. The shops on both sides of the alleyways had no shop floor or window displays as we would expect today; they took the form of simple niches called *dolaplar*, separated only by curtains or slats. The goods were laid out on shelves or in cabinets, and from here shone forth the finest fabrics – muslin, velvet, silks of all kinds – hanging on hooks for the public to feast their eyes on. Visitors from abroad would compare the rich colours to those they had seen on church windows. This open display of wares suited the local women too, as they did not have to squeeze into a narrow shop in order to haggle with the seller, but could stay outside in the street, thus avoiding any possible accusations of immoral conduct.

The traders themselves would sit on a wooden stool or bench, behind which there was a niche where they could wash before prayers. Many of them had little glass cases or chests in which they kept particularly valuable items. Customers would often sit down beside the owner in order to haggle, and they would examine the goods at their leisure, drinking a coffee or smoking a pipe. At closing time, the vendor would pull two shutters over his shop, one from the top and one from the bottom – Hans Christian Andersen described these shops as upended boxes – and then head for home.

Although it is hard to imagine today, the Grand Bazaar at that time was far from a traffic-free zone. Goods were transported by mule and apparently even by camel through the streets to the different shops. And of course the wealthier customers did not come on foot but on horseback.

Fires and earthquakes and their aftermath

This splendour was all too transient. Since time immemorial, the city on the Bosporus has fallen victim to fires and earthquakes. 'Fires are inseparable from an Istanbul built of wood, and they have created a singular history of disaster. The saying "Fire in Istanbul, plague in Anatolia" summarizes in just a few words the experience of our capital city and our homeland for seven hundred years,' wrote a government official at the beginning of the 20th century. After its reconstruction in the early 18th century, the

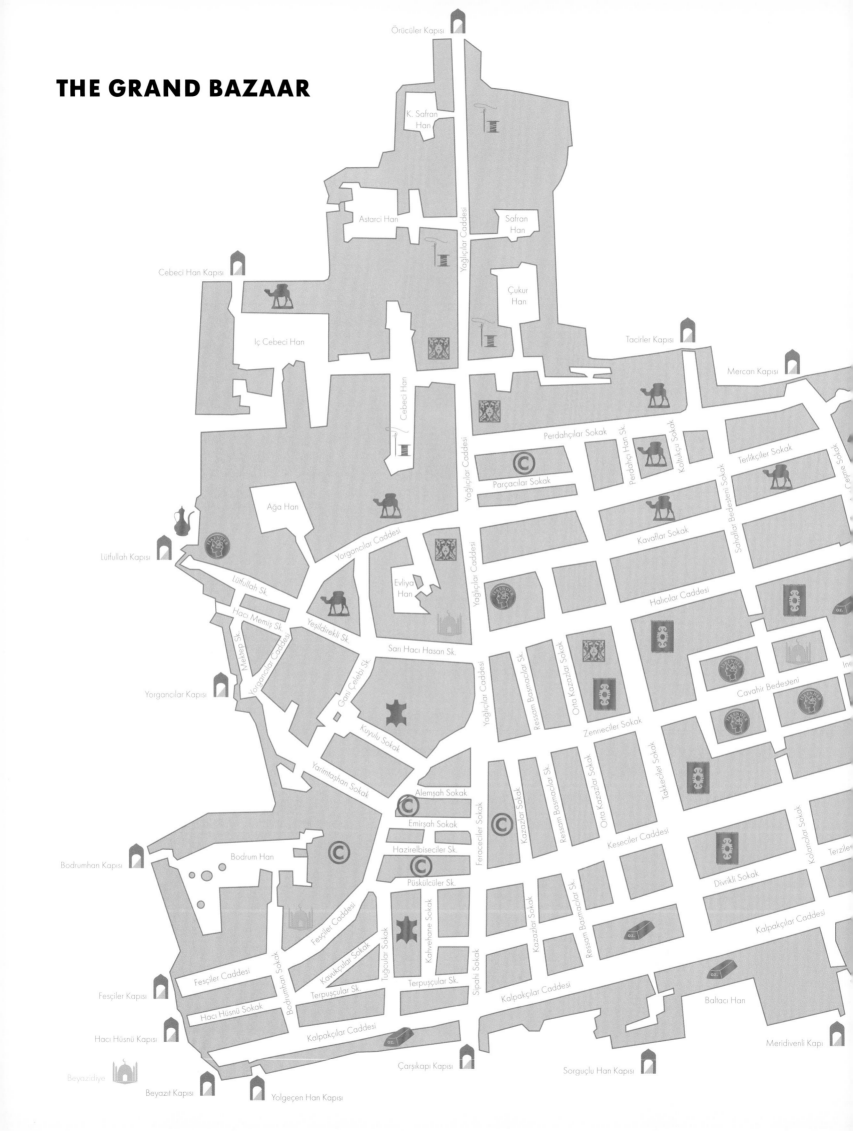

THE GRAND BAZAAR

Örücüler Kapısı

K. Safran Han

Astarci Han

Safran Han

Çukur Han

Cebeci Han Kapısı

Tacirler Kapısı

İç Cebeci Han

Mercan Kapısı

Cebeci Han

Perdahçılar Sokak

Yağlıçılar Caddesi

Perdahçı Han Sk.

Koltukçu Sokak

Terlikçiler Sokak

Sahaflar Bedesteni Sokak

Çeşme Sokak

Parçacılar Sokak

Ağa Han

Kavaflar Sokak

Yorgancılar Caddesi

Halıcılar Caddesi

Evliya Han

Yağlıçılar Caddesi

Lütfullah Kapısı

Lütfullah Sk.

Hacı Memiş Sk.

Yeşildirekli Sk.

Sarı Hacı Hasan Sk.

Orta Kazazlar Sokak

Ressam Basmacılar Sk.

Cavahir Bedesteni

Mektep Sk.

Yorgancılar Caddesi

Gani Çelebi Sk.

Yağlıçılar Caddesi

Zenneciler Sokak

Yorgancılar Kapısı

Kuyulu Sokak

Takkeciler Sokak

Yarimtaşhan Sokak

Alemşah Sokak

Emirşah Sokak

Kazazlar Sokak

Ressam Basmacılar Sk.

Orta Kazazlar Sokak

Keseciler Caddesi

Divrikli Sokak

Kolancılar Sokak

Terzile

Bodrumhan Kapısı

Bodrum Han

Hazirelbiseciler Sk.

Feraceciler Sokak

Püskülcüler Sk.

Fesçiler Caddesi

Kahvehane Sokak

Tuğcular Sokak

Sipahi Sokak

Kazazlar Sokak

Ressam Basmacılar Sk.

Kalpakçılar Caddesi

Kavukçular Sokak

Bodrumhan Sokak

Terpuşçular Sk.

Terpuşçular Sk.

Kalpakçılar Caddesi

Baltacı Han

Fesçiler Caddesi

Hacı Hüsnü Sokak

Fesçiler Kapısı

Hacı Hüsnü Kapısı

Kalpakçılar Caddesi

Meridivenli Kapı

Beyazidiye

Çarşıkapı Kapısı

Sorguçlu Han Kapısı

Beyazit Kapısı

Yolgeçen Han Kapısı

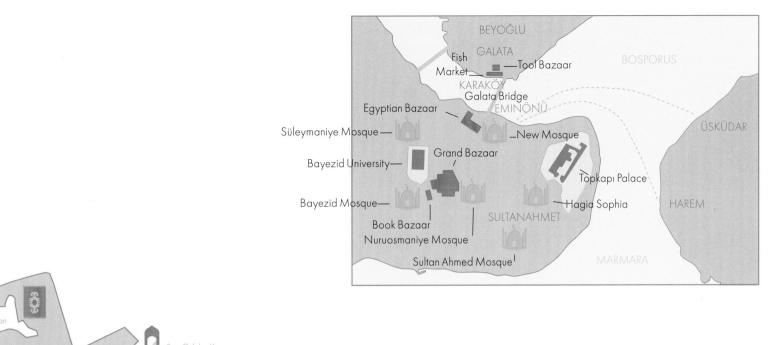

BEYOĞLU

GALATA

BOSPORUS

Fish Market — Tool Bazaar

KARAKÖY

Galata Bridge

Egyptian Bazaar

EMINÖNÜ

ÜSKÜDAR

Süleymaniye Mosque —

New Mosque

Grand Bazaar

Bayezid University —

Topkapı Palace

Bayezid Mosque —

Hagia Sophia

HAREM

Book Bazaar

SULTANAHMET

Nuruosmaniye Mosque

Sultan Ahmed Mosque

MARMARA

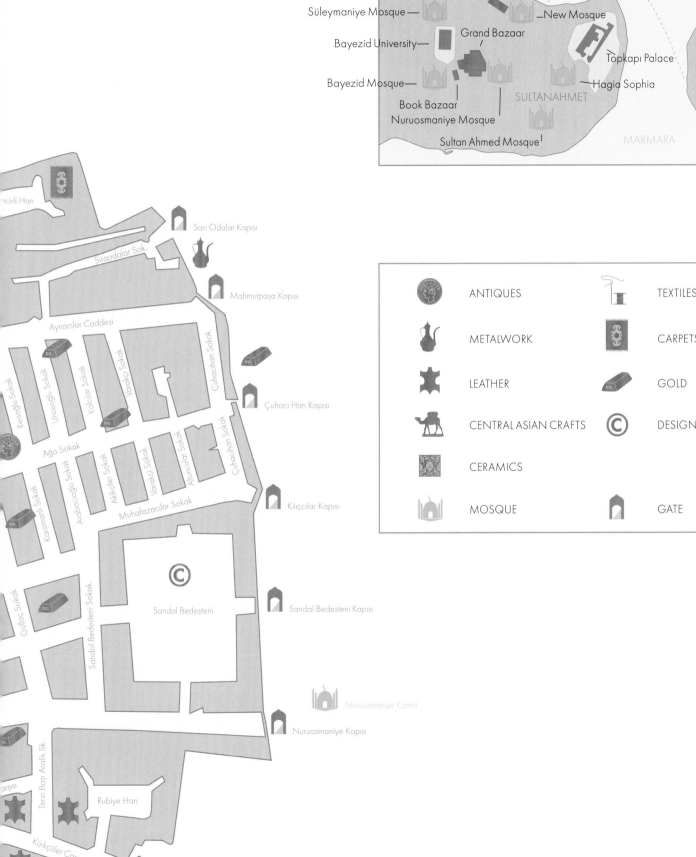

Hacirli Han

Sarı Odalar Kapısı

Sıraodalar Sok.

Mahmutpaşa Kapısı

Aynacılar Caddesi

Çuhacıhan Sokak

Reisoğlu Sokak

Uncuoğlu Sokak

Kalcılar Sokak

Varakçı Sokak

Çuhacı Han Kapısı

Çuhacıhan Sokak

Ağa Sokak

Arabacıoğlu Sokak

Akikçiler Sokak

Varakçı Sokak

Altuncular Sokak

Karamanlı Sokak

Muhafazacılar Sokak

Kılıççılar Kapısı

Güllaç Sokak

Sandal Bedesteni Sokak

© Sandal Bedesteni

Sandal Bedesteni Kapısı

Nuruosmaniye Camii

Nuruosmaniye Kapısı

Çarşısı

Terzi Başı Aralık Sk.

Rubiye Han

Kürkçüler Çarşısı

Kürkçüler Kapısı

	ANTIQUES		TEXTILES
	METALWORK		CARPETS
	LEATHER		GOLD
	CENTRAL ASIAN CRAFTS	©	DESIGNER FAKES
	CERAMICS		
	MOSQUE		GATE

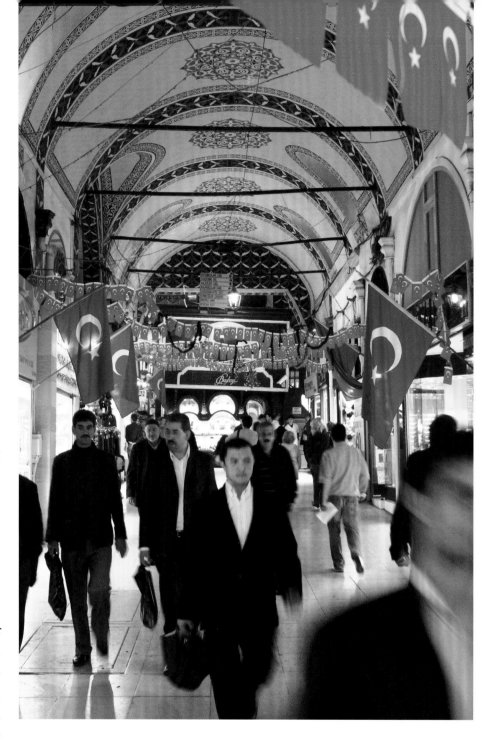

Grand Bazaar may well have been better protected against fire, but like the rest of the city it had no defence against earthquakes. In 1894, Istanbul suffered a quake that lasted 45 days. Not a stone was left standing. Whole sections of the Grand Bazaar collapsed, and even a year after the quake, there were still great chunks of masonry blocking the streets. In fact, it was not until the 1970s that the Iç Cebeci Han was finally cleared of the remaining rubble. The traders had no alternative other than to lay their wares out on the ruined walls.

The Grand Bazaar was never the same after this devastation. The reconstruction work robbed it of much of its original charm. Two large gates were erected at the ends of the main street, the Kalpakçılar Caddesi, and the roofs were strengthened with iron supports, while the ceilings and walls were decorated with paintings. The wooden benches and the *dolap* system gave way to modern shops with large display windows, and so the bazaar gradually took on the form we know today. A few of the streets lost their vaults, and some of the *hans* – the typical Ottoman warehouses that had formerly served as inns for travelling merchants – were separated from the Grand Bazaar. Today the Kapalı Çarşı extends from the Divan Yolu (originally Constantinople's main Byzantine thoroughfare, which even in Ottoman times provided a vital link between the Hagia Sophia and the present-day Bayezid Square) to the Nuruosmaniye Mosque and down towards the Golden Horn. The name of the Grand Bazaar is therefore hardly surprising.

The bazaar as a reflection of its time

It was not only fires and earthquakes that changed the face of the bazaar. Another factor was the social and economic state of the Ottoman Empire. During its golden age, wares came to Istanbul from every corner of this gigantic Empire – gold, silver, silk, jewelry and crystal were sold in vast quantities. People came from all over the world to trade here. But the fall of the Empire brought with it the end of the romantic, oriental image of the Grand Bazaar, and by the end of the 19th century fewer and fewer of the expensive craft products were being sold. The country found itself in the midst of an economic crisis, and in any

On 29 October, a national holiday commemorating Kemal Atatürk's proclamation of the Republic in 1923, Turkish flags are hoisted in the streets of the Grand Bazaar.

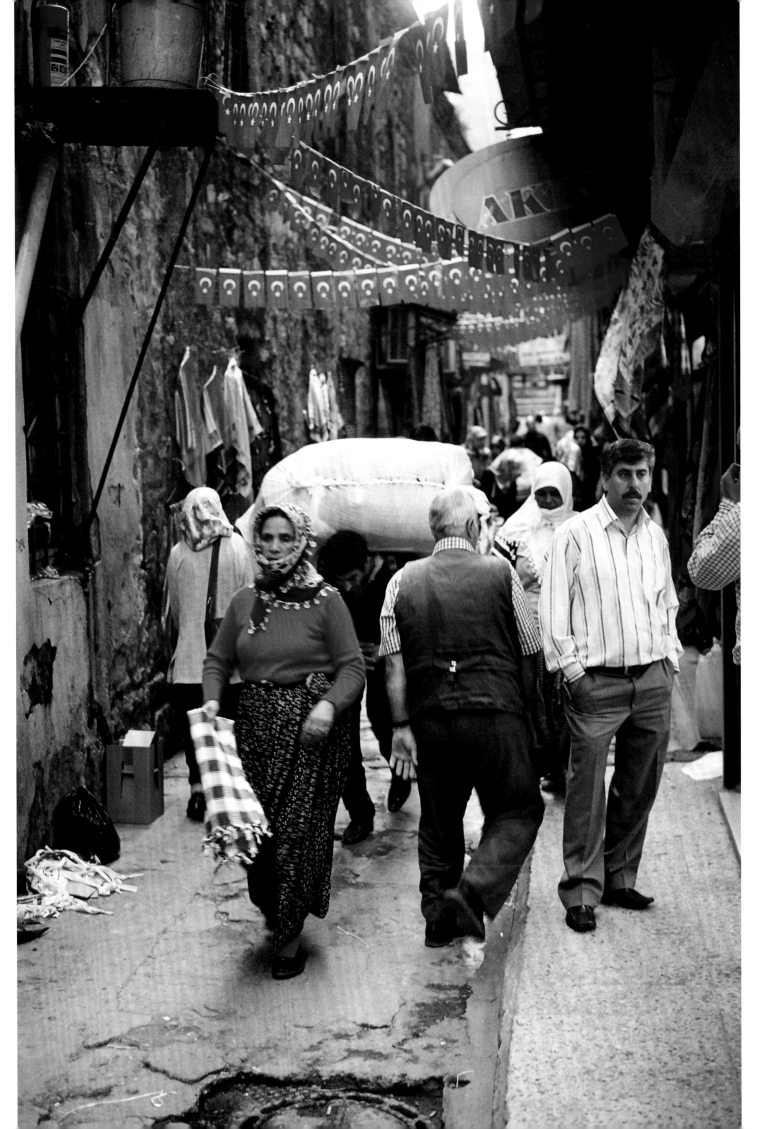

Mehmed II – a scholar and a soldier

It may be thanks to the persistence of a precocious, highly intelligent boy that Istanbul today lies in Turkey. When Murad II abdicated in 1444 to hand the throne and a huge empire to his twelve-year-old son, Mehmed II was already dreaming of conquering Constantinople, the last remnant of the Byzantine Empire. Deeply concerned about his son's ambitious plans, Murad took back the throne, and only when the boy had become into a man of twenty-one did he get a second chance, due to the death of his father. His dream, however, had never left him, and just two years after his accession, the Ottomans began their siege of Constantinople.

The young Sultan was prepared to go to any lengths to achieve his goal. The Byzantines had laid chains across the entrance to the Bosporus, and so he used block and tackle and a road of greased logs to have seventy of his warships hauled overland, past the present Taksim Square and Galata as far as the Golden Horn. And since he evidently had a taste for the theatrical, while some men were dragging the ships, others were made to sit in them and move their oars through the air in time to the commands of their officers. The sails had been hoisted, and this extraordinary procession was even accompanied by a military band. To encourage his soldiers, Mehmed rode through the camp announcing that when the city had been conquered, his men would be allowed three days to plunder it. Evidently it had the desired effect, for just two days later, on 29 May 1453, the 'Golden Apple', the ancient capital of the Byzantine Empire, fell into the hands of the Turks after a fierce and bloody battle. Constantine, the last Byzantine ruler, died in the fighting. There were horrific scenes, and blood is said to have flowed through the streets like rainwater after a storm. The soldiers took their ruler at his word, and plundered houses and churches, killing men, women and children.

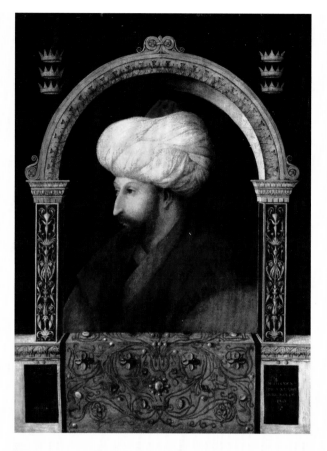

In around 1480, the Venetian artist Gentile Bellini – staying as a guest at the Sultan's palace in Istanbul – painted this portrait of Mehmed II.

Thus Constantinople finally became the new capital of the Ottoman Empire, and was unofficially renamed Istanbul. Mehmed conferred the title of *Fatih* or Conqueror upon himself, for now he was the ruler of two oceans and two continents. Many Christian churches, including the Hagia Sophia, were turned into mosques, although Mehmed did allow people of other faiths to build their own places of worship or to use existing ones. There followed a veritable building boom. More than 300 mosques, 57 madrasas (Islamic colleges) and 59 hamams (baths) are said to have been constructed during Mehmed's reign. When he died in 1481 – officially of gout, but unofficially of poisoning – the population of Istanbul had quadrupled. Apart from his efforts to revive trade and culture, he introduced an effective, centralized system of administration and drew up a written set of laws. Among others, he made it legally permissible for future sultans to kill their brothers, thereby helping them to ensure that their own descendants would accede to the throne.

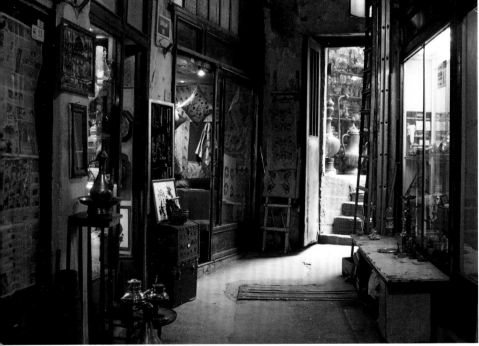

Wandering through the winding alleys of the Kapalı Çarşı, you are scarcely aware of just how huge it is. Its true size only becomes apparent when you look out over the roofs of the vast complex.

case tastes were changing. People now hankered after goods imported from Europe, and the once lively and bustling bazaar became a poorly frequented market for cheap and shoddy wares. The French author Claude Farrère wrote scathingly at the beginning of the 20th century: 'This labyrinth of vaulted walkways strives to be the setting for a tale from *The Thousand and One Nights*, but it only succeeds in being the scene of a comic opera.' The fall of the sultanate and the two world wars resulted in even further decline.

In 1954, another fire devastated the Grand Bazaar, and once again many features were lost during reconstruction. The decorated ceilings were plastered over, and the whole building was modernized. Most of the workshops were moved outside. Rebuilding took five years, but it was not until the growth of tourism and the economic boom of the 1980s that the traders began to breathe more easily again. All the same, the bazaar has lost a lot of its earlier oriental mystique, which has been replaced by souvenir shops and fashion boutiques like the ones found all over Europe. Over the shops you now see flashing neon signs and advertisements.

The city was unprepared for the wave of immigrants that arrived in the late 20th century, and the effects of this population explosion were also felt in the bazaar. In every street and at every corner of the Kapalı Çarşı new shops and stalls opened up, and the previously open and spacious market – especially in the summer months – was now humid and sticky. A major renovation project in the 1980s led to the closure of all shops that had been built without plan-

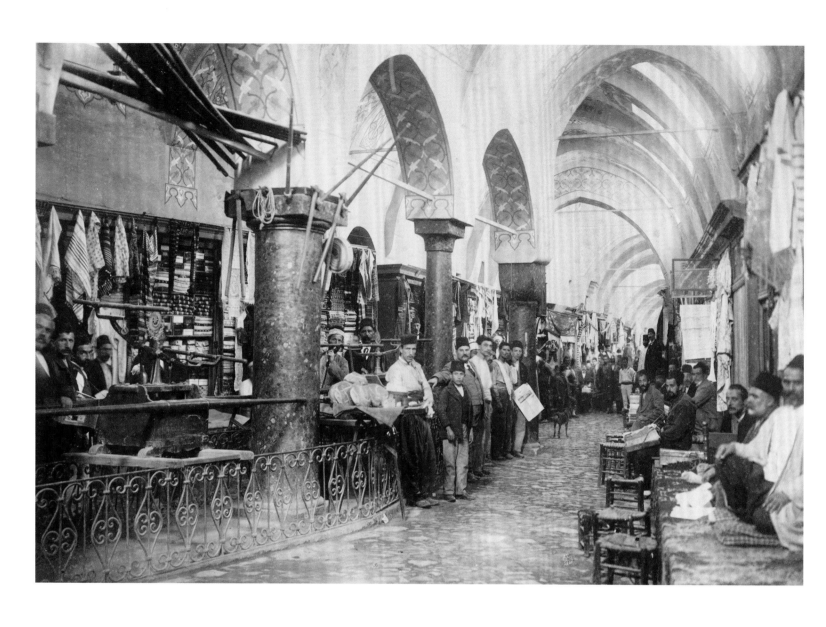

ning permission, and these included many furniture stores, whose beds and cupboards had caused severe obstruction. The ugly advertising hoardings were also removed, and the Sandal Bedesteni, which since the early 20th century had been used as an auction house for carpets, jewelry and antiques, was divided up into individual shops.

The Kapalı Çarşı in the 21st century

Even today, after more than five hundred years, the Grand Bazaar still provides an accurate reflection of the city itself, with nearly 3,500 shops, 40 warehouses, and 61 streets and alleys. Some 25,000 people work in the bazaar, and here beats the heart of the Turkish gold trade as well as the unofficial stock exchange. Every day, more than half a million tourists, traders and locals rush, stroll or wander through the twenty or so doors and gateways that lead through

the old wall. The glories of the past can only be imagined, but the sheer variety and colour of the present is still hugely impressive. Displays of gold are brightly lit, and the light is reflected back from the countless bracelets, chains and rings. Semiprecious stones of blue, green, turquoise, purple, black and red hang from threads on the walls. Brass jugs as tall as a man and trays as broad as table tops block the entrance to a small shop, and in a dark alleyway, a cat stretches out on a pile of carpets.

If you wander aimlessly through the alleyways, go up and down the steps, accept an invitation to drink a glass of tea or just to chat with a shopkeeper, look at the people jostling in the streets, past the fountains, across the squares, or watch the barber shaving, cutting, trimming, then you will understand why the Turkish author Celik Gülersoy has described the Grand Bazaar as a closed casket. For that is precisely

The bazaar in the late 19th century (above) and today (opposite). In earlier days, there were no real shops; the traders displayed their wares in niches or alcoves, or on simple stands.

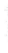

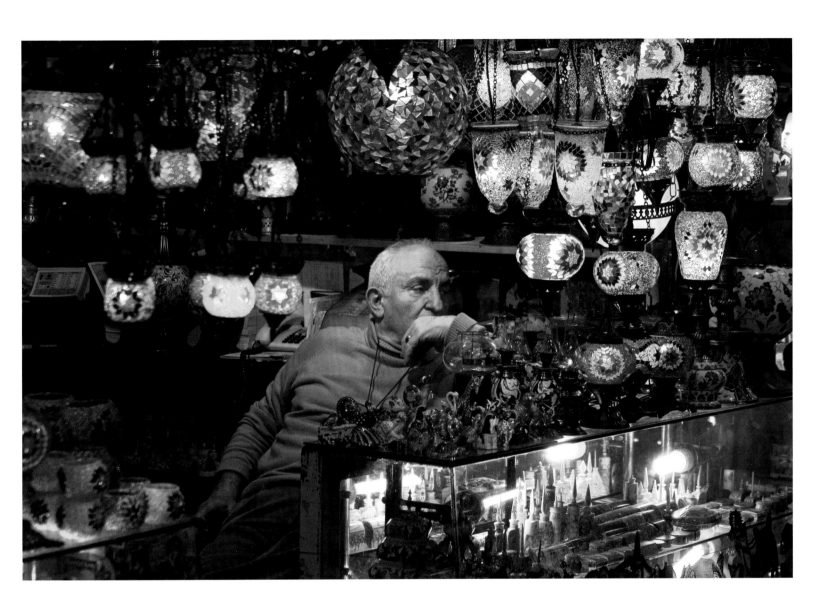

what it is, even today – a closed casket, a miniature Istanbul, a jewel handed down from generation to generation. And it carries with it all the marks of the turbulent history of the Ottoman Empire and the Turkish Republic. 'In Constantinople the stranger should above all visit the bazaars, for only then can he say he has truly entered into this gigantic city. One is overwhelmed by the sights, the splendours and the hubbub; one enters into a beehive, and each bee is a Persian, an Armenian, an Egyptian, a Greek. East and West sell their wares here. There is such a crowd, such a variety of costumes, such an abundance of goods as you will find in no other city.' What Hans Christian Andersen wrote almost a hundred and seventy years ago is still, despite all the changes that have taken place, as true now as it was then.

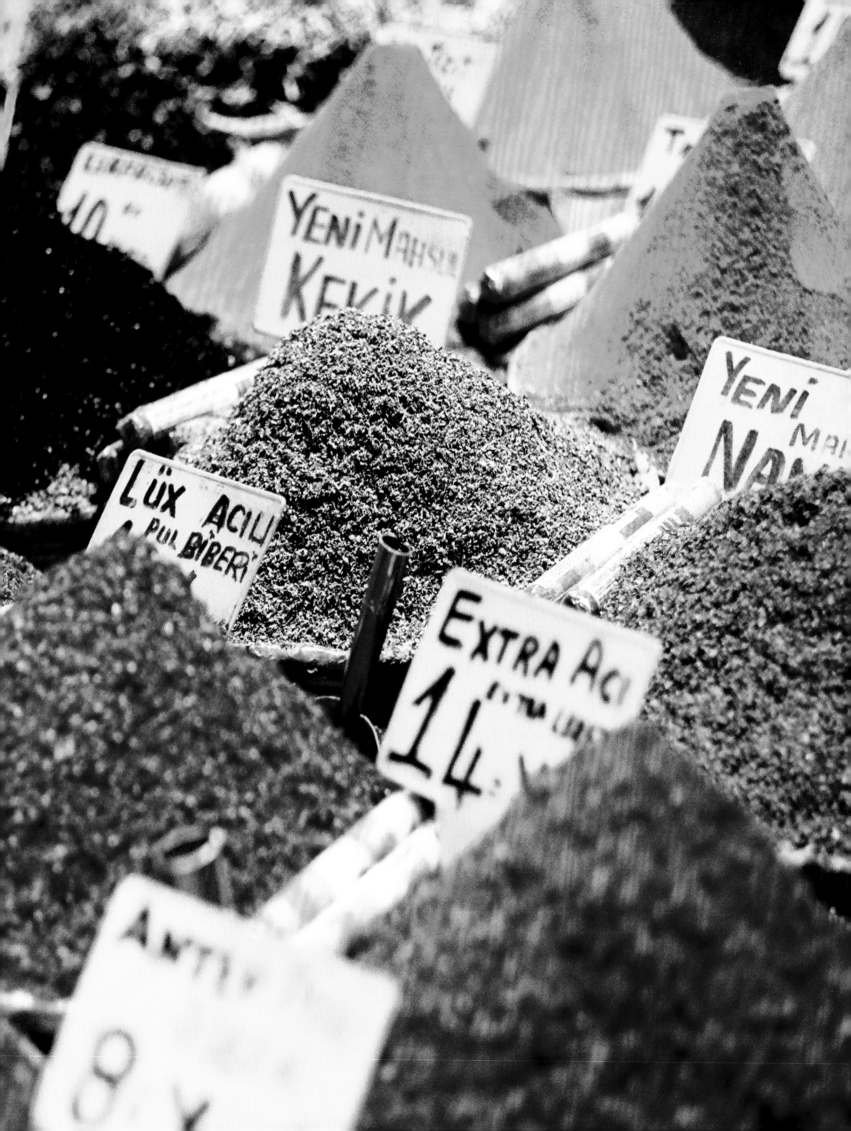

THE EGYPTIAN BAZAAR: ENCHANTING THE SENSES

On the shore of the Golden Horn, the beguiling scents of spices, sweets and perfumes entice people to enter the ancient walls of the Egyptian Bazaar, built by the mother of a sultan, 350 years ago.

A royal patroness

Sultan Ibrahim I, known as 'Ibrahim the Mad', had a favourite wife: a beautiful young Russian with long, flaming red hair. But Turhan Hatice was not only beautiful; she also knew how to get her own way. In order to secure her own power and to ensure that her son Mehmed IV would accede to the throne, she had Ibrahim's mother – one of her most dangerous rivals – strangled. This cold-blooded murder did not, however, inhibit a French scholar from describing her as 'the greatest and most enlightened woman ever to grace the seraglio.' The same scholar also found it perfectly normal that, in the middle of the 17th century, the beautiful Russian decided to leave 'to posterity a jewel of Ottoman architecture'. It was to combine mosque and bazaar, in order to provide 'an eternal monument to her magnanimity'.

It was not unusual for ladies of the court to make their mark as patrons of fine buildings. When discussions were going on as to an appropriate site for her project, someone remembered the ruins of an unfinished mosque in Eminönü, on the shores of the Golden Horn. Almost sixty years previously, another sultan's mother had also commissioned the construction of a mosque here, but her plans had failed to materialize.

The first failed attempt

Even in the days of the Byzantines, Eminönü had been a lively trading centre. The old spice market of the Genoese and Venetians is believed to have been situated here, close to the port, and today there is the same hustle and bustle. At the quayside, ferries and pleasure boats rhythmically come and go, swallowing or discharging their cargoes of people, while the fried fish vendor tries to shout down the breadseller. A broad street now separates the mosque and bazaar from the shore of the Golden Horn, and in the subways that lead from the water to the mosque, you can buy shoes, bags and trousers, all with fake designer labels. Children stand mesmerized before the dancing plastic dolls and the whirring toy helicopters, while their mothers rummage through a huge sack of socks to find a pair that will fit their little darlings. Outside the mosque, old men and women sit on their stools selling birdfeed. The thousands of pigeons are not regarded as a nuisance here, and the birds themselves take not the slightest notice of either the tourists or the locals that throng the Spice Bazaar. 'The sharp shrill voices of the volatile, talkative Greeks, the menacing aggression of the Armenians, the solemn, melodious tones of the stately Turks, the rushed greetings of the traders hurrying to and from the bazaars, and the loud cries of the rival boatmen to their impatient customers echo through the air…' wrote a 19th-century British traveller, describing the district on the shore.

Two hundred and fifty years earlier, when the mother of Mehmed III was planning her mosque complex, the district had been comparatively rundown, and scarcely worthy of a mosque. However, the Sultan's mother had apparently made up her mind that this was the right spot. She hoped that by building a mosque in a quarter mainly occupied by Christian and Jewish traders, she would make herself popular with the Muslims. For her project to be fulfilled, some private houses, a synagogue and a church would have to be demolished, but she promised to renovate two abandoned places of worship in another district and to provide compensation for the owners

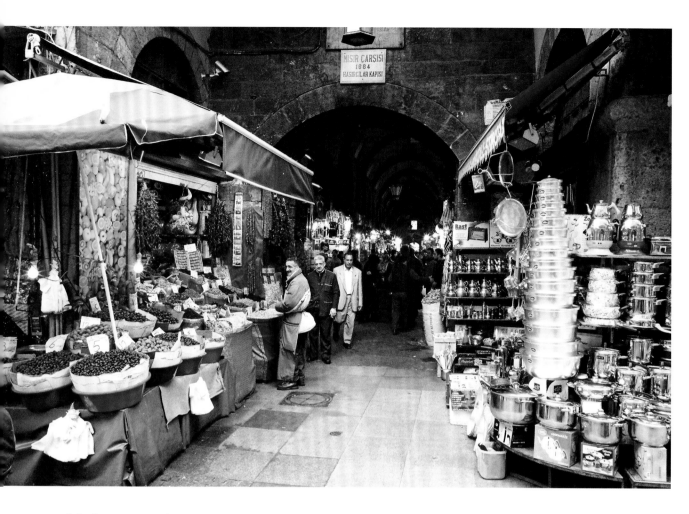

of the houses. But these promises were never kept: the ousted home-owners waited in vain for their money, which had gone into the pockets of corrupt court officials. It is therefore not surprising that the unfinished mosque was equated with *zulüm* – oppression – and clearly the whole enterprise was doomed from the start. The architect died, and shortly afterwards the client's son followed him to the grave. With the death of Mehmed III, his mother lost her influence at court, and was forced to leave the Topkapi harem. Work on the mosque came to an abrupt end, and not until half a century later were the reins taken up by the beautiful Turhan Hatice.

The Sultan's mother builds herself a monument

When Turhan Hatice ordered her mosque to be built, all that remained of her predecessor's project were the foundation walls. In the meantime, the Jewish traders had rebuilt their hovels, and the whole area had become a slum. Turhan Hatice thought it was disgraceful that an unfinished place of worship was being allowed to disintegrate in this manner. In order to drive out the non-Muslims, she sent criers round to

threaten the occupants with death, which not surprisingly created a good deal of resentment. Nevertheless, despite these overbearing tactics, the fiery Russian had a better reputation than her predecessor. One Turkish chronicler even wrote: 'What was once an act of oppression had become an act of justice.'

The complex, called a *külliye*, underwent a number of changes from the original plans. Beside the Yeni Valide Cami, or 'New Mosque of the Mother' (now known simply as the New Mosque), there were to be a bazaar, a sepulchre, a madrasa, two fountains and a palace. The income from the bazaar was to help finance the other institutions within the foundation. Initially, it was mainly products from the land of the Pharaohs that were sold in the L-shaped building – especially spices and cotton – and this gave the market its name of the Mısır Çarşısı or Egyptian Bazaar. Down through the centuries it also became known for its medicines. 'The Egyptian quarter… seems to be one large apothecary extending over two streets; all the spices of India and Arabia, all the herbal remedies and precious dyes exude their heady mixture of scents here. A yellowish brown Egyptian in a long

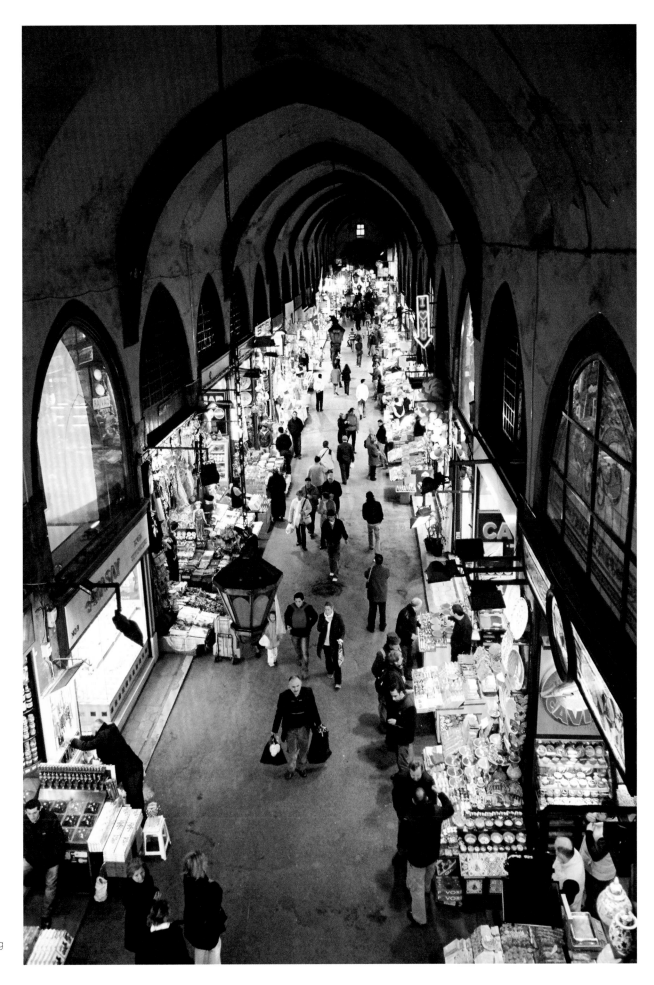

It is not only the ninety or so shops in the Egyptian Bazaar that sell spices, dried fruits and other foodstuffs. Nestling against the outer walls of the L-shaped market are lots of small stands that are overflowing with delicacies.

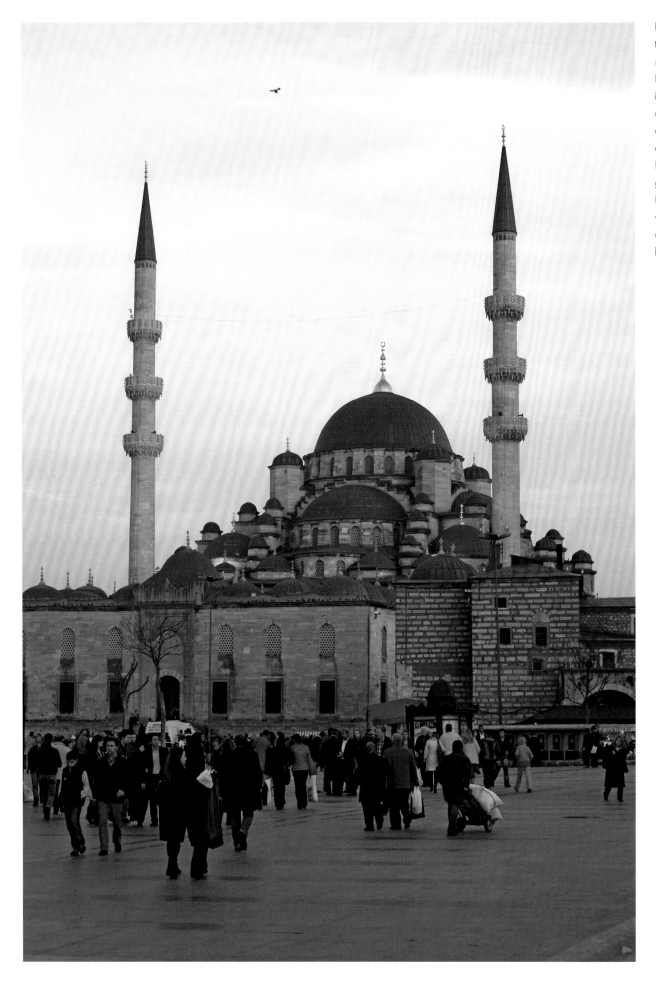

Next to the Egyptian Bazaar, the minarets of the New Mosque soar into the sky. In former times, part of the income from the market was used to maintain the mosque complex. On the nearby shore of the Golden Horn, where the Bosporus ferries now come and go, in the days of the Ottoman Empire ships laden with spices would moor at the quayside, and their cargoes would then be sold in the bazaar.

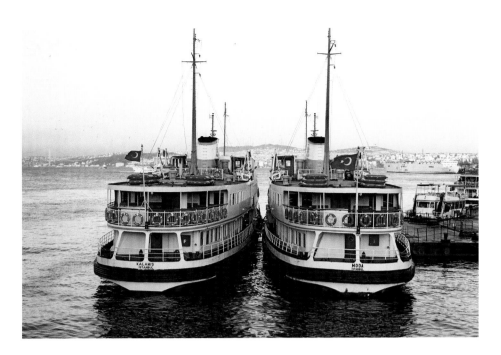

Above one of the two main entrances to the bazaar is the Pandelli restaurant, which is over a hundred years old. Its illustrious guests have included Kemal Atatürk, Robert de Niro and Audrey Hepburn.

robe stands behind his table, looking just the way one would paint an alchemist,' wrote Hans Christian Andersen in the mid-19th century.

In order to prevent the valuable spices and fabrics from being stolen, Turhan Hatice laid out in the foundation charter precise details as to how the place was to be guarded: 'Two honest, pious men suited to the task will be appointed guardians. They will alternate in closing the gates of the market in the evening and opening them again at morning prayers. These must be serious-minded and reliable men. They should do all that is necessary to prevent anyone from losing anything of greater or lesser value.' The mighty gates that protected the bazaar from any would-be thieves are also believed at one time to have housed two separate courts: one to settle disputes between traders, and the other for disputes between traders and their customers.

The spice bazaar survives the centuries

Many of the buildings in Turhan Hatice's mosque complex failed to survive the ravages of time, but haggling is as animated as ever in the almost ninety shops that make up the Egyptian Bazaar – despite the fires, earthquakes and other events that have drastically altered the face of the bazaar and its surroundings. In 1845, for instance, the Galata Bridge was constructed to link the two European sides of Istanbul. The walls which had originally surrounded

First my route took me through the spice bazaar, where all the sweet perfumes of Arabia wafted towards me.

Anna Grosser-Rilke, German writer, 1937

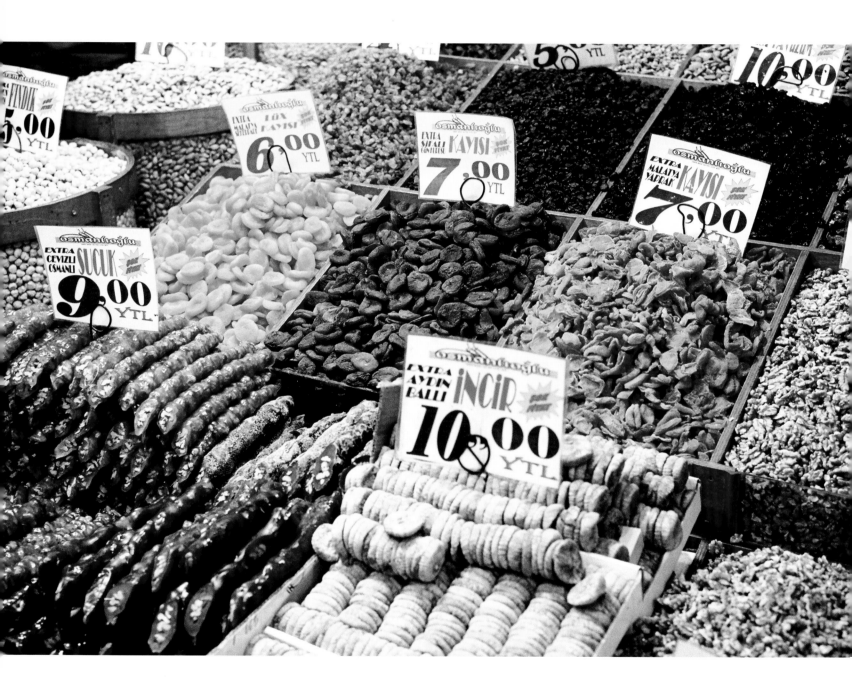

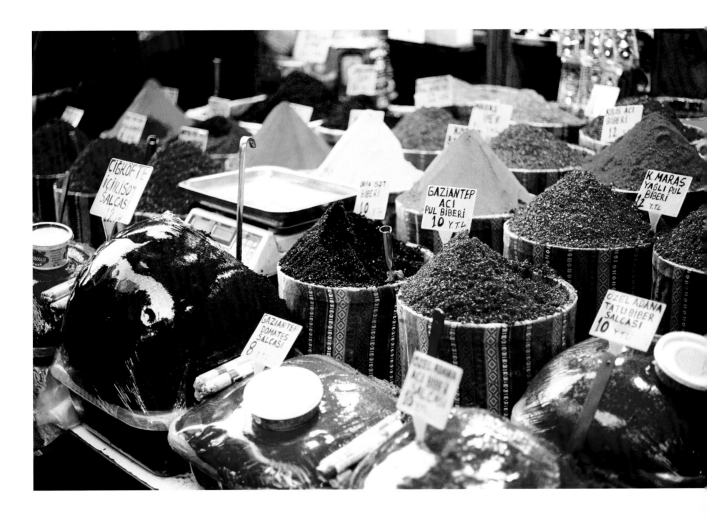

the whole complex were demolished. The courtyard that separated the New Mosque from the Spice Bazaar was gradually filled with shops – some of them little more than improvised cabins, which were often torn down and replaced by new ones. Today this area is occupied by the flower and animal bazaar. Perhaps due to a kindly gesture of fate, opposite the booths of the flower-sellers lies the tomb of Ahmed III, whose love of plants and gardens gave its name to a whole epoch, the 'Tulip Period'.

As soon as you enter the building through one of the four large or two small gates, you are greeted by the scent of an infinite variety of spices. Rose oil mingles with saffron, cloves and paprika. But it is not just the smells that enchant visitors; their eyes too can feast on the gorgeous displays of yellow, red, green, orange and white spices and powders. Great piles of pistachios, walnuts, dried apricots, sultanas and prunes set the mouth watering, along with artistically constructed towers of brightly coloured sweets. In addition to food, beneath the massive vaults that cover the two streets of the Egyptian Bazaar you can also buy jewelry and souvenirs. But of the Egyptian wares that gave the market its name no trace remains.

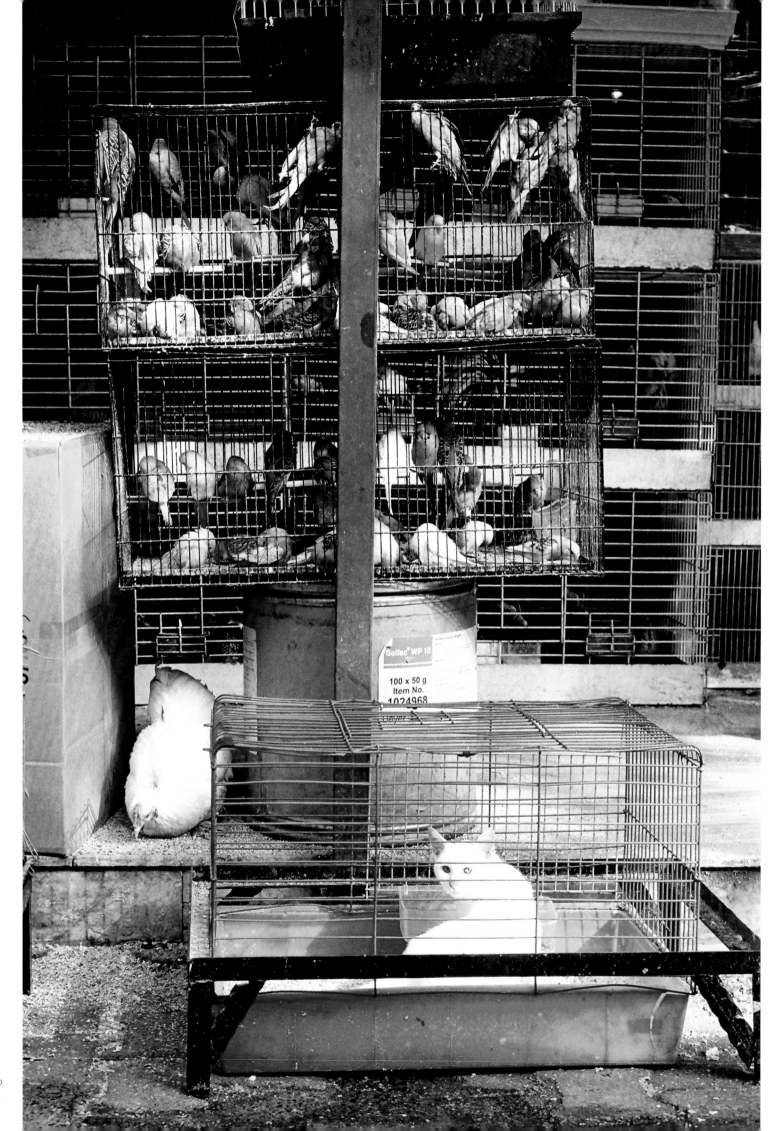

In the courtyard of the Spice
Bazaar is the animal and flower
market. Here you can find
everything from budgerigars
and iguanas to tulip bulbs.

In the animal and flower market, there is even a trade in telling fortunes: for a small contribution given to its owner, a little white rabbit will poke its nose into one of the folded papers, and there you will learn all about your future.

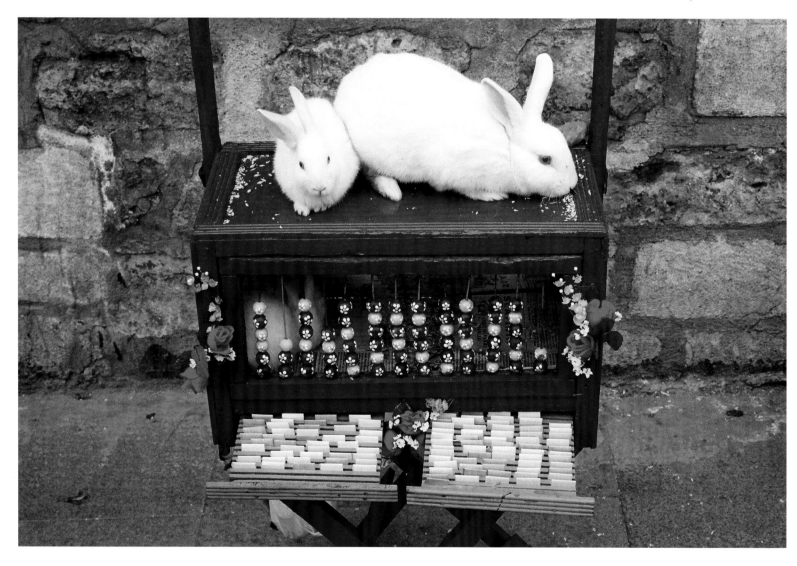

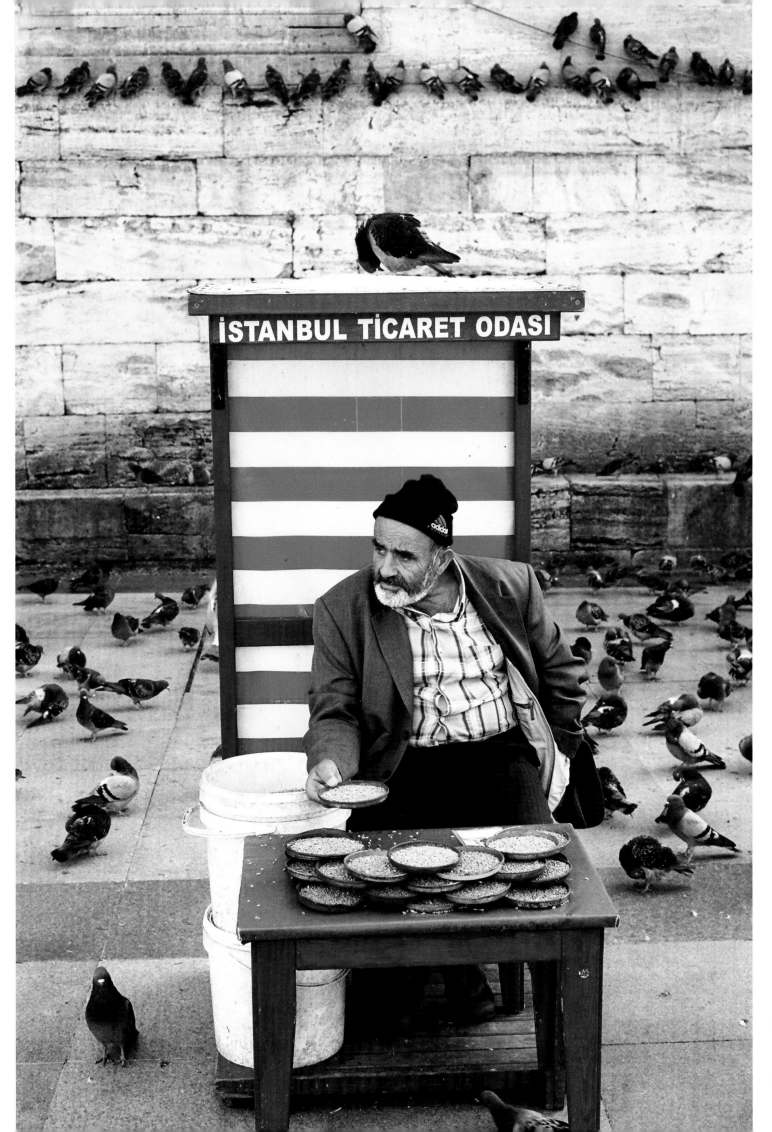

İSTANBUL TİCARET ODASI

THE BOOK BAZAAR:
IN THE REALM OF THE WRITTEN WORD

The site of the modern book market or Sahaflar Çarşısı is also where the Byzantines used to buy their manuscripts and paper. Until well into the 20th century, it was the main antiquarian market, but through the spread of libraries and bookstore chains, it has now lost much of its economic importance. The charm of this little vine-covered square, however, remains undiminished.

A ban on printed books

The idyllic, sleepy little book market lies between the Grand Bazaar and the Bayezid Mosque. In a flowerbed right in the middle of the square, which is filled with stalls and shops, stands a copper bust on a solid marble plinth. Few visitors even notice it, and even fewer know who the stern-looking bearded man actually was. But Ibrahim Müteferrika was the Turkish equivalent of Johannes Gutenberg. He was a Hungarian, born Ibrahim Pasa, and in 1727 he opened the first Ottoman printing press in Istanbul – albeit some 250 years after his German counterpart had invented the letterpress and started a media revolution. Although the Ottomans were the first Muslims to use such presses, printing was for a long time regarded as undesirable, since the oral communication of stories was deeply rooted in Islamic tradition.

Towards the end of the 15th century, Sultan Bayezid II imposed the death penalty on anyone who founded or worked with such a press, and his son confirmed this strict decree. But the ban did not apply to everyone. In 1493 the Sultan allowed Jewish refugees from Spain and later also the Christian minority to print books, but they were not allowed to do so in Arabic script. A century later, the ban was also lifted on non-religious books printed in Europe in Arabic script. But for Muslims, the printed word continued to be taboo. Duplication in Arabic of the Koran, which was perceived to be the Word of God, was restricted to the calligraphers, and Muslims continued to view the printing press as an offence against the basic tenets of their faith.

The first Muslim books

Despite the opposition, Ibrahim Müteferrika persisted in his campaign to be allowed to print books. He laid special emphasis on the fact that the technique would enable correct texts to be made widely available at reasonable prices, thus providing a reliable means of disseminating knowledge for the benefit of all Ottomans. He also argued that the printing of books would help substantially to raise the general level of education. Furthermore, the many fires and earthquakes to which Istanbul was constantly falling victim would result in the loss of countless sources and documents that would somehow have to be replaced. And finally, a *fatwah* was issued – a formal legal decree – which at least partly invalidated the official ban. Permission was granted for medical, astronomical and geographical books to be printed, although the ban remained in force for books on theology and law. The Koran itself was not even mentioned.

However, Müteferrika now found himself confronted by a technical problem: it was not possible for him to obtain Arabic type, because there were no Arab countries in which books were being printed. He therefore had to manufacture the type himself.

His printing press was as large as a cupboard. But he only succeeded in producing seventeen volumes. The Ottomans still preferred their handwritten texts, and by comparison with their gracefully curved calligraphy, they found the printed letters ugly. A further obstacle lay in the fact that the copyists, who were a powerful group of professionals, put up heavy resistance. A report published in Frankfurt in 1728

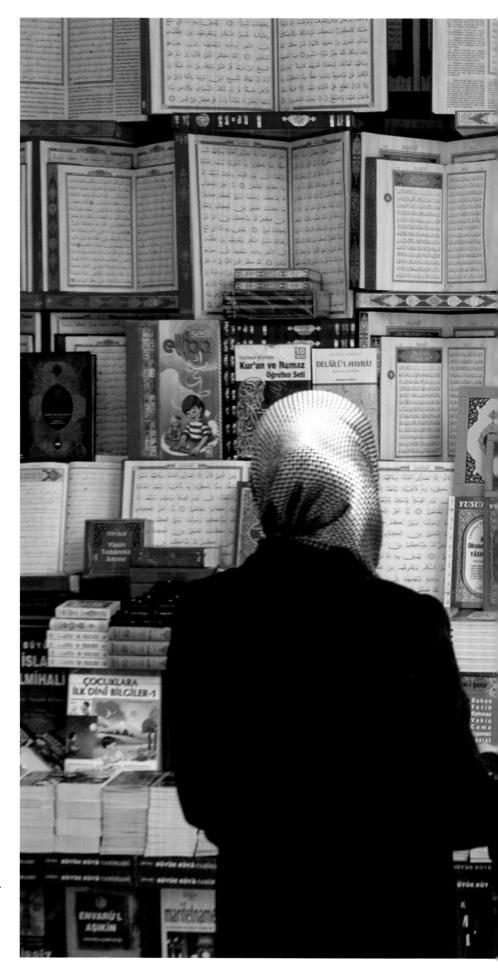

> *In Constantinople there are vast quantities of books. The libraries and bazaars are overflowing with them.*
>
> Abu'l-Hasan al Tamgruti, Moroccan envoy, 1589–90

described the situation as follows: 'The Mufti was strongly opposed to the innovation, regarding the establishment of a press as the equivalent of holding God hostage, which would be as damaging to the Sultan's subjects as the plague. Indeed, the danger of the innovation was not confined to the teachings of the Prophet but could also be of no possible benefit to the State if a million scribes, who had hitherto made their living by copying, were now suddenly reduced to beggary and became a burden to the Sultan.'

Only when Alois Senefelder invented the technique of lithography in Munich at the end of the 18th century did printing establish itself in the Ottoman Empire, because this method enabled the calligraphers to create the script that was to be transferred into print. 'Lithography, which in Europe was only a minor aid to typography, became supreme in the Orient and the Maghreb,' wrote a Tunisian historian. In 1828, thanks to this method of printing, Tehran saw the first publication of the Koran printed by Muslims for Muslims. Not until fifty years later did the Ottomans print the first official edition of the Holy Book. All the same, there had been a few earlier editions which had been sold in junk shops but had then invariably been confiscated. Today, no one in the Islamic world objects to the Koran being printed, but most modern editions are produced by lithographic or digital techniques, because they are best suited to retaining the similarity to handwritten texts.

Booksellers of the Grand Bazaar

After the introduction of lithography, the number of presses increased and the book trade expanded considerably. The Istanbul Book Bazaar became the main book centre of the Ottoman Empire, as well as being

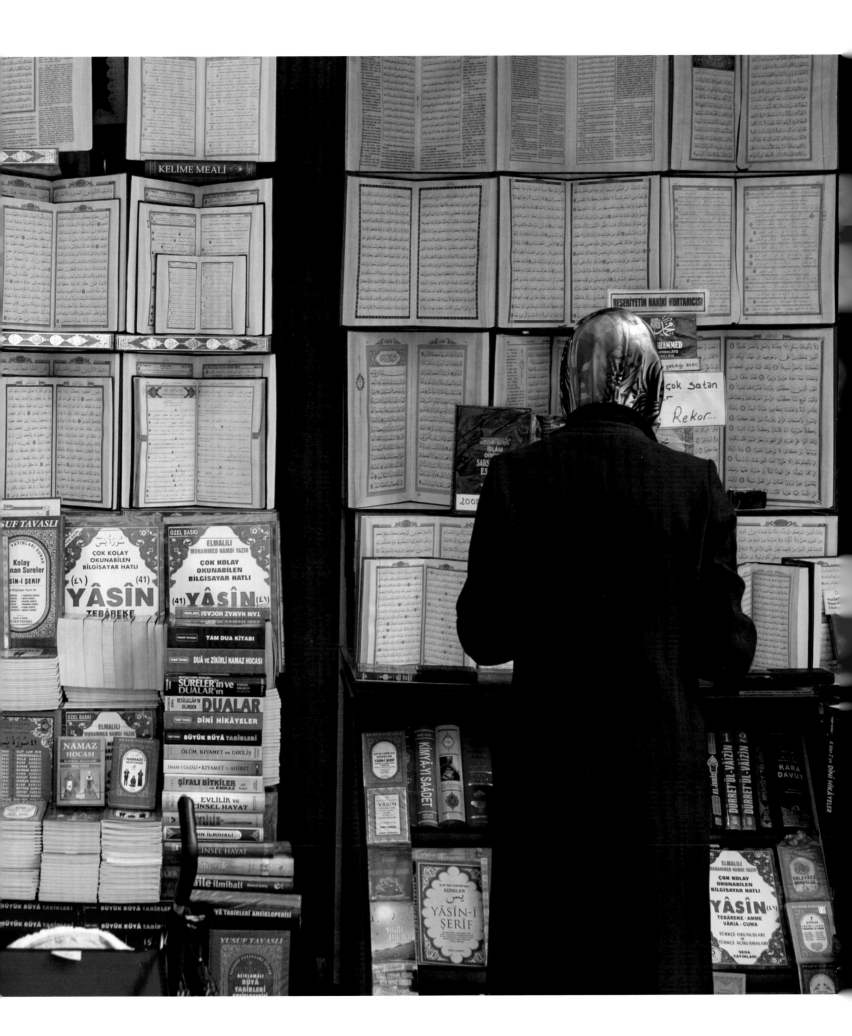

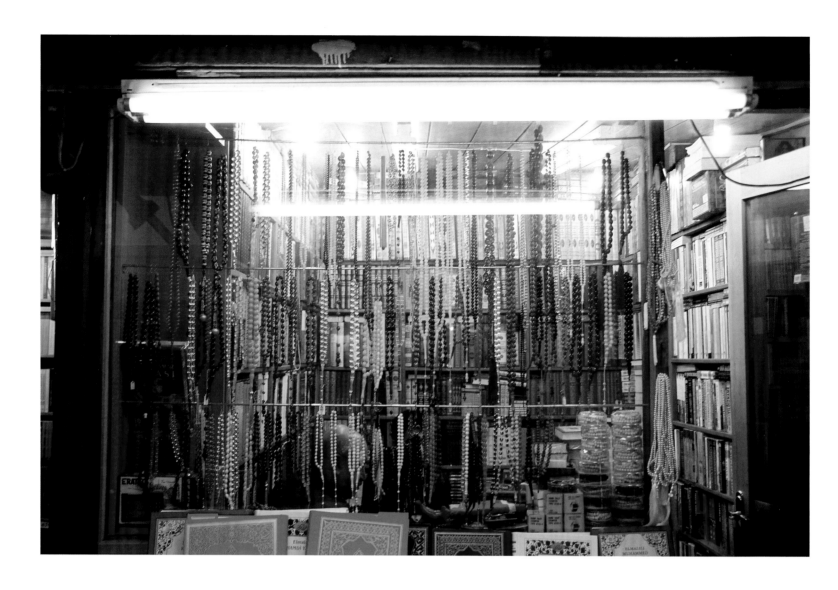

a meeting place for intellectuals, students and scholars, though even before the arrival of print, the guild of booksellers had played an important role. But in those days, the city's largest Book Bazaar was situated by the exterior walls of the Old Bedesten in the Grand Bazaar. The northern gate of this building is still called the Sahaflar Kapusu or 'Gate of the Booksellers'. Many unique editions are believed to have been brought to Istanbul as booty from the war against the Persians in 1514. A Habsburg envoy wrote in the 16th century that there were valuable collections of ancient Greek manuscripts in the Grand Bazaar. He donated many of the works that he bought there to the imperial library in Vienna. Christians were not, however, allowed to buy the Koran; they had to find a Muslim go-between to do that for them.

Booksellers who did not have a shop of their own would simply spread their books on the ground, while others lent out their manuscripts and pamphlets for a silver coin – a kind of mobile library. Even though booksellers belonged to a highly respected guild, an Englishman who lived in Istanbul for three years in the middle of the 19th century found them anything but respectable: most of them, he said, were old, badly dressed and unfriendly. Little wonder, then, that a common saying was 'worse than the booksellers'.

The booksellers move house

Until the devastating earthquake of 1894, the booksellers were housed in the Grand Bazaar. After the quake, they moved to their present site, where tourists and locals alike can examine their wares. Even during the days of the Byzantine Empire, books and especially paper were on sale in the little square that now nestles between the Bayezid Mosque and the Grand Bazaar. Until the early 20th century, this market was the largest book centre in the whole of the

In the antiquarian book market, you can buy prayer beads and other religious objects as well as books. That may well be the consequence of the market's proximity to the Bayezid Mosque. A tale often told in the bazaar is that of a muezzin whose call to prayer was so beautiful that many an unbeliever, on hearing his dulcet tones, was converted to Islam.

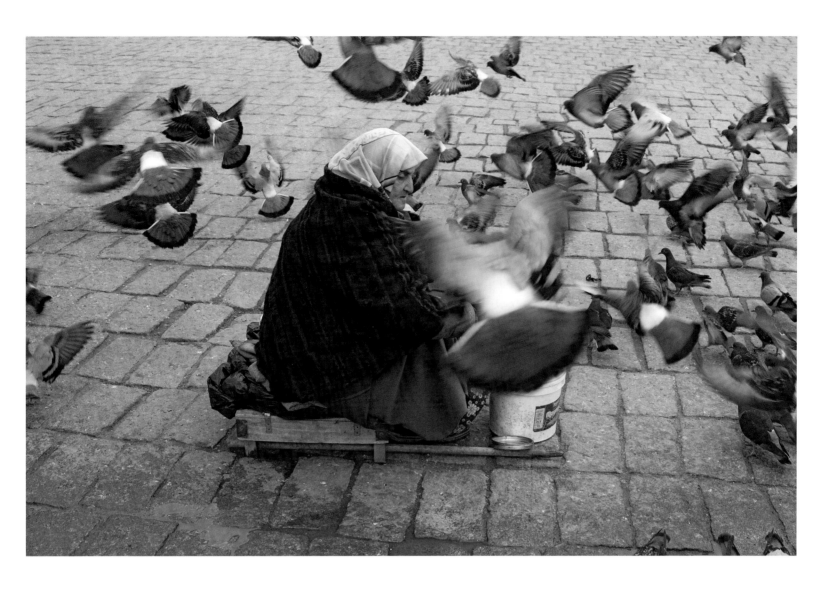

Middle East, but since the 1920s the advent of libraries and modern bookstores all over the city has greatly reduced its importance.

Nevertheless, this idyllic bazaar has lost none of its charm. It is an oasis of peace by comparison with the turbulence of the Grand Bazaar. Vines form a roof over it, with the sun shining through their tender green leaves, which in autumn turn a fiery red. Books are piled outside the shops, many of them computer guides, history books, and other weighty tomes for students from the nearby university; but there are also picture books, cookbooks, calligraphy, Ottoman miniatures, editions of the Koran, and old prints and maps. Many of the dealers will even search the city if you are after a particular volume that they don't have in stock. If Ibrahim Müteferrika could see this vast treasure house of printed works today, he would surely be proud to have laid its foundation stone.

THE MANY FACES
OF THE BAZAARS

Even today there is a romantic aura and an oriental charm pervading the old buildings, the winding alleys, the friendly vendors, the busy craftsmen and the vast array of colourful, exotic wares that fill the bazaars of Istanbul. Streets that offer nothing but gold or carpets are a reminder of the time when the bazaars were strictly organized into sections and the craftsmen into guilds. The tightly packed complex of mosques, Turkish baths, fountains, warehouses, workshops and bazaars looks back to an era when trade and religion were closely bound together, and there was a strict market code which in the traditions of Islam were a guarantee of honesty and good conduct.

The bazaars of Istanbul are trade centres from a bygone time, and yet even in the present they still draw and enchant people from all over the world. The tourists and the locals do not come here only to stroll through the labyrinth of alleys, to gaze in wonder at the displays, or to breathe in the unique atmosphere; now, as they have done for centuries, they come to the bazaars to buy. Here they can find everything a shopper's heart desires, from the commonplace to the rare. Competition from shopping malls and auction websites has not yet been able to rock the foundations of this institution. Perhaps the continued attraction of such historic centres as the Grand Bazaar and the Egyptian Bazaar lies in the fact that 'doing business' here still follows a very special ritual. You do not simply buy a carpet, a kaftan or a bracelet. The act of buying is an event in itself.

As in a game of chess, dealer and customer weigh each other up with an equal degree of suspicion and respect. Then they each take turns in making their move. The one aims high, the other low, with the seller praising the excellent craftsmanship of this extraordinary piece, and the buyer bemoaning his lack of funds. The seller sighs that times are hard, and he has a large family dependent entirely upon himself. The customer tells of the fine carpet that he was offered elsewhere at a far, far lower price. Each studies the reactions of his opponent for a possible sign as to whether he has gone too far or perhaps can make another move in the game. It can take hours for the ritual to be played to a conclusion, but then it may well be that both parties will finish claiming victory: the seller has done good business – for he would never sell anything below its market value – while the customer pays as much as the object is worth to him, so feels he has made a good deal.

During these tense negotiations, it is not just a matter of closing the deal and exchanging goods for money. You are completely taken over by the whole process, immersed in a timeless world that scarcely exists beyond the walls of the bazaar. People drink tea together, tell each other about their lives, build up a sense of trust. Islamic bazaars are not simply trade centres, but markets in the original sense – community centres where goods and stories are exchanged. And in this context, they are also accurate reflections of Eastern life.

COMMERCE AND CRAFTSMANSHIP: A SCHOOL FOR TALENT

The Ottomans gained a reputation far beyond the borders of their Empire for their fine craftsmanship. The employees of the palace workshops set the tone for the Ottoman style, and their designs created fashions that spread throughout the Empire. Today, however, mass production has taken over, and very few items are produced by hand in the workshops of the bazaars.

The forgotten pattern of the bazaars

One street contained a whole row of carpet shops; the next was for shoes, and around the corner you would find only fabrics. If you go to a bazaar or souk in any Islamic country, you will still find the same division of goods, but the pattern is nothing like as strictly pronounced as it was in former times. 'When you wish to buy a pair of shoes you have the swing of the whole street – you do not have to walk yourself down hunting stores in different localities. It is the same with silks, antiquities, shawls, etc.,' wrote Mark Twain, lauding the advantages of the system after a trip to Istanbul at the end of the 19th century. Grouping products together certainly made life easier for the consumers, because they could simply compare the quality and value as they moved from one shop to the next. In those days, the system was strictly enforced. If in one particular street traders dealt in gold, then it was strictly forbidden for anyone to offer other products. And if you had a shop in one street, you were forbidden to open up another one elsewhere or, for instance, to trade in silver and carpets at the same time.

In Istanbul's Grand Bazaar, the only relic of this traditional style of organization is the street names, for nowadays all kinds of products are sold in all streets. Jewellers have shops in the street of the fur hat sellers, and you can buy leather goods in the street of the polishers. Many of the old trades disappeared long ago, and their place has been taken by a whole variety of newer products. Furthermore, the traders and craftsmen are no longer organized into guilds, which in former times were responsible for maintaining the traditional order.

The guilds

In addition to the wholesalers and import and export traders who brought luxury goods to Istanbul from all over the Ottoman Empire and from elsewhere in Europe, there were the shopkeepers themselves, and they were organized into guilds that handled the products made by local craftsmen. According to the Turkish historian Evliya Celebi there were nearly 80,000 craftsmen in Istanbul during the 17th century, working in more than 23,000 shops and workshops, and divided up into 1,100 different professional groups. These groups were combined into the larger units of the guilds.

The guilds had an important role to play in the Ottoman Empire. During ceremonies such as the circumcision of a prince, or if the army was going to war, the guilds would parade in all their splendour. Evliya Celebi takes almost sixty chapters to describe just one of these parades. The Sultan himself watched the spectacle from the procession pavilion at the Topkapi Palace. It was led by the palace staff, followed by less prestigious groups, such as the manure collectors and the gravediggers. Even pickpockets, pimps and male prostitutes formed themselves into guilds, although they had to be accompanied by guards. Later the butchers, slaughterers and cheesemakers filed past the Sultan, all demonstrating their arts to the watching crowds. Apprentice butchers, for example, would cut up a ram, its horns decorated with layers of pure gold and silver. Right at the end came the wine merchants.

In the early 18th century, the wife of the British ambassador, Lady Mary Wortley Montagu, also described one of these spectacular processions which could go on for days. 'Then a little machine drawn by

oxen, in which was a windmill, and boys employed in grinding corn, followed by another machine, drawn by buffaloes, carrying an oven, and two more boys, one employed in kneading the bread, and another in drawing it out of the oven. These boys threw little cakes on both sides amongst the crowd... and after them two buffoons, or jack-puddings, with their faces and clothes smeared with meal, who diverted the mob with their antic gestures. In the same manner followed all the companies of trade in the empire; the nobler sort, such as jewellers, mercers, etc. finely mounted, and many of the pageants that represent their trades, perfectly magnificent; amongst which, that of the furriers made one of the best figures, being a very large machine, set round with the skins of ermines, foxes, etc. so well stuffed, that the animals seemed to be alive, and followed by music and dancers. I believe they were, upon the whole, twenty thousand men, all ready to follow His Highness, if he commanded them.'

But these processions were not the main purpose of the guilds. Far more important was the fact that they regulated competition and gave aid to members in need. They helped craftsmen to open shops or workshops, gave money to the sick, and took on the costs of burial if a member died. They also paid the wages of guards and firemen, gave alms to beggars in the bazaars, and made sure that the master craftsmen gave proper training to their apprentices, for only by qualifying as masters could the latter open a work-shop of their own. Each guild had a fixed number of members, and if one died, his place went to his son, or a travelling trader would buy the tools and wares of the deceased, and the money would go to his family. The *kethüda*, or president, was the link between the guilds and the state and was responsible for collecting taxes. In addition to the secular head, the guilds also had a spiritual leader, the *şeyh*.

Stimulating the economy, safeguarding morality
Competition and profiteering were frowned on by the guilds. If a member accumulated too much money and had therefore violated the unwritten laws, he would be expelled. Traders therefore did not object

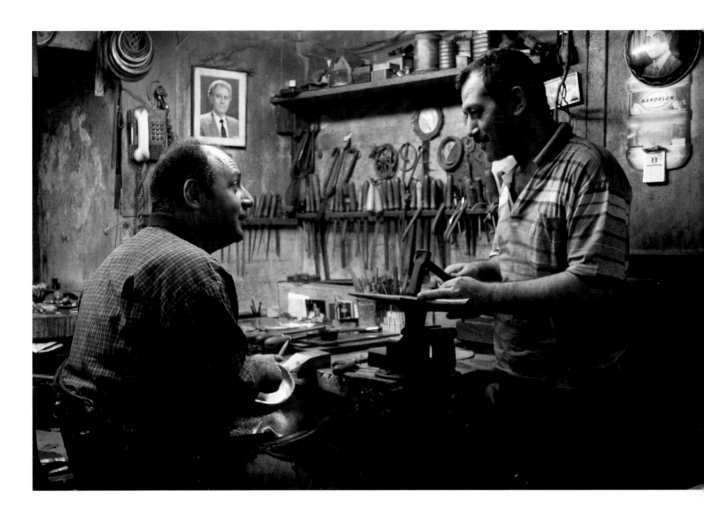

to selling the same wares as their neighbours, or being forbidden to put up signs in order to draw attention to their own business. On the contrary, any attempt to attract customers, e.g. by praising one's own goods and talents, was regarded as dishonourable. The sole permissible argument for the sale of products was their beauty and artistic quality. Traders only showed their customers pieces which the latter explicitly asked to see, and if they decided not to buy, the trader would make no attempt to talk them round.

This mode of conduct goes back to Islamic law. Traders and craftsmen were subject to the *Hisbah*, according to which all Muslims are bound to promote good and avoid wrongdoing. A market supervisor kept strict watch to ensure that these moral principles and indeed all the precepts of Islam were adhered to. He checked the accuracy of weights, made sure that rules of hygiene were observed, and prevented price fixing and unfair competition. He had the right to collect contributions and taxes, and also to punish offenders. At the beginning of the 17th century, a German traveller described one form of punishment:

'Sometimes a cheat is made to carry around a thick plank with a hole cut in the middle, so his head can go through it…Whenever he wants to rest, he has to pay out a few aspers [silver coins]. At the front and back of the plank hang cowbells, so that he can be heard from a distance. On top of it lies a sample of the goods with which he has tried to cheat his customers. And as a supposedly special form of mockery, he is made to wear a German hat.'

Today you will find very few traders in Istanbul's bazaars who adhere to these strict regulations. The guild system and the Islamic code of marketing lost their influence in the 19th century, and Western forms of trading took over. Another factor in the decline of the guilds was the importation of cheap, machine-made goods, to the detriment of local products. Traders in the Grand Bazaar later formed a new union, and the different branches founded new associations, but their functions were nothing like as extensive as those of the old guilds. There is no longer, for instance, any check on the qualifications of those who trade.

The whole of Istabul is one great bazaar. It is not only around the Kapalı Çarşı that people sell their wares – every city district has its own weekly market and street traders.

Ehl-i hıref: the community of the talented

In addition to the craftsmen who sold their goods in the bazaar, there were others who worked for the court. These men, who determined the aesthetic style of the Ottoman Empire, worked in studios and workshops attached to the court in Istanbul, and they were known as the *ehl-i hıref*, meaning the 'community of the talented'. This association might best be described as a forge of ideas. Their aim was to set standards and to promote research and development. This community was founded in the reign of Sultan Bayezid II, and its artists worked predominantly for the court and the cities of Istanbul, Edirne and Bursa. In the early 16th century, there were over 600 members of this elite body, and in the 17th century the number had increased to 2,000.

The backgrounds of these men were as varied as those of the citizens of the Ottoman Empire. Artists, masons, weavers, metalworkers and tailors from Egypt, Persia and Syria worked side by side with calligraphers, draughtsmen and miniature painters from Georgia, Bosnia, the Balkans, and even Austria and Hungary. With their foreign styles and special techniques they all influenced one another and thereby enriched the artistic world of the Ottomans. Some of these men were following in the footsteps of their fathers, and continuing a family tradition, but many

came to Istanbul after the conquest of Tabris and Cairo. Non-Muslims were also taken to the palace in Istanbul through the *devşirme*, a system of recruiting boys whose artistic talents were then developed. As in the municipal guilds, every member of the *ehl-i hıref* had to start as an apprentice and work his way up to the status of master craftsman. The most talented or most influential of them would then be appointed director of the court workshops. The artists were given a fixed wage according to their status, ability and range of responsibility, but employment at the court did not stop them from also working for others, so long as they continued to discharge their duties. Many of the craftsmen who had been recruited as boys went on to work independently in the city. The designs of the artists and miniature painters from the royal studio – known as the *nakkaşhane*– were known and used for all kinds of decorations throughout the Ottoman Empire. From here, for instance, came the designs for Iznik tiles and Bursa silks, but other workshops at the court also used motifs such as elaborate flower decorations on their weapons, book covers and silver salvers.

Inspiration from abroad

Another influence on Ottoman style was the luxury goods that were imported from other countries

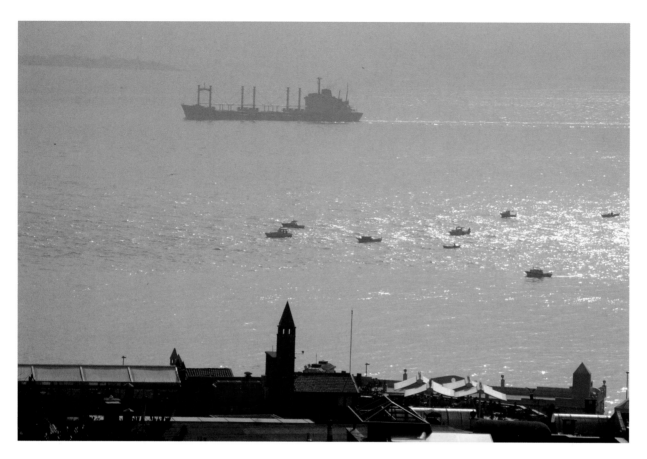

The huge freighters coming from the Sea of Marmara can only navigate the narrow Bosporus one at a time on their way to the Black Sea. Ships often have to wait for days before taking their turn to pass through.

after the fall of Constantinople. The Ottomans had trade relations with Genoa, Venice and Ragusa (now Dubrovnik), and European wares such as furs and fancy clocks came to the metropolis on the Bosporus as war tribute from the defeated nations, while silks and satins went back and forth between Istanbul and Venice. The court was particularly fond of Chinese porcelain, and the cloud motifs even found their way into Iznik ceramics. In Bursa, silk from Iran and spices from India were exchanged for fabrics from Europe. This constant interchange between East and West had a strong influence on Turkish crafts, and even in those fields in which the Ottomans achieved an international reputation – such as Iznik tiles – the influence of their foreign models can still be seen. In the 17th and 18th centuries, Western influences on Ottoman art became increasingly obvious. Bowls of fruit and bouquets of flowers made their appearance on porcelain, embroidery and woodwork, later to be joined by baskets, shells, bows and garlands. This style became known as Turkish rococo.

The most important Ottoman artworks were, however, produced in the 16th century. The patronage of Sultan Süleyman I in particular gave enormous impetus to the creative powers of the craftsmen. Istanbul became one of the largest and richest cities in the world. Diplomats, traders and artists flocked there to seek wealth and inspiration. But the introduction of American silver into Europe resulted in devaluation of the currency, and the shift of trade routes from the Mediterranean to the Atlantic meant a considerable reduction in taxes. During the second half of the 16th century, the income of the state fell by about fifty per cent. After that, the budget was regularly in deficit, which meant ever higher taxes to be paid by the people. The decline in the economy inevitably affected the arts, and the end of the conquests also brought an end to the flow of talented artists. The sultans continued to live beyond their means, but even they eventually had to realize that there was no money left for the fine arts. By the end of the 18th century, the court artists were no longer significant figures, and the Crimean War of the mid-19th century was the final blow. They were replaced by poorly trained craftsmen whose inferior work and materials bore no comparison to the products of their predecessors. Many of the traditional crafts have now died out.

At the Perşembe Pasarı or Thursday Market in Karaköy, tradesmen can buy all the supplies they need, from drainage pipes and tools to toilets and traffic signs.

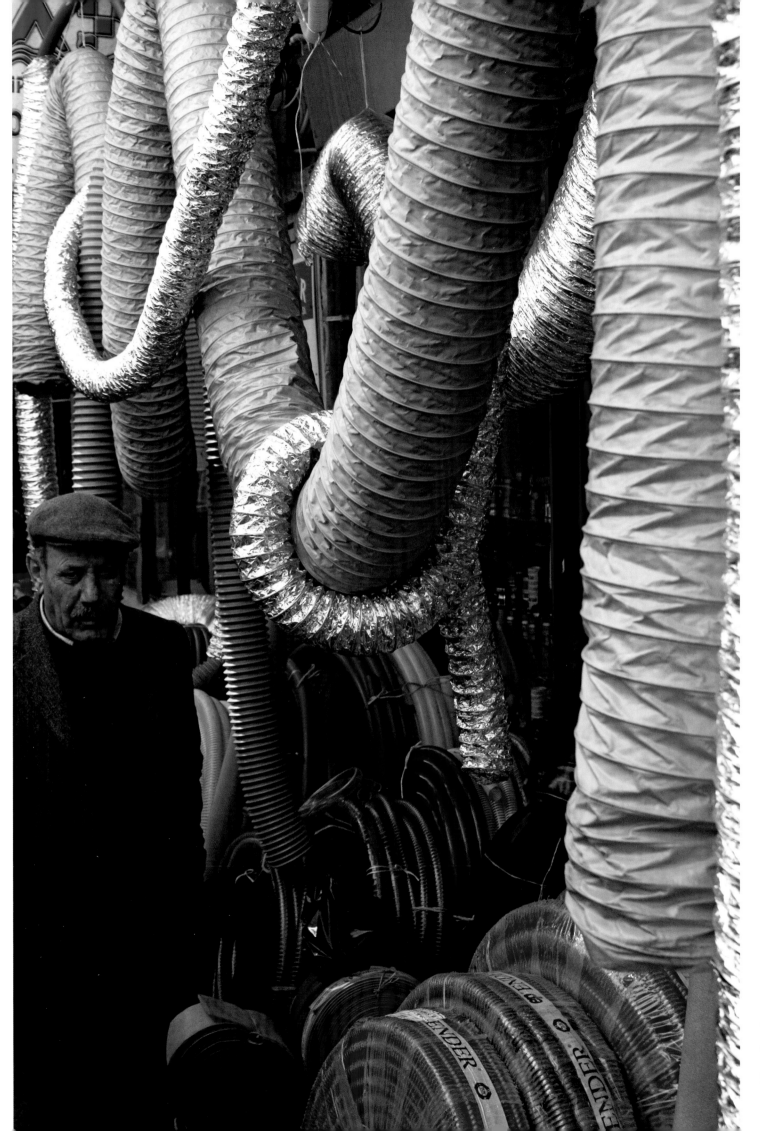

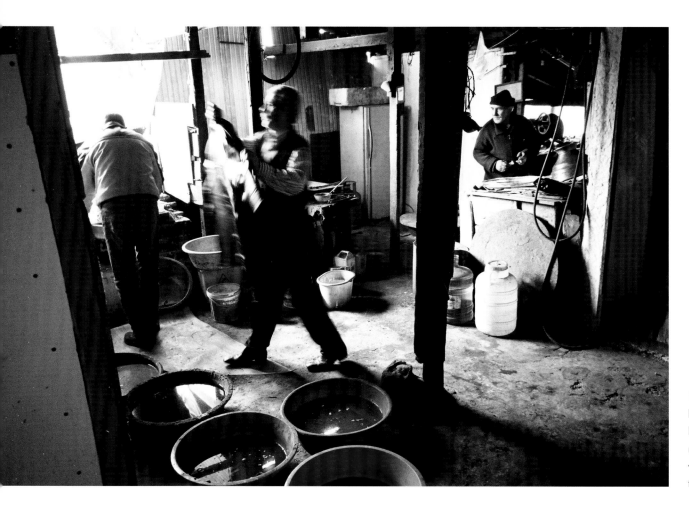

Kenan Kahya used to make leather hoses for water pipes, but these are now machine-made. Now he dyes and waterproofs leather jackets in the attic of the Iç Cebeci Han.

Craftsmen: an endangerered species

There are, however, still a few craftsmen hidden away in the workshops and backrooms of the bazaars, practising their arts. If you happen to come upon one of these old-fashioned workplaces, you will feel as if you have been transported back in time to a different century. On the second floor of the Iç Cebeci Han in the Grand Bazaar, you can hear the regular hammering of one of the last coppersmiths, who uses his heavy hammer to beat out gigantic copper vats from thin metal plates or dishes; these are used to make Turkish Delight. There are even students from the Faculty of Arts who come to watch him at work, for this is now a rare sight.

How long the copper-beater will go on hammering in his tiny workshop no one knows. Rents in the Grand Bazaar are getting higher and higher, and there are few customers now willing to pay the price for good, handmade products. The last three clothes-menders in the bazaar are also feeling the pinch – who wants to pay for a patch in a suit that only cost thirty euros to start with? Altan Örme, one of the menders, looks back nostalgically to the good old days: forty or fifty years ago there were at least ten of them busily stitching away, and if one of them was overworked, he would send new customers to his neighbour. 'Things like that don't happen any more. Money is all that matters. We clothes-menders are crazy people,' he confesses with an embarrassed smile. But even crazier is the man with whom he shares his small space in the bazaar. With just two pairs of pliers, Mustafa Dipevliler makes chain mail shirts. He has never sold a single one. But he believes in his business plan, and goes on adding ring to ring until after nine months he has completed another of his iron shirts, each weighing nearly 20 kg (44 lbs).

Not all the craftsmen have the same talent for endurance. Kenan Kahya dyes and waterproofs leather jackets. Previously, he made leather hoses for water pipes, but these are now mass produced. Many traders are no longer willing to pay the increasingly high cost of wages in Turkey, but they still want to go on selling handmade products. The solution is to get their ivory figures carved in Egypt, or their ornate swords and daggers forged in India – in the Ottoman style, of course.

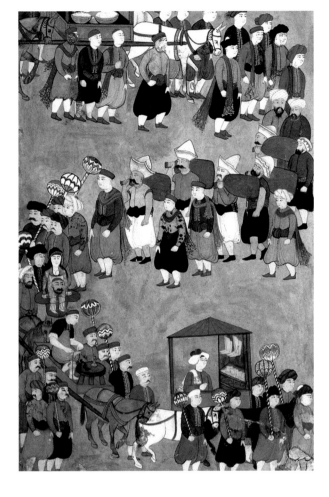

The procession of the guilds past the Topkapi Palace was often captured by Ottoman miniature painters. The spectacle, in which over a thousand professions took part, used to last for days on end.

Workshop closures

Goldsmiths, gem-setters and polishers are still fairly common in the vicinity of the Grand Bazaar. They have studios and smithies in nearby business premises or *hans*, but for some time now they have not been welcome neighbours. The toxic chemicals used by goldsmiths disfigure and corrode nearby buildings, and the cyanide, nitric and sulphuric acids are not always properly disposed of. A new industrial complex, the Kuyumcukent, has been purpose-built in a suburb of Istanbul for these craftsmen, with all the latest technology, modern workshops and display rooms, along with access to ecologically sound waste disposal methods. But this town of gold is still for the most part empty, because the craftsmen are reluctant to leave their traditional quarters. They are afraid of losing their regular clientele, and in any case it would cost most of them far too much to maintain a work-shop outside the city and run a shop in the bazaar at the same time.

There are, however, more than green concerns behind the move. On one hand, many of the sellers suspect that in the new industrial zones the tax authorities will find it easier to check exactly how much jewelry is being sold and how much gold is being processed, and by whom. And on the other hand, the whole area around the Grand Bazaar is due for renovation. There are plans to convert the historic *hans* into hotels, restaurants and cafés, and so the powers-that-be want to demolish the illegally built houses, of which there are plenty. Market stalls and booths which for decades have snuggled up against the exterior walls of the bazaar would also fall victim to these measures. Whether the tourists would gain from them is also questionable, for what would the bazaar be without its craftsmen?

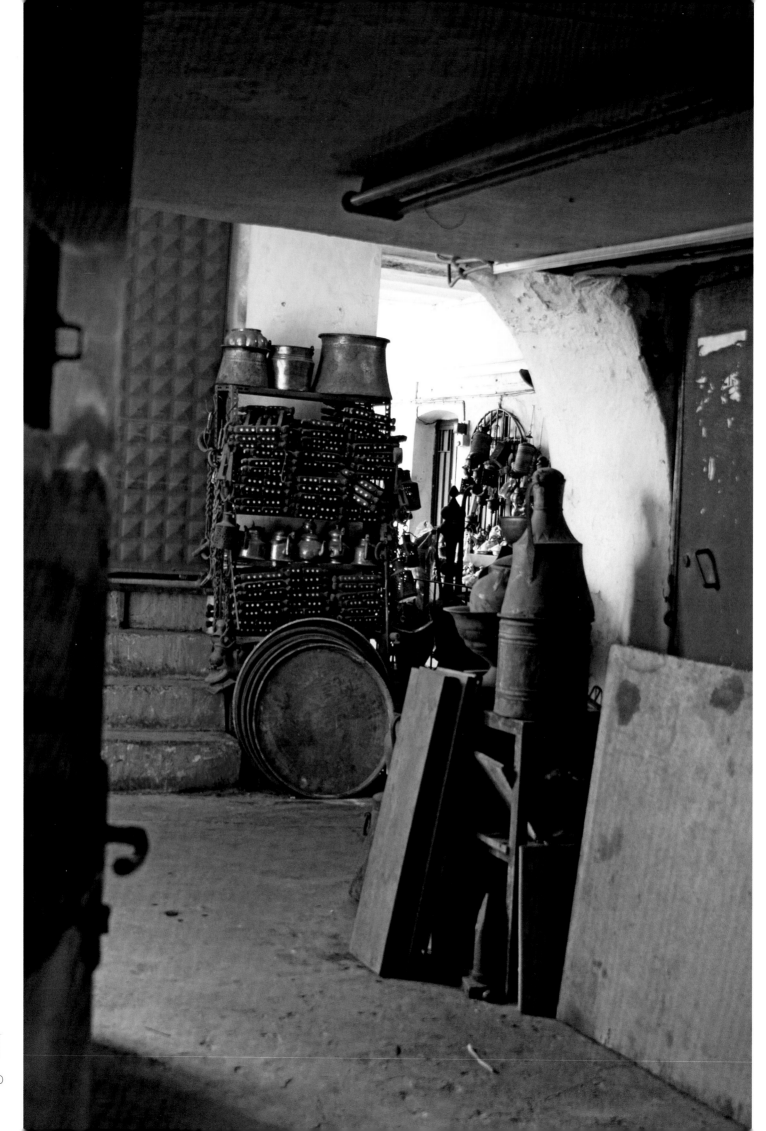

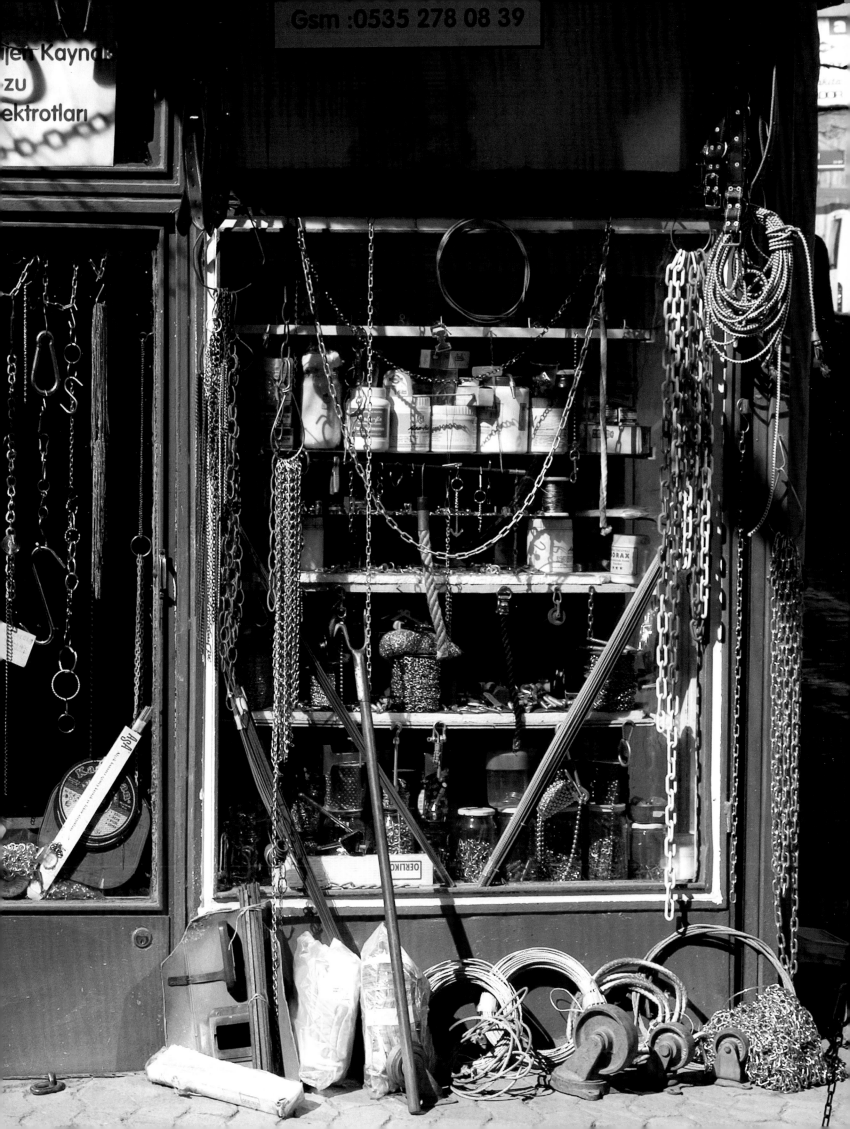

PEOPLE OF ISTANBUL:
THE CITY AS A MELTING POT

Of course, it is the people who make the bazaars special. Whether they are traders, tea boys, porters or nightwatchmen, each has a particular task and is an indispensable cog in the great wheel of trade.

Everyone has a part to play

Without the constant hustle and bustle of people, the Grand Bazaar would be nothing but an empty shell. It is the human parade that fills the old walls with life from the moment when the watchmen open the gates in the morning to let in the thousands of traders and customers. Every day, up to half a million people come in and out. Tentatively, the blind lottery-seller moves through the crowd, trying to earn his living by selling luck. A dwarf, hip-high, wanders among the passers-by, looking for the right spot to place his scales, and then for a few cents a client can learn whether or not he or she should lose that extra kilo. In the tea kitchens, hidden away in the unlikeliest corners of the bazaar, tulip-shaped glasses are filled with the strong, dark brew. The brewers themselves are busy preparing the first orders from the traders, and the tailors, watchmakers and postmen cut, peer, deliver, while the barber trims a few beards or puts the finishing touches to a hairstyle before the tidal wave of customers descends.

A place of international understanding

There are many traders who have passed through the great gates of the Kapalı Çarşı virtually every day for a lifetime. They began as simple errand boys or apprentices, and now they have their own shops. They grew up here, and any other kind of life would be almost unimaginable, even though many of them would concede that things have changed for the worse. But there is one thing that has never changed and that they would not allow to change: since time immemorial, people of different races and religions have worked together here in peaceful coexistence. Hans Christian Andersen described the melting pot of Istanbul through the example of the bazaar: 'It is extremely interesting to observe the characteristic ways in which each nationality manifests itself. The Turk sits grave and solemn, with his long pipe in his mouth, while the Jew and Greek are busy shouting and gesticulating. Meanwhile, the colourful swarms of people move beneath the intersecting vaults – Persians in their furry pointed caps, Armenians with black hats in the form of an upturned ninepin, Bulgarians in sheepskin coats, Jews with tattered shawls and tall black turbans, dressed-up Greeks and veiled women – what a crowd!'

The basis of this international hotchpotch was laid by Mehmed II after the conquest of Constantinople. He granted religious freedom to the Christian community, which was a clever move because the Greeks and Armenians were skilled traders and craftsmen. By this means, Mehmed hoped to revive the economy of the former Byzantium. He also encouraged those who had fled before the conquest to return to the city. His son Bayezid II welcomed the Jews who had been driven out of Europe, and joining all these non-Muslims were the immigrants who came from all corners of the gigantic Ottoman Empire: Hungarians, Albanians, Bulgarians, Serbs, Egyptians and Syrians – all thronging together in the great metropolis on the Bosporus.

Generally, the different groups had their own specialities, and that has remained the case right up to the present. Armenians are often gold- and silversmiths, and they have taught their craft to their Muslim successors. The Jews have always been the best businessmen. But the number of non-Muslim traders is shrinking: in 1520 they accounted for sixteen per cent, whereas today they are barely two per cent.

Down through the years, new groups have joined the others. The Syriacs – or *Süryaniler*, as they are called in Turkey – settled in Istanbul during the 19th century, and they now constitute one of the largest ethnic groups in the bazaar, controlling between twenty and thirty per cent of the gold business. There are increasing numbers of Afghans and Kurds who have settled in the Kapalı Çarşı. Not surprisingly, this contact with so many different nationalities and religions has had its effect on the local traders. A vendor who has worked in the Grand Bazaar for the last twenty years put it very succinctly: 'If I hadn't spent my life here, I would never have been so open and tolerant towards other people.'

New generations bring new ideas

Regardless of which part of the earth the traders called their home, and which God they worshipped, under the centralized regime of the Ottoman Empire there were strict rules that everyone had to follow. Morality in business was sacrosanct, and the traders in the bazaar did not envy a neighbour's success but, on the contrary, were grateful because he would attract customers from whom they might also benefit. Changes

came in the second half of the 19th century when the Ottoman Empire opened itself up to the West. Moral attitudes and values shifted their ground. Many traders preferred the freer European ways and resented being held back by the rigid discipline of the central government in Istanbul. Industrialization also gave new powers to the people, and above all the abolition of the guilds brought about gradual changes in the way business was done in the Grand Bazaar. Now the prime purpose was to earn money.

Today there are few traders of the old school who have prospered under the influence of the guild system. Those that do exist deal mainly in antiques, fabrics, copper objects or carpets. Suit and tie are indispensable accoutrements, for these men see themselves as representing an historic institution in the Grand Bazaar. Stoically they sit behind their counters, arrange their wares, and watch the people passing to and fro outside their shop windows. The passers-by will never hear more than a single greeting, for polite restraint is a top priority in the code of conduct. Only if an interested customer enters the shop will the trader then respond to questions and supply information. An 18th-century visitor to

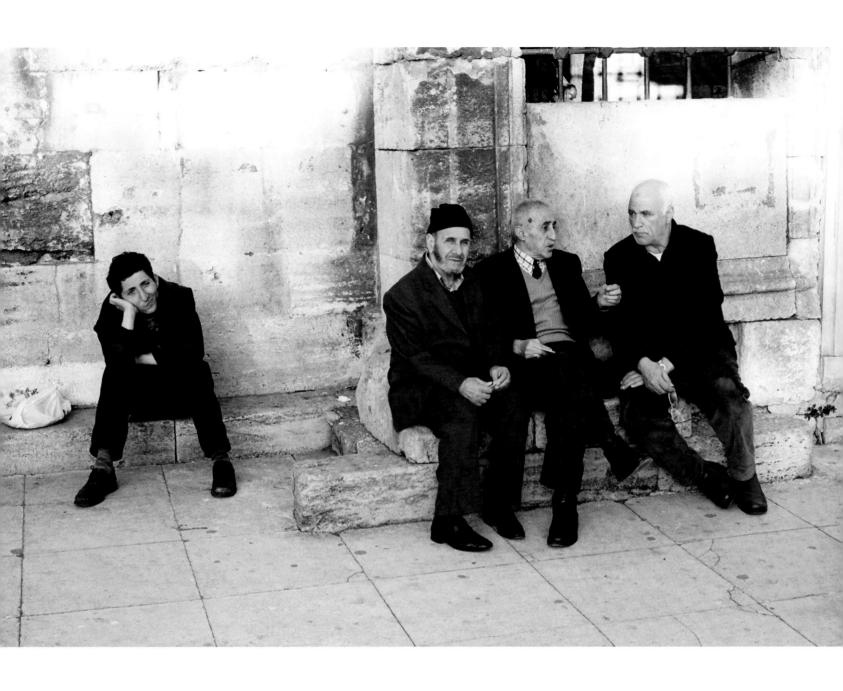

Istanbul described the process as follows: 'Here too the seller sits like a statue and smokes. He does not lure in any customers but waits patiently for them… If he wants to recommend an item, he simply lays his finger on his lips, which is a sign of admiration, or he stretches out his fist as if to say that the item is well made.'

Many of the older traders wax lyrical when they talk of the past, when everyone knew his neighbour, they played *tric-trac* [a form of backgammon] together, and talked shop. Today, the anonymity of the big city has also caught up with the bazaar. An antique dealer who has worked for over forty years in the Kapalı Çarşı put it this way: 'In those days, we all respected one another and above all respected the

rights of the customer. Today, many lack simple good manners.' But of course the younger generation of vendors see things differently. They deal in leather jackets, souvenirs, fake designer bags, T-shirts or jeans. Their openness and ability to lure potential customers into a conversation are powerful aids to selling. With a mixture of charm and engaging humour, they entice tourists to enter their shops – and they can do it in five, six, or even seven different languages.

In the Grand Bazaar there are now women shopowners. Their shops are easily distinguishable because of the modern furnishings and carefully chosen decor, but it has to be said that women traders are still a comparative rarity. This is not the case, however, in the neighbouring bazaars, where there are plenty of

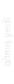

young saleswomen, especially in bridal boutiques and fabric shops. Nevertheless, it is always men that stand outside these shops, shouting out the prices. In this respect, the status quo remains the same as it has always been in Muslim countries. Before the fall of Constantinople, it was Byzantine women who sold their wares in the city's markets, but Ottoman bazaars came under Islamic rules and traditions, and so trade became the province of men. The fact that there are so few women working in the Grand Bazaar, however, no longer has anything to do with religion. Many male vendors say themselves that the atmosphere there is too tough for women, and the general tone is too coarse. One young trader admitted openly: 'That's why I don't like it if my mother or my sisters come and see me here.' But if you ask one of the few female shop-owners, you will hear a different story: 'Men are extremely polite to me, and even very shy.' The great advantage, of course, is that female customers – who represent the majority of those who buy – feel more at ease with her.

You can tell a well regarded and successful dealer, not by his designer watch or his expensive suit, but by the respect paid to him by others. Respect is also paid to the few female vendors in the Grand Bazaar.

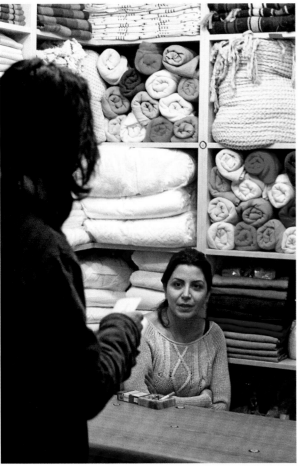

altmış sekiz

Turkish jealousy forbids the fairer sex to stay too long in stores, which it calls a school for coquetry and a cloak for intrigue.

Edmondo de Amicis, Italian travel writer, 19th century

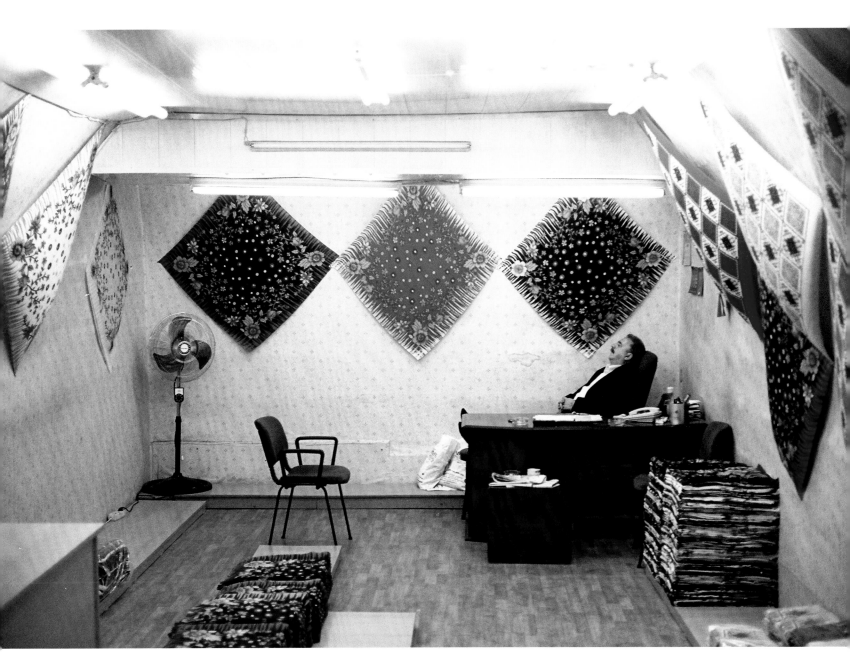

Despite the bustle of Istanbul, there are still moments of calm. Here a trader is taking time off for a midday nap.

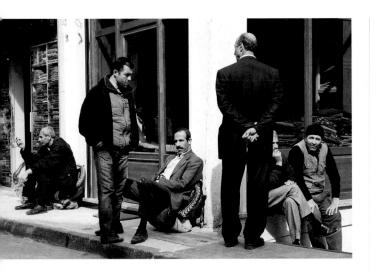

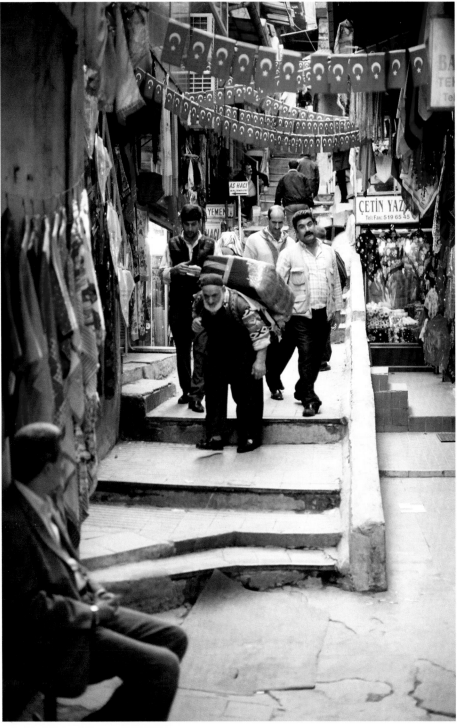

Porters: fetching and carrying

In the morning, when the bazaar district gradually comes to life, you will see in many of the alleyways strange, hard cushions made of old pieces of carpet lying scattered on the ground. Sitting on some of them are men drinking tea. These 'cushions' are an indispensable piece of equipment for the *hamallar*, or porters. They serve as a kind of luggage carrier on the backs of the men bearing packets, mattresses or heavy sacks. In former times, these porters are even said to have carried sick people to hospital and taken drunkards home from the taverns in Galata. A particularly strong porter can carry up to 150 kg (330 lbs). Trucks cannot drive through the steep, narrow alleyways, and so goods have to be transported on the backs of these men, who then deliver them to the workshops, warehouses and shops. If the consignment is large, you will see a long line of porters waiting their turn to be loaded. Those who are not needed must then look for a commission elsewhere, but in the bazaar district at least there is still plenty of work for them, even if fewer and fewer of them are needed in other parts of the city. In any case, it is almost impossible for a *hamal* to change his place of employment, because the porters are divided into groups, and each one is

allocated a particular area. If a place falls vacant, it cannot just be filled by any applicant – the whole group must agree, and a transfer fee has to be paid. In the 17th century, there were 300 *hamallar* working for traders outside the Old Bedesten. Every evening, they used to carry the goods into the safety of the building, so great was the general fear of fire.

When the porters aren't heaving boxes and cases through the narrow alleyways of the bazaar, they rest on their padded luggage carriers and wait for new commissions.

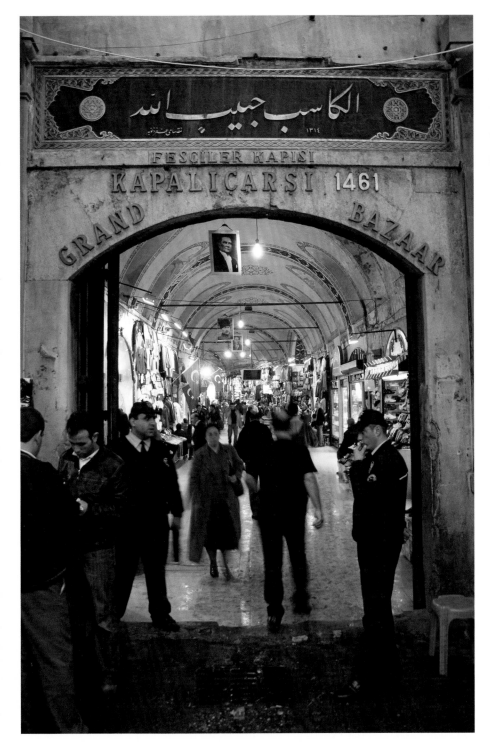

As another day's work comes to an end, the shops are locked up and the goods stowed away under tarpaulins. Only when the last trader has left the bazaar do the watchmen close the gates and begin their nightly rounds.

Nightwatchmen: keeping goods safe

In the days of the Ottoman Empire, the Old Bedesten was guarded like a fortress. During the 17th century, according to a Turkish historian, there were seventy watchmen patrolling the building. They belonged to a special unit that was supervised by the Black Eunuchs. These men were so reliable that at night the little sales alcoves could be left open without any of the jewels or other valuables ever being stolen. They illuminated the dark alleys of the bazaar with their lanterns. The owners of the shops were not allowed under any circumstances to return to the building after closing time, and the watchmen would not open the gates outside normal hours unless there had been a direct decree from the Sultan. This happened only in emergencies, such as fire in the bazaar. Not much seems to have changed since then. Once the security men have locked the gates of the bazaar in the evening, only the police can issue a permit allowing a trader to return to his shop during the night. The records show just how effective these strict rules have been: in the long history of the bazaar, there has never been a break-in of any note. The rules cannot, however, protect traders or their customers from terrorist attacks. In 1994, a bomb hidden in a shoeshine boy's box exploded in the heart of the bazaar. A militant Kurdish organization, the PKK, were held responsible for the attack. Measures were promptly taken, and today the men with the colourful wooden boxes are only allowed to clean people's shoes outside the confines of the bazaar. There are also security guards present all day at the gates.

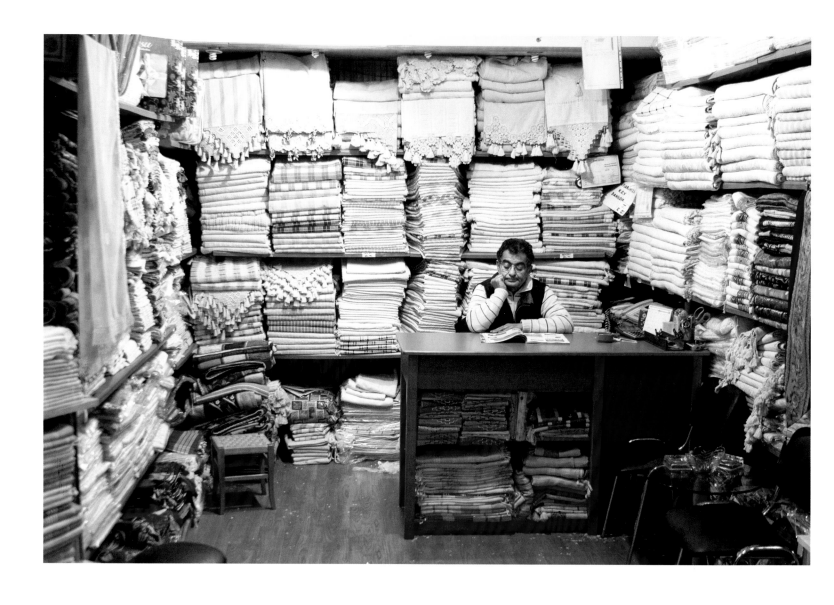

God loves all traders.

Calligraphic inscription above one
of the gates of the Grand Bazaar

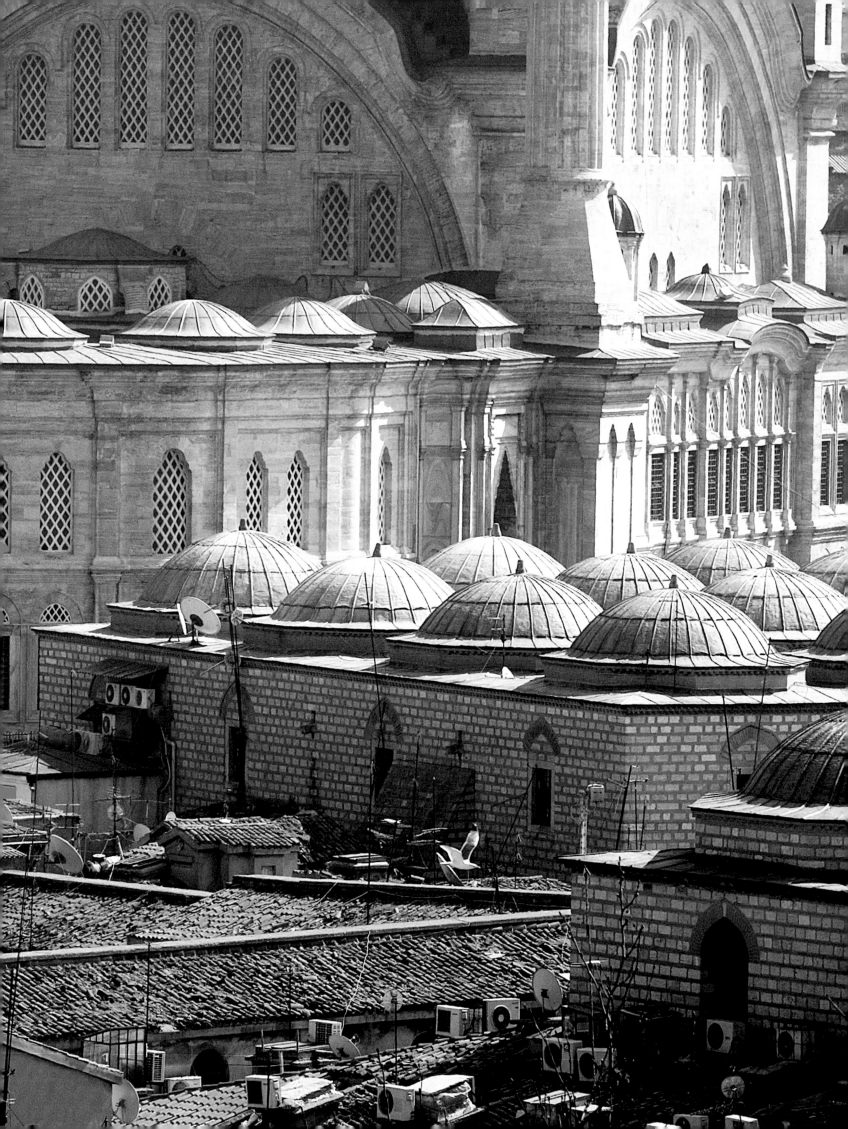

THE BUILDINGS: FOR TRADE AND FOR WORSHIP

The bazaar district of Istanbul is a town in itself. On the historic Bosporus peninsula, indoor markets, warehouses and workshops stand side by side with mosques, baths and fountains. Commerce and religion are inseparably linked together.

The bazaar: the heart of the city

Getting lost in the bazaar district is an unavoidable hazard. In this maze of winding alleys and dingy cul-de-sacs, there are hardly any signs to orientate you. And yet you will always find your way, because all roads lead to the Grand Bazaar. As if by magic, the twenty or more entrances to the market draw people from all directions. Ottoman towns, with their labyrinth of lanes and their densely packed and often crooked houses, seem to follow no plan, but each one has a centre point: the bazaar. It always played a crucial and active role in the life of Istanbul, and not until the middle of the 20th century did the advent of department stores and modern shopping malls elsewhere in the city deprive the Kapalı Çarşı of its absolute pre-eminence.

Now, as in former times, the bazaars are devoted almost exclusively to trade and crafts. There were and are scarcely any residential buildings here, for the worlds of business and private life have always been far apart. The Ottomans guarded their homes with fierce pride. No stranger was allowed to enter the sanctuary uninvited, and even invited guests could see only some of the rooms, while women were kept away from the eyes of male visitors. Muslims, Jews and Christians had their own separate districts. The bazaar gave men the opportunity to do their work and make their social contacts independently of their private homes, and although the bazaar district was not residential, the traders could find there everything they needed for their daily lives. This is still the case today, for the Grand Bazaar is surrounded by mosques, baths, fountains, tearooms, workshops and warehouses.

The daily summons to prayer

The mosques in the bazaar district are of prime importance to the Muslim traders. At least two of the five daily prayer sessions required by Islam fall during business hours. The sellers are allowed to say their prayers on their own, but on Friday they must go to the mosque, as instructed by the Koran: 'O ye who believe! When the call is heard for the prayer of the day of congregation, haste unto remembrance of Allah and leave your trading. That is better for you if ye did but know.' And so many of the traders shoulder their prayer mats and hurry to the nearest mosque as soon as they hear the muezzin calling them to midday prayers from the minaret. However, they do not have to leave the bazaar building to do this. Often unnoticed by visitors, there is a *mescit* or small mosque that can be entered via a narrow flight of steps or through unobtrusive doors between shops in the Grand Bazaar. If the prayer rooms are full, the men simply unroll their mats in the passageway, and kneel down in the direction of Mecca to say their prayers there.

As commercial and religious life were and to a certain extent still are so closely linked, it seemed only logical that after the construction of the Old Bedesten – the heart of the present Grand Bazaar – under Mehmed II, large places of worship should follow. During the late 15th century, the mosque complexes of Mahmud Pasha and Atik Ali Pasha were built, the Bayezid Mosque on the square of the same name accommodated still more worshippers at the beginning of the 16th century, and sixty years later came the New Mosque on the shores of the Golden Horn. They were joined in the middle of the 18th

century by the Nuruosmaniye Mosque at the eastern entrance to the Grand Bazaar.

Religious complexes

The mosques were parts of larger complexes that generally included shops, a madrasa, a library, a soup kitchen, a hospital and a fountain. The Koran exhorts people to do good deeds, and in the Hadith it is made clear that, among other things, regular gifts to the poor will have a positive influence on the salvation of the soul. Religious foundations – called *auqaf* – therefore have a long tradition in Islamic culture. The founders of these complexes were often sultans, viziers, wealthy merchants, or women from the palace. It was not unusual for a trader to transform his house or shop into a foundation, for this not only secured the inheritance for his descendants, but he could also make it a condition that his heirs

should pray for his salvation. These religious and charitable foundations were financed by rents and donations from the attached bazaars, businesses and shops. Thus the income from the two Bedesten in the Grand Bazaar, in accordance with the foundation deeds drawn up by Mehmed the Conqueror, went to the Fatih Mosque and the Hagia Sophia – originally a Christian church but transformed into a mosque after the conquest, and now a museum. In this manner, it was not just the traders who benefited from the mosques, but the mosques also drew their sustenance from the traders.

The hans: lodging for travellers

Rich citizens also liked to establish warehouses, known as *hans*. In the area surrounding the Grand Bazaar, there are still about forty of these historic buildings, though many of them are in a sorry state.

From the roof of the Büyük Valide Han, there is a fine view over the Büyük Yeni Han. The two-storey building was constructed in the 17th century, and covers an area of 4,400 square metres (47,000 square feet).

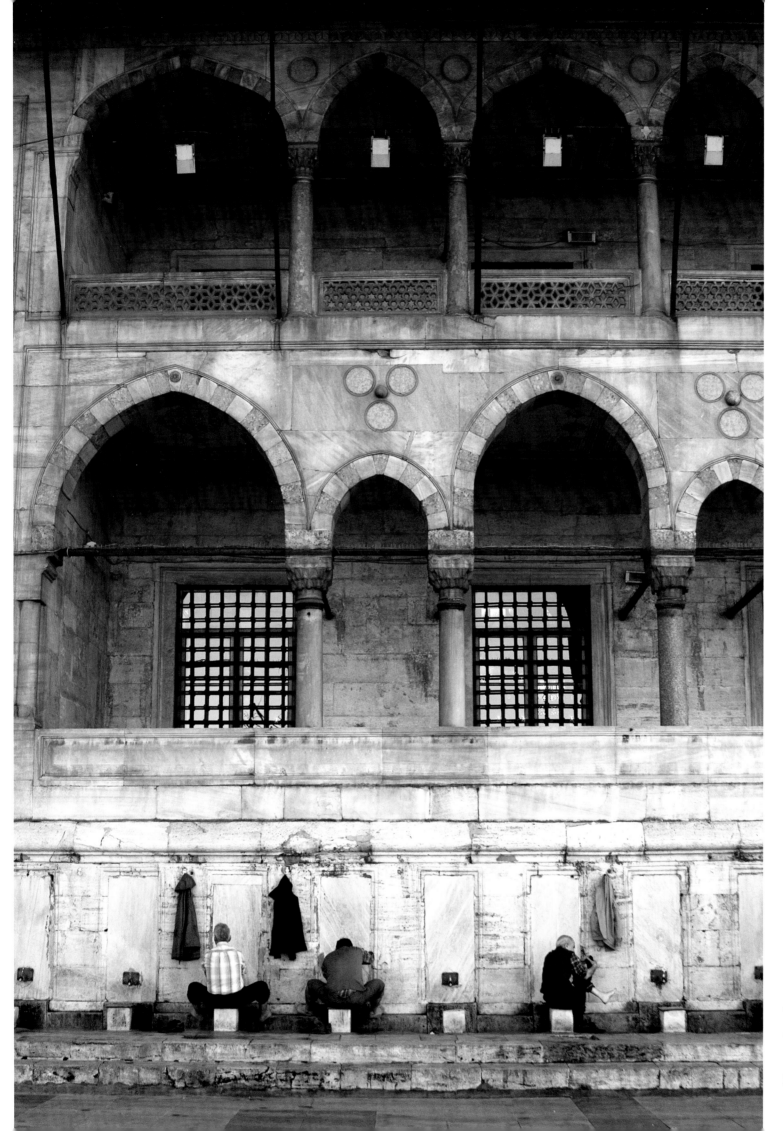

In former times, travelling merchants used to stay in inns known as *hans*. These buildings with large inner courtyards could also accommodate their beasts of burden as well as store their goods. Today most *hans* are dilapidated and bear little resemblance to their original form. Corrugated iron huts or wooden shacks are constantly being added on, and the buildings themselves have been transformed into workshops, warehouses, tearooms and shops.

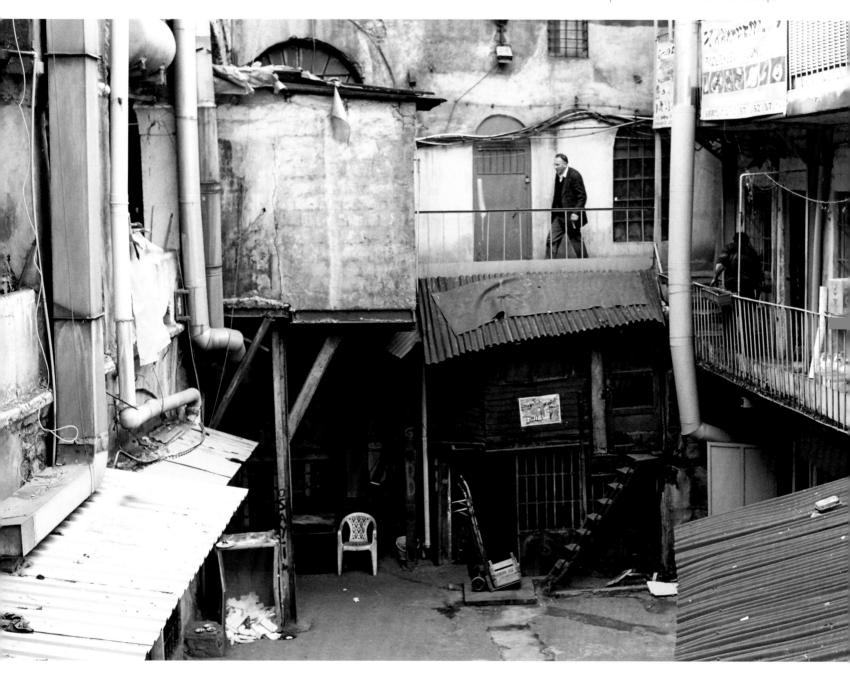

For centuries they served both as stores and as inns for the travelling merchants who followed the caravan route from Asia Minor to Istanbul. Generally, the ground floor was for the stables, and the upper floor contained the bedrooms. There was no charge for the first three nights, including meals, fodder for the camels and a candle, and the men were also allowed to sell their products from here. In the centre of the larger establishments there was a small mosque. These *hans* were a sort of urban equivalent to the caravanserais that lay along the major highways, and they were financed by a tax which the traders had to pay once a year. Today, the buildings are used for storage by wholesalers, but some of them also house workshops, tearooms or shops

Baths and fountains: sources of life

In addition to the bazaar buildings, another source of income for the foundations was Turkish baths (hamams) and fountains. The tenants who leased the baths had to pay a large annual sum to the administrators of the foundation. The Mahmud Pasha, Tahtakale and Sinan Pasha baths near the bazaar

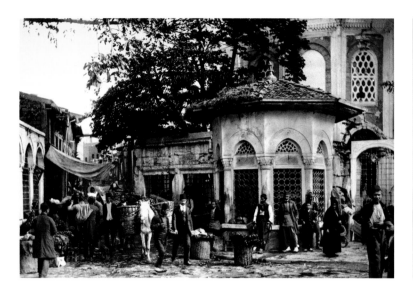

We made from water every living thing.

Passage from the Koran and inscription on a fountain

were built in the reign of Mehmed the Conqueror, and many more followed. According to the Turkish chronicler Evliya Celebi – though he did admittedly have a penchant for exaggeration – during the 17th century there were 4,536 private and 300 public hamams. Baths and fountains were important not only for hygienic but also for religious reasons. Muslims got ready for prayers by washing themselves – a symbol of inner purification. A Muslim must not go into a mosque straight after work; first he must wash. It is also a ritual that is meant to calm the spirit and dampen aggression.

Of course hamams and fountains could not be built without the close proximity of fresh water. 'Drinking water for more than half a million people who drink nothing but water, the massive demand for the many baths, mosques and five daily washes which their religion prescribes for every Muslim, therefore had to be brought in from outside,' wrote Helmuth von Moltke, the German military adviser

to the Ottoman army in the early 19th century. The Ottomans therefore piped water across the ancient aqueducts of the Byzantines – the Valens Aqueduct is still to be seen today – from the Forest of Belgrade (Belgrat Ormanlı) to Istanbul. This forest lies 20 km (12 miles) outside the centre of the city. The legendary architect Mimar Sinan repaired and rebuilt the aqueducts, and as a result by the end of the 16th century the number of fountains had vastly increased. Fresh water, however, was reserved for the mosques and the houses of the rich, and everyone else had to fetch it from the public fountains. Many philanthropists set up elegant little booths where water was given away free of charge. These are now used almost exclusively as sales kiosks, while most of the Turkish baths have been turned into warehouses. Only ten per cent of Istanbul's hamams remain. Most homes have their own running water nowadays, and so the traditional Turkish bath has become a special treat just for relaxation.

In Islam water is regarded as blessed. It symbolizes the omnipotence of Allah, and it gives life. Muslims express their veneration of water in their architecture and their writings. The richly decorated public fountains from which water was once dispensed have now been turned into sales kiosks.

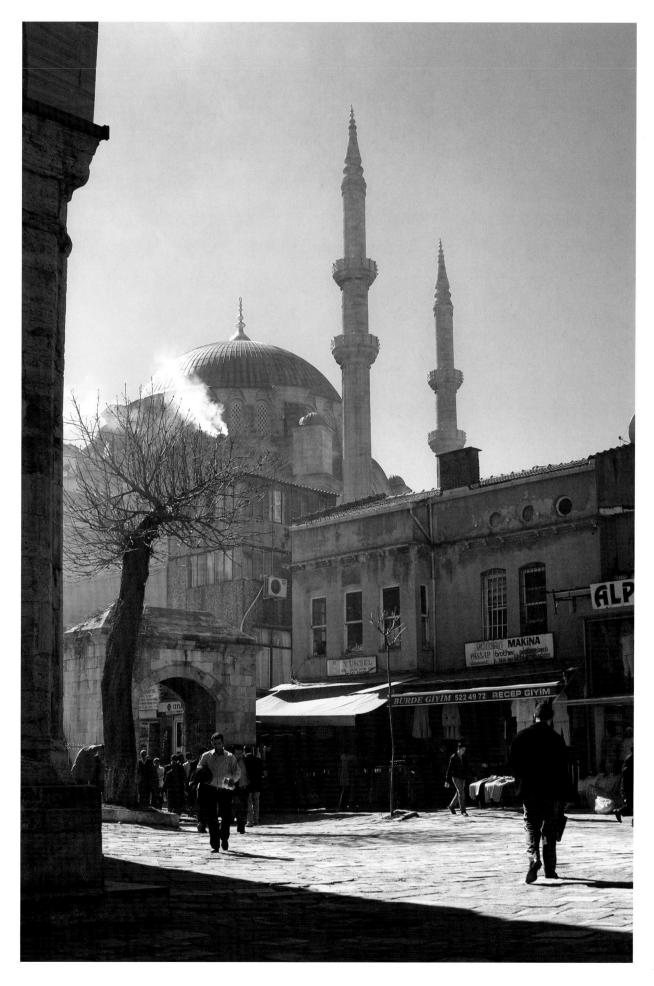

TREASURES OF THE BAZAARS

'The building is as busy as a beehive from sunrise to sunset, and overloaded with precious wares. There are traders here who own as many as one thousand or even two thousand ships,' wrote Evliya Celebi in the 17th century. Although the displays in Istanbul's bazaars are no longer quite so opulent today as in the days of the Turkish chronicler, the selection of products to be found in the countless shops is still quite overwhelming. Of course, over the centuries, the range and quality of the goods has constantly varied according to economic and political conditions and the tastes of the customers.

Many products that were sold at the time of the Ottoman Empire have long since disappeared. The only remaining sign of them is the street names in the Kapalı Çarşı – fur hat sellers, turban makers, mirror manufacturers. The second-hand clothes market, which some travellers described as the most unwelcoming section in the whole bazaar, has also disappeared. The reason: the old clothes contributed to the spread of disease. Until the end of the 19th century, opium and hashish could be bought on the open market, and no one raised an eyebrow. It was the same with the sale of slaves. Not until 1847 did Sultan Abdülmecid forbid the trade in human beings, but before that men and women had been auctioned off to the highest bidder. 'Before the person who wished to buy me handed over his money, he looked at my hands, arms and teeth, my body and my head. He did this in order to make sure that there were no afflictions… And if after this they like what they see,

they pay the money and take the person away,' wrote Johann Wild, a German who had himself in the 17th century been passed as a slave from one owner to the next. He added: 'Thus I was sold for the fifth time in one and a half years, this time for sixty ducats. I had stayed barely seven months with this pasha.' The Ottoman historian Latifi, on the other hand, described the slave trade from the standpoint of a potential buyer: 'One of the most delightful features of the *Bezzazistan* is the youthful beauties, young men and maidens who previously, much like Joseph, were ordinary people coming and going in this world, but who because of their fate have become slaves and are sold here…They are weighed on scales and valued in terms of gold. Among them one finds girls and boys of such extraordinary beauty that people lose control of themselves and spend their entire fortune, announcing that by comparison with the soul and love, money is of no importance.'

Fortunately, it is no longer possible to spend one's entire fortune on a slave. Instead, customers go wild at the sight of the vast array of gold, jewelry, antiques, carpets and fabrics on sale in today's bazaars. Of course, the colourful goods now available through globalization have their own charms, and so there are streets full of so-called 'Gucci' handbags, 'Prada' sunglasses, and leather jackets apparently straight from the latest Paris fashion shows. But in one sense little has changed over the centuries: if you search long and hard enough in the bazaars of Istanbul, eventually you will find that elusive treasure.

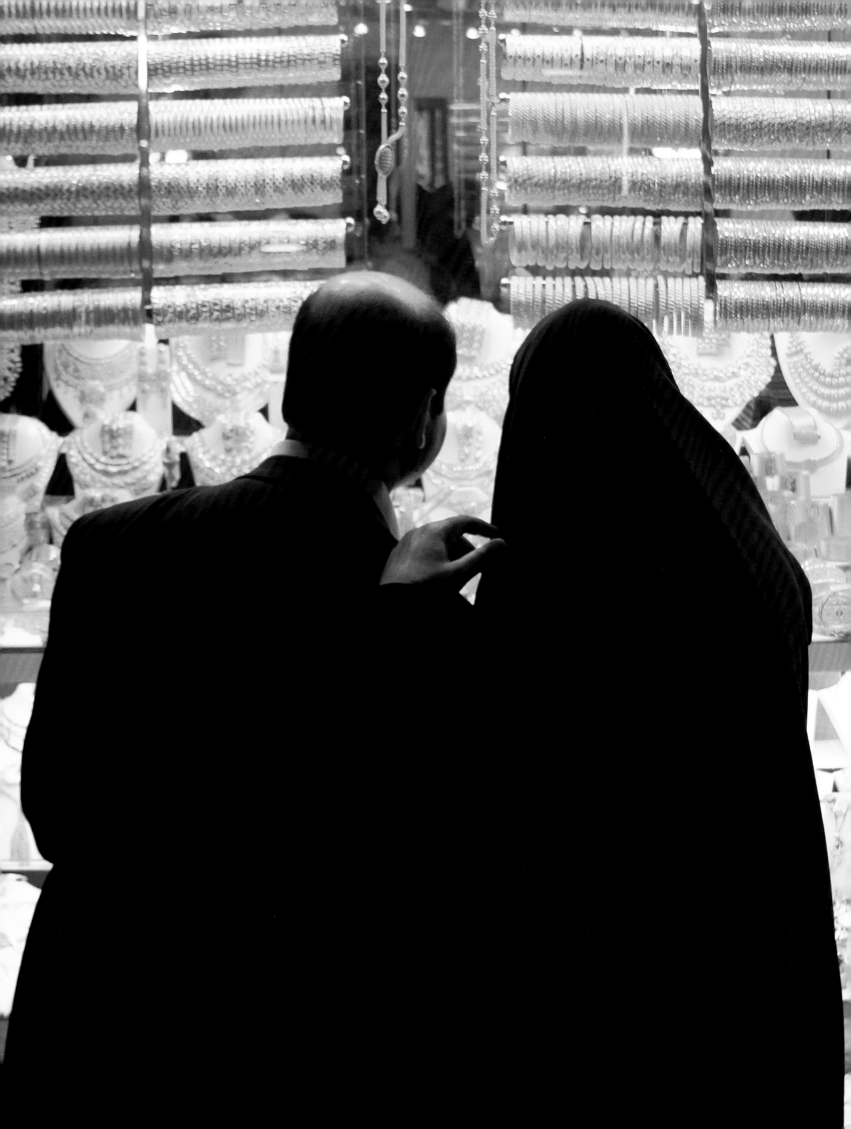

GOLD:
A SECURE FUTURE

In the Grand Bazaar, more than one hundred tonnes of gold change hands every year. Many of the people who work here earn their living directly or indirectly from trading in the precious metal. This is due to a mixture of old traditions and fear of an unstable currency.

All that glisters may well be gold

At first sight, the young man seems to be holding an old lump of metal. Only when a corner of the cloth eludes his grasp is the true nature of the treasure that he is carrying so carefully through the alleys of the Grand Bazaar revealed: it is a bar of gold. He has just bought it from one of the gold dealers whose little shops are scattered all over the market – especially around the Kalpakçılar Caddesi, the street of jewelry and gold. The windows of these unobtrusive shops are often covered in posters illustrating gold in all shapes and sizes, from small coins and flat dishes to heavy gold bars. Of course the posters also serve to hide the interior from prying eyes. An old-fashioned slate or a modern digital display announces the current price of gold. It is from these shops that the goldsmiths obtain their raw material, while traders and local people exchange their earnings or savings – whether in Turkish lira, dollars or euros – for some of the precious metal. Gold, like the reserves in Fort Knox, stands for one thing above all others: security. Everyone is still nervous of the lira's instability.

The coveted chunk of gold is simply handed across the counter like a loaf of bread. There are no special security arrangements here. Perhaps the fierce expression of the dealer is enough to deter potential thieves, for until now there have never been any noteworthy attempts at robbery. This is perhaps surprising, in view of the vast quantity of gold that moves around the Grand Bazaar. Over half of the 250 tonnes a year that are handled in Turkey are traded or processed here. The jewelry alone that is displayed by the 600 or so jewellers must weigh many tonnes, and over half the people who work in the Grand Bazaar earn their living directly or indirectly through gold. Some check the quality, and some buy, some sell the bars and coins. Out of one bar, the goldsmiths fashion glittering bracelets, dazzling rings, delicate chains, while other craftsmen gently ease diamonds and sapphires into gold settings, and a polisher puts the finishing touches to each precious piece.

A secure future for the bride

The jewelry is sold predominantly to local people, because Turks hold fast to the tradition that on her engagement and at her wedding a bride should be given gold jewelry and coins. The richer the family, the more opulent the jewels. Inlaid diamonds, rubies and sapphires are highly desirable, but even among poorer people, a few gold bracelets would constitute the bare minimum. The bride's family might put their entire savings into this dowry. Guests also bring gold coins to the wedding, but the point of all this generosity is not to encourage vanity in the young woman. On the contrary, this custom is based on very practical reasons: bracelets, rings and necklaces provide the newly married couple with a nest egg. Even if there is a divorce, or the husband dies, the wife still has the right to this reserve, and so in the jewellers' shops in the Grand Bazaar you will only come across the finest gold of 14, 18 or 22 carats (24 is too soft to wear). If bad times come, the wife will quickly find a buyer for her jewels at the current market rate. Many people still come to Istanbul from all over Turkey to buy gifts of gold for births, circumcisions, engagements, weddings and birthdays.

The gold centre of Turkey

It is thanks to gold that at the beginning of the 21st century the Kapalı Çarşı has once again become an

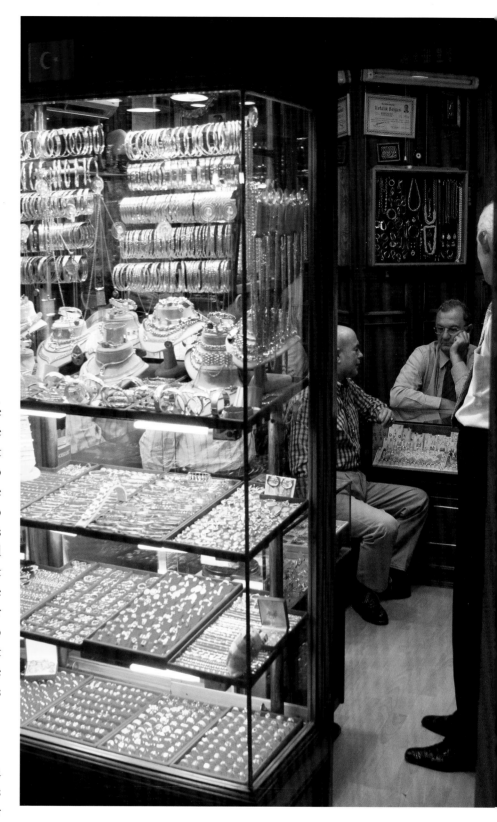

important trade centre. The liberalization of the market in the 1980s gave powerful impetus to the gold industry, because it then became legal to import and export the precious metal. There were now no barriers to separate the bazaar from the rest of the trading world – in contrast to those of Cairo, Aleppo and Tehran. More and more jewellers opened shops in the Grand Bazaar, which became the new gold centre of Turkey. The construction of a gold market and a gold refinery in the 1990s encouraged the public to bring their reserves out from under their mattresses and from inside their treasure chests, so that it could go into circulation. Another important factor was that this put a stop to smuggling, because imported gold has to be registered. This also provides a guarantee that the gold is of good quality.

Alleys of the foreign exchange dealers

In spite of, or perhaps because of these measures, a parallel world has grown up in two of the many alleys of the Grand Bazaar. You can hear the cries from far away, and the nearer you come, the more discordant and animated are the voices. Only when you stand directly at the entrance to the dark alley of Altuncular will you distinguish in the shadows the outlines of a crowd of men. Standing cheek by jowl, they shout into their mobile phones, gesticulate wildly, and hurl snippets of information at one another that even for

seksen altı

86 GOLD

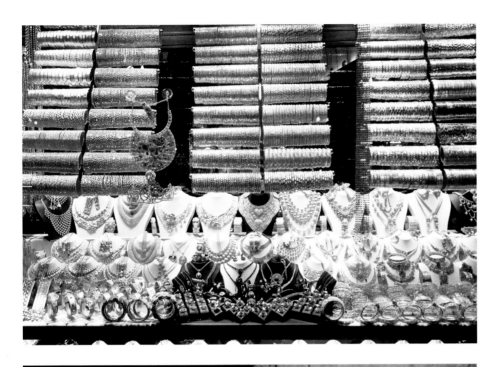

Gold provides a living for many of the people who work in the bazaar. Rings, chains and bangles are made in the workshops, and there are about six hundred jewellers selling the finished products.

other Turks will be incomprehensible. Here, on the eastern fringes of the Kapalı Çarşı, beats the heart of the unofficial gold and foreign exchange market. It is said that every day transactions worth about 25 million dollars take place here. The official bureaux de change in the Grand Bazaar, which work on behalf of banks and other companies, send their own representatives to these alleys, and private speculators are also to be found here, buying and selling dollars, euros, lira and gold.

At first sight, you might think that the dealers coming and going in this remote corner of the bazaar are engaged in some criminal activity, but they are not breaking any laws. Prices here are better, and in this way one is spared the inconvenience of bureaucratic formalities. Deals are struck verbally, for in the Kapalı Çarşı a man's word is still his bond. Everything works on a basis of trust, and once a trader has accepted a deal, there is no going back. If he tried to, he would lose all respect. In any case, most of these thirty or forty men have known each other for a long time. Many were there at the very beginning of the unofficial exchange market, which established itself in the Grand Bazaar back in the 1980s.

Ottoman coins: gold and silver

Not until twenty-five years after the conquest of Constantinople did Mehmed II mint the first Ottoman gold coins. That may seem strange, since one would think that 1453, the year of glorious victory, would have been the ideal point in time. But the Sultan waited until he had made what was originally a small princedom into a mighty power, so that he could then show that power to the outside world by minting his own gold currency. 'Sultan Muhamad bin Murad Han, may his conquests be glorious, minted in Constantinople in 1477 – minter of gold, Lord of power and victory over sea and land' – thus proclaimed the bombastic inscription.

But the *sultani* was not the first coin to be minted in the Empire. The silver *akçe*, called the 'asper' by Europeans, was first minted in 1326 under Orhan, son of Osman I, founder of the Ottoman dynasty, and for centuries it remained the common currency. There were also other coins made of silver, gold and copper. In the course of time, the quality and weight of the *akçe* was gradually reduced until eventually minting ceased. Already in the 16th century the *akçe* had become hugely devalued against the *sultani* and by the beginning of the next century, payments had to be made with whole sackfuls of the silver coins.

The monetary system in the Ottoman Empire was very complex and not always consistent. In the newly conquered provinces, the local people generally retained their own currency, even though the authorities in Istanbul tried to prevent that. When the Republic was proclaimed in 1923, the first gold coins of the Atatürk era made their appearance, but people used these primarily as an investment. Ordinary coins and paper money became increasingly common in everyday life, while precious metal in the form of coins fell into disuse as a means of payment.

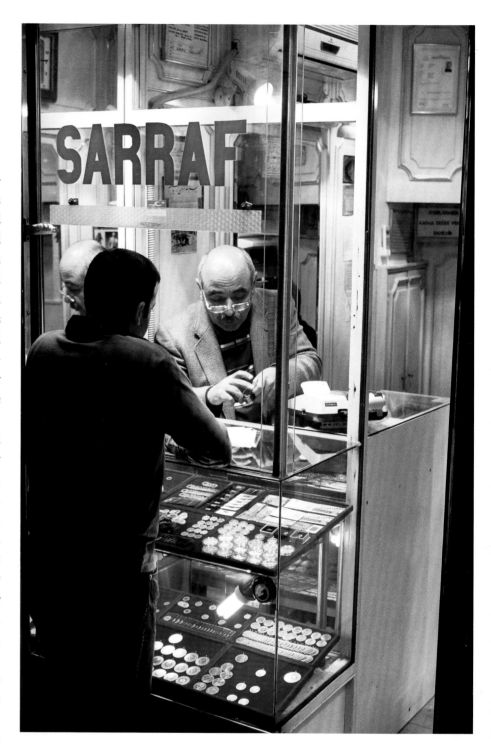

At weddings, birthdays and circumcisions, gold coins are often given as presents, along with bracelets and money.

The Kalpakçılar Caddesi,
one of the longest streets in
the bazaar, stretches from the
Nuruosmaniye Mosque as far
as the entrance to the Bayezid
Mosque. It was named after the
vendors of fur hats, who used to
work in it. Today it is nicknamed
'Gold Street', because it
consists of one jewelry shop
after another.

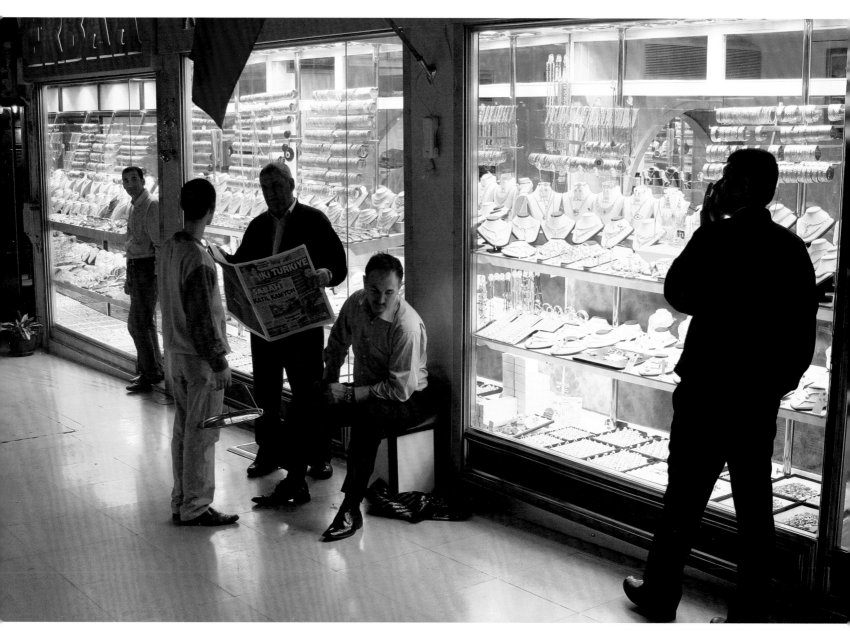

CERAMICS:
ART FROM THE EARTH

No other form of Ottoman art has achieved the unique splendour of the ceramics produced in the provincial town of Iznik. Even today, these magnificent tiles can be found decorating mosques, tombs and palaces all over Turkey.

The glory of Iznik

The little mosque of Rüstem Pasha stands on a terrace overlooking the houses of the lively district of Tahtakale, close to the Golden Horn and the Spice Bazaar. Two narrow flights of stone steps lead to the forecourt of the mosque, which was built by Mimar Sinan, regarded as the greatest of all the Ottoman architects. After the hustle and bustle of the alleyways down below, this is an oasis of peace and quiet. The walls to the left and right of the entrance are covered with bright coloured tiles, but even these will not prepare you for the magnificence of the interior. The walls inside the mosque are tiled in an astonishing range of radiant colours and intricate patterns, with constantly changing forms, shades and flower motifs. There are almost eighty different designs here, and the tiles of the Rüstem Pasha Mosque are regarded as among the finest ever produced by the famous workshops of Iznik. But before the artists and potters could achieve this degree of perfection, a long period of experimentation was required.

Decorative ceramics

Ever since the 12th century, ceramic decorations had played an increasingly important role in the Islamic world. This may have been due to the fact that earthenware tiles had proved to be more durable than wall paintings. In the Ottoman Empire, buildings like the Green Mosque and the Green Tomb of Mehmed I in the former capital of Bursa were decorated with simple glazed tiles of turquoise, blue and green. These were produced locally, but as time went by, the ceramic artists began to settle in the little town 200 km (120 miles) southeast of Istanbul, on the shores of Lake Iznik. One reason may have been that there was already a tradition of ceramic making here, but this in turn went back to the fact that the necessary raw materials were already abundantly present in the region. The soil is rich in clay, and there is plenty of water and firewood readily available. Iznik was also well situated, as it lay on the main trade route from Damascus to Istanbul. The early pieces produced by this little provincial town – rustic vessels of rough clay – were nothing special, and gave no hint of the elaborate flower and tendril decorations that covered the bowls, dishes and tiles later to emerge during the golden age of Ottoman ceramics.

Experimenting with materials and motifs

In order for this perfection to be achieved, the blend of clay and the glazing had to be just right, and the range of colours and patterns had to be expanded. In due course, the potters developed a hard white body, which they painted with cobalt blue patterns and – in contrast to the then customary form of coloured glazing – covered with a transparent lead glazing. Initially this new underglaze painting was confined to a variety of vessels, but it was soon applied to tiles as well. The motifs of flowers, tendrils, arabesques and clouds were stilted and stylized at this time, and inscriptions were awkward and painted with exaggerated care. The artists often borrowed their motifs from Chinese models, which is still reflected in the Turkish word for tile, *çini*, and for ceramics, *çinicilik*.

The masters went on working at their patterns, and with the so-called *saz* style, these gradually became more spontaneous and natural. The *saz* motif, which is said to take its name from an enchanted forest in Turkey, consists in long, curved, feathered leaves combined with rosettes and lotus blossoms.

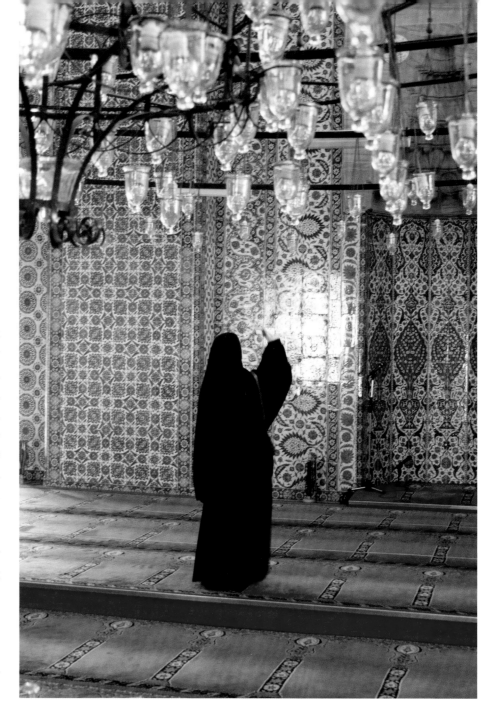

Sometimes between the flowers you can see exotic birds or antelopes with flames shooting from their bodies. Building on this motif, the artists developed a new style of flower painting, and soon their tiles and vessels were covered with tulips, roses, carnations and hyacinths, all of which grew in Turkish gardens. The traditional, stylized flowers, arabesques and Chinese clouds were still in use, but now the focus shifted to these freer, more natural plant motifs. Human figures, however, did not find a way into the picture: Islam forbids this kind of portraiture in many contexts in order to prevent idolatry, though the rigour with which this rule is implemented varies according to the region and the art form.

The colours of nature

The freer the pattern, the greater the range of colours. The original blue and white were supplemented by chrome black, used for edging, and by turquoise, pale violet and pale green. But it was only with the discovery of a bright tomato red that these new, exuberant flower patterns took on their full glory. This paint was derived from red clay, rich in iron oxide. Later came emerald green, but that was particularly difficult to apply because during the firing it often ran beneath the glaze. Artists were no longer content to limit themselves to the characteristic Chinese white and blue or the Ottoman blue, purple and olive green. These new, vibrant colours and lively patterns communicated the Islamic vision of a paradise filled with flowers. The first known example of the dazzling tomato red is in the tiles decorating the Süleymaniye Mosque in Istanbul (completed in 1559), although it had not yet been perfected. After this somewhat tentative debut, it reached its full intensity in the small

but quite astonishingly decorated Rüstem Pasha Mosque. This was later followed by other buildings, such as the tomb of Süleyman I, the Selimiye Mosque in Edirne, and the Sokullu Mehmed Pasha Mosque in Istanbul. The tile decorations of these buildings marked the peak of Iznik ceramics during the second half of the 16th century. The tiles, bowls, dishes, plates and jugs from this period are the epitome of Ottoman ceramic art, and to this day they serve as models for ceramic painters.

The master artists of the court

The success of Iznik ceramics was due in no small measure to the artists working in the *nakkaşhane*

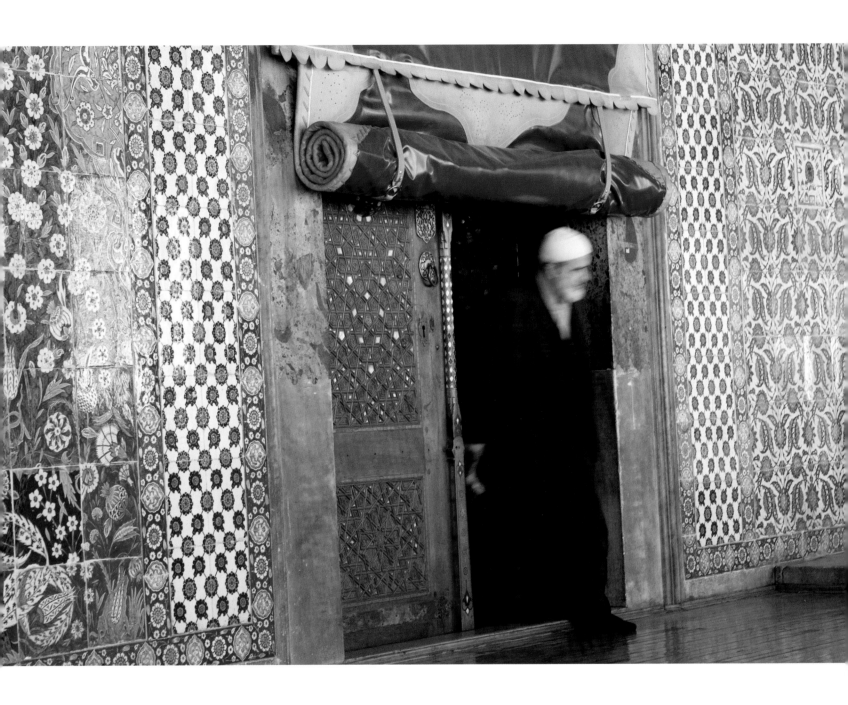

(workshops) at the Sultan's court in Istanbul, because it was they who supplied the sketches for many of the patterns. Their drawings were sent to the workshops in Iznik, in accordance with a command issued by the Sultan in 1590 to the authorities there: 'I have ordered that on the reception of this order you lose not a minute nor an hour, but that you assemble the tilemakers, and that they immediately prepare tiles according to the designs I have sent…'

Some of the court artists were slaves who had been recruited as children. When Selim I conquered Tabris, now in Iran, he is said to have sent a vast number of craftsmen from there to Istanbul. Other artists who had distinguished themselves in Iran also emigrated

to the Ottoman capital, and one of them, the famous Shah Kulu, became head of the court studio in Istanbul during the second quarter of the 16th century. It was rumoured that he had come to Turkey after being thrown out of the palace in Tabris because of moral misconduct. 'Shah Kulu, the designer, was a well-known master who received from the Sultan the extraordinary salary of one hundred silver coins a day, but he was unfortunately also known for his bad morals…' wrote one chronicler. His immorality does not, however, seem to have had any negative effect on his artistry, and indeed it was he who established the *saz* style. The potters of Iznik did not confine themselves to the patterns drawn up by the court artists;

they also designed their own. In the 1570s especially, the ceramic artists vied with each other for sheer originality and creative fertility, and no two patterns were alike.

The decline of Ottoman pottery

With the achievement of technical and aesthetic mastery, demand naturally grew. It was also boosted by the fact that in the 16th century, especially under Süleyman I, there was a veritable building boom throughout the Ottoman Empire. Not only mosques and monuments were decorated with tiles, but also the private chambers of the Sultan, the harem in the Topkapi Palace, and many other palaces. Even the sovereign's barque was decorated with tiles. Until well into the 17th century, the workshops of Iznik were at full capacity. For the Sultan Ahmed Mosque alone, which took seven years to complete (1609–16), more than 21,000 tiles were produced. The potters could scarcely keep pace with demand, and indeed some tiles were removed from the nearby Topkapi Palace to be incorporated into the decor of the new mosque.

The court paid a fixed rate for the work, but when the prices of food and raw materials began to rise, the craftsmen rapidly became discontent. In order not to make a loss, they cut their costs, and the quality of their products duly suffered. According to the Turkish chronicler Evliya Celebi, there were over 300 workshops in Iznik at the beginning of the 17th century, but with the gradual decline of the Ottoman Empire, the amount of building also eased off. Then the potters found themselves without work, and so they had to search for other sources of income. They began to produce cheap goods for export – mainly crude plates and dishes with designs of human figures

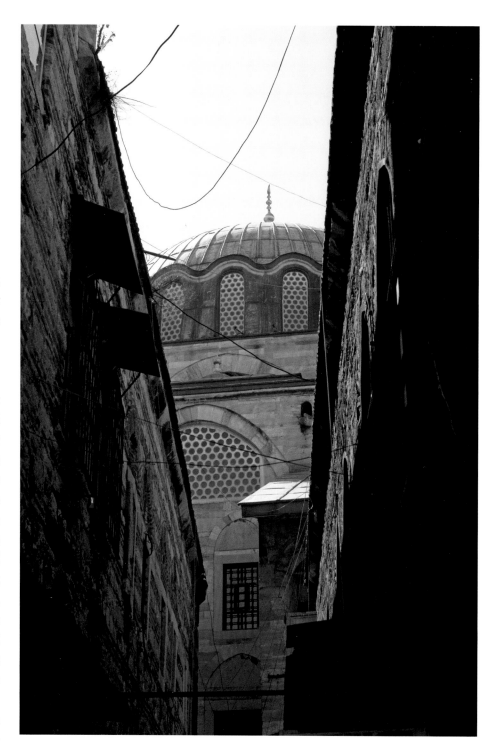

Collecting tiles was apparently a passion of the Grand Vizier Rüstem Pasha. In the middle of the 16th century, he commissioned the famous architect Sinan to build this small mosque with its magnificent tiled decorations. Today it lies hidden between the houses of the Tahtakale business district.

The Ottomans' love of flowers

On one of the very few surviving portraits of Mehmed the Conqueror, he is holding a rose – *gül* in Turkish. It is a symbol of the Ottomans' love of flowers and of plants in general. When the Sultan conquered Constantinople in 1453, it is said that he would not enter the Hagia Sophia, which at the time was still a Christian church, until it had been 'cleansed' with rose water. Subsequently, it was transformed into a mosque. At court, the love of flowers lasted literally from cradle to grave, for all newborn babies were immediately wrapped in rose petals. 'They do not even leave rose petals lying on the ground, for just as the ancients believed that the rose came from the blood of Venus, so the Turks believe it came from the sweat of Muhammad,' wrote an envoy from the Habsburgs.

It was not just roses that the Turks raved over. Ever since the time of Süleyman, there had been a veritable craze for tulips in Istanbul. This was naturally due in part to the beauty of the flower, but also to the fact that its Turkish name, *lale*, in Arabic script is an anagram of Allah. In one year, Sultan Selim III ordered 50,000 tulip bulbs, some at astronomical prices. At the beginning of the 18th century, there were believed to be more than a thousand known varieties of tulip in Istanbul. Many other plants also found their way to Vienna, Prague and Venice, and later to the Netherlands and Great Britain, thus inaugurating a new era of horticulture in Europe.

In the Ottoman Empire, flowers were not just a pleasure in the house and garden; they were also a favourite subject of art and literature. They decorated pottery, were embroidered on towels and fine fabrics,

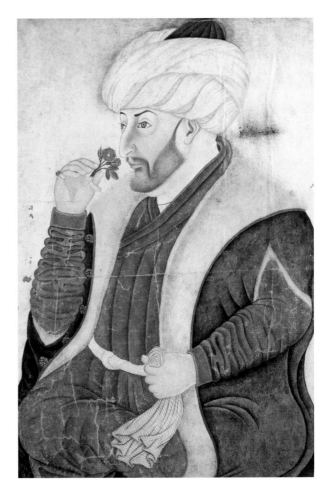

and were to be found in paintings and on the covers of books. They were carved on tombstones and fountains, and were used as decorations on weapons and armour. Tulips, roses, hyacinths and carnations were among the favourite flower motifs in the field of decorative arts, which reached its zenith in the second half of the 16th century. During the reign of Ahmed III, at the beginning of the 18th century, there was an attempt to revive this extravagant floral style, but it was not too successful. Nevertheless, the era is still known today as the *Lale Devri* or 'Tulip Period'.

I saw countless parks that belong to the Sultan and are situated in enchanting valleys. What dwellings for nymphs! What homes for the Muses!

Ogier Ghislain de Busbecq, Habsburg envoy, 16th century

A language for lovers

The language of flowers was an expression taken quite literally in the days of the Ottoman Empire, especially by the ladies of the harem. Lady Mary Wortley Montagu, wife of the English ambassador in Istanbul, wrote a letter describing this secret language of lovers, the so-called *selam*. The word was derived from *selamlık*, the Turkish name for the room in which visitors are received. The women in the harem would use this 'language of objects' to send messages to their lovers. All kinds of things would be wrapped in a cloth, and the recipient would duly decipher the content. The ambassador's wife, who as a woman had access to the harem, explains the meaning of some of these objects: paper, for instance, stood for 'I faint every hour!' while a match meant: 'I burn! I burn! My flame consumes me!' She added: 'You may quarrel, reproach, or send letters of passion, friendship, or civility, or even of news, without ever inking your fingers.' In the 19th century, it was from this language of objects that there developed the language of flowers. This was not just a matter of the colour or species, but also of the way in which they were arranged. Even precise details could be agreed by this means: a fading rose stood for one o'clock, and a heliotrope for two. Sadly, even in Turkey this language without words is now a thing of the past.

and sailing ships. These inferior products were also sold in the bazaars of the Ottoman Empire, but by now the red had lost its impact, the white had become dirty, and the glazing was fragile and full of air bubbles. But even trading on the open market could not halt the decline of the workshops in Iznik. By the middle of the 17th century, there were just nine left, and by the beginning of the 18th century, the ceramic industry had finally collapsed, and the potters moved to Istanbul in the hope of reviving the workshops there. But the products produced there were never in any way comparable to those of Iznik at its peak.

Competition from Küthaya

The situation was better at another centre of production which had been in existence longer than Iznik but had never attained its degree of fame: the Armenian potteries in Küthaya, Western Anatolia. In contrast to Iznik, the painting was done without any preexisting pattern. There were many religious themes, which the Christian Armenian potters produced for their churches. Thanks to state support, these workshops have survived right up to the present day. Küthaya tiles are to be found in late Ottoman buildings like the tomb of Sultan Mehmed V Resad in Eyüp, dating back to 1918. Even decorative plates

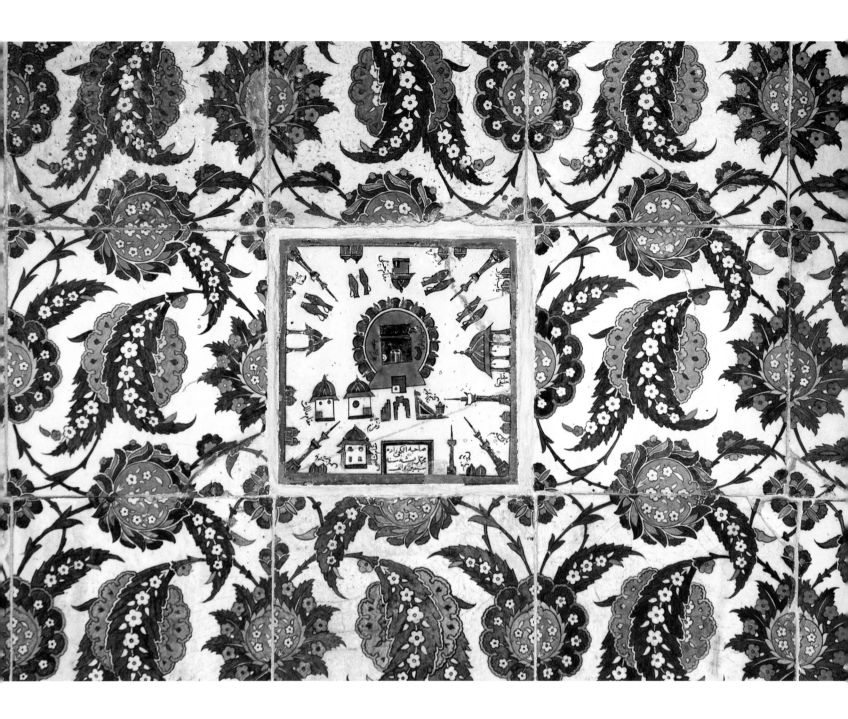

Mosques often include a tiled panel with a stylized representation of the Kaaba in Mecca. One such panel decorates the outer wall of the Rüstem Pasha Mosque.

and dishes using Iznik designs from the 15th and 16th centuries and on sale in the bazaars today have been manufactured mainly in Küthaya. The artists also use modern motifs as well as copying Ottoman miniatures. By reviving the patterns of tiles, plates and dishes from the great days of Iznik, they hope to keep something of the centuries-old tradition of this Ottoman art form alive.

CARPETS:
WOVEN DREAMS

Marco Polo raved about the magnificent carpets of the Orient. The splendour of their patterns and colours was due originally to the nomad women, who worked their own symbols and dreams into the weave. But it was only when production began in the workshops of the sultans that the patterns were made to fit in with the taste of the times.

Nomadic symbols

The nomadic women of Anatolia had their own unique method of gaining the attention of the men in their family and of the tribe generally: they would weave and sew their feelings, fantasies and desires into their carpets. The patterns expressed their grief, pain and fear, but also their joys and their hopes. Each tribe had its own repertoire of designs, as well as family and clan symbols to denote ownership. The weavers would never take over the motifs used by other tribes. Mothers taught their daughters all the forms and meanings, but sadly there is no written record of the secret codes, so that many of the symbols remain unexplained. There are, however, a few that have been deciphered: for instance, the *elibelinde* – a diamond pattern which looks rather like a figure with its hands on hips – stands for motherhood, femininity and fertility. Its counterpart is the *koçboynuzu*, or ram's horn, which expresses power, productivity and masculinity. If there is an eye in the middle of the composition, it is meant to protect the whole family from the Evil Eye, and the same effect is intended with the symbol of the *pitrak* or burdock. Birds have a variety of meanings: some symbolize love and good fortune, but owls and ravens mean the opposite. The tree of life denotes eternity, and promises hope of life after death. For young girls especially, weaving played a central role in their lives. They spent a great deal of time and effort on making their own dowry. If they wished to get married, they would weave earrings or ribbons into the carpet, and a chest signified the dowry, so everything the bride wove into it represented the expectations she had of her future husband and her new life. The production of all woven goods lay exclusively in the hands of women, apart from mending carpets and sometimes dyeing the threads. Their work gave the women a special social standing, for people's living standards were measured by the number and quality of the fabrics a family owned.

Weaving and wandering

It was flatwoven carpets, as opposed to knotted-pile rugs, that were part of the everyday lives of the nomads. These woven pieces were functional objects rather than merely decorations for the minimally furnished tents, and as they were made mainly for personal use, the nomads went on using them until they were literally threadbare. That is why very few antique kilims and weavings have survived. Women made tents, wall and door hangings, bags, purses, cushions, cradles, saddlebags, blankets, dough cloths, salt bags and carpets from sheep's wool and goat and camel hair. All these woven articles were light and easy for the nomads to carry on their wanderings. They also wrapped their dead in thinly woven blankets to take them to their graves. Kilims used for this purpose can be identified by the slits down the sides, through which strings were drawn.

Flatweaves were also produced in the towns and in the court workshops. The tents of the Ottomans, when they went to war, would be fitted out with kilims – the higher the rank of the soldier, the finer would be the carpets that decorated his tent. The pieces from the court workshops conformed to the taste of the time. Even today, there are more than forty techniques for producing flatweaves, and indeed a single carpet might contain up to ten different kinds of weave. Nonetheless, the best-known

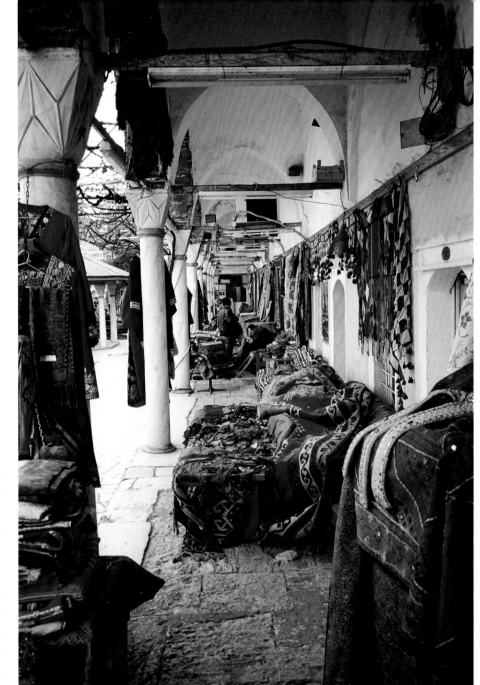

form is probably still the kilim, which has become very popular in Europe since the 1970s.

Pile carpets come to Europe

While the nomad women produced flatwoven carpets for their own use, knotted-pile carpets served as a form of household decoration. The Venetian explorer Marco Polo, who travelled through Asia Minor in 1271, reported that in Anatolia he had seen the most beautiful carpets in the world. During the Crusades, merchants and knights brought the first pile carpets back to Europe, but these were so expensive that they were only used to cover tables or divans, and never placed on the floor. Many a crusader, in gratitude for his safe return to Europe, laid a carpet on the altar steps of his church. But Turkish carpets only achieved true fame after the world exhibitions in London (1851) and Vienna (1873), where large numbers of magnificent specimens were put on display. Then they were all the rage, and practically overnight the carpet became a must-have status symbol. Anyone could afford to do so began to collect them. Museums in London, Berlin, Vienna and Budapest bought carpets for their collections, and pile carpets were also to be found in the houses of the middle classes. Thanks to the new prosperity resulting from industrialization, more and more people were able to afford these Ottoman luxuries.

Carpet-making, knot by knot

It is not surprising that one has to pay a high price for a handwoven carpet, even if it is not an antique. Depending on the thickness of the threads, the complexity of the pattern, and the nimbleness of the weaver's fingers, between 4,000 and 10,000 knots a day have to be tied. The finest Hereke silk carpet ever produced has a density of almost 5.8 million knots per square metre. It took five women five years to finish this masterpiece. However, a more usual knot-count would be something like 200,000 knots per square metre. Each weft thread is wound and knotted round two warp threads, and the cut ends of the threads form the pile on the carpet's surface. Additional weft threads are also woven between the individual rows of knots. Apart from the density of the knots, other factors affecting the quality and price of a carpet are its size, design, colour and material.

As new Turkish carpets are generally garishly bright, the dealers often lay them out in the sun to fade them. This process is less damaging to the weave than washing it with chemicals.

Carpets in European paintings

As with woven textiles, there are many types of pile carpet. Peasants and nomads produced only small carpets for their own use, whereas those from urban factories – in towns like Usak, Konya, Ladik, Gördes and Bergama – were larger and made for use at home and abroad. The patterns were predominantly taken from nomad designs, though some were original. It is thanks to a number of European painters that we are able to trace these different carpet types and their time and place of production. Artists such as Hans Holbein the Younger and Lorenzo Lotto immortalized pile carpets in their works and these paintings have survived, unlike the carpets themselves.

Another type of pile carpet came on the scene during the Ottoman Empire and was produced mainly as a luxury item for the court. The patterns – just like those of tiles and metal objects – were designed by the masters of the *nakkaşhane*, the court workshops in the Topkapi Palace. In this instance, they worked in strict conformity to the current taste of their ruler. The plant motifs of floral rosettes, feathered lance-shaped leaves, and curved tendrils had no connection with the mystic symbols of the nomads. They were forms that were quite new to the Turkish carpet.

With the capture of Cairo in 1517, probably the most famous carpet factories of all fell into the hands of the Ottomans. The designs for the carpets that were made there also came initially from the court studio in Istanbul. These magnificent court carpets were distinguished by a high density of knots, but the range of colours was limited to seven or eight. A particular favourite was a warm red, though unlike the carpets from Anatolia, the contrasts were generally very weak. In addition to the factories in Egypt, the end of the 16th century saw the opening of workshops around Istanbul, but from the late 18th century onwards, the Anatolian towns of Hereke, Bandirma and Kumkapi (near Istanbul) took over production.

A carpet for prayer

Prayer mats represent a class of their own. In the past as in the present, they are an indispensable piece of equipment for every practising Muslim. It is written in the Koran that ritual prayers must be said on clean ground. There is no specific mention of carpets, but

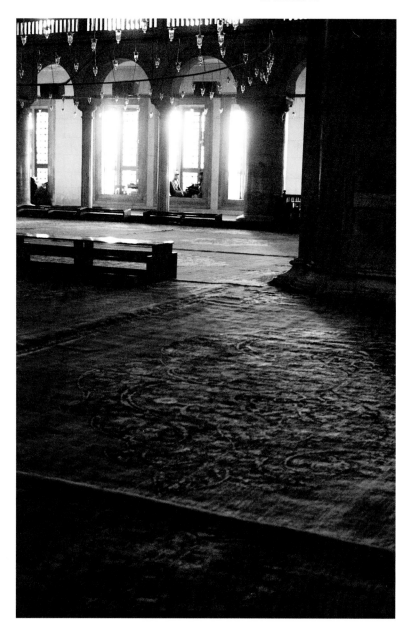

all the same, skins, rugs or specially knotted or woven mats are used for the five daily prayers. A prayer mat can be recognized by its pattern: it contains a picture of a *mihrab* or prayer niche; during prayers, the pointed end must lie in the direction of Mecca. The niches may vary from simple triangles to elaborately decorated areas with columns and candlesticks, the latter being a reference to the Koran: 'Allah is the Light of the heavens and the earth. The similitude of His light is as a niche wherein is a lamp. The lamp is in a glass. The glass is as it were a shining star.'

The search for lost dyes

One of the biggest breakthroughs in carpet manufacture came to the Orient with the introduction of synthetic dyes during the 1860s. Previously, wool and silk had been coloured with natural dyes made from plants, including brazilwood, saffron, safflower, buckthorn berries, pomegranates, walnuts and onions. Insect dyes were also widely used: these included cochineal, kermes and lac. Natural dyes were used until around 1900, but subsequently practically everyone switched to the cheaper, synthetic forms. Within a period of just eighty years, vegetable dyes disappeared, and with them the knowledge of how to make them. But initially, the synthetic dyes were resistant neither to light nor to water, and so many carpets lost their lustre after just a few years, whereas carpets even centuries old retained their vibrant colours. Not until the 1980s did a German

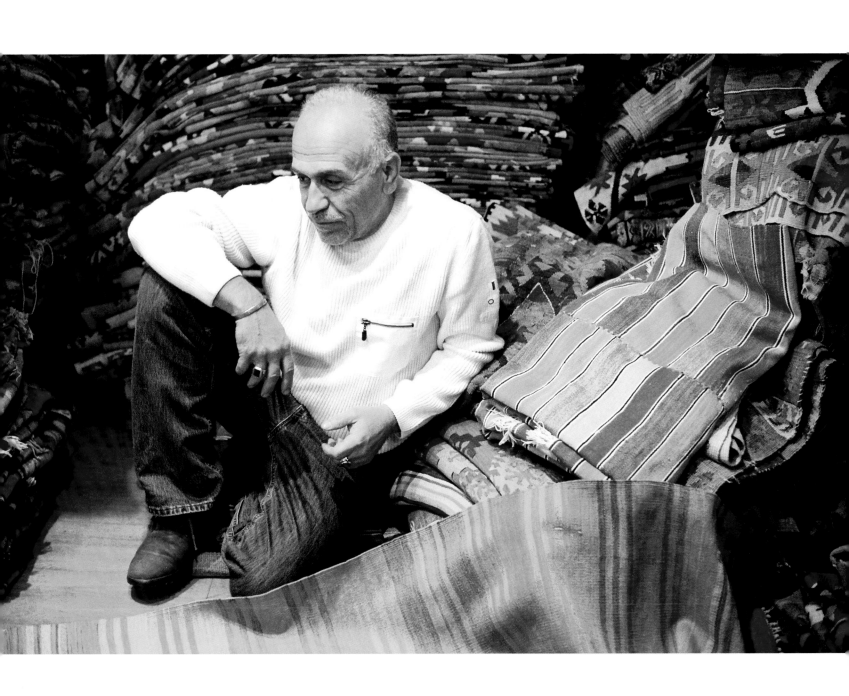

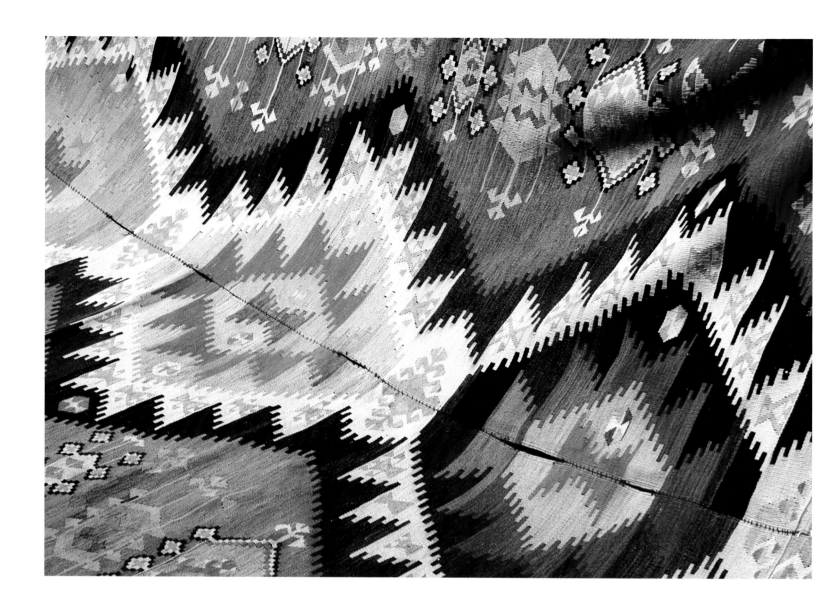

chemist rethink the whole process. Harald Böhmer travelled the length and breadth of Turkey in search of the lost dyes. It took him several years to reconstruct the formulae for those natural dyes, but as a result, many carpet manufacturers returned to the ancient traditions of the nomadic tribes.

Changing tastes

It was not only the dyes that changed over the centuries. With the political and economic fall of the Ottoman Empire, the level of craftsmanship suffered too. The quality of woven and knotted carpets declined, and another factor was that traders and manufacturers had to adapt their products to the tastes of their clients, whether at home or abroad. In the 1920s, when Kemal Atatürk modernized the state and carried out far-reaching reforms, the Grand Bazaar was suddenly flooded with old carpets. The

people of Istanbul felt the need to modernize themselves, and this entailed redesigning their houses and apartments. Even more carpets came from the Dervish monasteries, which were forced to close all over the country as a result of the reforms. The call was for new carpets.

It was the same with the European market. If carpets were to sell, they had to be in the colours and forms of a foreign culture. However, the knotted carpets and kilims that the nomads had made for their own use remained exempt from these modernizing trends, which is why wonderful specimens dating from the early 20th century can still be found. Since then, however, the individual talents of knotters and weavers have seldom been called on. Nearly all of them work in the large factories, and they have to adhere to given patterns. The few remaining semi-nomads and peasants no longer have to

Handwoven carpets often consist of two sections sewn together. The looms used by the nomads were very narrow, so that they were easy to transport.

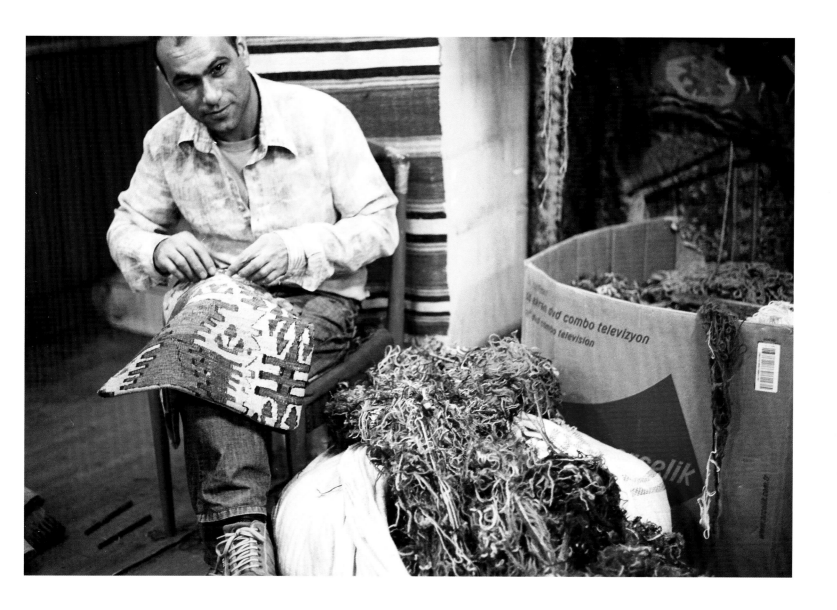

While women weave or knot the carpets, men do the mending. The brighter and more elaborate the designs, the easier it is to repair them. With a simple weave, the colour of the new threads must correspond precisely to that of the original.

produce their own textiles in the form of sacks, bags, covers or carpets. They pack their belongings in cases and boxes, and put them in the car. In most places, houses replaced tents. Only where hand-made goods are declared to be craft work – and hence provide a source of income for the maker – do they continue to be produced, but the future of such expensive crafts is insecure, because today the rising cost of wages makes hand-knotted carpets and kilims inaccessible to all but the wealthiest.

Woven motifs and their meanings

*Ram's horn (***koçboynuzu***)*

The horns of the ram indicate masculinity, power, productivity and heroism. The weaver hopes that her husband will remain endowed with all these qualities. It is believed that the motif is derived from the spiral, which represents infinity.

*'Hands on hips' (***elibelinde***)*

This motif is also associated with the concept of a child in the womb; it stands for life, birth and fertility.

*Fertility (***bereket***)*

A combination of the *elibelinde* and ram's horn/*koçboynuzu* motifs represents fertility. Pomegranates and corn motifs have the same meaning.

*Tree of life (***hayat ağaci***)*

The tree of life symbolizes the wish for eternal life. Carpets are often hung on walls with the roots of the tree pointing upwards. It is believed that strength and power come from heaven and are directed through the branches down to earth.

Wolf jaws and wolf tracks
(**kurt agzi, kurt izi**)

These are a defence against wolves and other wild animals. As the nomads depended on their sheep and goats, they were in constant fear of predators that could attack their herds. The wolf's jaws also symbolize the wish for solidarity.

*Hand, Finger, Comb (***el, parmak, tarak***)*

These represent fertility, and the hand is that of Fatima, the Prophet's daughter. The comb expresses the desire to be married, and it is believed to offer protection to children from the Evil Eye.

*Amulet and the Evil Eye (***muska, nazarlik***)*

There is an Anatolian superstition that a look can kill or bring great misfortune. An eye symbol acts as a defence against this evil, while a *muska* is a protective formula generally carried around in a triangular holder, also to ward off evil.

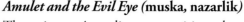

*Running water (***su yolu***)*

Water gives life to everything, and so this important motif is often woven into the borders of the carpet.

*Star (***yıldız***)*

This expresses the happiness of the weaver. For technical reasons, Anatolian kilims often feature octagonal stars.

*Bird (***kuş***)*

When birds leave the branches of the tree of life, the soul rises to Heaven. The vulture, however, symbolizes death. The bird motif is particularly important, as it also represents good fortune, love, power, strength, and the arrival of good news.

*Dragon (***ejder***)*

The Turkic peoples of Central Asia depict the mythical dragon, ruler of Heaven and Earth, with a beak, wings and lions' claws. When used as a decorative motif, it symbolizes the wish for life-giving rain.

*Hairband and earrings (***saçağı, kupe***)*

These are the weaver's way of saying that she would like to get married. In Anatolia, girls do not cut their hair until their wedding – hence the symbol of the hairband. Earrings are a popular wedding gift for a bride.

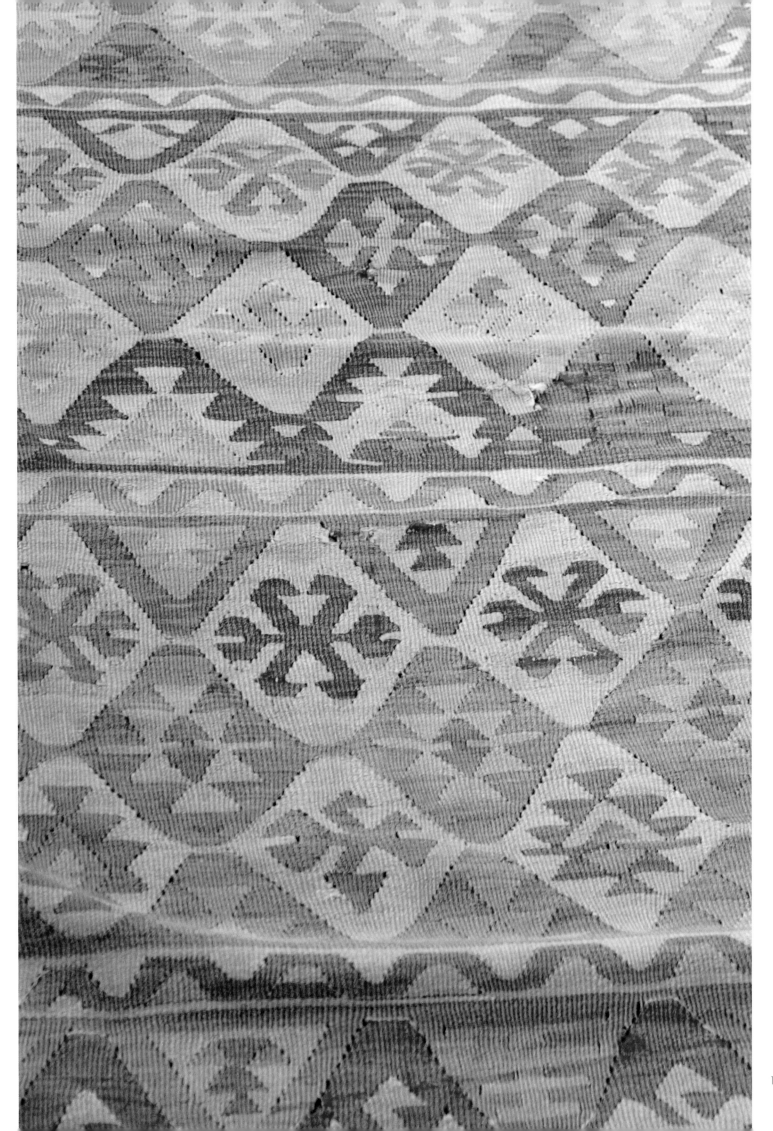

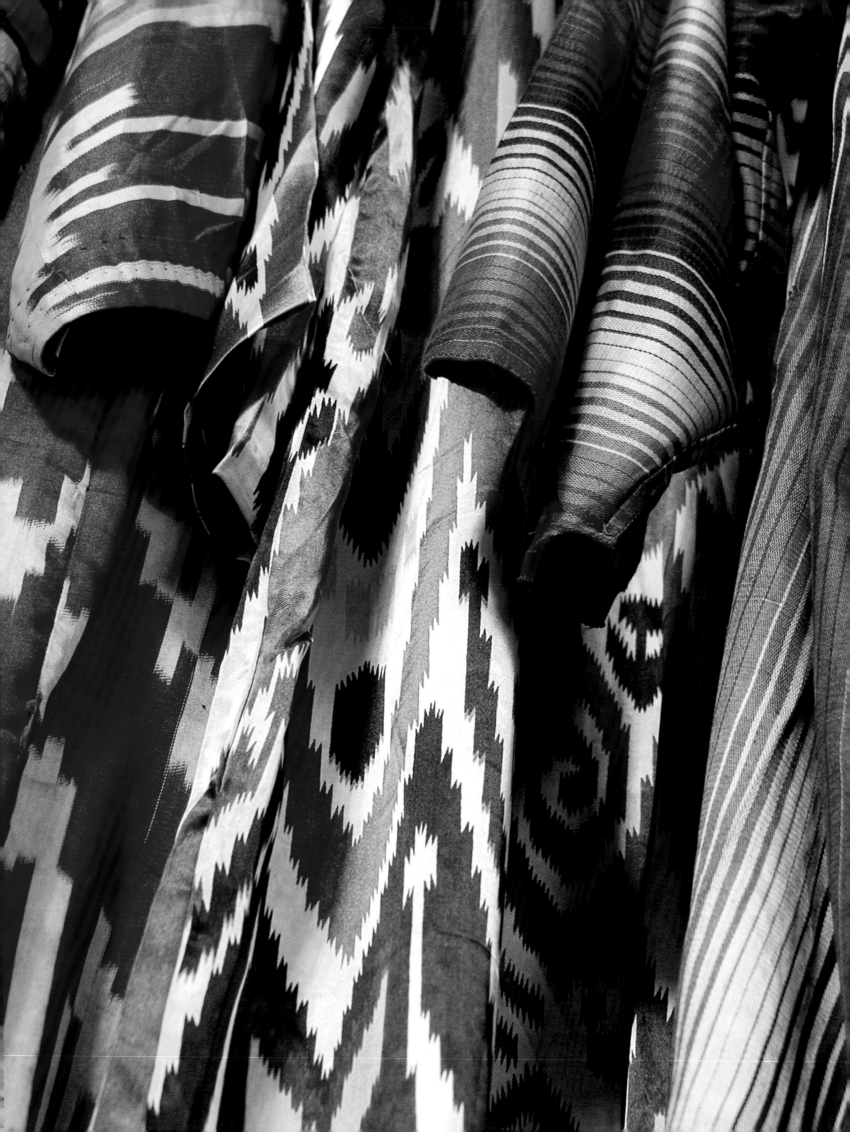

TEXTILES:
MATERIAL LUXURIES

From Bursa, silk centre of the Ottoman Empire, magnificent fabrics made their way to the Grand Bazaar and the palace workshops in Istanbul. Here they were turned into ceremonial robes, sultans' kaftans, cushions and cloths, often richly embroidered with silk, gold and silver threads. These textiles played an important role in distinguishing between tribal communities and social ranks.

The travels of the silkworm

For thousands of years the Chinese succeeded in keeping the secret of how to produce silk. Anyone who tried to smuggle the precious silk moth eggs or larvae out of the country would be put to death. But the Byzantine Emperor Justinian was so keen to spin his own silk that he sent two monks to find out the secret. After many months in the remote regions of China, the two men returned to Constantinople in AD 555. Hidden in their staffs were the precious, smuggled eggs of the silk moth, and so the West was able to join China, India and Japan in the production of silk.

Nevertheless, it was not until the middle of the 16th century that Bursa, the silk capital of the Ottoman Empire, was able to breed the silkworm locally and thus free itself from dependence on the Persians, who until this time had had to supply the raw materials. It was a crucial development for this town on the Silk Road, because supply chains were often interrupted by wars between the Ottomans and the the Persian dynasty of the Safavids. But even before then, Bursa was an important centre for the production and sale of silk. Persian and Italian merchants had settled there, and some had grown extremely rich by trading in both the raw materials and the finished fabrics.

Istanbul becomes the new textile capital

The sultans' desire for fine fabrics appears to have been insatiable. The weavers in Bursa and the other two textile centres, Amasya and Edirne, could not keep up with the demand, and so at the end of the 16th century the court in Istanbul set up its own silk factories. By the middle of the century, the quality of the fabrics made in Bursa had declined, and now they were specializing in silk-weaving and producing the raw materials. In Istanbul, however, the number of weaving mills rapidly increased: in 1557 there were already 156, compared to 27 just thirty years earlier. Twenty years after that, the number had grown to 268, despite strict regulations imposed by Süleyman I in order to maintain the high quality of the fabrics. At about the same time, a decree was issued forbidding Bursa to produce any more fabrics containing gold thread, as this was now to be limited to the royal workshops. It appears that excessive use of gold in the manufacture of fabrics had drastically cut into the country's reserves of the precious metal.

As in every area of life, the state imposed strict controls over raw silk as well as the finished fabrics; after all, the textile trade brought in taxes. The thickness of the warp was prescribed by law, although quite often the weavers would try to cheat and would then – if found out – be severely punished. Only after rigorous quality testing could the fabrics be sold in the bazaars of Istanbul and Bursa, or exported to Europe. Until well into the 17th century, the textile industry on the Bosporus flourished and expanded. But then came the political and economic fall, and with it a corresponding decline in quality. The rapid development of the textile industry in the West from he beginning of the 19th century led to an immense demand for raw materials to satisfy the voracious appetite of the new machines. The Europeans bought up all the silk that Bursa could provide, with the result that the local looms came to a standstill. The raw materials had gone, and the golden age of the

Ottoman Empire's textile industry had come to a close. Although Turkey has once more become an important centre for textiles, very little silk is produced in Bursa now.

A variety of silks

At its peak, the Ottoman textile industry produced an impressive variety of fabrics. In 1504, there were 91 different types of material being woven in Bursa alone, including three main forms of silk. *Kadife* is a satin silk, the best known variety of which is embroidered with gold and silver with a generally red *çatma* weave. The liveliest patterns were to be found in the silk brocades known as *kehma*. The motifs were taken from a standard repertoire, though this was constantly extended by the court painters. In total contrast were the simple *tafta* or *atlas* satins. The different fabrics were produced in all shapes and sizes, from little patches for cushions to rolls of various lengths to be made into rich robes or decorative wall hangings. The rolls were of limited width, however, because unlike the looms of the Persians and Italians, those of the Ottomans had a standardized width of just 65 cm (25 ½ in.).

Ranks and robes

Of course, not everyone could afford these expensive and sophisticated materials. Ordinary people bought simple woollen articles in the bazaar, and only the sultans, viziers and wealthy citizens were dressed in silks and satins. The sovereign set himself apart from the hoi polloi with long rolls of silk which he even used instead of the conventional red carpet. What people wore in the Ottoman Empire was, as usual, precisely regulated by a long list of royal prescriptions. Thus by a single glance at the colour and cut of a robe or turban and the quality of the material, one could tell the social status, religion and profession of the person concerned. Those who wore turbans had their own individual style of winding them round their heads, but religious distinctions were clear: Muslims wore white, Jews yellow, Greeks blue and Arabs multicoloured. Other religious denominations wore caps of fur or leather. If a non-Muslim wore a white turban, he could face the death penalty. High priests were forbidden by the Koran to wear silk, and so their clothes were made of fine wool – not sheared, but combed from the fleece of a live angora goat and then spun.

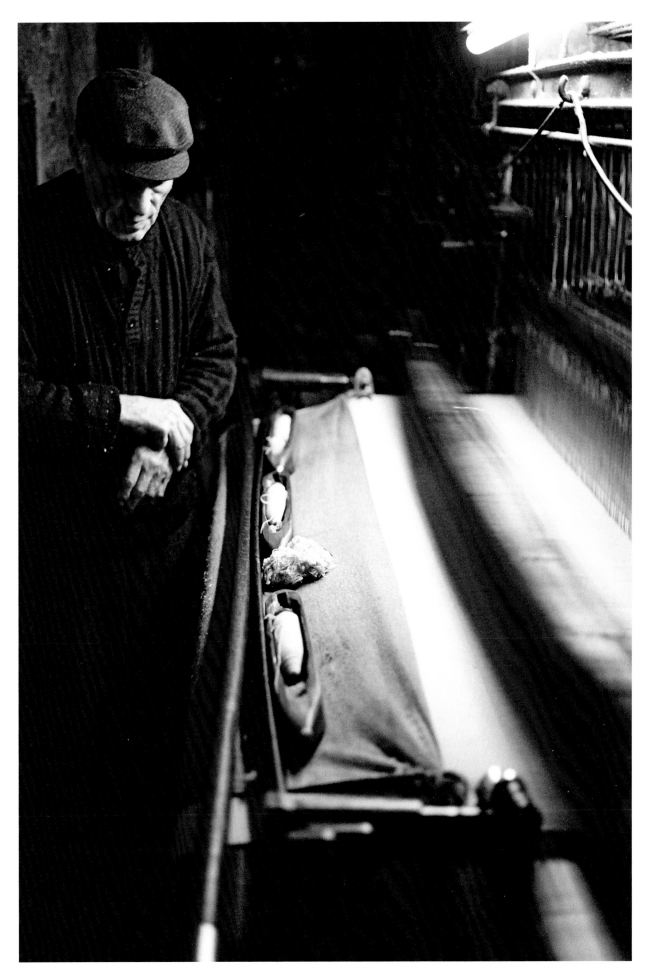

Most new kaftans, shawls and fabrics are now mass produced. In the Büyuk Valide Han you can still find the old methods being used.

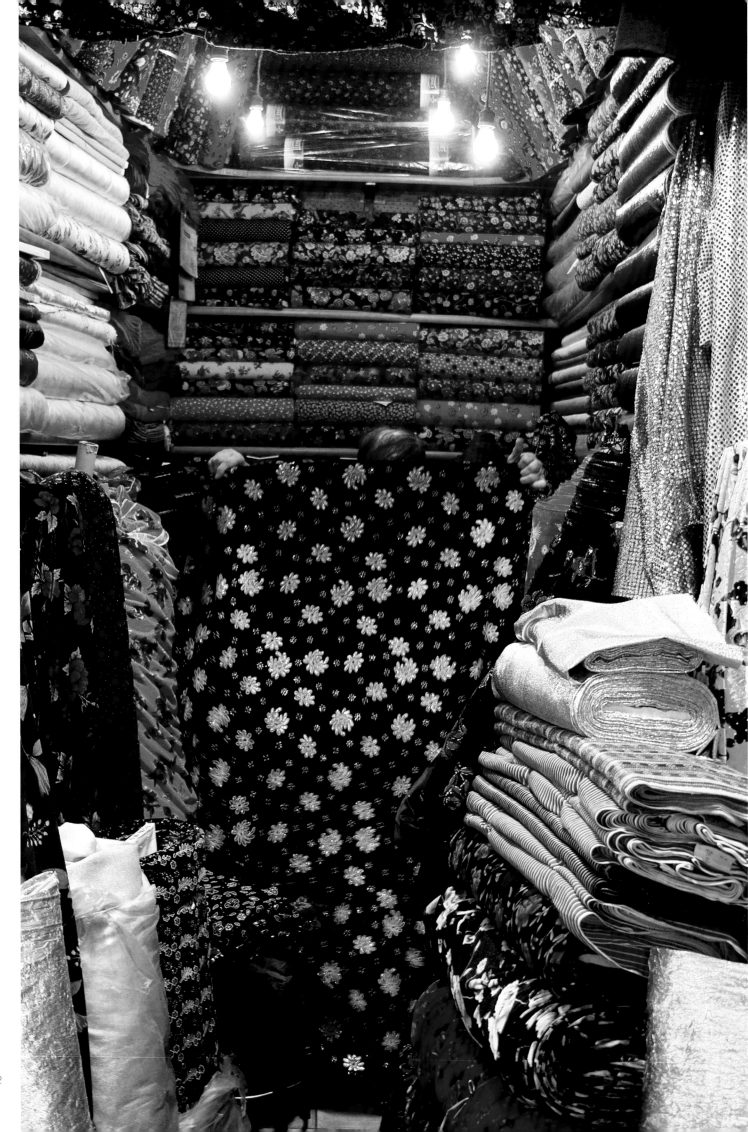

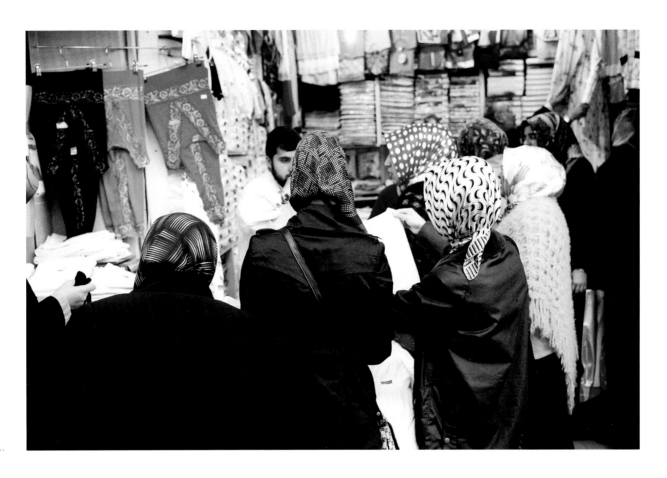

In Çarçiler Street, outside the walls of the Grand Bazaar, shop after shop is stocked with brightly coloured headscarves..

The most magnificent robes were, of course, reserved for the Sultan. Many court tailors were employed exclusively to make these exquisite clothes, while others made ceremonial robes awarded for special services or promotion. Particularly sought after, and a sign of the greatest esteem, were clothes that the Sultan had already worn himself. After an audience with the ruler, foreign ambassadors never left the court without one of these robes. However, it was a tradition that they would be met at the gates of the palace, and there the gift would be repurchased from them and returned to the treasure chamber. Very soon, it would be passed on to the next visitor. The elegant silk robes and colourful turbans went out of fashion in the early 19th century, after the clothing reforms of Mahmud II. The introduction of Western-style uniforms made the ceremonial robes superfluous, and the turban was replaced by the fez.

Furnishing fabrics

Fabrics were immensely important in the private sphere as well. Rooms and houses contained very little furniture. People did not sleep on wooden beds or sit on sofas; instead they used mattresses, thick blankets and cushions to rest on. Carpets lay on the floors and decorated the walls. There were no chests or cupboards; instead, clothes and other possessions were wrapped in cloths or kept in woven bags. In the 18th century, Lady Mary Montagu described the advantages of this way of life: 'The rooms are all spread with Persian carpets, and raised at one end of them (my chambers are raised at both ends) about two feet. This is the sofa, which is laid with a richer sort of carpet, and all round it a sort of couch, raised half a foot, covered with rich silk, according to the fancy or magnificence of the owner. Mine is of scarlet cloth, with a gold fringe; round about this are placed, standing against the wall, two rows of cushions, the first very large, and the next, little ones; and here the Turks display their greatest magnificence. They are generally brocade, or embroidery of gold wire upon white satin. Nothing can look more gay and splendid. These seats are also so convenient and easy, that I believe I shall never endure chairs as long as I live.'

Silk embroidery: stitch by stitch

It was mainly women whose nimble fingers decorated Ottoman homes. Every young girl's upbringing

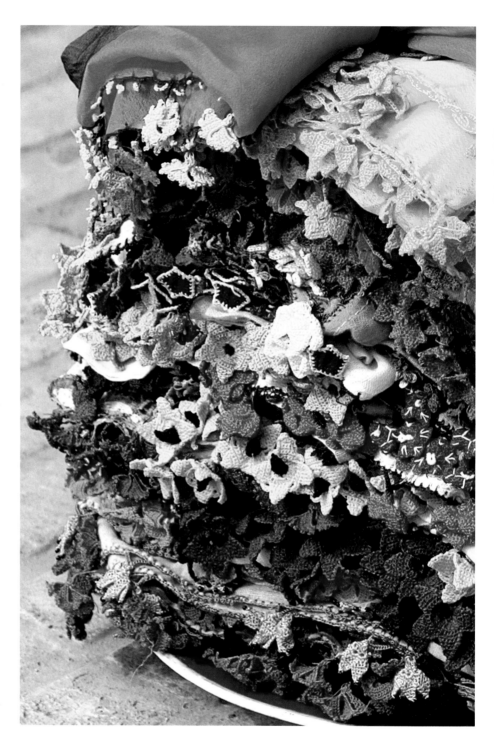

included learning to embroider, but there were also a few men who were devotees of the art. Thus it was that Ahmed III, ruler during the Tulip Period and evidently a man with an eye for beauty, sat with his wives 'embroidering and fondling'. Embroidery was a pastime for the women, who were rarely allowed to leave their apartments in the city. This work was not controlled by the guilds, and the patterns were not prescribed by the court, so the women were able to give free rein to their imaginations as they embroidered their scarves, headdresses and cloths (all for domestic use only). They would put these cloths in cradles, make turbans out of them, or lay them on the coffin as it made its way to the cemetery. Particularly well known, and still to be found in the bazaar, are the little white towels with brightly coloured silk embroidery at either end.

Not until the 17th century was the handiwork of these women exploited commercially. A hundred years later, some embroidery workshops near the Bayezid Mosque were forced to close. Perhaps the guardians of the harem felt that the new forms were merely a means of seduction, though it is doubtful whether the ban lasted for very long.

Turkish needle lace or *oya*, seen here on the fringes of the colourful headscarves from Anatolia, provides a wordless means by which women can express their feelings. Old women wear lace in the form of little flowers which symbolize the approach of death; unhappy wives show their dissatisfaction with their husbands through chilli pepper flowers.

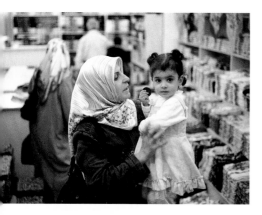 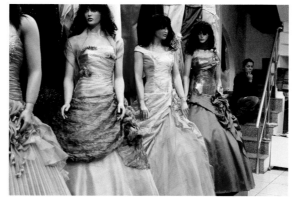 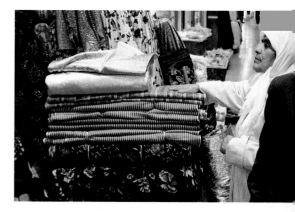

A girl in the cradle, a trousseau in the chest.

Turkish proverb

In bygone times, nomad women used to sew, knit and crochet their trousseau themselves, whereas today they buy their readymade towels, bed linen and electrical gadgets in the bazaar.

Needle lace: a flower for every occasion

There are as many types of flower in the Anatolian countryside as there are in the embroidery work of the women who live there. Traditional Turkish needle lace is known as *oya* in Anatolia, and generally takes the form of three-dimensional lace flowers which are sewn onto the edges of printed headscarves. In earlier times much more than today, women used these *oya* headdresses to give expression to their feelings. This was especially so at weddings. Girls marrying the love of their life would choose *oyalar* in the form of pink hyacinths or almond blossom. In some regions of Turkey, brides still send lace headdresses to their future mother-in-law before the wedding. This can be a moment of some tension: a headdress with grapes and vine leaves means a good relationship with the groom's mother, but *oyalar* in the form of tombstones means watch out for trouble. With the flowers of the chilli pepper plant, the bride is declaring that she is not happy with her fiancé. Outside the Grand Bazaar is a whole street where nothing but headdresses are sold, many of them decorated with *oyalar* but very few of them are now made by hand. Many Turkish fashion designers and traders in the Kapalı Çarşı have transformed these old lace flowers into modern accessories, putting them on chains or rings.

The trousseau: the life's work of a bride

Immediately after the birth of a daughter, the Turks begin to fill a chest with *oya* work, embroidered linens, carpets and undergarments. Handkerchiefs are taboo, however, because they denote tears and separation. In the days of the Ottoman Empire, the trousseau of the Sultan's daughter would be carried to the new husband's house with a musical accompaniment. Today the custom of the trousseau has only survived in rural regions. The chest is presented in the presence of relatives and neighbours, and one woman is especially chosen to organize the exhibition. Of course the objects must be shielded from envious eyes, and so they are strewn with carnations and caraway seeds. In order to make the husband's life all the sweeter, sugar tongs are included in the chest. A precise record is kept of all the bride's possessions, because if there should be a divorce, she has a right to all of them and they may form a valuable reserve fund. Today, there are virtually no places remaining in Turkey where young women spend years sewing and embroidering their trousseau; they now prefer to go out and buy things – furniture, towels, kitchen goods and a TV. In Istanbul's bazaars you can find all the important items for the trousseau and the wedding: white wedding dresses made of satin, chests of artificial leather, hair decorations with precious stones, miniature brides and grooms to place on the cake, and salvers on which to present the rings.

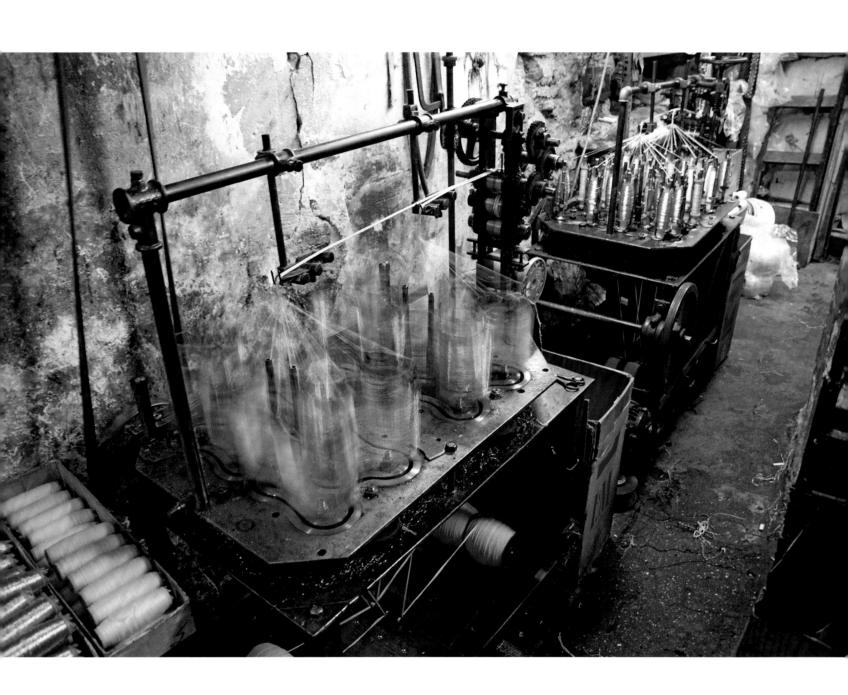

No lover can wander through this bazaar without feeling what a disaster it is not to be a millionaire, and without being tempted just for a moment to become a robber.

Edmondo di Amicis, Italian travel writer, describing the textile market in the Grand Bazaar, 19th century

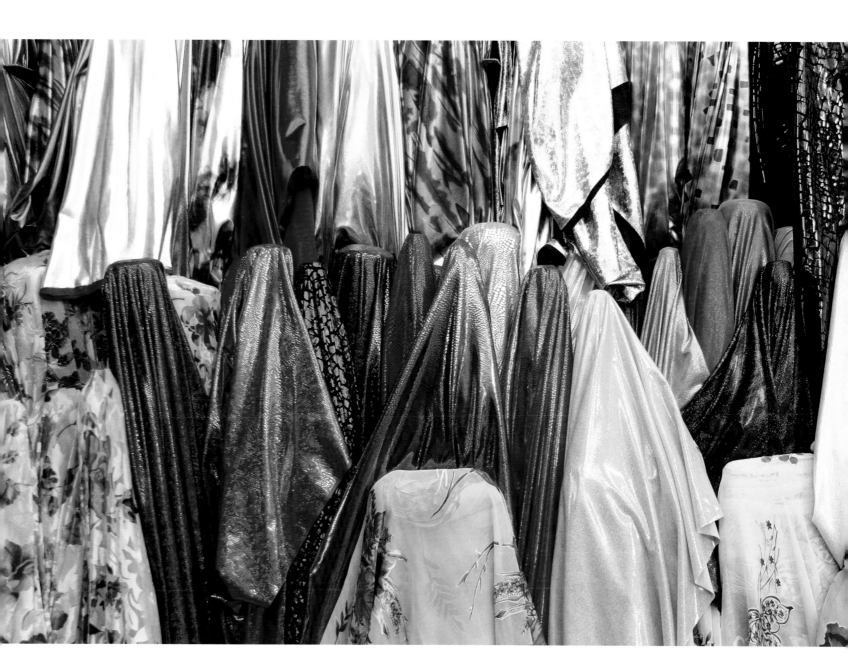

CALLIGRAPHY: THE ART OF BEAUTIFUL SCRIPT

For Muslims, calligraphy is the highest and most sacred form of art. Until well into the 19th century, the Koran could only be copied in calligraphic writing. The importance of text in the faith and Islamic constraints on the making of images meant that this craft was more highly developed in the Ottoman Empire than in any other culture.

Religion and the written word

When the young prince Bayezid II ruled over the provincial capital Amasya, a certain Seyh Hamdullah introduced him to the art of calligraphy. In 1481, Bayezid became sovereign over the whole of the Ottoman Empire, and he remembered his old teacher, had him brought to the capital, and gave him his own studio. The Sultan had so much respect for the master and his art that he would even hold the inkwell for hours on end while Seyh Hamdullah concentrated on his calligraphy. No other Islamic art is so venerated, as the Muslims regard every handwritten copy of the Koran as an image of the original, which is kept in Heaven. The beauty of the Word of God and the Prophet was to be emphasized by a correspondingly beautiful outer form. Furthermore, the Koran could only be copied in Arabic script, and the infinite variety of shapes and combinations gave the scribes endless scope for invention. However, the order of the letters and words, as well as the straightness of the lines and the distance between them, were all governed by strict calligraphic rules.

It was not only the Koran that was written in this way. Until printing was permitted in the Ottoman Empire, scribes copied manuscripts of poetry, history and religion in this way. Official documents and decrees were also written by calligraphers, while tombs and the exterior walls of buildings such as schools, Dervish monasteries, libraries, mosques and baths were adorned with decorative inscriptions.

Islam and images

In Islam, divine truth is revealed only through the written word as set out in the Koran. The pictorial depiction of living creatures is regarded as potentially blasphemous, for the work of a painter or sculptor is like the act of creation, and this is for God alone to perform. The faithful are also forbidden from idolatry, the worshipping of images. The ban on representation of living creatures is not, however, expressly mentioned in the Koran – it is based on the Hadith, a series of oral traditions that relate the life and deeds of the Prophet Muhammad. For instance, it is written that 'The makers of pictures will be punished on the Day of Resurrection, and it will be said to them, "Give life to what you have created."'

When you enter a mosque, the absence of such figurative images is immediately striking. There are tiles lavishly decorated with flowers, carpets with extravagant geometrical patterns, and calligraphic inscriptions on the walls, but images of people are nowhere to be seen. An early 18th-century traveller wrote: '...other mosques are simply painted white, without any decoration at all, because they consider the use of pictures to be idolatrous, and they think that on the Day of Judgment, artists will be asked to provide souls for their human images.'

Illumination and marbled paper

As figurative illustrations were not permitted, artists concentrated on calligraphy, but what they produced was not just beautiful lettering; they also decorated their manuscripts with colourful flowers and stems, and elaborate patterns and arabesques. Most of these designs were in glowing gold, combined with blue or red, and that is why this art form is known as illumination. The colours were assumed to have a meaning: gold symbolizes the sun, and the yellow colour of light

Emblem of the sultans

The *tughra* was a form of seal which was stamped over the text of official documents in order to validate them. Except for the very first sultan, all thirty-six Ottoman rulers had their own emblem. The *tughra* was composed of different painted sections which were so florid and interwoven that they were scarcely legible. But anyone able to decipher the text would recognize the name and title of the sultan and his father and the formula introduced by Murad II of *muzaffer* – 'forever victorious'. The emblem was always designed by the leading calligrapher, and decorated by members of the court workshop. Only the Ottoman rulers used the *tughra* as a calligraphic seal.

The *tughra* of Mahmud II, an Ottoman Sultan of the early 19th century, can be read as 'Mahmud, son of Abdülhamid, forever victorious'.

The art of calligraphy is hidden in the teachings of the master, its essence lies in repetition, and it is there to serve the faith of Islam.

Saying attributed to the Caliph Ali

means wisdom. Light is also an important element in the Koran. Blue indicates the heavens and represents infinity. Once the scribes had copied out the text of the Koran, other artists would illuminate it, and it is estimated that in Istanbul during the 17th century there were more than a thousand illuminators in a hundred workshops.

Other works were also written on marbled paper or *ebru*, which was very expensive to produce. First a viscous mixture known as a 'size' was made by mixing water and gum. Pigments were then sprinkled on its surface and drawn out with a kind of comb, to create decorative swirls. Finally the artist laid the paper on the surface of the size to transfer the beautiful coloured pattern.

Many calligraphers found ways of circumventing the ban on figurative images. They devised new cal-ligraphic compositions by combining letters, words and lines to form a picture. These could depict animals, as well as sailing ships and fruit.

Istanbul as the centre of calligraphy

Between the 15th and early 20th centuries, Istanbul was regarded as the centre of calligraphy. The great master Seyh Hamdullah revolutionized the six classic Arabic scripts that were used in calligraphy, and created a unique Ottoman style that served as a model for succeeding generations. There was even an Arabic saying: 'The Koran was revealed in Mecca, recited in Egypt, and written in Istanbul.' Generation after generation of scribes perfected the art. Apprentices had to study for several years under a master, and only by repeating and imitating the strokes of their teach-ers could they attain this perfection. Then they were

Ottoman gravestones are decorated with calligraphic inscriptions. Their form indicates the sex and rank of the dead person. Thus according to the size of the grave, a turban indicates a vizier or a pasha, while flowers denote a woman.

presented with a diploma and were allowed to sign their own works. Even today, there are many who add to their signatures an epithet such as 'the Poor' or 'the Sinner', in order to underline their humility.

There was, however, very little need for such modesty. Calligraphers were highly respected, even by their rulers, and during their lifetime their works could change hands for a great deal of money. This is illustrated by a story from the life of the famous calligrapher Hafiz Osman. One day he was being rowed across the Bosporus, but when he was about halfway across, he realized that he had no money with him. He therefore took out his paper and pen and wrote a single word on the page. The boatman was not at all pleased at being presented with this 'paper money', but accepted it out of respect for the elderly gentleman. That evening, when he sat in the coffee house

with his friends and showed them the paper, people immediately began to gather round the table and offer him money for it. In the end, for just one word he was paid the equivalent of a whole week's wages. By coincidence, the same calligrapher got into the same boat again the following day. When it was time to pay the fare, he pressed a coin into the boatman's hand, but the ferryman gave him a piece of paper and said: 'Sire, just write a single letter, and that will be more than enough.'

The tools of the trade

Like Hafiz Osman, calligraphers always carried the tools of their trade with them. Pens and ink were kept in a kind of box – called a *divit* in Turkish – which hung like a dagger from their belt. These often beautifully decorated boxes of bronze or silver

Forms of script

One word – 'Istanbul' – written in four different scripts: *kufi* (top left) an early form of calligraphy, gave rise to six different basic scripts. These included *nesih* (top right), which was used for transmission of the Koran, and *sülüs* or *thuluth* (bottom right), one of the most common and yet most difficult to master. As spaces must be uniform down to the last millimetre, mistakes are immediately visible. *Diwani* (bottom left) is a cursive style which was particularly hard to copy and so was used for official documents. The different forms of calligraphy reached their peak towards the end of the Ottoman Empire, but the introduction of Latin script in 1928 led to a decline in the importance of such writing, particularly in official contexts.

are often to be found even today in the Old Bedesten in the Grand Bazaar. The calligraphers did not, of course, use any old pen, ink and paper. Instead, there were whole craft industries designed to produce the high-quality materials that each artist needed. Of particular importance was the reed pen. This was imported to Istanbul from countries as far away as India, although the best reeds came from Persia. In the first revelation to Muhammad it is written that 'It is your most magnanimous Lord that has taught you the use of the reed pen, and has taught man that which he did not know.' Muslims therefore regard the reed pen (*qalam*) as an instrument of divine revelation. However, before the reed can be used as a pen, first it must be buried in manure for up to four years in order to attain the correct degree of hardness. It is said that the Prophet advised his cousin and son-in-law Ali, who is considered to have been the originator of calligraphy as an art form, to write the words close together but to leave adequate space between the letters. The reed must therefore always have a sharp point, because the breadth of the script depends on the breadth of the point. In Istanbul there used to be a particular street that was occupied only by smiths and their apprentices; they produced special knives for sharpening pens.

Just as important as the pen was the paper. The Ottomans initially imported it from China and India, then later from Europe. In the 17th century, demand was so high that many paper mills lived entirely on commissions received from the Ottoman Empire. Before a sheet could be written on, it had to be treated, because untreated paper would absorb the ink immediately, and so it was not possible to make corrections. There were craftsmen who specialized in treating paper. The sheets were dyed, then varnished, and finally burnished. For them to reach the correct degree of 'maturity', they then had to be stored for one or two years. After this period had passed, they could survive unscathed for centuries. For the Ottomans, paper had a very special significance: '…the Turks show great reverence towards paper, because the name of God is to be written on it. Therefore they never leave paper lying on the ground, and if they should come across it there, they immediately pick it up and place it in a crack or crevice so that it will not be trodden on.' So wrote a Habsburg envoy in the 16th century.

When the calligrapher Mustafa Erol began his training, it took eleven months for him to perfect a single letter and for his strict teacher to express satisfaction with his work. Even today, artists use expensively prepared and specially sharpened reeds, but one scarcely ever sees the traditional *divit* – a portable writing case which calligraphers used to carry on their belts.

The ink was made by a complicated process using the soot from burning linseed oil. A particular favourite was the soot from the chimneys of the Süleymaniye Mosque in Istanbul, mixed with a kind of lime from Sudan. The ink-maker would then add his own particular ingredients, which could include rose water, saffron, pomegranate peel or vinegar. The exact 'recipe' was, of course, a closely guarded secret. The liquid was kept in an inkwell, and the calligraphers would put a piece of silk inside it, so that the pen would not pick up too much at a time and drip on the paper. Armed with all these expensive implements, the artist could then set to work.

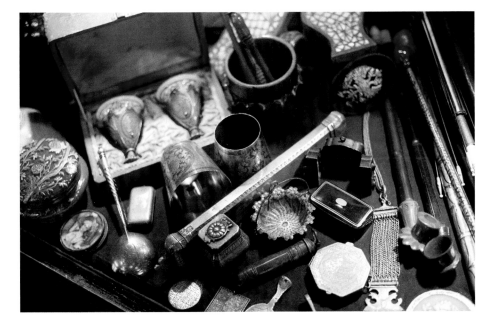

Miniature painting: scenes from palace life

Islamic strictures on images were strictly enforced in sacred contexts, but a little more latitude was allowed in others. This is apparent from the fact that many European portrait painters were invited to the court in Istanbul, and also from the art of miniature painting. As only a small and elite circle had access to this genre, and the works were not seen by a wider public, the Sultan and the religious scholars tolerated the depiction of people and animals.

The dominant theme in miniature painting was scenes from Ottoman history. One popular subject was the family trees of sultans and other important personages, but primarily it was current political and official events that were recorded. The Sultan was always at the centre of things, his deeds were glorified, and artists depicted him hard at work discharging his duties as sovereign. Some sultans even commissioned whole chronicles to capture their life in pictures. Probably the best known of all these works is the *Süleymanname*, which was painted for Süleyman I. Other favourite themes were spectacular festivals and important ceremonies, such as the circumcision of Prince Mehmed III. Thanks to these miniatures, we have precise details of how the Ottomans dressed in those days, and how the towns looked.

The pictures were not the work of individual artists, but were done by a collective. The master would sketch the composition with brushes made from thin cat's hair, and then the apprentices would fill in the empty spaces. Most of these miniatures are now only to be seen in museums, but in the Book Bazaar and sometimes in the Grand Bazaar you will occasionally come across new, but equally decorative pictures painted on the pages of old books – a reminder of the days when these miniatures filled whole volumes.

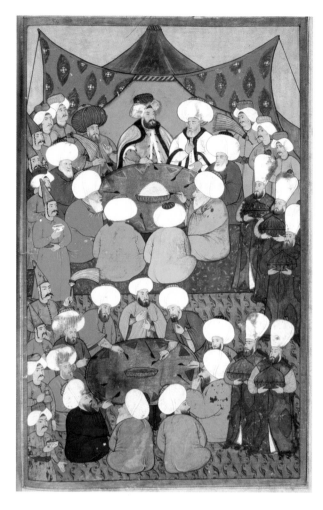

Ottoman miniatures often depict scenes from palace life, such as festivals and processions, as well as everyday events. The three men in the picture below are an author, calligrapher and miniature painter, all working together on a *Shahname*, or royal book for Mehmed III.

And thy Lord is the Most Bounteous,
Who teacheth by the pen,
Teacheth man that which he knew not...

The Koran, sura 96, 3–5

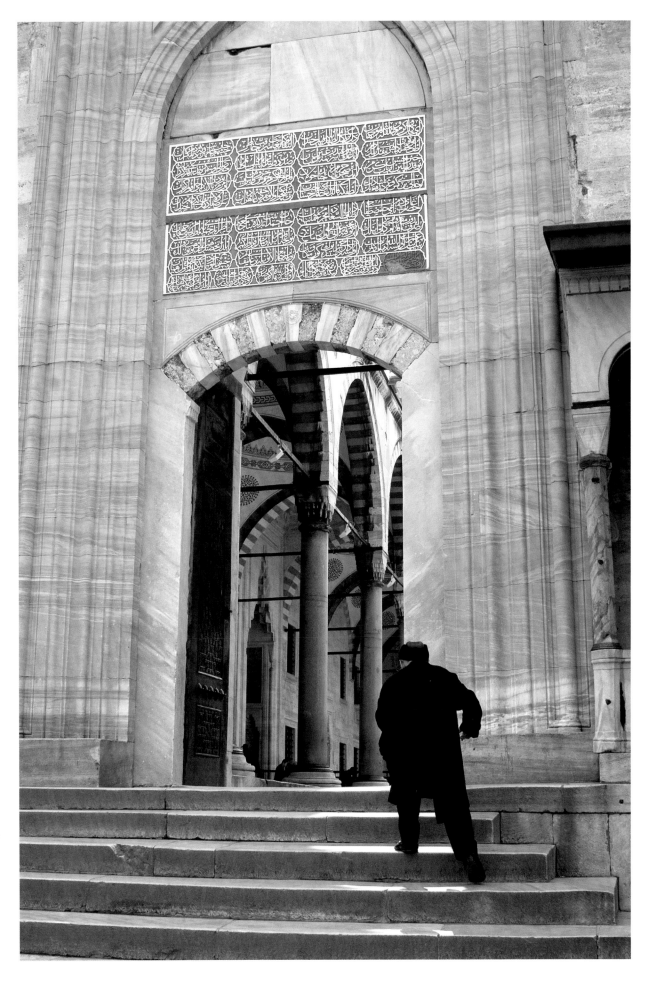

Calligraphy was not used solely for copying the Koran or for official documents. In mosques too, calligraphic religious inscriptions are a common decorative feature, as seen here above the side entrance to the Sultan Ahmed Mosque.

For Muslims, calligraphy is the highest form of art. To give a suitable form to the beauty of the Word of Allah, the Koran was always written in the finest script. This is also why inscriptions taken from the Koran, as in the domes of the New Mosque and the Fatih Mosque, are always calligraphic.

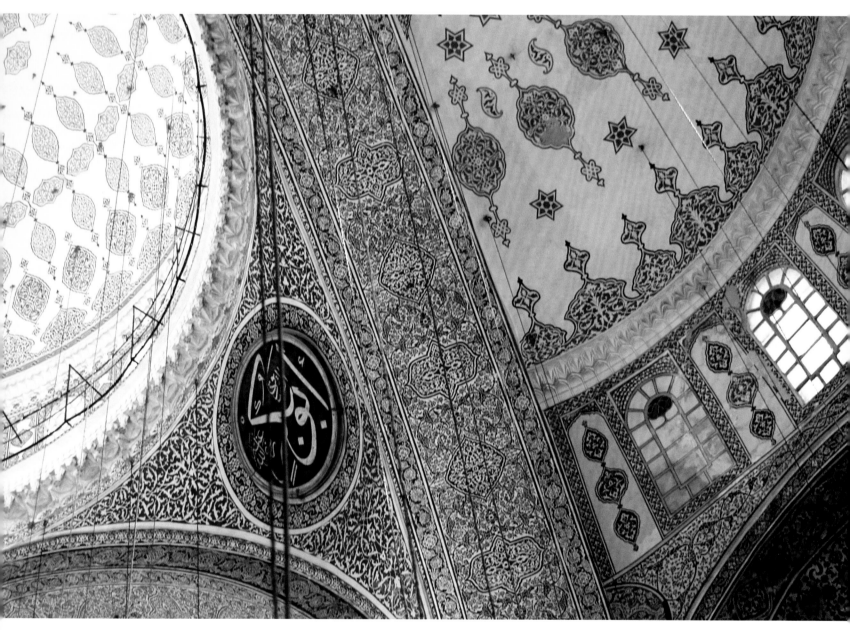

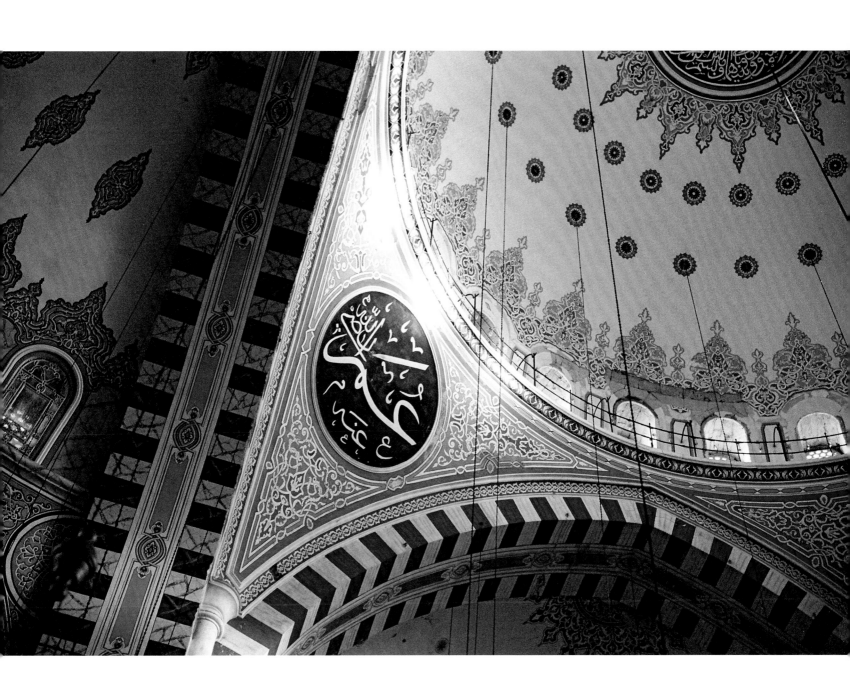

ANTIQUES AND EPHEMERA: THE ANCIENT AND THE SACRED

In the Old Bedesten, the heart of the Grand Bazaar, you can find antiques, souvenirs and religious objects from all over the world. With the slow decline of the Ottoman Empire and political upheavals in other countries, many very special pieces came into the possession of the dealers. Today, traders often surf the Internet in search of new treasures.

A colourful mixture from all over the world

If you go into one of the antique shops in the Old Bedesten, you will feel as if you have travelled to a distant land in an ancient time. Countless golden icons from Russia cover the walls, depicting Mary with or without the infant Jesus, Jesus himself, God the Father, the apostles and the saints – all in every conceivable form and variation. On a dusty shelf you may see the beautifully carved begging bowl of a Dervish – a member of a sect of Sufi Muslims who are renowned for their whirling dances of meditation. Next to it is St George, patron saint of the sick, mounted on his ivory steed and doing battle with a mighty dragon. In another shop you might buy everything you need to equip an entire church – from crosses and bibles, fonts and rosaries, to monstrances, Eucharist cups and figures of the saints. Beside this religious paraphernalia stand cabinets full of clocks – again in all sizes, shapes and colours. The image of one of the last sultans smiles gently at you from the face of an alarm clock. The particular pride and joy of the dealer is a little grandfather clock, its pendulum a plastic doll with a 1960s hairstyle. Hidden behind a huge birdcage, which has come from an old wooden villa on the Bosporus, stands the pointed copper top – 2 metres (6 ½ feet) high – of a mosque. Dresden china figurines and Ottoman coffee cups with silver saucers stand next to a row of Nazi medals, a Lion's Club badge, a cigarette case with a picture of the Swiss mountains, and an enamel thimble with a portrait of Queen Elizabeth II. The Old Bedesten offers an inexhaustible selection of religious ephemera, strange souvenirs from the last century, and genuine and not-so-genuine antiques from all over the world.

Changing times, changing wares

Down through the centuries, the extraordinary mixture of goods available in the Old Bedesten has kept changing according to the political and economic situation both at home and abroad. In the late 19th century, a British woman named Lady Annie Brassey wrote that the effects of the economic downturn after the war between Russia and Turkey could be felt in the Grand Bazaar. The middle classes had to sell their jewelry in order to make ends meet, and the traders were offering gems, silver and ivory at absurd prices. In 1917, the Russian aristocracy arrived, fleeing from the October Revolution. Piece by piece they sold off their valuables in order to survive in their new homeland. They could admire their own silverware and samovars only in the display cases of the antique dealers. Then the sultanate fell, and the Turkish aristocracy itself went into exile, leaving its own precious goods behind to be sold in the bazaars. The foundation of the Republic under Kemal Atatürk had further consequences in the years that followed: the modernization of the country went hand in hand with the modernization of domestic furnishings. People no longer treasured their old-fashioned, hand-made bric-à-brac, and so they sold it. Another factor was the closure of the Dervish monasteries. After the collapse of the Soviet Union in the 1990s, the Grand Bazaar was once more swamped with icons both old and new, Orthodox crosses and samovars. Today many dealers from Russia are buying back their own cultural artefacts at many times the price at which they were sold, while middlemen are bringing other treasures from Anatolia and selling them to the shops in the Old Bedesten.

The Grand Bazaar is not only a place for selling wares; it also houses people who practise their special skills. In the Old Bedesten you will find this watchmaker and, not far from him, a collector and mender of old gramophones.

A museum of Ottoman and European culture

For centuries the iron gates, barred windows and thick walls of the Old Bedesten, the beating heart of the Grand Bazaar, protected only the most valuable treasures against theft and fire. At the time of its construction, under Mehmed II, it was mainly jewelry, fine fabrics and decorative weapons that were traded here, but during the last few decades all that has changed. More and more antique dealers are closing down, and their place is being taken by cheap jewelry shops. In addition, one frequently comes across supposed antiques, but they have been doctored by experts who can make new things look old. 'The Old Bedesten used to be a museum of Ottoman and European art,' recalls Murat Bilir, who for almost forty years has regarded the Grand Bazaar as his home from home.

Many of the dealers pine for the old days. Only ten years ago, says one, very few of his customers would leave the shop without an icon, a pocket watch or a little curved dagger. Now not even the British or the Americans seem to have the cash to spare for such things. The only dependable customers are the collectors, but even they are becoming increasingly scarce. If you want to survive, you have to adapt to the changing times. And so the antique dealers of today sit at their laptops, surf the auction sites, hunt for stock on the Internet, and keep informed about the prices at the auction houses in London, Paris and New York.

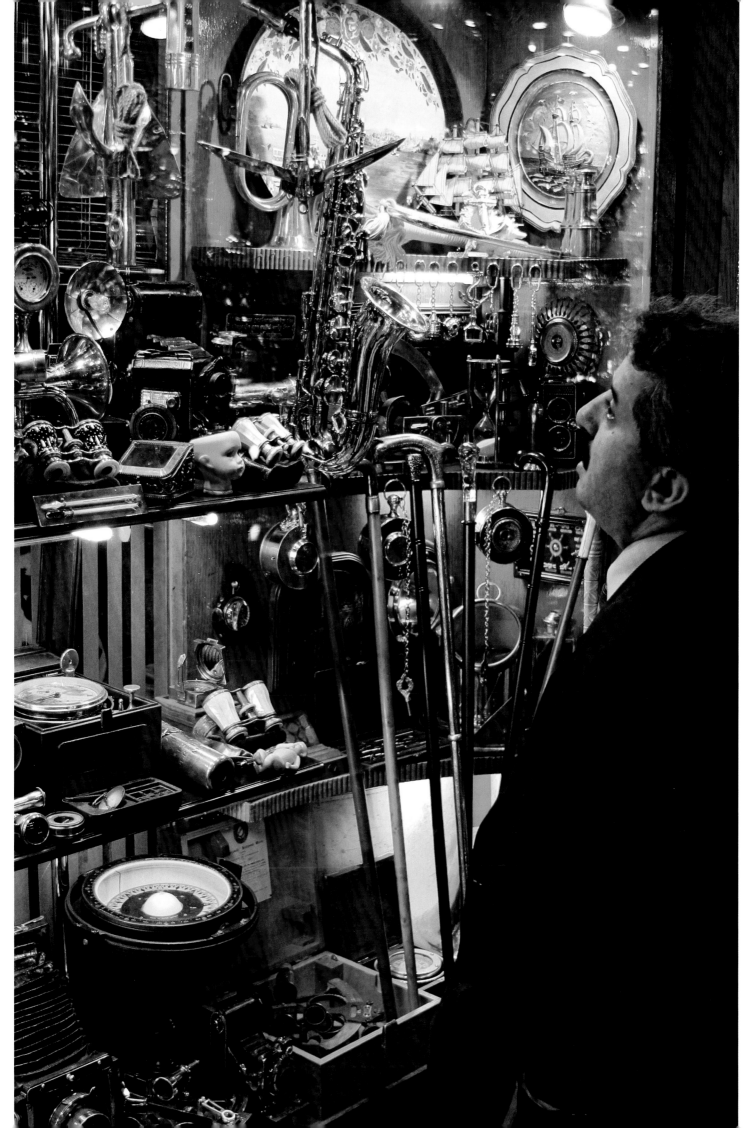

A Turkish saying goes: 'Do not believe in fortune-telling. But do not look away from it either.' A blue eye charm is an essential protection against the Evil Eye.

Blue eyes for the Evil Eye

Wherever you find faith, you will also find superstition. Concerning the existence of supernatural beings, it is written in the Koran: 'Say: I seek refuge in the Lord of Daybreak, from the evil of that which He created; from the evil of the darkness when it is intense, and from the evil of malignant witchcraft....' It is therefore natural to seek to protection by all manner of means against these so-called *jinn* – creatures of smokeless fire. 'Demons can even slip into food,' wrote the author Friedrich Schrader in the early 20th century. 'To protect against this, one needs black caraway seeds…which are scattered mainly over cheese, yoghurt and bread.'

The universal remedy against evil was, however, and indeed still is the *nazar boncuğu* – blue eyes made of glass or plastic. The word *nazar* simply means 'gaze'. In the Islamic world, and throughout the Mediterranean lands, these charms are meant to protect people against the Evil Eye, which is thought to kill children and leave women barren. It is even said to drive husbands into leaving their wives. In

Turkey you will see these magic eyes hanging over the entrances to houses, in workshops, attached to clothing, or in the form of jewelry. There is scarcely a household without them. Many bearers of the Evil Eye are not, incidentally, even aware of the fact, and what is even stranger is the belief that it is especially people with bright blue eyes that have this power. Others, though, are fully conscious of it and know exactly how to use it. Some over-protective mothers even used to dress their sons in girls' clothing or in particularly disgusting rags in order to ward off envy. According to Schrader: 'In order to protect her child from the Evil Eye, the mother gives it a whole array of charms against the power of the demons, and these are fixed to the headdress, the arm and the neck of the child. Not only people but also animals are protected by the *nazar boncuğu*, or charm made of blue glass beads, from the evil that lurks everywhere in order to do its wicked deeds.' In especially beautiful and luxurious objects like carpets or fine fabrics, small faults are deliberately incorporated in order to ward off the perils associated with the Evil Eye.

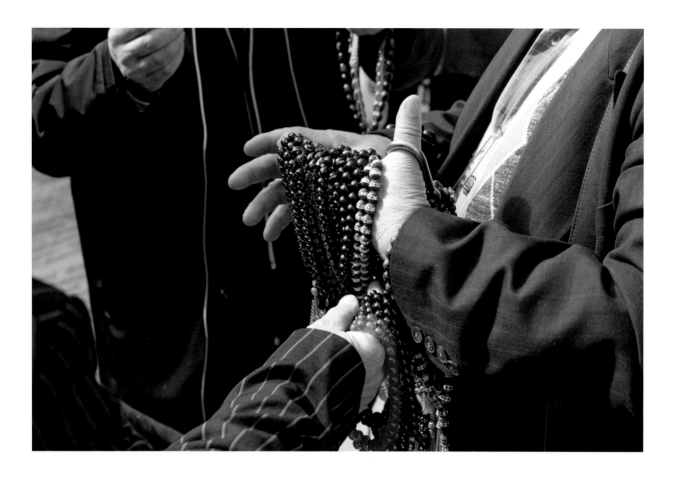

Islamic prayer beads

One bead after another slides through the fingers of the old vendor. Click clack, click clack...there is something calming about this rhythmic sound. Prayer beads are indispensable to Muslims, whether for prayer, meditation or simply as a diversion. Most of these so-called *tespihler* consist of 33 or 99 beads, which are used for the ritual counting of prayers, which may sometimes be repeated 999 times or more. For Muslims, the prayers beads are the equivalent of a St Christopher charm for Christians – they are believed to protect people against accidents and misfortune. You might hang one over your rear-view mirror in the car, or simply carry it around with you, wrapped in a white handkerchief. In earlier times, these Islamic rosaries were made by hand, and many craftsmen made a name for themselves through their exquisitely carved beads, which were strung together on a silken thread. A particularly delicate touch was needed to drill the holes, and a single set could sometimes take months to make. But even in this specialized field, the traditional silken threads and beads of wood, ivory or amber have now been replaced by nylon and plastic.

A string of Islamic prayer beads (*tespih*) is used to count three maxims, which are repeated in multiples of three: 'Praise be to God'. 'There is no other God but God', and 'God is great'. With the repetition of each line, worshippers pass one of the beads through their fingers.

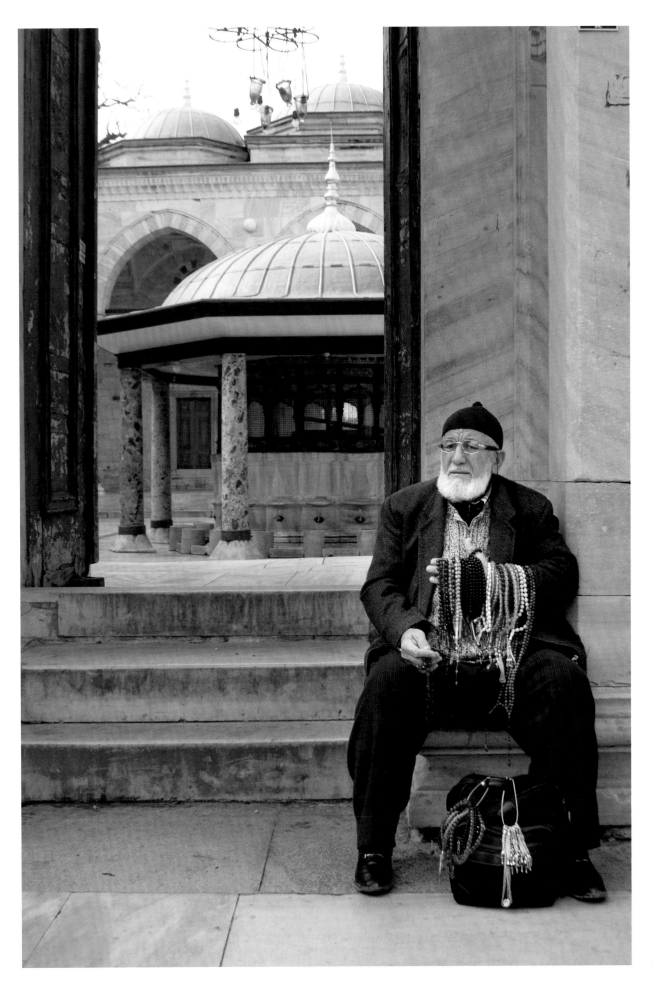

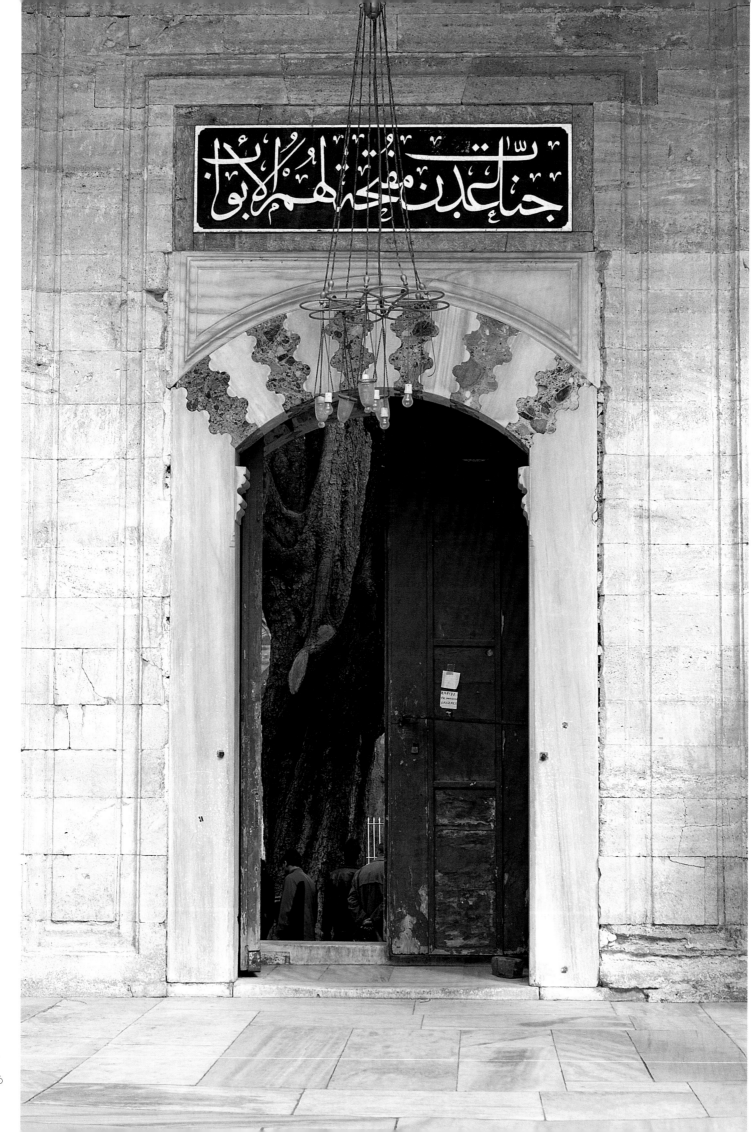

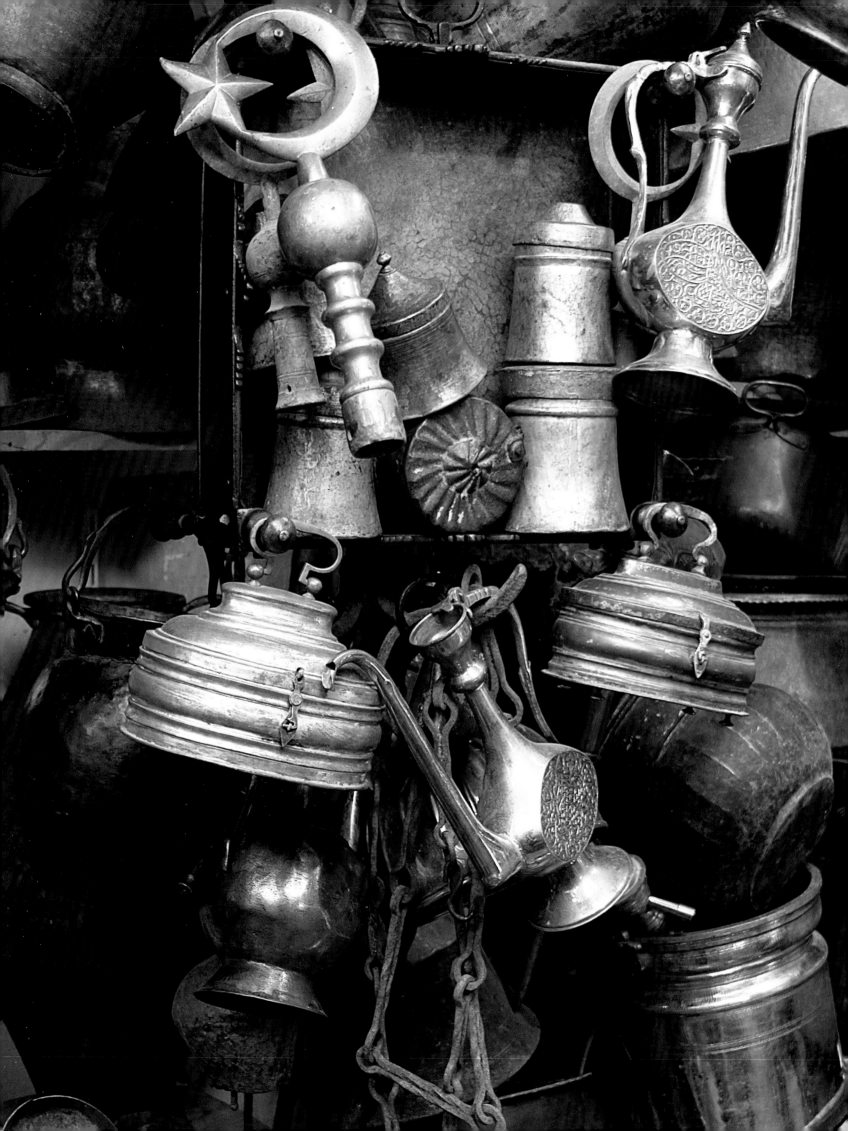

METALWORK:
IN WAR AND IN PEACE

Europeans feared the pointed daggers and sharp swords of the Ottomans, but it was not only their weapons that were of outstanding quality. The silversmiths, coppersmiths and goldsmiths produced superbly decorated dishes, pots, candlesticks, plates and other household objects.

The tears of a young Sultan

When Sultan Murad IV ascended the throne of the Ottoman Empire in 1623 at the tender age of eleven, he asked to be taken to the treasure chamber of the Topkapi Palace in order to wonder at his own wealth. Imagine, then, how disappointed he was to find, in one corner of the room, just six bags full of money, one sack of coral, and one chest full of Chinese porcelain. When he saw that 'there were no vessels of gold, he filled the empty treasure chamber with his tears.' Thus wrote the Turkish chronicler Evliya Celebi. Although the Ottomans had the good fortune – unlike the Iranian Safavids and the Mamelukes – never to have experienced the plundering of their capital city by invaders, the rulers themselves had done the plundering – especially when yet again they decided to wage war. And this was not an infrequent occurrence. Murad II, for instance, had all his silver and gold services, trays and ewers melted down and made into coins, and at the end of the 18th century Selim III ordered 300 objects of silver and fifty of gold also to be made into coins.

The treasure chests were not only raided for the sake of making war; objects were also sold off if the ruler felt they were no longer worth keeping or were too worn out. According to tradition, the chosen objects were taken from the palace by the sweet-sellers. Already waiting at the gates there would generally be Jewish merchants with bags of money, ready to buy these valuable objects and then sell them again in the bazaar.

Gold and silver: ostentation versus morality

After the conquest of Constantinople, there was plenty of room in the sultans' treasure chambers for objects made of gold. The art of the gold- and silversmiths had come to an almost complete standstill. In the old capitals of Edirne and Bursa there were ceramics factories and silk mills, but hardly any progress had been made in the sphere of metalwork. And yet even under Mehmed II, a vital precondition for this art form had already been met. Thanks to their conquest of the Balkans, the Ottomans had obtained possession of substantial gold and silver mines. Resources, especially in Novo Brdo (in present-day Kosovo) – the 'city of silver and gold' – were considerable. Furthermore, the craftsmen in these regions could look back over a long tradition in the art of metal craft, and so there was a long list of Serbian and Bosnian names on the payroll of the Topkapi Palace. But the quantity of metal objects collected in Mehmed II's treasure chests was just a tiny foretaste of the wealth accumulated under Bayezid II. The pomp and circumstance reached its peak after victories over the Safavids in 1514 and the Mamelukes in 1517, when whole caravan loads of treasures were transported to Istanbul.

However, in the context of the Muslim faith, excessive luxury was frowned upon. In the words of the Prophet: 'Do not wear silk or embroidery, and do not drink from silver or golden vessels, and do not eat from plates of such metals, for such things are for the unbelievers in this worldly life and for us in the Hereafter.' It was believed that whoever drank from such vessels would be tormented by the fires of hell, and indeed many rulers took the Prophet's words to heart – at least part of the time. A pageboy said of Bayezid II that he never ate from silver or gold, and the finest service was only used when he received representatives from foreign lands. On the other

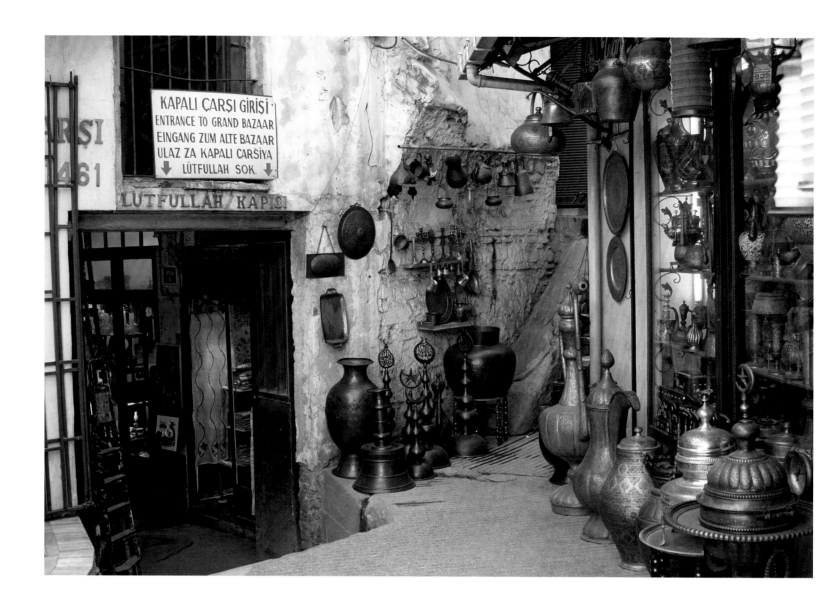

KAPALI ÇARŞI GİRİŞİ
ENTRANCE TO GRAND BAZAAR
EINGANG ZUM ALTE BAZAAR
ULAZ ZA KAPALI CARŠIYA
↓ LÜTFULLAH SOK. ↓

LÜTFULLAH KAPISI

hand, the Sultan's drinks were served in silver goblets. A Venetian ambassador at the beginning of the 17th century reported that, for reasons of piety, gold tableware was replaced by yellow porcelain during the month of Ramadan.

This surfeit during the reign of Bayezid II did, however, have a major influence on the development of decorative metalwork. The Sultan's long list of commissions was fulfilled in the workshops he himself established, employing about seventy goldsmiths. During the last quarter of the 16th century, around five hundred skilled craftsmen are believed to have been at work producing objects of gold and silver. The sultans themselves helped to develop the art of smithery, for it was a custom among the Ottomans that every prince must learn a craft. Selim I and Süleyman I were both trained as goldsmiths. This also greatly enhanced the status of the guild.

Old and new silver

After the abolition of the sultanate, many 18th-century silver services, vessels and pots found their way to the Grand Bazaar. These pieces had belonged to the Sultan's family or to local aristocrats, but other objects came from Izmir, where they had been the property of wealthy Levantine merchant families. Items from Istanbul were mainly braziers, candlesticks, lanterns and mirrors, whereas those that came from Izmir were tea and coffee services, spoonholders, jam jars and silver tableware.

Even today, you can still come across pieces of Ottoman silver in the bazaar, but it is more usual to find new reproductions of old forms and motifs. In the Kalcılar Han, outside the Grand Bazaar, you can watch craftsmen in their sooty little cubicles making new candleholders and dishes out of molten silver. At the back are the flickering flames of a stone furnace in

Many copper dealers have set themselves up around the Lütfullah Gate, which leads into the Grand Bazaar. In former times, this was also the area of the coppersmiths, but there are very few left now.

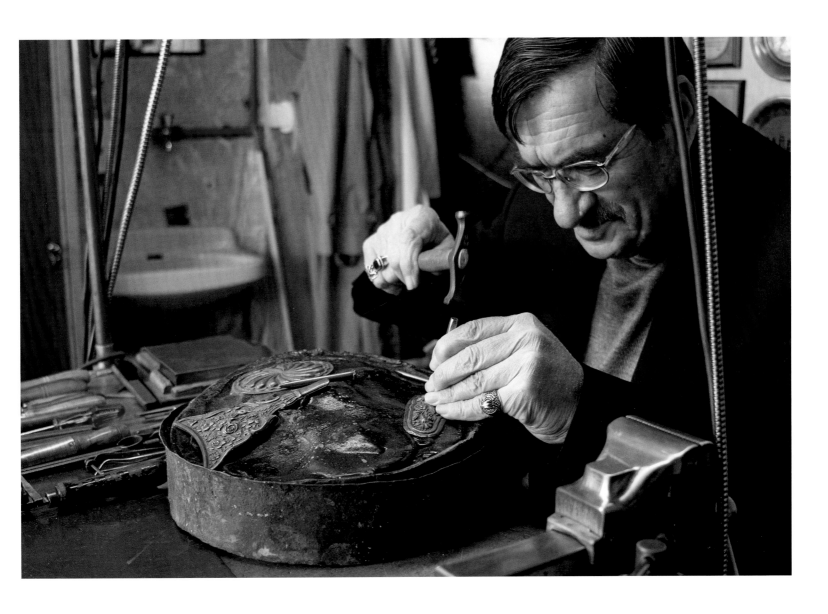

Hüseyin Azmi Baykal has been working as a silversmith since 1947. To create a relief design, he sticks the flat pieces of silver on tar – this prevents the metal from breaking as he works on it – then he carefully hammers the pattern into the silver.

which the metal is melted down. The heat is almost unbearable. Here one feels that the centuries have rolled back, and one is standing in the workshops of the distant past.

For everyday use: copper, brass and bronze

In the Ottoman Empire, all that glistered was not gold. Precious metals were available only to a small percentage of the population, for few people could afford to dine off silver and gold. The rural communities and the nomads used utensils that were mainly made of copper, and even in the palace, plates, bowls, pots and jugs of copper, brass or bronze were good enough for everyday use. Gilded vessels made of a copper alloy called *tombak* were especially popular, because they looked so authentic that they could compete with genuine precious metals. The thin layer of gilding made very little difference to the cost,

but a less costly alternative was to use a tin coating. This was a cheap way of imitating silver, and it also had a purely practical advantage, because the tin prevented the build-up of toxic materials. In fact, this precaution became obligatory, as can be seen from an edict issued to hot food stallholders in the early 16th century: 'Your pots and ladles must not be without a coating of tin. They must always be (newly) tin-coated when necessary.'

Base metals were used for everything, from mosque lamps, water jugs, candleholders and coffee sets to rosewater sprinklers. Fine examples of such objects from all over the Ottoman Empire are still sold by a few dealers in the bazaar. Even nowaday, utensils of this type are being made in the traditional manner in many villages, though there are hardly any copper workshops in Istanbul's bazaars, where most new pieces are mass-produced.

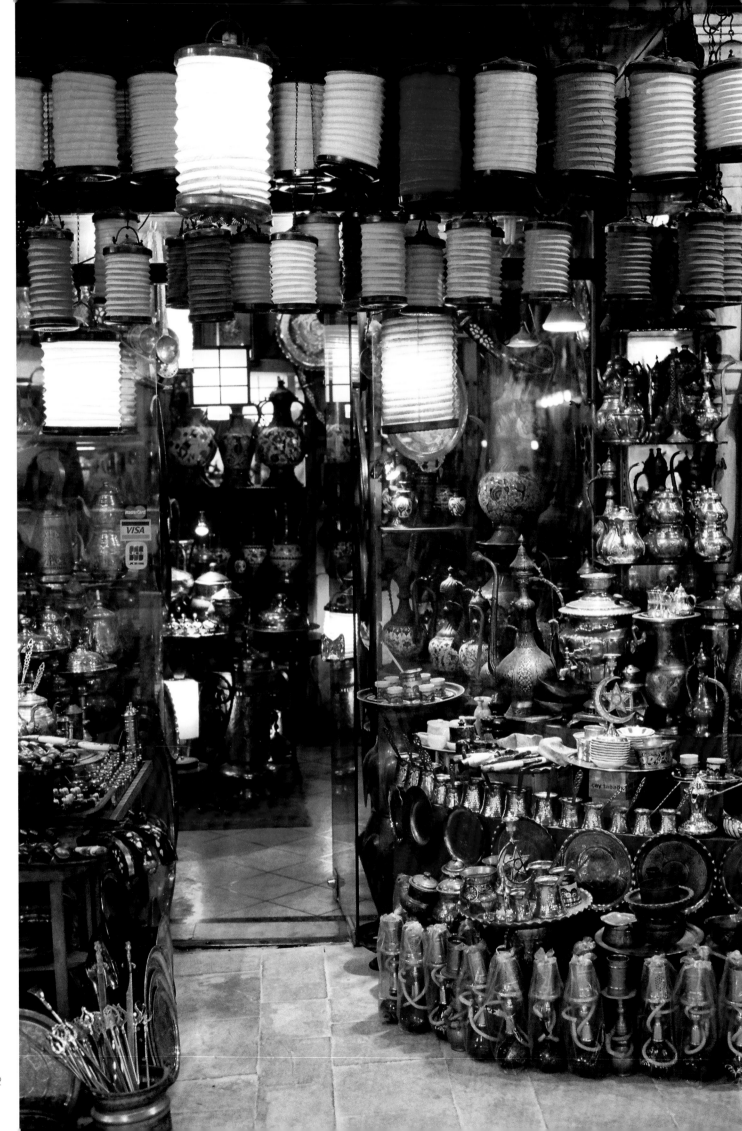

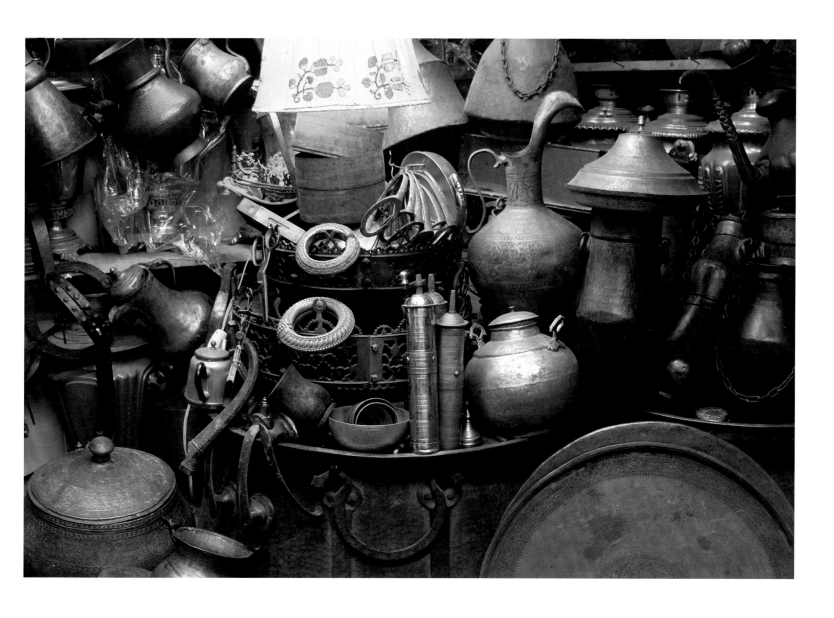

Most of the trays, lamps, coffee pots and grinders on sale in the Grand Bazaar are old or mass-produced. Very few pieces are made by hand nowadays.

Swords and scimitars

Istanbul's craftsmen did not confine their arts to the manufacture of utensils for the palace and the people; the Ottomans were famous if not notorious for their weapons. Highly prized and greatly feared were blades made from the legendary Damascene steel, which was extremely tough but at the same time very flexible. Europeans were particularly wary of the so-called *yataghan* or 'head-slicer'. During the 17th and 18th centuries, the janissaries often had two of these cut-and-thrust weapons dangling crosswise from their belts. The handle was made of horn, bone, ivory or wood, and traditionally the leather sheath – frequently decorated with silver – was thrown away after the weapon had been drawn. If the warrior survived the battle, he would have time to hunt for it afterwards, but if he didn't survive, he wouldn't need it any more. The cavalry and foot soldiers used the

kiliç or scimitar. It was said that a single blow from the sharp blade was enough to separate the enemy's head from his body. There were also swords with straight blades which were carried on the saddle, and others that could pierce the enemy's armour. Women and pageboys in the harem carried *hançar* – small daggers. Weapons and armour were not designed purely for practical purposes. The handles and blades were elaborately decorated, and the finest pieces were even engraved. The weapons and armour forged for the Sultan contained many precious stones and were true works of art. They are still to be seen and admired in the Topkapi Palace – status symbols made to impress friend and foe alike.

The 19th-century Italian author Edmondo de Amicis was positively ecstatic about the weapons he saw in the Kapalı Çarşı: 'But the weapons bazaar is the richest and most picturesque. It resembles a

> *There are those crooked scimitars, which cut feathers in mid-air*
> *and sliced the ears off impertinent ambassadors…*

Edmondo de Amicis, Italian travel writer, 19th century

museum full of treasures, memories and ideas that carry us off into distant realms of legend and history, and arouse an indescribable feeling of astonishment and admiration in us. All the strange and terrible weapons wielded in the defence of Islam from Mecca to the Danube are exhibited here in fine condition, so brightly polished you might think the fanatical soldiers of Muhammad or Süleyman had only just laid them down. Between these blades we seem to see the bloodshot eyes of those terrifying sultans, those rampant janissaries, devoid of fear or pity, who filled Asia Minor and Europe with severed heads and mutilated corpses.'

Elaborate patterns or simple elegance

As in all their crafts, the Ottomans loved to create extravagant decorations for metal objects. The decorative techniques were extraordinarily varied, whether the objects were for household or military use. Initially the motifs were based on the cultural heritage of the Seljuks, but later the designs came to reflect the melting pot of cultures that the Ottoman Empire had become by the 16th century. Flower motifs – lotus palmettes, leaves and spiralling tendrils – found their way onto the blades, dishes and pots of all kinds.

At the same time, these artists in metal introduced a very different form of decoration which seems quite uncharacteristic of the Ottomans. The emphasis was not decorating on the surface of the metal but on the perfection of form and composition. Simplicity was the keynote here, and it has no parallel in Ottoman art or architecture. There was, however, also a hybrid form of simple style mixed with elaborate flower decoration. In the late 18th and 19th centuries, however, as with so many other art forms, metalwork adapted itself to Western taste, and the imported European baroque and rococo style made its mark on the Ottoman Empire.

In the Old Bedesten you can find weapons in the Ottoman style. The more modern pieces are not made in Turkey, however, but in India or other Asian countries, where manual work is much cheaper.

yüz kırk dört

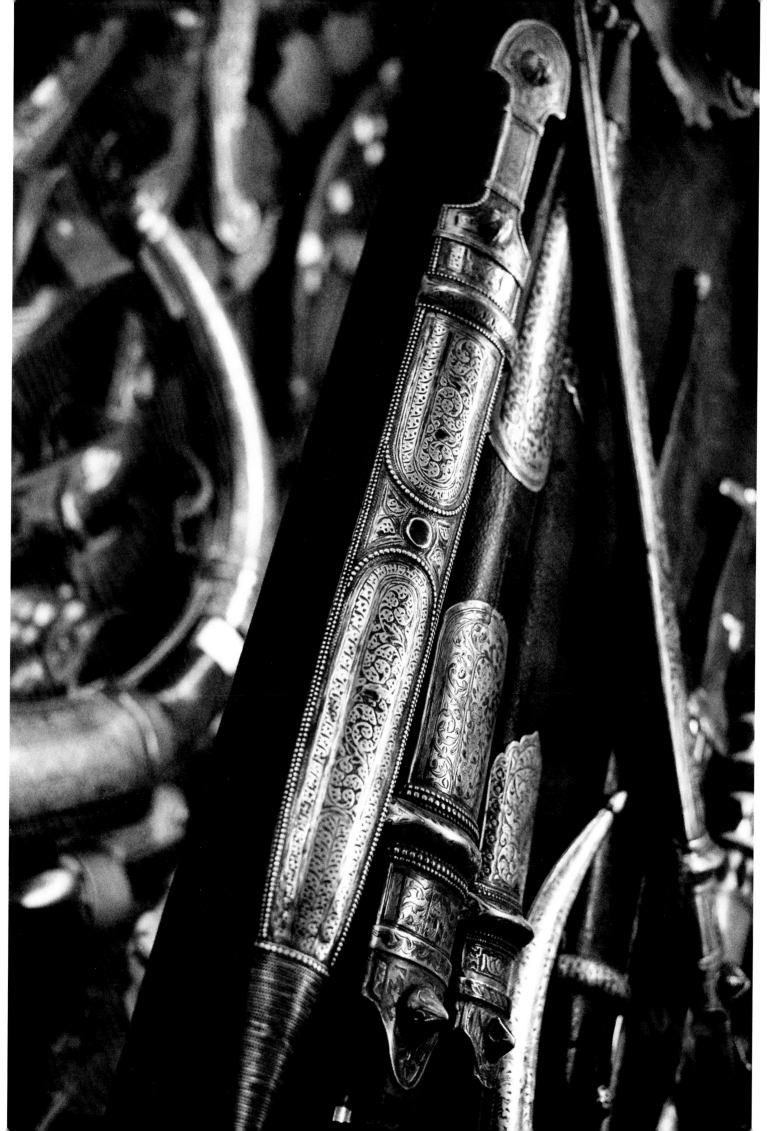

Silversmiths and retailers have
taken over the Kalcılar Han.
The silver is melted in furnaces
and then poured into soot-
covered moulds.

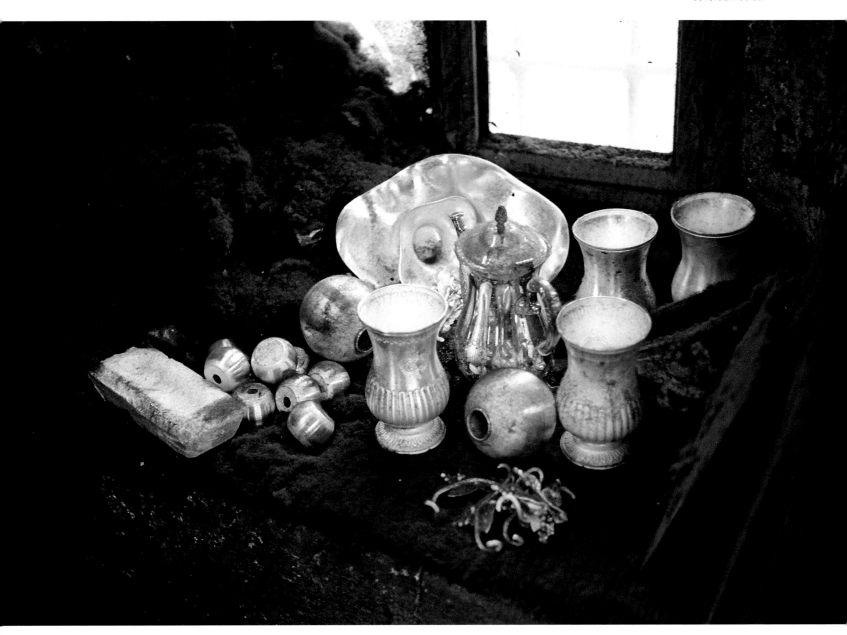

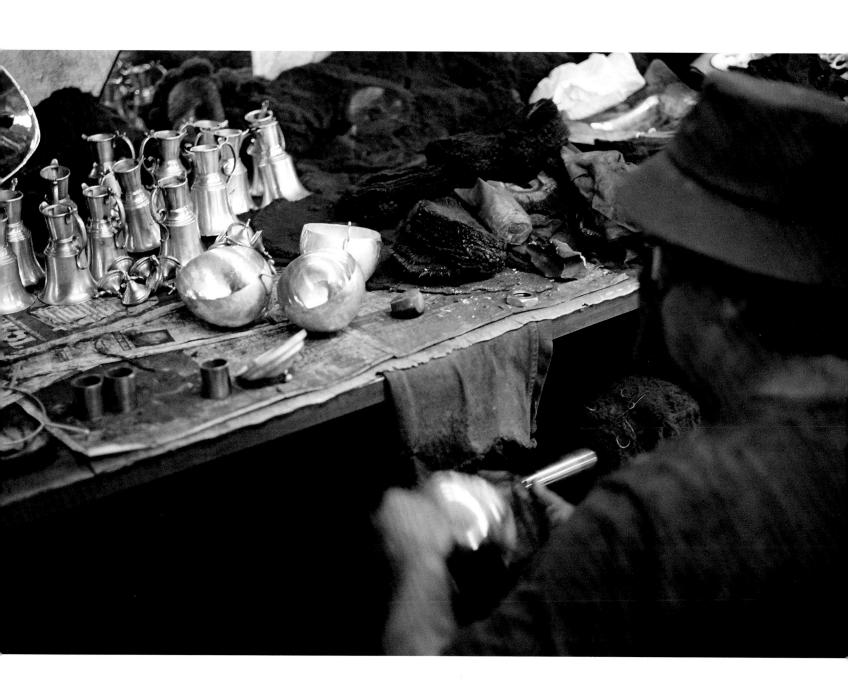

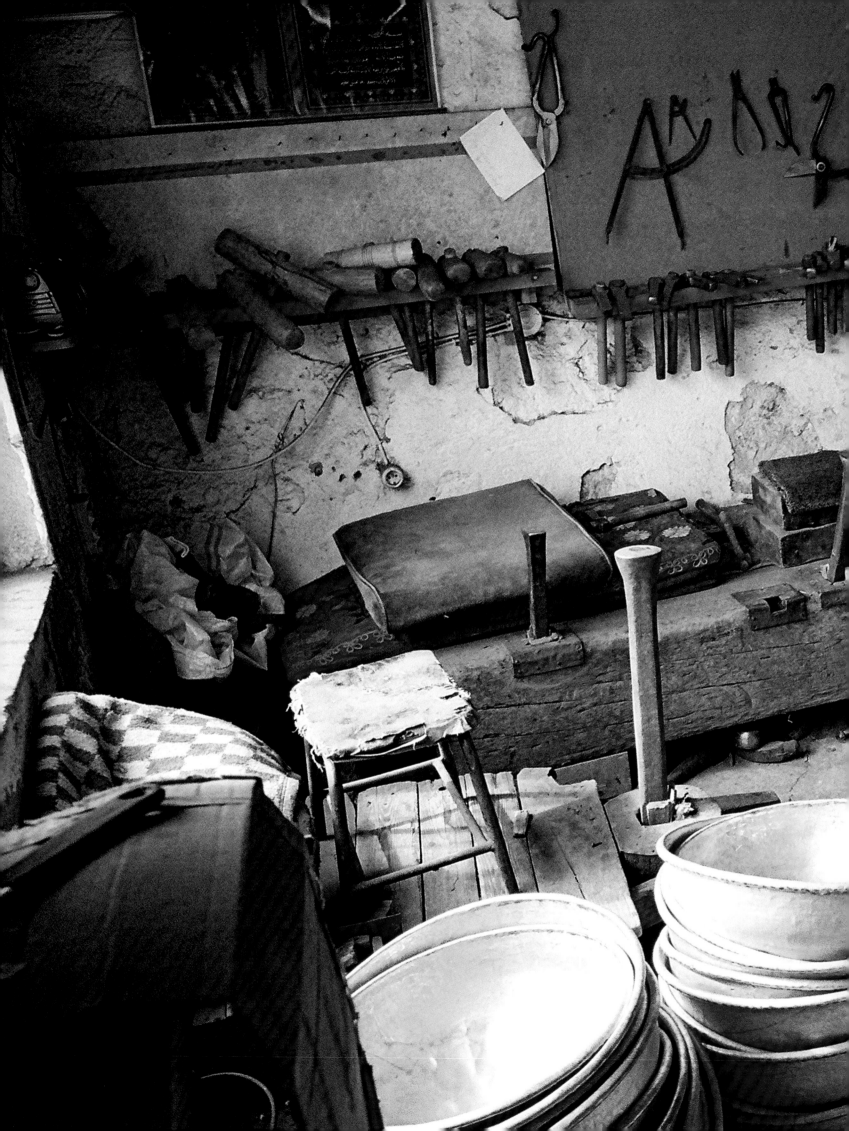

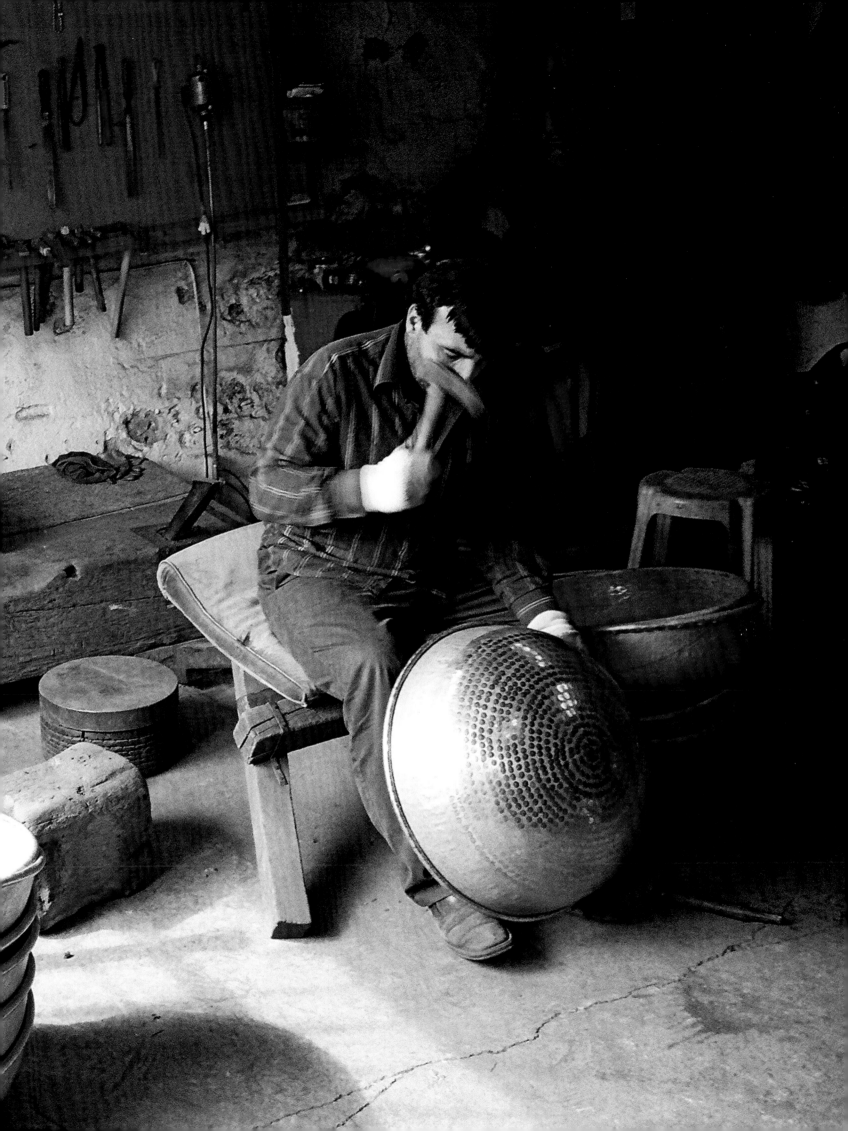

LEATHER GOODS: SHOEMAKERS AND SADDLERS

Shoes, bags and leather jackets are sold all over the world by Turkish dealers. Even in Ottoman times, the products of the shoemakers and saddlers were famed and admired. Today, almost all are made by machine. Tanneries have had to leave the inner city, and the traders in the Grand Bazaar must adapt their wares to the fashions of the day.

The shoemakers of Istanbul

They were more dazzling than the Iznik tiles in the Rüstem Pasha Mosque, and more varied in shape than the pieces of a jigsaw puzzle. The shoes worn by the people of Istanbul at the time of the Ottoman Empire made foreign visitors gasp: 'It is especially interesting to direct your gaze to the ground...and look at nothing but people's feet. Every type of shoe from all over the world, from those of Adam to the latest boots from Paris, passes across the bridge: the yellow slippers of the Turks, the red of the Armenians, the blue of the Greeks, the black of the Israelites, sandals, boots from Turkestan, Albanian leggings, slashed shoes, *gambass* of many colours, as worn by the horsemen of Asia Minor, gold-embroidered slippers, *alpargatas* [hempen sandals] in the Spanish style, feet shod in leather, satin, rags or wood follow one another in such swift succession that by the time you have looked at one pair, a hundred others have already passed by.' This was how the 19th-century Italian travel-writer Edmondo de Amicis described the parade of shoes across the Galata Bridge. One reason for this wide range of footwear fashion was the strict dress code of the Ottomans. Only Muslims, for instance, were allowed to wear yellow leather *pabuçlar*. Christians, Jews and other minority ethnic groups had to wear red, purple or black leather slippers respectively. With this huge variety, it is scarcely surprising that the shoe-sellers' street was described as the brightest and most beautiful in the Grand Bazaar. The traders hung their wares out on strings, so that they dangled from the walls. An English authoress compared this very special place to a tulip field. The Pabuççular Çarşısı continued to ply its trade until well into the 20th century, but the economic boom of the 1950s saw the final disappearance of the shoemakers from this street.

Turkish leather conquers the world

As well as shoes, the Ottomans used leather to make saddles, book covers, and sheathes for daggers and sabres. Throughout the centuries they proved to be experts at the production and processing of leather. 'At working with and preparing leather, the Turks are extremely industrious, and in this one field they surpass all other nations.' So wrote Salomon Schweigger, an envoy from the Habsburgs, as long ago as the 16th century.

After the conquest of Constantinople, the tanners and leather workers were given an area of 70,000 square metres (750,000 sq. ft) in Kazlıçeşme, outside the city walls of Istanbul. This was as a result of measures taken by the town-planners in order to protect the inhabitants from the stink. Over thirty slaughterhouses and 360 tanneries were built. The Europeans were especially eager for Turkish leather until well into the 19th century, but from then on the leather guild found it impossible to keep up with European methods of production. By 1913 there were only eleven tanneries left. Raw materials had to be imported, and shoes were still made mainly in little workshops and on commission. The age of machinery had not yet reached Istanbul's shoemakers and saddlers, and it was not until the collapse of the Soviet Union that the Turkish leather industry experienced a new upsurge. Izbeks and Russians came on shopping tours to Istanbul, and orders began to flood in again. The tanneries, which had been banished from city centres for environmental reasons, now expanded again. Today the raw materi-

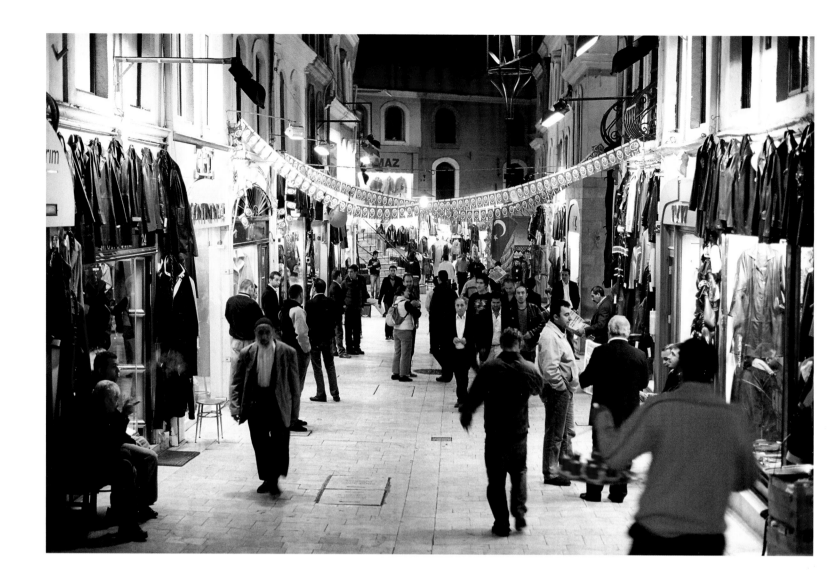

als come almost exclusively from Turkey itself, and is made into jackets, bags, belts and shoes of lamb and calf's leather – the Muslim faith forbids the slaughter of pigs and the processing of their skins. The supply of skins is particularly prolific after the important festival of Kurban Bayramı, during which sheep are slaughtered all over the country.

Straight from the catwalks

Today, Turkish leather finds customers all over the world. The Russians and Chinese generally buy untreated materials, whereas Americans and Germans tend to have bags, cases and jackets made to order. The big advantage of this is the fact that it only takes one or two days for these items to be produced. Many of the styles come direct from the catwalk in Paris, London or New York. On the other hand, Turkish firms are increasingly designing their own collections, though of course local people as well as tourists are still happy to purchase fake 'Louis Vuitton' or 'Prada' handbags and purses. In the Grand Bazaar, there are about a thousand shops vying for customers to buy their leather bags and jackets, but scarcely any foreigners will be interested in leather shoes. Potential buyers prefer fake designer sneakers or the colourful *pabuç* slippers, which resemble fields full of flowers.

The centre for leather goods is the Kürkçüler Çarşısı, the former Furriers Market in the Grand Bazaar.

As well as jackets, bags and belts, there are unprocessed leather remnants of all colours, shapes and sizes on sale. Mostly they are turned into purses and other accessories.

Puppets and shadow plays

After the Ottoman conquest of Egypt in 1517, Sultan Selim I gave orders that the defeated ruler of the Mamalukes should be hanged. Shortly afterwards, the Sultan is said to have watched a shadow play being performed in a palace on the Nile, with the execution as its subject. He enjoyed it immensely – the rope broke several times during the many attempts to carry out the execution – and took the actors with him to Istanbul. But there are many other legends about the origin of the various plays performed. During the reign of Sultan Orhan I, the smith Karagöz and the mason Hacivat worked together on building a mosque in Bursa; with their various pranks, they kept distracting the other craftsmen from their work, and the furious Orhan had them both hanged. He soon regretted having done so, and to cheer him up, a Dervish presented him with two puppets of camel skin. Thus the two comedians were resurrected, though only as shadows on a screen.

Regardless of how shadow plays actually came to Istanbul, this new pastime became popular with the Ottomans. The sultans also took great delight in this form of theatre, although the performances offered to them were nothing like as bawdy as those seen by the general public. Most of these took place at family celebrations like circumcisions, births and marriages. The actors' greatest successes came during Ramadan, when on the evening before breaking their fast, people would crowd into the coffee houses to watch a show and shorten the time before the next meal.

In the eyes of the sultans, however, shadow theatre was not an altogether harmless entertainment; sometimes the plays addressed social and political issues. The rulers were also uneasy about the fact that these Karagöz plays – named after the most popular of the characters – were mainly performed in the coffee houses, which were the meeting places of the lower social classes. From time to time, performances were even banned. Priests too had their problems with what were considered to be 'immoral' subjects, with the actors often portraying female characters whose behaviour left a great deal to be desired. To make matters worse, Islam forbade the depiction of living beings. However, with just one or two holes in the brightly painted leather puppets, it was possible to kill two birds with one stone: the actors could fit the sticks into them in order to move them, but because of the hole (which was generally in the region of the heart), the characters could not be deemed capable of life, and so they could not be considered to depict living beings.

Although shadow theatre performances are very rare now, you can still buy colourful, handmade leather puppets. There are said to be about 150 different characters.

Until the beginning of the 20th century, the Pabuççular Çarşısı or shoe market still stood in the bazaar district of Istanbul.

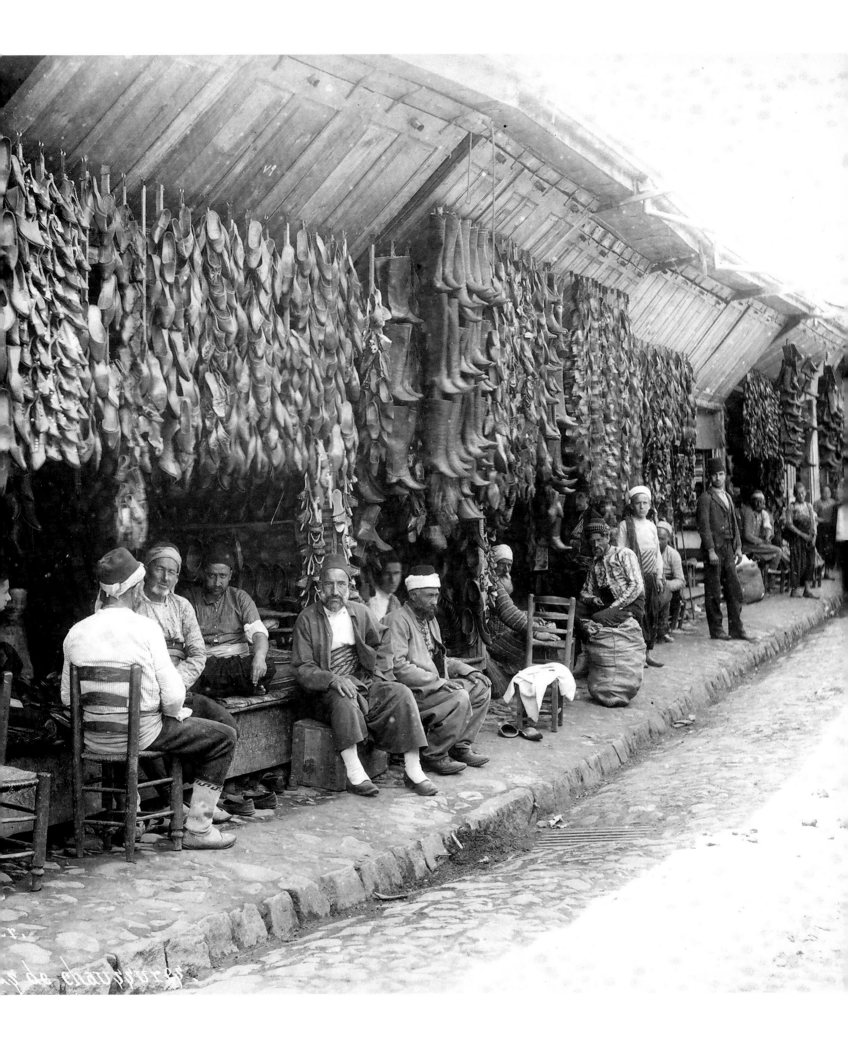

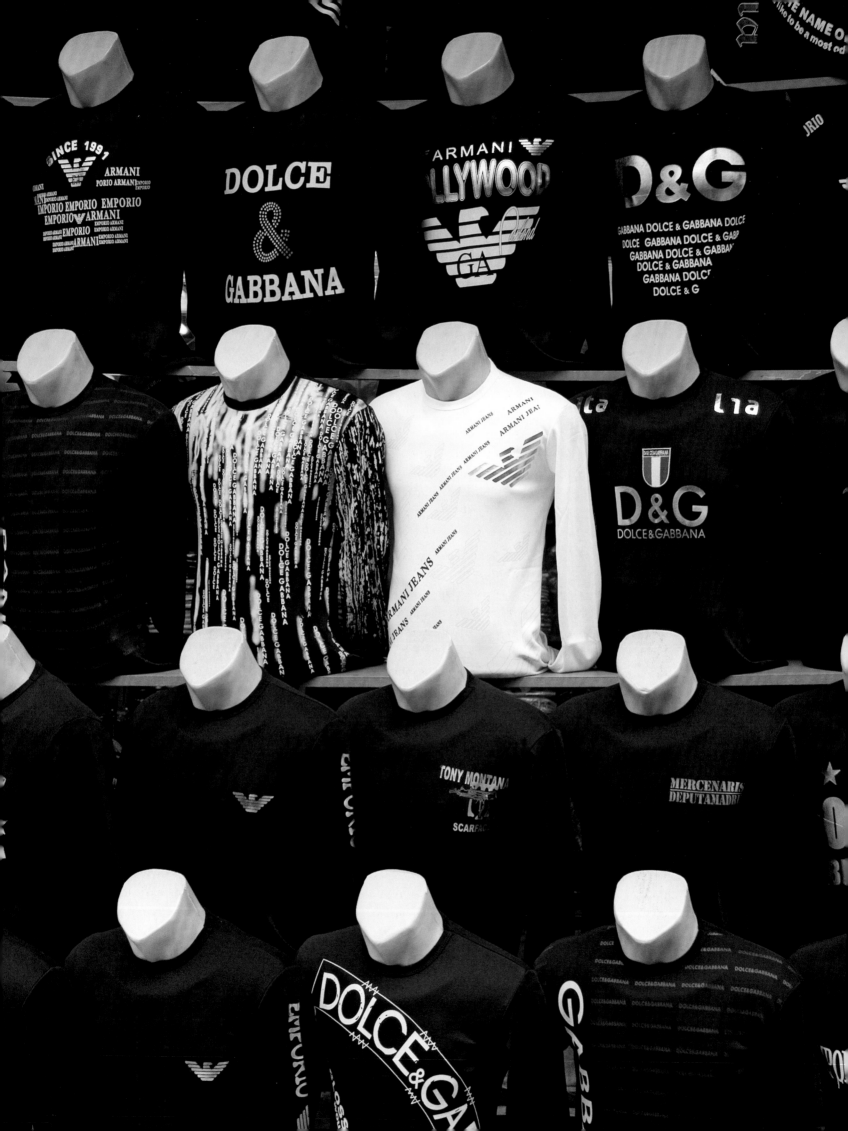

DESIGNER FAKES: MADE IN TURKEY

The trade in fake branded goods is booming in Turkey. The Grand Bazaar is the place to find forgeries and pirate versions of anything: 'Louis Vuitton' bags, 'Lacoste' shirts, 'Hugo Boss' underwear and 'Bulgari' rings are among the front runners. Often the fakes are almost indistinguishable from the originals.

Patterns for the forgers

A surveillance camera tells the men in the workshop who is outside their thick steel door. Not everyone is granted access to the little room in which four goldsmiths are hard at work producing necklaces, bracelets and rings. The gems, gold and finished articles are kept in a safe, but next to them is something just as valuable: a pile of catalogues from Fabergé, Cartier and Chopard. These are indispensable tools for craftsmen whose work consists almost exclusively in copying international luxury brands. The forgers get the catalogues from the elegant boutiques in the fashionable areas of the city, or have them sent over by friends in London, Paris or New York. Many of them don't even bother with the paper versions, but simply use the photos displayed on the websites of the big names. In this way, they get designs straight from the current collection. The similarity to the originals is astonishing, and the standard of craftsmanship first class, while the price is often a mere tenth of what it ought to be. It is an open secret that many of the fake workshops are concealed in cellars, *hans* and ordinary houses in and around the Grand Bazaar.

A modern craft in itself

Jewelry is not the only fake item to be found in Istanbul. The logos of major brands shine forth from handbags, purses, jeans and even football jerseys. Fake underwear, trainers and perfumes emerge in abundance from the workshops, and in one shop you can even buy designer labels to sew on yourself. Whole streets in the Grand Bazaar are devoted exclusively to reproduction T-shirts, caps and belts in the latest Western fashion – all 'made in Turkey'. Although the logos are meant to act as a seal of quality, it is the polo ponies, crocodiles and stripes that bring in the money for the sellers. The items being faked depend entirely on the fashion of the moment, and of course the dealers always try to offer the very latest collection or at least that of the previous season. With handbags, it is often just the design that is copied while the label is left off so that the goods will not be confiscated, but a degree of creativity is still permissible. For example you may see a 'Longchamp' bag with a 'Prada' logo. In the 1980s and 1990s, the quality of these fakes was very dubious, but today – especially with handbags and jewelry – the layman will find it hard to distinguish the imitation from the original.

Many of these fakes are imported from abroad, because it would be too expensive to make them in Turkey. Sunglasses and watches, for instance, come mainly from China. The Turks prefer to concentrate on their traditional talents: the Ottomans were masters in the making of textiles, leather goods and scents, and modern craftsmen and dealers are equally proud of their fake handiwork: 'I don't understand how people can spend so much money on a bag when they can get the same or even better quality for a fraction of the price,' said a bag-seller who makes no secret of the fact that he sells fakes.

Business as usual

Doing business through the intellectual property of other people is not without its dangers. It is not infrequent for a lawyer to turn up, accompanied by the police, and seize the goods. But this is not what generally happens. Legal and court costs are high, and although the law forbids the import and sale of fakes, the culprits are only prosecuted if the injured party pursues the case. And many companies apparently

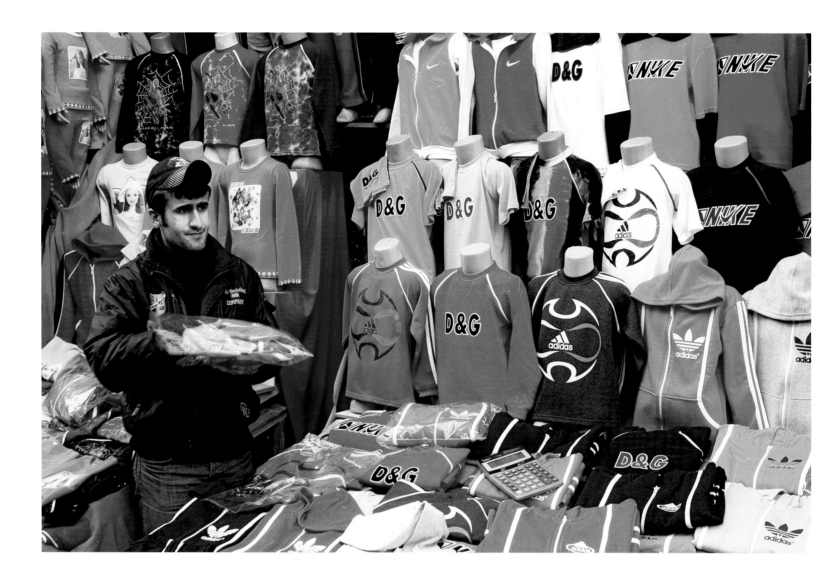

tolerate the illegal practices of makers and sellers, according to one of the jewellers who deal in fake rings, chains and bracelets: 'A few weeks ago a rep from a well-known jewelry firm came into my shop. We drank tea together. As far as they're concerned, it's good publicity if we sell their name.'

In order to protect themselves against police raids, however, many of these men print their telephone numbers on their business cards, but leave out their address. Customers who cannot find the shop can phone, and then within a few minutes they will be met at an agreed spot and taken to the store. Other dealers avoid products by firms that have a base in Istanbul. And so the pirating business seems to be flourishing, in spite of fines and the occasional seizure of goods. The Turkish government does very little, as it is caught between two stools: on the one hand, this powerful but illegal industry causes resentment among foreign investors, as well as depriving the tax

authorities of vast sums of money – an estimated three billion dollars in lost taxes – but on the other, it keeps large numbers of people in employment. The pirates are in constant fear that the government will suddenly clamp down on them in order to curry favour with Europe, but in their heart of hearts, no one believes it will ever happen. The fakes are not bought only by tourists; local people too go wandering among the stands and shops wearing their 'designer' jeans, hoodies and T-shirts, especially in the area around the Grand Bazaar.

The allure of faking

Copying is always easier than creating. It is not only luxury foreign brands that are faked, but also any new and original ideas from individual craftsmen, designers and fabric sellers in the Grand Bazaar itself – whether in terms of patterns, materials or manufacturing techniques. No sooner has a creative brain

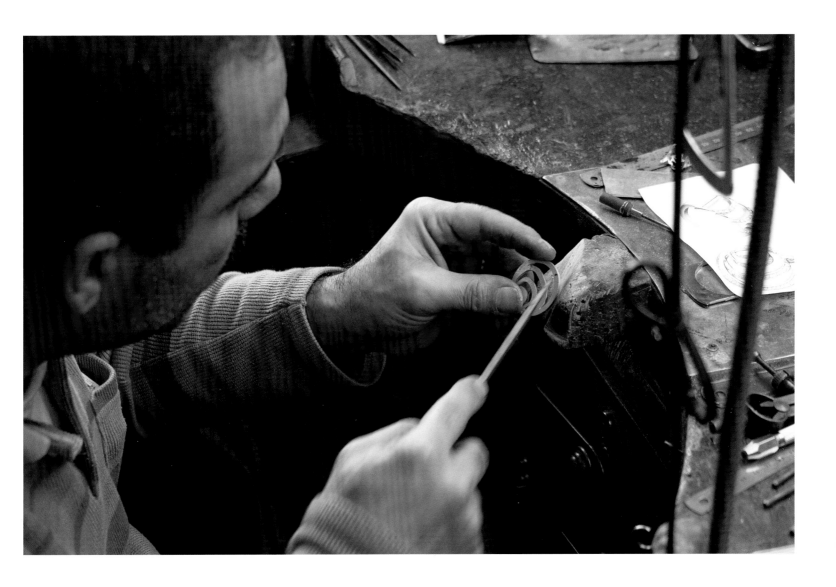

produced a new model for the market than the copyists are hard at work bringing out the same or a very similar design; within a few days or at most weeks, the fake will be on sale in a shop just a few metres away from the original. The fabric dealer Süleyman Ertas actually took out a patent on his own design and on the special weave of his towels and materials. 'But it won't put a stop to the practice of copying,' he says. That is why many such people hide away in backrooms and are reluctant to let any stranger in. It may mean losing out on passing trade, but at least the goods remain exclusive. Süleyman Ertas takes it all in his stride, though, if he does come across one of his designs in another shop. After all, it is some consolation to know that the original design – and therefore the fake – is the product of his own imagination.

Generally, the forgers make no attempt to hide the fact that they are selling copies – as with these perfumes. They are proud to offer their copies for a fraction of the price of the real thing.

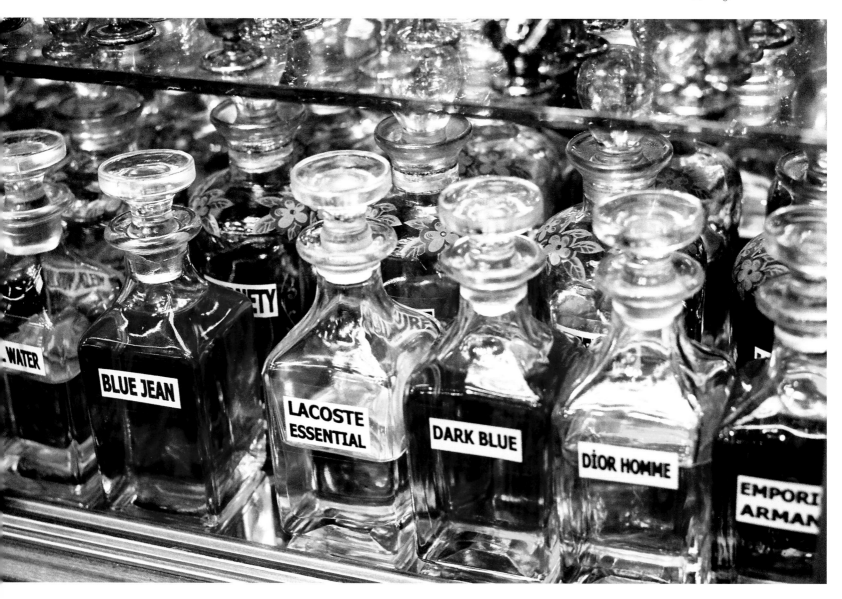

Fake 'Prada' or 'Gucci' sunglasses are made in Asia. It would be too expensive to produce them in Turkey.

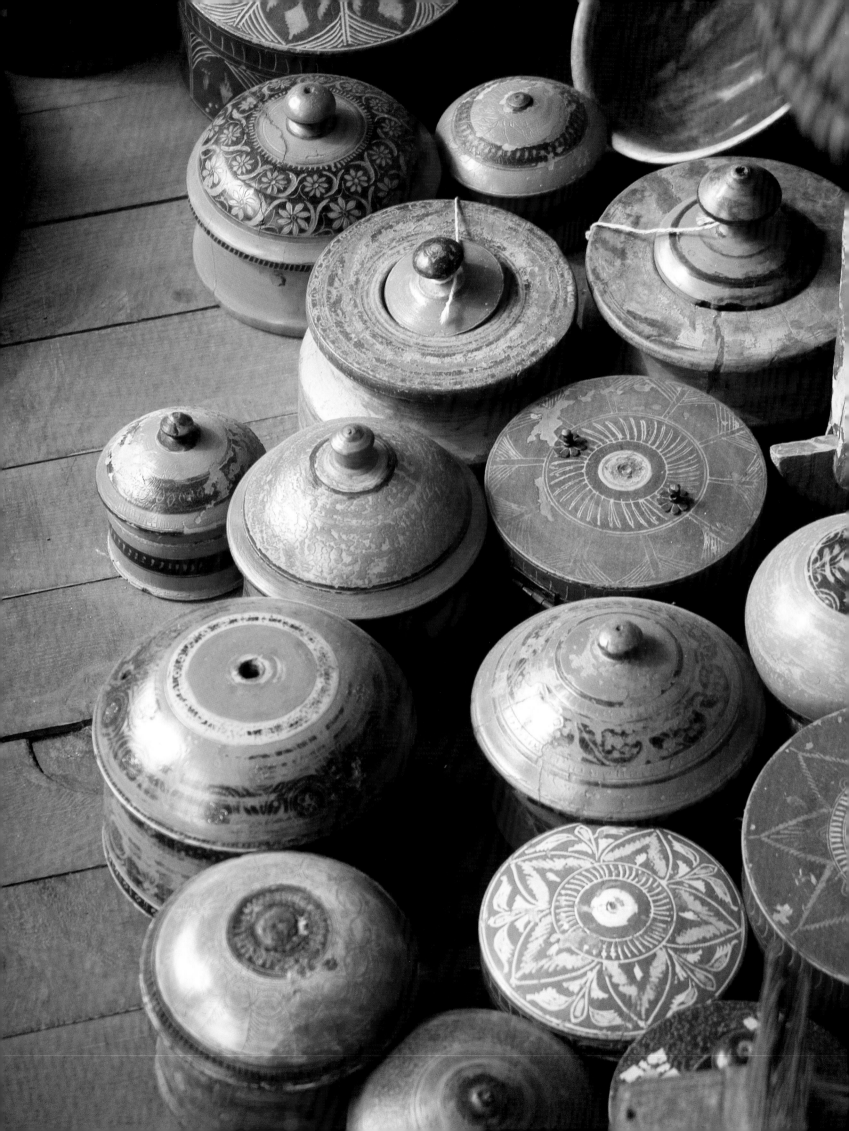

CENTRAL ASIAN CRAFTS: TREASURES FROM THE EAST

Fine ikat silks, embroidered cloths, exotic costumes and beautiful tribal jewelry were not always to be found in the bazaar. It was not until the end of the 20th century that these items came to Istanbul from Afghanistan, Uzbekistan and other Central Asian lands, following the years of strife in Afghanistan.

Expulsion and exile

In the Grand Bazaar, Afghan traders tell stories that they have heard over and over again from their fathers. They are stories of war and destruction, murder and expulsion. 'There were so many planes in the sky that the moon was no longer shining, and so many Russian soldiers came that one could no longer see the ground.' Those are the tales of the fathers. Most of the sons grew up in Pakistan, where their families had fled after the Russian troops had marched into Afghanistan. On donkeys, horseback or foot they had made their way across the mountains. A second wave of refugees followed in the early 1990s, when civil war broke out. 'The country became a football ground. Every week there were different teams playing one another,' says one man who, like many of his compatriots, has built a new life for himself in Istanbul. For many of the refugees, Pakistan was just a transit station, and especially those of Turkic origin made their way to Turkey at least ten years ago – though some of them came as long ago as the early 1980s. Their Muslim forebears had once fled from Turkmenistan and Uzbekistan, for even then – in the late 19th and early 20th centuries – they had been driven out by the Russians. Many went to Afghanistan, but they shared their roots with the Turks, because all of them were descended from the Oghuz people. The language is almost the same, which of course makes it easier for newcomers to adapt to life in Turkey.

Crafts from the mountains

Today there are about forty shops in the Grand Bazaar run mainly by Afghans of Turkic origin, selling products from Afghanistan, Uzbekistan, Turkmenistan and Pakistan. The traders have made a name for themselves among local people and tourists alike; Terlikçiler Street, where most of these shops are situated, is now known to many as 'Little Afghan Street'. Initially, they sold mostly the famous Ersari or Afghan carpets, but today there is a huge variety of products from Central Asia. Many Kurdish businessmen have sensed that there is a niche here, and you can buy musical instruments from India, semi-precious stones from Pakistan, silver jewelry and headdresses from Afghanistan, flower-embroidered cloths, silks and shawls with colourful patterns from Uzbekistan, costumes from Turkmenistan and wooden spice boxes from Kashmir.

Close family ties

There is something quite nostalgic about this exchange of goods between Turkey and Central Asia. It awakens romantic memories of the old Silk Road, of camel caravans plodding their way westwards, resisting the remorseless heat of the desert, and constantly exposed to attacks from bandits. Not all the merchants reached their destination, which was Istanbul, the great trading centre of the Ottoman Empire. Today, it is a different world. Products are usually sent as air freight from Pakistan, and they arrive a few days later in Istanbul. The fathers and brothers of the Afghan traders in the Grand Bazaar are often in the same trade in Pakistan, so they deal in jewelry, fabrics or carpets, which they supply to the family branch in Turkey. Sometimes the Istanbul Afghans themselves go on a buying tour of Central Asia, and not infrequently they may even return with a young bride. Marrying a Turkish woman would be

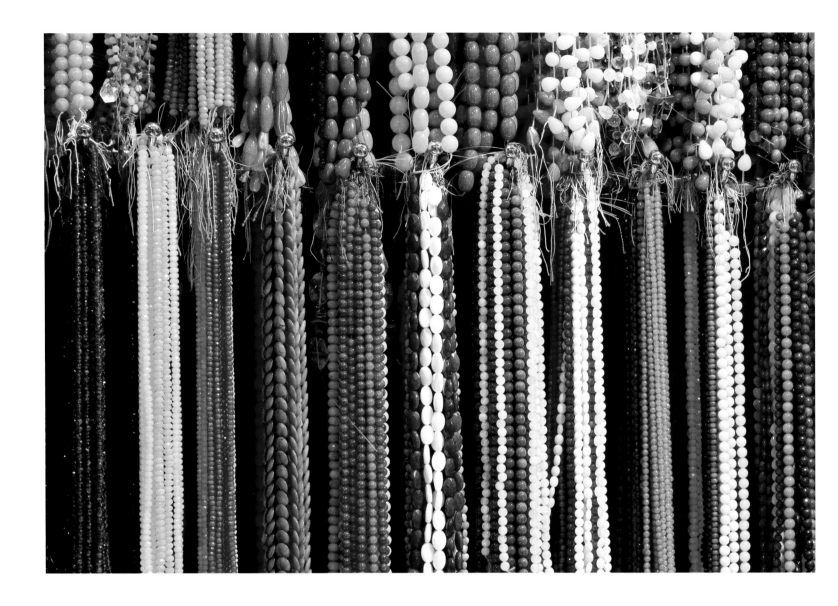

almost unthinkable, as traditions among the Turkic Afghans are very strict. Family and national bonds are fundamental, especially in the diaspora, and the importance of the family is drilled into the children at a very early age. This is illustrated by a little story: one day a father lay dying, and he gathered his offspring around him, sending one son out to fetch some twigs.

Then he ordered the boy to break one of the twigs, which he did easily enough. The boy also succeeded in obeying the order to break two, three and then four twigs. But when the father told him to break the whole bundle in a single go, the child had to admit defeat. When the 'twigs' of the family stick together, even the flimsiest of them cannot be broken.

These colourful strings of semi-precious stones come mainly from Pakistan and India.

yüz altmış dört

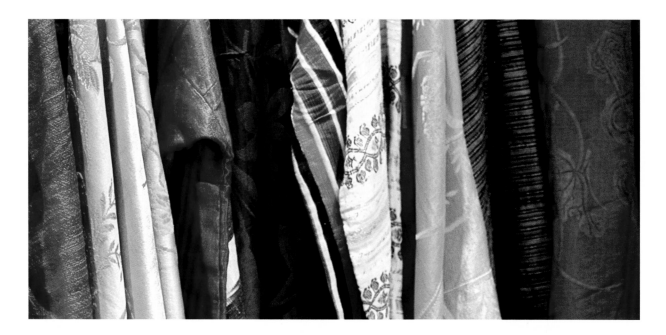

Embroidery from Uzbekistan

One important product from Uzbekistan is *suzani* embroidery, which in Persian means 'needle'. Unlike Turkish kilims, these fabrics are not made by nomads but by village women. The gigantic wall-hangings, embroidered with colourful flower patterns, are part of a bride's dowry, and it is the responsibility of the bride herself and her family to make them. In order for everyone to be able to work on the cloth at the same time, the materials are divided and then sewn together again when they are finished, which accounts for the often irregular patterns and shades of colour. The design, however, is drawn by an artist, and in more recent cloths one can sometimes even discern the patterns outlined in pencil or ballpoint pen. One particular form, which is embroidered only on the two long sides and one short side, is used by the couple as a bedsheet on their wedding night.

The basis of the *suzani* is usually a whitish beige cotton material which is sometimes dyed brown with tea or onion skins. The cloths are mainly embroidered with silk thread in red, black, yellow, green and blue. Particularly old *suzanis* are valuable collectors' items both in Europe and in the United States. In addition to the antique cloths and those currently being produced – mostly in imitation of older designs – there are the very colourful ones made during the second half of the 20th century, most of which have a dazzlingly bright base and equally glowing embroidery.

Ikat: the fabric of shimmering colours

The bright colours of ikat fabrics bring a bright touch to the otherwise bare landscapes of Central Asia. This complicated weaving and dyeing technique takes the name *ikat* from the Malay word *mengikat*, meaning 'to tie or bind', because the warp threads are tied tightly in certain areas and dipped in dye. Only the untied sections are therefore coloured by the dye. When the resulting multi-toned threads are woven, the ikat fabric – which may be of silk or cotton or a combination – gains its characteristically shifting, shimmering appearance. The dyed threads merge into a pattern which has given the fabric its other name of *abr*, meaning 'cloud'.

This very special fabric was used especially to make the long coats known as kaftans. It was once the custom that when a rich man held a feast, he would honour his guests by presenting them with ikat robes. Tajik and Uzbek women still wear trousers and tunics made of this colourful material as part of their everyday dress. The colours that they choose will depend on their age. Younger or unmarried women often wear red, while older women choose darker, more subtle shades.

Leave your village, but do not let your village leave you.

Afghan proverb

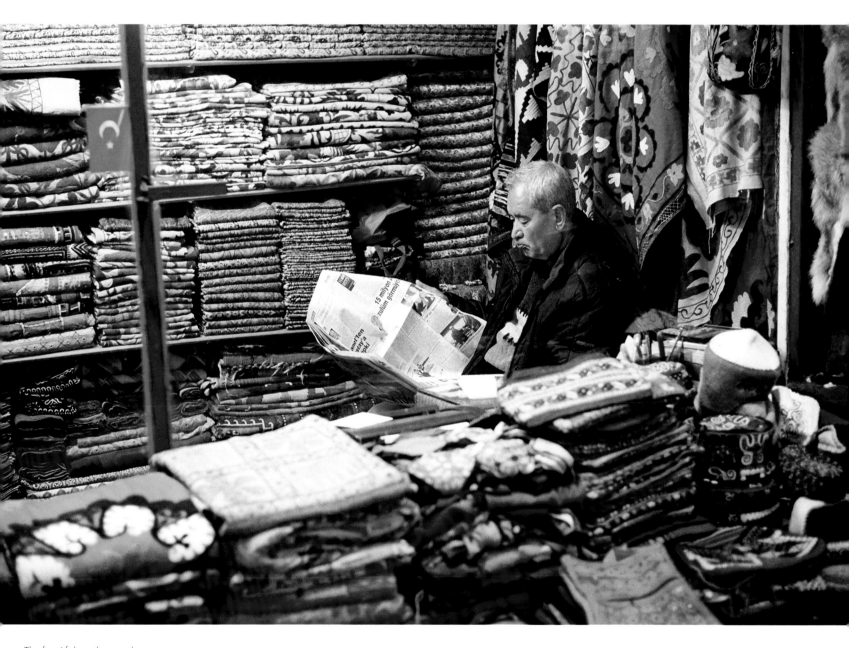

The first Afghan shops in the Grand Bazaar opened in the mid-1990s. Today there are around forty dealers, who sell *suzani*, costumes and jewelry from Central Asia.

THE ART OF RELAXATION: CARING FOR BODY AND SOUL

The countless herbs and spices that can be bought in and around the Egyptian Bazaar do not serve only to add flavour to food. They also relieve sickness and promote wellbeing. Scented oils, essences and perfumes are an aid to beauty and to morale. For Muslims, personal hygiene also has a spiritual dimension.

A potion for the Sultan's mother

When Ayşe Hafsa Sultan learned of her husband Sultan Selim I's death in 1520, she fell seriously ill. It is hard to believe, however, that this was caused by a broken heart, since Selim had been a brutal ruler who had had his nephews and four of his sons murdered and is even believed to have poisoned his own father. It was not for nothing that he was known as 'Selim the Grim'. But whatever may have been the cause of his widow's illness, not even the most experienced doctors could do anything to cure her. As the new Sultan, Süleyman I, did not want to lose his mother as well as his father, he wrote a desperate letter to the head of the hospital in a mosque complex in Manisa – today a sleepy provincial capital in Anatolia. The man had made a name for himself as a healer, and he set to work at once. Using forty-one different herbs and spices, he concocted a thick syrup which he sent to the palace in Istanbul. And wonder of wonders, the potion did indeed save the ailing widow. Out of gratitude for her miracle cure, she ordered that the syrup should be distributed once a year to the people, and this tradition has persisted to the present day: every March or April crowds of people flock to Manisa, where they stand in front of the mosque and the *mesir macunu*, or mesir paste, is thrown to them in the form of a sweet. Those who eat it are reputed to remain free from illness for the rest of the year.

The healers of Istanbul

Both in and around Istanbul's Spice Bazaar there have always been crowds of men busily making ointments, pills and tinctures. The Turkish chronicler Evliya Celebi said there were over 2,000 of them in the 17th century, selling around 3,000 different medicinal herbs and spices. 'As we enter, we are struck by such an overpowering scent of spices and perfumes that we almost turn back. This is the Egyptian Bazaar, where the sweet-smelling products of India, Syria, Egypt and Arabia are piled up as essences, pastilles, powders and creams to colour the faces and hands of the odalisques, to perfume rooms, baths, food, beards and mouths, to strengthen weak pashas, to bring sleep to unhappy wives, to anaesthetize smokers, and to spread dreams, oblivion and intoxication all through the endless city,' wrote the Italian Edmondo de Amicis in the late 19th century. Apparently even gunpowder was used as medication – against haemorrhoids. However, it was quickly banned from the bazaar because of the high risk of explosion! Many traditional healers made effective pills from ambergris, a secretion from the alimentary tract of the sperm whale: it was believed to strengthen the nerves and stimulate the senses. These tablets were so attractive, with inscriptions such as 'health and good appetite' or 'for the health of your heart' that people collected them as art objects in themselves, and some have survived till today.

Even now the Spice Bazaar still offers plants and roots that promise to cure every conceivable ache and pain: lavender for the veins, tree bark for the prostate, rosemary against infection, avocado leaves to get rid of kidney stones. Cherry stalks will help you slim, incense relieves rheumatism, and the mesir paste with its 41 herbs and spices – now manufactured on a commercial scale – is said to be an aphrodisiac. Signs saying 'Turkish Viagra' or 'The Sultan's Aphrodisiac' hang impressively over the products on offer in the tiny shops. Remedies may be sold in the form of tea, paste, cream, syrup or powder.

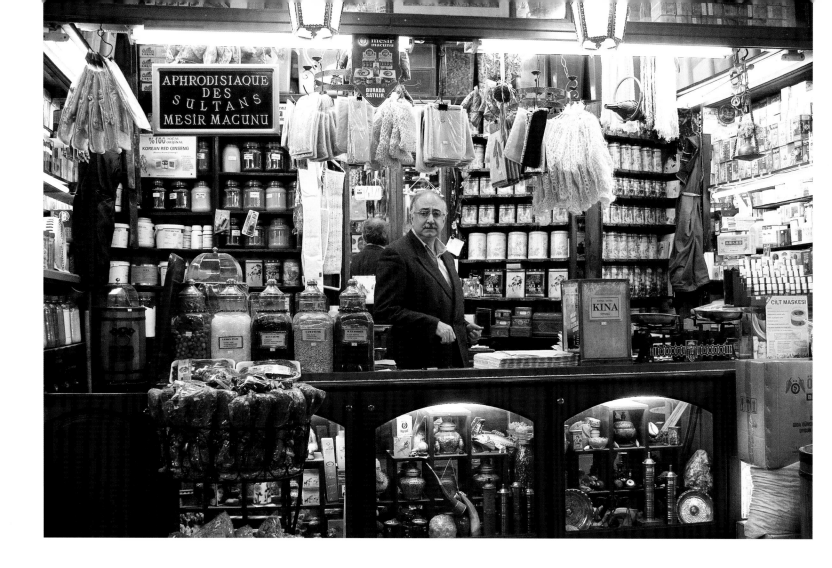

Although many of the traders will still give their customers plenty of advice on the wondrous effects of their various cures, there are now hardly any genuine healers among them. Very few have learned the art of healing from their fathers and grandfathers. They simply go on mixing the potions to treat the symptoms described by the customers, but there is a question mark over how long these men will go on using the recipes concocted by their forefathers. For one thing, the government is not keen on unqualified people selling herbs as medicines, and for another it is becoming increasingly difficult to find the right plants. Many species have already died out, and others are now protected.

Oils and essences for the soul

While herbs may relieve afflictions of the body, scented soaps, oils and essences of flowers can restore the balance of the soul. In Islam, scents also have religious significance. Rose oil is especially important, not only because of its gentle perfume and its calming effect, but also because of the belief that the flower originated from a drop of sweat shed by the Prophet Muhammad. Especially before to Friday prayers, men put on large quantities of strongly scented oils, and outside many of the large Istanbul mosques, there are traders selling vials of scent or fake brand-name perfumes.

The hamam: an oriental dream

Like essential flower oils, a trip to the Turkish baths is good for the body and the soul. The very expression 'hamam' stimulates the imagination: steam rising from marble basins and veiling the room in a warm mist; men and women lying on divans, being cooled by the fanning of waving palm fronds; naked bodies being massaged with relaxing, sweet-scented oils and essences. Every step, every movement is done in slow motion, and muffled voices in the background gently lull you to sleep. A vision indeed, but the reality both in the days of the Ottoman Empire and in modern times is rather less romantic. A visit to these steam baths involves a number of painful experiences, and it is only after these that you can relax. At the begin-

In the Egyptian Bazaar there are still a few healers mixing pastes and powders to cure the illnesses of their clients.

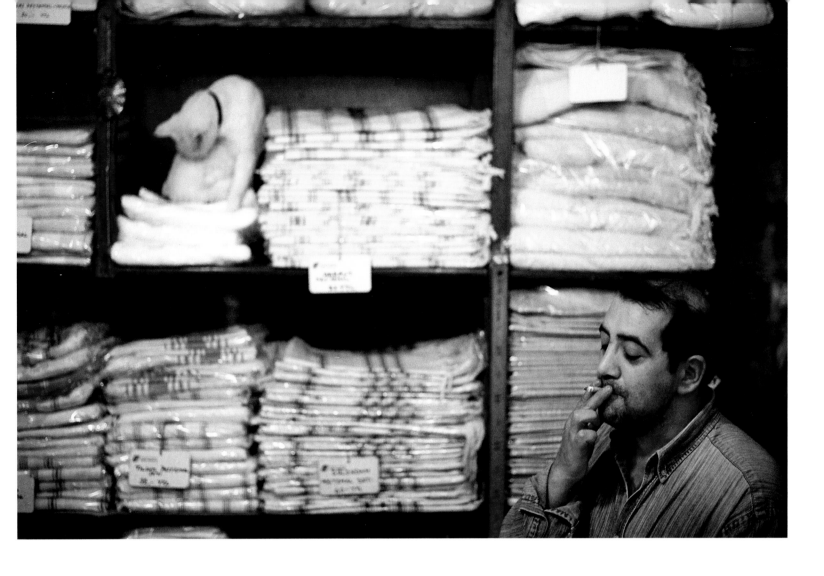

ning of the 17th century, Salomon Schweigger – who travelled extensively through the Orient – wrote: '…a bath attendant comes, puts his arms round him and jerks his body back and forth as if he was trying to straighten everything out. In the same way, he stretches out all his limbs…as if trying to wrestle with him. After that, he lays him out lengthwise on the stove and stands on his body, though gently. That is why our servants have come up with the vulgar expression: "I'm off to get myself kicked for a while", which means "I'm going to the baths". This pushing and pulling of the body almost seems to do you good, because you feel somewhat smaller and lighter.'

Bathing in company

Although local people and tourists alike now go to the Turkish baths in order to relax and be pampered, the hamam originally had a very different meaning for Muslims. It was part of the purification ritual before prayers and other important events. This was where brides prepared for their wedding, and forty days after the birth of a child, or twenty days after

the death of a relative or friend, it was customary to visit a hamam. Apart from these ritual functions, the baths had another purpose: they were the centre of social life, particularly for women, because they were among the few places outside the four walls of their homes where women could move around freely. Wealthy ladies came with their servants and friends, loaded with baskets of fruit and other delicacies, and they would spend the whole day there. This was even the place where they would select potential brides for their sons. Children accompanied their mothers, but once a boy had reached the age at which it was no longer seemly for him to be in the same room as scantily dressed ladies, he had to go to the baths with his father. Men and women were naturally segregated in the hamam.

The Turkish beauty salon

No matter whether men and women are visiting the hamam for religious or social reasons, the ritual is always the same. You undress, and wrap a thin, generally red or blue checkered bath towel – the

The Çemberlitaş Hamam in the bazaar district is one of the finest of the old baths in the city. It has been continuously in operation since it first opened in 1584.

yüz yetmiş dört

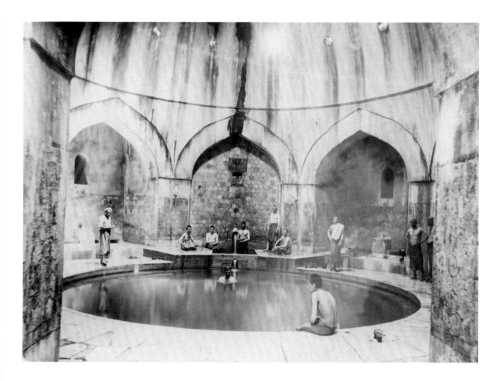

They cover themselves in the bath with fine modesty and decency, not in a shameful fashion... in this instance, we Christians should learn modesty and decency from these barbarians.

Salomon Schweigger, 17th century

peştamal – round your waist; you throw another towel over your shoulder, and wrap a third round your head. Then the men shave and the women remove unwanted hair – as prescribed by Islam. Next comes a rub-down and massage with an abrasive glove.

The utensils used in the hamam were often miniature works of art. A lady might have some fourteen different accessories: in addition to embroidered towels and wooden slippers inlaid with mother-of-pearl – so high that their feet never touched the wet floor – each lady had her own hamam bowl. According to how wealthy she was, it could be made of silver, bronze or copper and decorated with fish or other motifs, and was often engraved with the name of the owner. Soap, comb and flannel were kept in a metal box with a handle, and the really elegant ladies also had a metal container in the form of a pumpkin, where they stored their jewelry. Men made do without such luxuries. They wrapped their things in a simple cloth and then set out on their way to this temple of relaxation.

Musk and amber are good for the spirit.

Inscription on an incense burner from around 1600

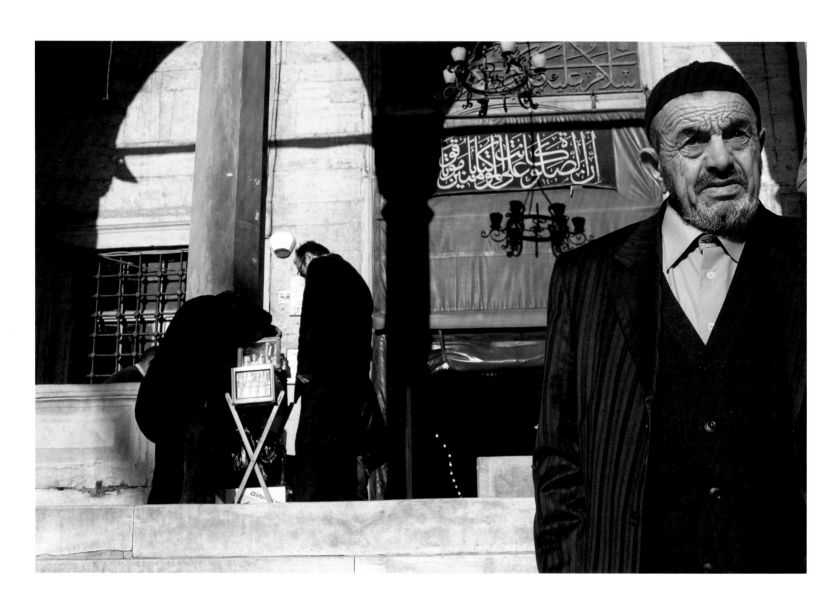

Before prayers, Muslims anoint themselves with scented oils or perfumes. The scents are sold in little flasks outside the mosques. A particular favourite is rose oil, as the rose is believed to have been grown from a drop of sweat shed by the Prophet Muhammad. It is also very expensive to produce – 5,000 kg (11,000 lb) of rose petals must be processed in order to extract 1 kg (2 lb) of rose oil.

In Islam, ritual washing before prayers is obligatory – as we can see here in the washroom of a small mosque in the Grand Bazaar. There are very precise guidelines: as well as cleaning one's hands, teeth and feet, one must wash and rub one's face from the roots of the hair down to the chin, and from one ear to the other.

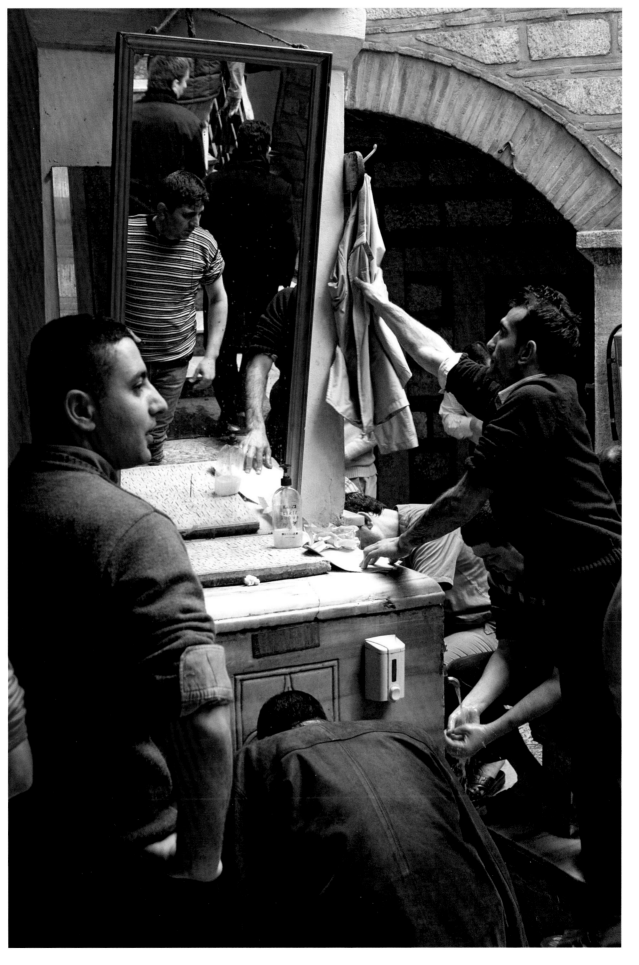

yüz yemiş yedi

SIMPLE PLEASURES:
BLACK GOLD AND BLUE SMOKE

Drinking very sweet coffee and slowly inhaling the smoke from a hookah pipe are part of everyday life in Turkey. But before this happened, heads had to roll. In the historic days of the Ottoman Empire, the pleasures of coffee and tobacco were regularly punished by death.

Coffee and tobacco reach the Ottomans

There is a saying: 'Praise be to him who first dreamed up / The magic found in the coffee cup.' To whom we should give the glory remains a bit of a mystery. There are many legends about the discovery of coffee as a drink. One is the story of a young goatherd from Kaffa in Ethiopia, who was surprised to find his animals so full of energy; he went to a nearby monastery and complained to the monks about how his insomniac goats were making him suffer. At the place where the herd always grazed, they found a plant with red fruit which the animals had been nibbling at. The monks made a brew from the berries, and suddenly they were able to pray and chatter all through the night. According to another legend, the Archangel Gabriel gave the dying prophet Muhammad a beaker filled with a hot, dark liquid. After Muhammad had drunk it, his spirits returned to him in full force.

In addition to these legends, however, we also know some facts. The first documentary evidence of this stimulating drink comes from the 16th century, and refers to the cultivation of the coffee bush in what is now Yemen. The Yemeni town of Mocha on the Red Sea thus became one of the most important ports in the region, where English, Dutch, Indian, Turkish and Arabian merchants filled the holds of their ships and carried the black gold all over the world.

Tobacco, on the other hand, was imported from the New World, but by 1700 the Turks were cultivating their own plants in Macedonia, Anatolia and Syria. Unlike coffee, which had been around for much longer, tobacco became cheaper, and so it was not confined to the rich town-dwellers, but the poorer folk in the country could indulge as well.

Tobacco was also easier to handle: all you needed was a pipe of wood or clay, and practically everyone could afford that. In the Ottoman Empire, as in Europe, people smoked through long pipes known as *çibuk*. Gradually, countless different shapes and sizes were created out of materials such as meerschaum, amber and clay. Many pipes were so short that if necessary they could swiftly be hidden away in one's sleeve. The pipe had now become an indispensable piece of male equipment, as Helmuth von Moltke observed in the early 19th century: 'One cannot conceive how Turks were able to live before the great invention of the pipe occurred.' In time, an alternative was found in the form of the rather unwieldy *nargile*, or hookah pipe.

Thus smoking and coffee drinking became two of the Ottomans' favourite pastimes. Women were not immune to their attractions either. An Egyptian scholar bemoaned the fact that some women even smoked in public, and many lost their rounded figures because of it. A Hungarian historian was also somewhat put out by the high consumption of tobacco: 'Because of the excessive use of tobacco by certain vagabonds and parasites, the coffee houses were so filled with smoke that the people inside could scarcely see one another…Places and whole districts stank of it.'

A fight for pleasure or death

Pleasure brings people together, and the spread of coffee throughout Arabia coincided with the opening of more and more coffee houses, which quickly became known for their relaxed and worldly ambiance. In 1554, two Syrians opened the first café in Istanbul. Reactions varied. The theologians especially

Meerschaum: the white goddess

Beautifully carved white meerschaum pipes adorn the displays of many shops in the Grand Bazaar. They come in a seemingly unlimited choice of shapes: lions' heads with gaping jaws, coiled snakes, eagles' claws, men's heads with beards and turbans, and even reclining, long-haired nudes. You can also find used pipes, which are brown or yellowish because the more often they are smoked, the darker they become. The raw material from which these coveted pipes are carved is a clay-like substance also known as sepiolite. Meerschaum means 'ocean spray' in German, but although the substance does look white and frothy, the name probably derives from the Levantine term *mertscavon*, and it was the Austrian traders who controlled the market in the 18th century that turned this name

When they are first made, meerschaum pipes are a brilliant white, but the more they are used, the darker they become.

into 'meerschaum'. Today sepiolite comes almost exclusively from Eskişehir, in Anatolia, but export is prohibited; the raw material has to be made into pipes or jewelry in the workshops of local craftsmen.

were furious; they compared the stimulating effects of coffee with those of wine, and to add insult to injury, the number of people going to the mosques dropped sharply, which many attributed to the reprehensible new pastime of coffee drinking. Smoking was equally controversial. Strict Muslims regarded tobacco as another stimulus which could bring the pillars of moral order crashing down. Smokers must expect the worst – though ironically not until after their death. It was said that sinners would appear before the Last Judgement with blackened faces and a hookah pipe round their necks, and would go up in flames within their tombs. In addition to the religious reasons for a ban on tobacco, there was the danger of fire, because most houses in Istanbul were made of wood. But it may be that all the fuss in truth had a much less lofty cause: coffee houses were a hotbed of gossip and revolutionary ideas, and they were regarded by the authorities as a breeding ground for dissent. 'The despot feared, not without cause, that from smoking cups and pipes there might arise a sense of dissatisfaction and resistance,' wrote the orientalist Joseph Freiherr von Hammer-Purgstall.

In the late 16th century, an intensive campaign was waged in Istanbul, first against coffee and then against tobacco. Under Murad III a ban – though

not very strictly enforced – was imposed on coffee. In 1622 Osman II passed a decree against smoking: 'Those who smoke or buy tobacco, or plant it and pick the tobacco leaves, deserve all kinds of censure… For this reason it is commanded that people be sent forth who in public and in secret should spy into rooms to see if everyone is doing his work or is occupied with something else…Those who do not abstain from it are to be seized and taken into strict custody. It is therefore to be announced that for this kind of person there shall be no mercy.' The situation for smokers and coffee-drinkers became absolutely critical ten years later under the rule of the cruel Murad IV. Coffee houses were torn down, and the consumption of not only coffee and tobacco, but also opium and wine was savagely punished. The Sultan himself would go through the streets, and if he caught smokers in the act, he would have them beheaded on the spot. It will have come to the coffee and tobacco lovers as a true sign of heavenly justice that the grim sovereign drank himself to an early death.

Coffee and tobacco triumphant

The fact that tobacco was not necessarily a gift from the Devil, and that the pleasure business could be very lucrative, was eventually recognized by the Ottomans

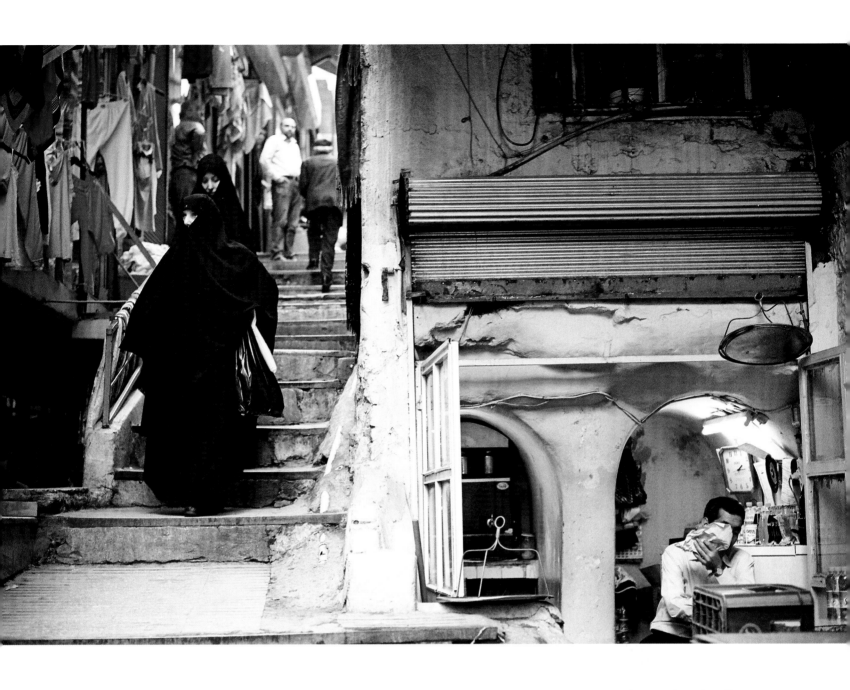

Hidden away in and around the Grand Bazaar, there are over a hundred little kitchens, where fresh tea is brewed all day long. The tea boys take this strong, bitter drink to the traders, workers and customers, and then collect the empty glasses afterwards.

in the 17th century. In the person of Mehmed IV, a smoker ascended the throne, and he not only promoted the cultivation of tobacco but also made it into an important trading commodity. By the imposition of a kind of tax on luxury goods, it also helped to double the income of the Istanbul customs department. It was only logical that the next step would be the complete liberalization of tobacco planting. Although coffee houses continued to be closed down until the Tanzimat [reorganization] – a period of massive reforms in the Ottoman Empire that began in 1839 – violations of the rules were no longer punished so severely.

In the end, pleasure won out. The richer households even engaged servants to brew fresh coffee,

and the large harems also employed coffee servants who were supervised by a committee of experts. These jobs were taken very seriously. If coffee was not brought regularly to the harem, it could be taken (quite literally) as grounds for divorce. A particular form of protocol was developed at court: for instance, if an ambassador was not offered coffee during an audience, it meant that the Sultan did not think much of the man's country. The coffee houses became even more popular with the development of the Ottoman newspaper industry towards the end of the 19th century. It seemed that nothing could be more enjoyable than to sit in one of the large cafés near the Bayezid Mosque, order a newspaper, drink a coffee and smoke a pipe.

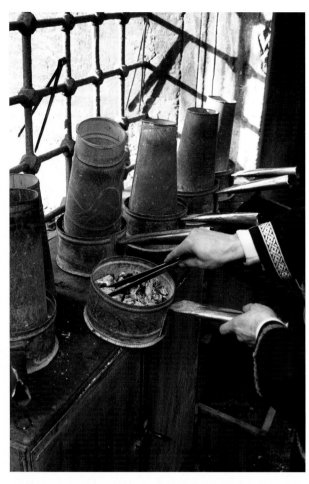

Relaxing with a pipe

With obvious relish, the seller draws on the little mouthpiece of his hookah. Thick bubbles of air gurgle their way through the water in the glass bowl, a sweet scent hangs in the air, and white clouds of smoke rise upwards. A waiter comes repeatedly with a pan full of glowing coals and carefully lays more embers on the pipe.

Although the hookah or water pipe is an established feature of Turkish culture, in fact it comes originally from India, where it is still made out of coconuts. In the 16th century, the pipe – called a *nargile* in Turkish – found its way to the Ottoman Empire. The better quality ones were ceramic, but glass bowls were later imported from Bohemia. In the 19th century, Helmuth von Moltke described the pleasure that the Turks derived from this pastime: 'The water is in a glass urn; the Turk puts a rose or cherry into it, and takes innocent pleasure in the way this dances on the moving surface with every puff he takes. A *nargile* such as this, a shady tree, a splashing fountain and a cup of coffee are all the Turk needs to keep himself happily entertained for ten to twelve hours of the day.'

The Çorlulu Ali Paşa Medresesi café has long been a meeting place for students, writers and shopkeepers. You can smoke a hookah, drink tea, and talk. In order to prolong the pleasure, a waiter goes from one table to another, laying glowing coals on the head of the hookah.

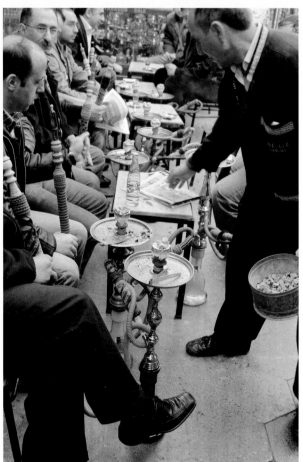

Coffee should be as hot as a girl's first kisses, as sweet as the night in her arms, and as black as the curses of the mother when she finds out.

Arab saying

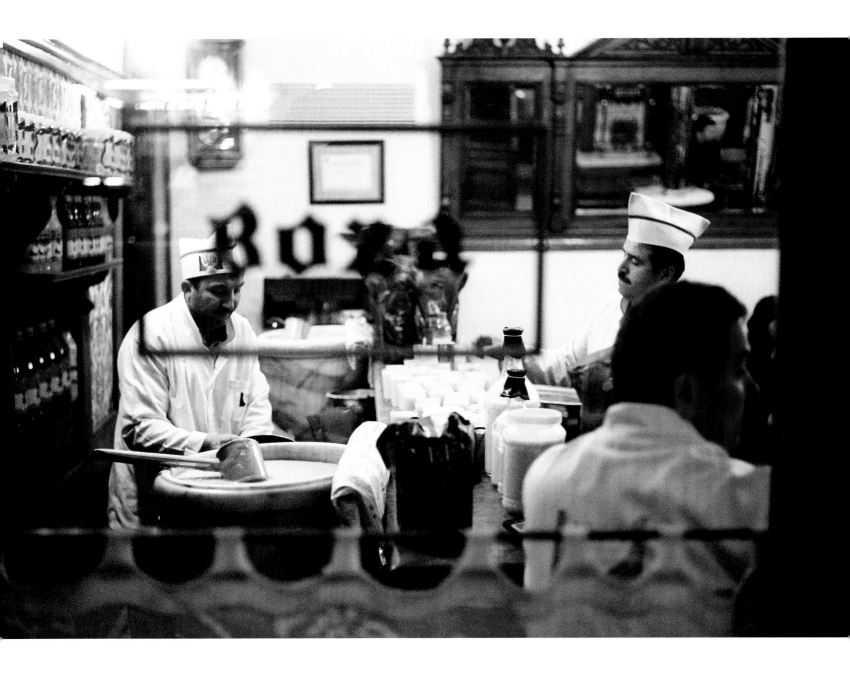

In 1876, two brothers set up a *boza* shop in Istanbul. Their sweet drink became famous far beyond the borders of Turkey; even today, tourists and Turks alike make their pilgrimage to Vefa Bozacısı near the Süleymaniye Mosque. It is now run by the two brothers' descendants.

The beer of the janissaries

Next to coffee and tobacco, a major thorn in the side of the Ottoman priests and sultans was a drink named *boza*. This thick liquid, made from millet seeds, is still sold today on the streets of Istanbul. *Boza*-sellers were very low down on the social scale, on a par with vintners – hence the saying: 'When the wine merchant needs a witness, he fetches the *boza*-seller.' The custom of mixing this slightly alcoholic drink with opium so appalled various rulers during the 16th century that they closed all the *boza* shops. But despite the ban, people went on consuming this nourishing drink – especially in the army. So long as the soldiers didn't get drunk, it was tolerated. Not until the 19th century did sweet, non-alcoholic *boza* come to displace the bitter, alcoholic version.

Turkish tea

The Turks boil their tea in a two-tiered set comprising one small metal pot standing on top of a larger one. The lower pot should be three-quarters full of water – sufficient for ten glasses of tea. Put four tablespoons of small-leafed black Turkish tea into the smaller pot with a few drops of water, and place it on top of the larger pot. Put both pots on the stove. Bring the water in the larger pot to the boil. Fill the smaller pot with hot water and put it back on the larger pot. On a low heat, let the remaining hot water simmer in the lower pot, and let the tea concentrate draw for ten minutes. Fill tea glasses with a few centimetres of the strong concentrate, and dilute with water from the lower pot. Serve the tea with sugar cubes.

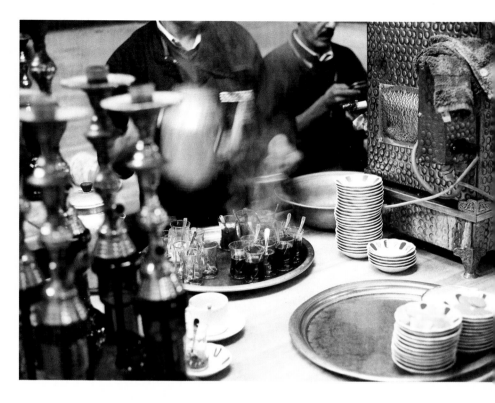

A conversation without tea is like a night without a moon.

Traditional saying from Sivas, Turkey

Tea becomes the new national drink

You can hardly walk ten metres through the Grand Bazaar without being invited for a glass of tea (*çay* in Turkish). A call or a whistle is enough – many shops have a direct intercom link with a kitchen – and in no time a boy will be wending his way through the crowd, carrying a tray with tulip-shaped glasses of black tea or apple tea, a variant specially for tourists. The traders do not pay cash; for every glass they are given a coloured plastic chip, and once a week these chips are counted and the debt is paid. You can also buy a kind of season ticket of chips. The tea boys make their rounds, gather up the empty glasses and give out the full ones. There are over a hundred of these tiny tea kitchens scattered all over the Grand Bazaar and surrounding alleyways, and they are continually brewing fresh tea.

If a trader invites you for a glass, you are under no obligation whatsoever to buy. Offering tea to a guest is simply a matter of good form in Turkey. In any case, it's far nicer to do business over a couple of glasses of strong tea, and it's all part of the ritual: first you drink – but there is no need to start haggling too soon. Have another drink. And then the first figures are thrown into the ring. When the deal is sealed, there will be more tea. Coffee is rarely on offer in the bazaar today. Over the last century, it is black tea that has fought its way to the number one spot as the national drink of Turkey. At the end of the 19th century, tea rooms began to open in the historic district of Sultanahmet. In the 1930s, the farmers on the coast of the Black Sea started planting the first tea bushes, and so great was their success that some villages were even given new names to include the word *çay*. For instance, Mapavri was changed to Çayeli and Cadahor became Çaykara. Tea was not only presumed to be healthier, but it was also cheaper and quickly became the nation's favourite drink.

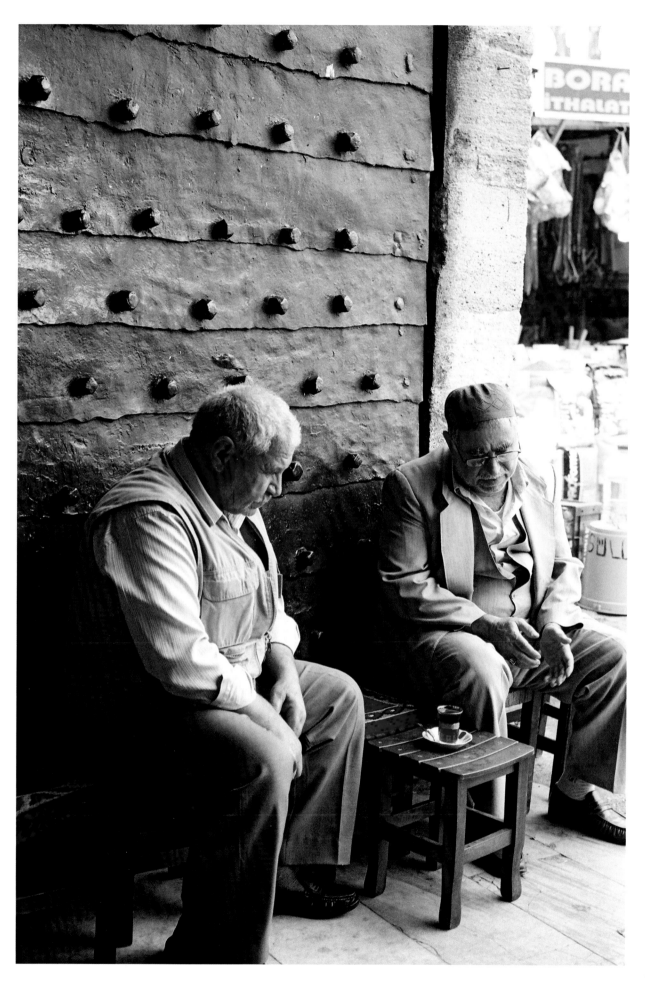

Turkish coffee

Pour just over two coffee cupfuls of water into a *cezve*, a long-stemmed copper pot, and stir in two heaped teaspoons of finely ground coffee. Add one teaspoon of sugar per cup. (If you want coffee without sugar, ask for *sade*; for a little sugar, *orta şekerli*; or for very sweet, *şekerli*.) Stir the mixture on a low heat until the surface begins to froth. Pour off some of the froth into two coffee cups, then bring the coffee to the boil again, and pour it into the cups. Serve with a piece of *sade lokum* (Turkish Delight).

The future in your coffee cup

According to myth, the tradition of reading the future in coffee grounds goes back to a love story. There was once a girl who was promised to a man but fell in love with another. In despair, she renounced life and poisoned her own coffee. By accident she spilled the drink, but when she saw the coffee grounds in the cup, she perceived the name of her beloved and both their initials in the form of intertwining rings. The girl plucked up courage to confess her love to the boy, and together they fled to a distant land, where they lived happily ever after.

Legends are all very well, but it is more likely that fortune-telling through coffee is derived from reading tea leaves, which had already been practised in Asia for centuries. The art of reading coffee grounds is still passed on from mother to daughter in Turkey, and even the emancipated women of today are reluctant to deprive themselves of this little piece of magic.

How to read coffee grounds

There are countless different ways of reading coffee grounds, so here is just one of them. First, make sure that the person drinks from one side of the cup only. When the cup is so empty that there is only a little liquid sloshing over the grounds, put the upturned saucer over the cup and make a wish. Cup and saucer should then be turned a few times in a clockwise direction. Next tip the cup upside down on the saucer, let it stand for a moment or two, and get the drinker to turn it the right way up. Patterns in the lower half of the cup will reveal something about the past, and in the upper half something about the future. Motifs towards the right have a positive effect on the meaning, whereas those on the left stand for something negative. If the saucer sticks to the cup, do not read the grounds. This is a 'prophecy by the Prophet', and it is assumed that the person who drank from the cup will have so much good fortune that the future does not need to be told. But if, on opening, the coffee drips onto the saucer, there will soon be tears. When you look into the cup, you can interpret the symbols you see in the grounds. What is all-important is the art of recognizing the signs and their meaning.

The first porcelain cups did not have handles. In order to prevent fingers from being burned, the cups were placed in metal holders, called *zarf* (see above). However, the advent of handled cups made these holders superfluous, and so nowadays you will only find them in antique shops in the Grand Bazaar.

Kurukahveci Mehmet Efendi is one of the oldest coffee-roasting houses in Istanbul. Right next to the western entrance to the Egyptian Bazaar, it has been roasting and grinding coffee beans since 1871. In former times, the Tahmis Sokak – *tahmis* is Turkish for 'roast' – housed row upon row of coffee dealers.

Reading the symbols in your coffee cup

- A fish stands for happiness and health

- A pearl necklace means that sacrifices will be needed to win someone's heart.

- A heart stands for new love and trust.

- A butterfly means indecision about a friendship. You need to make up your mind.

- A garland indicates success.

- An ear is a warning not to believe everything that you hear.

- A leaf means that you will soon hear from an old friend.

- An eye can mean envy, or that you have attracted someone's attention.

- A knife stands for imminent danger from enemies.

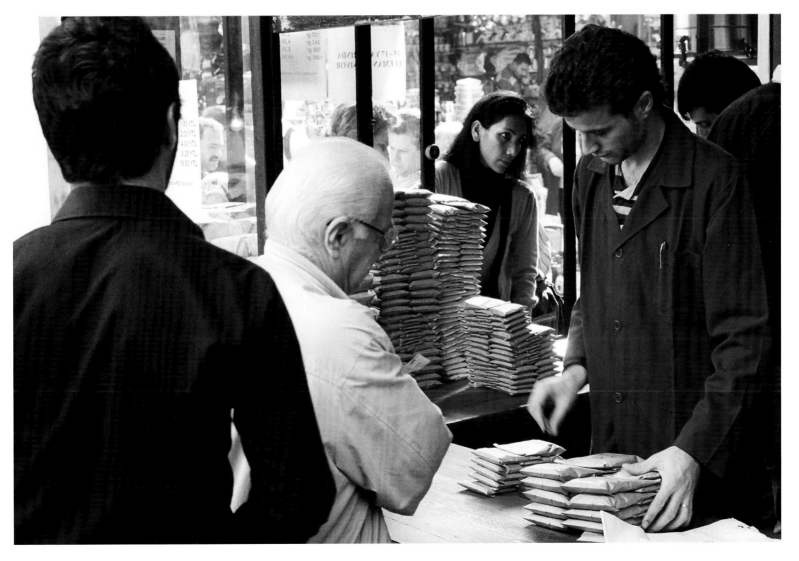

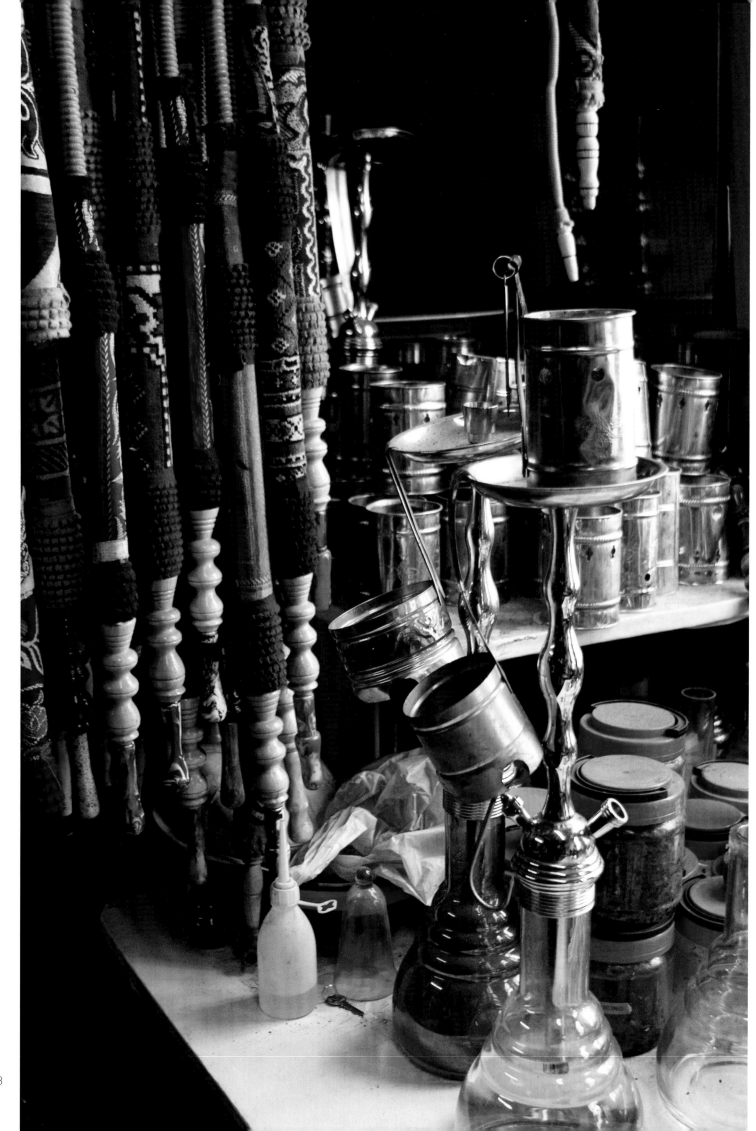

RECIPES:
THE SECRETS OF A TURKISH KITCHEN

If you think Turkish food is nothing but doner kebabs and baklava, then think again. Turkish cuisine is in fact among the most varied in the world. This is due both to the sultans' love of experimentation, and to the mixture of many different nationalities that made up the Ottoman Empire.

Eating in the Empire

The wide variety of Turkish cuisine goes back to the extraordinary melting pot of nationalities that peopled the Ottoman Empire. The original nomadic culinary traditions of the Turkish tribes mingled with those of the Indians, Persians and Arabians. These in turn were joined by influences from the Mediterranean and the Caucasus. The different climate zones of the country resulted in the development of regional specialities. For instance, the damp climate on the eastern Black Sea coast meant that wheat could not be cultivated there, and so maize became the principal grain crop. In South Anatolia, the speciality was cattle-breeding, and the meat was cooked in the form of mouth-watering kebabs. On the Aegean coast, the main influence was Mediterranean cooking, and even today the menu there is dominated by vegetables, fish and olive oil.

Food fit for a sultan

While the foods enjoyed by the farmers and shepherds tended to be simple, that of the palace chefs was highly sophisticated. From Murat II onwards, the sultans laid increasing emphasis on culinary creativity. There are still dishes that bear names such as 'Sultan's Pleasure' (lamb with aubergines), or 'The Imam Fainted' (stuffed aubergines). These are a clear indication of the importance of food to the rulers, and a visit to the Topkapi Palace in Istanbul bears this out. The large building in which the kitchens were housed boasts no less than ten domes, beneath which meals were prepared for the occupants of the palace; those for the Sultan and his mother, however, were cooked in a separate kitchen. Of course, anything that came out of their kitchen had to be tested first by a taster, and the meals were served on celadon dishes, a type of glazed pottery that was believed to change colour on contact with poison.

At the beginning of the 17th century, more than 1,300 cooks and kitchen hands were employed at the palace. Each had his own speciality, inspired by the recipes from his home region – the Balkans, Greece, Arabia. Every day some 10,000 people had to be fed, and servants carried trays full of food into the city – a royal gesture of magnanimity. The cooks excelled themselves on all important occasions and festivals: to celebrate the circumcision of a prince in the mid-16th century, one chronicler recorded the list of ingredients for the thirteen-day feast: 1,100 chickens, 900 lambs, 2,600 sheep, almost 8,000 kg of honey, and 18,000 eggs.

The titles of the different military ranks also reflected the importance of food: commanders of the janissaries were dubbed 'soup men', while other high-ranking officers were called 'head cook', 'kitchen boy', 'baker' or 'pancake maker' – although their work had nothing to do with ladles, whisks or saucepans. The soldiers also used cooking utensils to express their discontent with their masters. If they wanted to see a change of staff in the Sultan's entourage, they turned the rice pot around. Even today, the saying 'turning the rice pot' indicates a military rebellion.

Afiyet olsun! > Bon appetit!

Next to the Galata Bridge lies the fish market of Karaköy, where you will find freshly caught fish, mussels and vegetables. You can buy snacks at one of the little stalls.

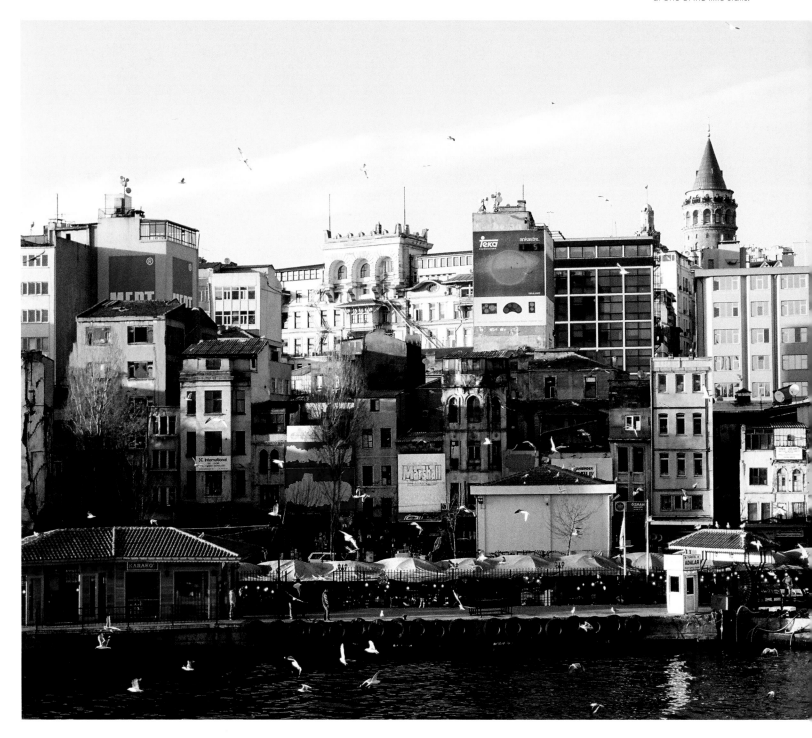

Rules for hygiene

Conditions in the food stalls and private homes of Istanbul were not quite as sumptuous as those of the palace, but nevertheless hygiene was strictly observed during the preparation and consumption of food. An edict issued to stall-owners in the early 16th century ran as follows: 'Owners of hot food stalls, sellers of cooked sheep's heads, makers of filo pastries – in short, all makers and sellers of food – must prepare it cleanly and thoroughly. They must wash the dishes with clean water, and dry them with clean cloths. They must not wash the dishes in other kitchenware or with dirty water... The market supervisor will have offenders beaten, with the sanction of the *qadi* [judge], but will not impose a fine.' There were also strict rules relating to spoons – the sole form of cutlery. Only the right half of the spoon – the ladling side – was to be dipped into the communal bowl, the left side being used to raise the food to the lips. For all other dishes, the Turks used the right hand, as the left was for wiping the body and was therefore considered unclean. Between courses, they always washed their hands and dried them with fresh towels.

The American author Mark Twain had a rather unpleasant experience during a trip to Turkey: 'I never shall want another Turkish lunch. The cooking apparatus was in the little lunch room, near the bazaar, and it was all open to the street. The cook was slovenly, and so was the table, and it had no cloth on it. The fellow took a mass of sausage meat and coated it round a wire and laid it on a charcoal fire to cook. When it was done, he laid it aside and a dog walked sadly in and nipped it. He smelt it first, and probably recognized the remains of a friend. The cook took it away from him and laid it before us.' Maybe the renowned humorist was simply unlucky in his choice of eating place. If he had sampled the true delights of Turkish cuisine, perhaps he would have written a very different account.

> *Take your meals together with your family, because such meals have the blessing of Allah.*
>
> Words of an Islamic prophet

KEREVIZ SALATASI
(Celeriac salad)

1 small celeriac, approx. 500 g

salt

juice of 1 lemon

1 garlic clove

250 g thick yoghurt

3 tbsp mayonnaise

100 g finely chopped walnuts

fresh dill to garnish

IMAM BAYILDI
(Stuffed aubergines)

4 small aubergines

125 ml olive oil

2 onions

3 tomatoes

4 green chillis, hot or mild

1 bunch flatleaf parsley, plus
 extra to garnish

2 garlic cloves

1 tbsp tomato puree

freshly ground black pepper

salt

1 tsp sugar

Meze: Turkish appetizers

Anyone who has tried meze will find them hard to resist. These delicious little dishes are mainly served in the traditional *meyhane* – which roughly translated means 'wine house'. In earlier times, these were the only places where alcohol was served. Meze are brought to the table on huge trays, and guests can make their choice from countless dishes of pickled fish, steamed vegetables, stuffed olives, nut paste, aubergine puree, bean salad and more. Meat, however, is used relatively rarely. There are some places in Istanbul where up to seventy different varieties of meze are on offer. The waiter will bring cold dishes first, followed by hot. The meze are traditionally accompanied by white Turkish bread, and *raki* – a kind of brandy generally made from grapes, but also from figs or plums.

KEREVIZ SALATASI *(Celeriac salad)*

Peel the celeriac, grate thickly, mix with salt and lemon juice and leave to marinate. Crush the garlic and mix with the yoghurt and mayonnaise. Squeeze out the celeriac by hand, and then mix with the yoghurt sauce and walnuts. Garnish with dill.

IMAM BAYILDI *(Stuffed aubergines)*

Keep the stalks on the aubergines. Beginning at the stalk end, peel off strips of skin lengthways, 2 cm wide and 2 cm apart, to create a striped pattern. To create a space for the stuffing, cut the aubergines crossways into quarters by slicing down the centre of each peeled strip, but leave the stalk end intact. Sprinkle salt on the cut surfaces and leave for about 20 minutes to allow the bitter juices to drain off, then rinse with water.

Heat 4 tbsp olive oil in a non-stick pan, brown the aubergines on all sides, and then place in an oven-proof dish with the cut side facing upwards.

For the stuffing, cut the onions into rings. Pour boiling water over the tomatoes, peel them, halve them and remove the seeds, then dice the flesh. Cut the chillis in half or leave whole, as desired. Finely chop the parsley and crush the garlic. Heat another 4 tbsp olive oil in the pan, and on a gentle heat sweat the onions until they are transparent. Stir in the tomatoes, tomato puree, parsley, salt, pepper and sugar, and cook until softened but not brown. Season, allow to cool slightly, and then add to the aubergines.

Stir the remains of the tomato mixture and garlic, the rest of the oil, and 200 ml water, and pour onto the aubergines. Place half a chilli on each aubergine. Cover the dish with tin foil, place on a central shelf in the oven, and leave to cook for about 40 minutes at 180 °C/gas mark 4. You may need to add a little water at intervals. After 40 minutes, there should be very little fluid left in the dish.

Leave to cool for a short while, and sprinkle with parsley to garnish.

Fact: The Turkish name for the dish means 'The Imam Fainted', reputedly because it was so delicious.

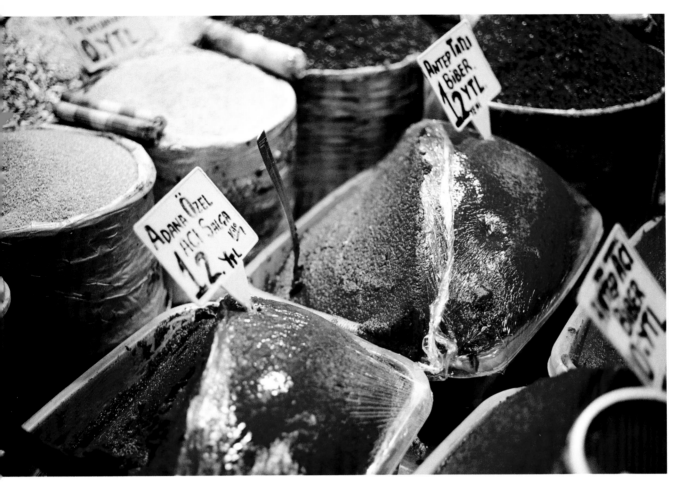

ŞAKŞUKA (Spicy vegetable stew)

Peel the aubergine and dice it. Heat 5 tbsp olive oil in a pan, cook the diced aubergine until it is golden brown, take it out and let it drain on kitchen paper. Pour boiling water over the tomatoes, skin them, cut them in half, and remove the seeds. Dice the flesh. Cut the chillis in half, remove the seeds and then cut into thin strips. Finely chop the onion and garlic and sweat in about 3 tbsp hot oil, stirring until transparent. Stir in the chilli, the diced tomato and tomato puree. Pour 125 ml water into the pan, and simmer on a high heat. Season with pepper, salt, paprika and sugar. Finally, mix in the browned cubes of aubergine, bring to the boil again, and stir in the rest of the olive oil. Serve hot or cold with Turkish bread.

Tip: Other vegetables, such as potatoes, courgettes or peppers, can be used in place of the aubergine.

FAVA (Broad bean dip)

Soak the beans overnight in very cold water. Dice the onion, put it in a saucepan, and cook it lightly in 2 tbsp olive oil. Peel and grate the carrot, dice the garlic, add both to the diced onion, and simmer. Strain the bean water, stir the beans, orange and lemon peel into the onion and carrot mixture, and add 500 ml cold water. Bring to the boil and cook for about 40 minutes until the beans are soft and the water has been absorbed. Puree everything in a food processor or pass through a sieve. Finely chop the dill and add to the puree. Season with salt and pepper. Let it cool, then add a little more seasoning if required. Pour the remainder of the olive oil over it, and garnish with dill. Serve with flatbread.

Tip: Always make sure that pulses have not been left standing on the shelf for too long, because they eventually lose their freshness. Their cooking time depends on their age, and can be much longer or shorter than the time allowed in the recipe, so taste as you cook.

ŞAKŞUKA
(Spicy vegetable stew)

1 large aubergine

150 ml olive oil

4 tomatoes

3 red chillis

1 onion

1–2 garlic cloves

1 tbsp tomato puree

freshly ground black pepper

salt

1–2 tsp hot paprika

1 tsp sugar

FAVA
(Broad bean dip)

150 g shelled, dried broad
 beans

1 onion

5–6 tbsp olive oil

1 small carrot

1 garlic clove

finely grated peel of
 ½ unwaxed lemon and
 ½ unwaxed orange

½ bunch dill

salt

freshly ground black pepper

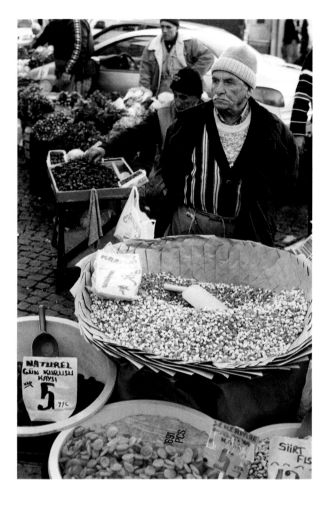

ARNAVUT CIĞERI
(Albanian liver)

1 red onion

salt

½ bunch flatleaf parsley

1 tsp sumak (a spice available from Turkish stores)

400 g lamb's liver

6 tbsp olive or sunflower oil

3 tbsp flour

freshly ground black pepper

1 tsp hot paprika

2 medium tomatoes to garnish

PORTAKALLI KEREVIZ
(Celeriac in orange sauce)

juice of 1 lemon

1 celeriac, approx. 500 g

2 carrots

2 onions

6 tbsp olive oil

250 ml freshly squeezed orange juice

½ garlic clove

½ tsp sugar

salt

freshly ground black pepper

finely grated peel of ½ unwaxed orange

dill to garnish

ARNAVUT CIĞERI *(Albanian liver)*

Cut the onion into fine rings, sprinkle with salt, then leave in a sieve or colander for ten minutes to drain. Rinse the onion rings in cold water and dab dry with kitchen paper. Finely chop the parsley and add to the onion rings, together with the sumac. Clean the liver, cut it into cubes and finely coat with flour.

Heat the oil in a pan, fry the liver cubes until they are brown on all sides, remove from the pan, and let them drain on kitchen paper. Season with pepper, paprika and salt. Let the liver cool, and serve with the onion mixture on a plate. Cut the tomatoes into wedges and garnish the liver with them.

PORTAKALLI KEREVIZ *(Celeriac in orange sauce)*

Mix the lemon juice with 700 ml water in a bowl. Peel the celeriac, cut it into strips and leave to marinate in the lemon water for 20 minutes. Next cut the carrots into strips. Cut the onions into halves and then into thin slices. Heat the olive oil in a saucepan. Lightly simmer the carrots in it, then add the onion slices and sweat them until they are transparent. Pour the orange juice and a little of the celeriac lemon water into the pan and bring to the boil, stirring regularly. Drain the celeriac strips, reserving the lemon water, and add the strips to the pan.

Add the garlic and season with sugar, salt and pepper. Cook on a low heat for about 20 minutes. Stir in the orange peel. Let the celeriac cook, and lay it out on a plate. Pour a little of the lemon water over it, and garnish with dill.

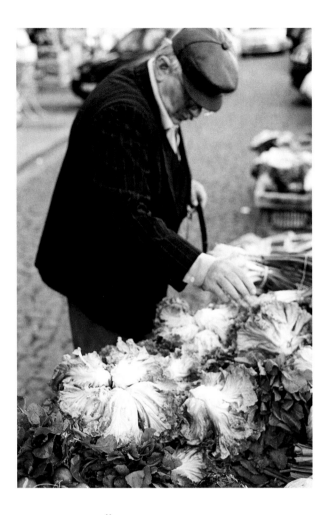

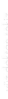

ÇERKEZ TAVUĞU *(Circassian chicken)*

Wash the chicken. Dice the carrot and onion. Put all of these in a saucepan along with 1 tsp salt, the bay leaf and peppercorns, cover with water, and bring to the boil. Partially cover, and allow to simmer on a low heat for about 30 minutes.

Take the chicken out of the saucepan, let it cool, and remove the skin. Take the meat off the bone, pull it apart into thin strips, and place in a dish. Season with salt and pepper.

Mix the walnuts and two types of paprika and lightly brown them in a dry pan. Let them cool.

Soak the breadcrumbs in 250 ml chicken stock, gently mash with a fork, and stir in the walnuts and paprika. Blend the milk into the walnut mixture and stir in the chicken meat. Season with salt and pepper and allow to stand for about 30 minutes. Garnish with parsley.

YOĞURTLU SEMIZOTU *(Purslane with yoghurt)*

Wash the purslane, remove the leaves from the stem and finely chop. Crush the garlic and mix it with the yoghurt and leaves. Season with salt and olive oil.

Tip: Purslane is a leafy vegtable that can sometimes be found at specialist greengrocers or grown at home, but endives or chicory can be used as a substitute.

KURU BÖRÜLCE *(Black-eyed bean salad)*

Boil the black-eyed beans in plenty of water for about 40 minutes until cooked. Strain, and allow the beans to cool. Crush the garlic, and add to the beans along with the olive oil and lemon juice. Finely chop the dill, parsley and green part of the spring onions and add to the bean mixture. Season with salt and pepper. Put into a dish and garnish with dill and parsley.

Tip: Soak the dried beans beforehand in cold water, strain, boil without salt until they are almost cooked, then add salt.

ÇERKEZ TAVUĞU
(Circassian chicken)

½ chicken, around 600 g

1 small carrot

1 small onion

salt

1 bay leaf

½ tsp black peppercorns

200 g finely chopped walnuts

½ tsp each of hot paprika and
 sweet paprika

3 slices of dry white bread

125 ml milk

flatleaf parsley to garnish

YOĞURTLU SEMIZOTU
(Purslane with yoghurt)

1 bunch of purslane,
 approx. 150 g

1 garlic clove

250 g thick yoghurt

salt

olive oil

KURU BÖRÜLCE
(Black-eyed bean salad)

200 g dried black-eyed beans

salt

1 garlic clove

125 ml olive oil

juice of 1½ lemons

½ bunch dill

½ bunch flatleaf parsley

3 spring onions

salt

freshly ground black pepper

On the Galata Bridge, in Eminönü and in the little side streets of Beyoglu (centre of Istanbul's nightlife), mussel sellers offer their *Midye Dolması* The seller opens the stuffed mussels for his customers, and sprinkles the rice mixture inside with lemon juice.

MIDYE DOLMASI
(Stuffed mussels)

150 g long-grain rice

Salt

25 g small currants

2 onions

25 g pine kernels

4 tbsp olive oil

2 tbsp tomato puree

¼ tsp freshly ground black
 pepper

¼ tsp cayenne

¼ tsp ground cinnamon

¼ tsp paprika

½ tsp ground cloves

1 tbsp sugar

½ bunch parsley

1 bunch dill

1 sprig mint

26 large mussels

8 slices of lemon

KÖZLENMIŞ PATLICAN
(Roast aubergine salad)

3 large aubergines

3 peppers

2 tomatoes

1 garlic clove

4 tbsp vinegar

5 tbsp olive oil

salt

freshly ground black pepper

parsley to garnish

MIDYE DOLMASI *(Stuffed mussels)*

Soak the rice in warm salted water until the water becomes cold. Soak the currants in warm water for an hour. Finely chop the onions. Brown the pine kernels in a dry pan, add the olive oil and onions, and sweat till the onions are transparent. Strain the rice, mix it in, and cook for three minutes.

Strain the currants and add the tomato puree, spices, sugar and a pinch of salt. Pour on enough boiling water to cover the contents of the pan. Cover, and cook on medium heat for three minutes, then allow to simmer for 15 minutes on a very low heat. The rice should not yet be completely cooked. Chop herbs finely, cover, and leave for 10 minutes.

Now brush the mussels under running cold water and remove the beards. Open the shells with a knife so that they form a butterfly. Bring 500 ml salted water to the boil in a wide saucepan. Pour the filling into the open mussels and close the shells. Lay the mussels in a metal sieve or steamer basket and weigh down with a lid so that they will not open. Place the sieve over the boiling water and steam for 20 to 30 minutes. Serve cold, garnished with lemon.

KÖZLENMIŞ PATLICAN *(Roast aubergine salad)*

Put the aubergines, peppers and tomatoes on a baking tray, place on the middle shelf of the oven, and cook for about 40 minutes at a high heat until the skin browns and bursts. Turn the vegetables at intervals, and remove the tomatoes after around 25 minutes.

Allow the vegetables to cool and then remove the skins. Crush the garlic. De-seed the tomatoes and peppers, and chop finely. Cut the aubergines into small pieces. Mix everything in a bowl with the vinegar and olive oil, and season with salt and pepper. Garnish with finely chopped parsley.

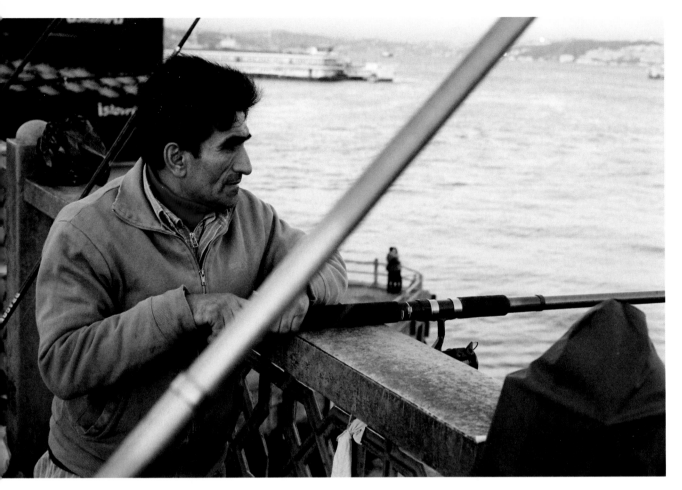

HUMUS (Chickpea dip)

Leave the chickpeas to soak overnight in plenty of water, strain and rinse, then put in a large saucepan with 1 litre of cold water, and bring to the boil. Cover and leave to simmer for about 1 hour until the chickpeas are soft.

Strain and save the water. Puree the chickpeas in a food processor. Crush the garlic and together with the tahini, lemon juice and cumin, stir into the mixture. For a smooth consistency, stir in some of the water. Season with salt. Before serving, drizzle with olive oil, and garnish with parsley and pomegranate seeds.

Tip: It is quicker to use canned chickpeas. The cooking time for dried peas will depend on their age.

ŞIŞ SARDALYA (Skewered sardines)

Slit the sardines open at the belly, remove the heads, open out and fillet. Lay out the fillets lengthways, rinse and dab dry. Puree the parsley, pine kernels and olive oil in a food processor. Season with salt and pepper. Coat the fish on both sides with the mixture. Stick the wooden skewers lengthways through the fish, and place side by side on a baking tray covered with foil. Preheat the oven to 200 °C/gas mark 6, and bake for about 5 minutes on a centre shelf.

Sprinkle with the juice of one lemon. Cut the second lemon into thin slices and use to garnish.

HUMUS
(Chickpea dip)

200 g chickpeas

2 garlic cloves

80 g tahini (sesame paste)

juice of 1 lemon

½ tsp cumin

salt

2 tbsp olive oil

parsley and pomegranate
 seeds to garnish

ŞIŞ SARDALYA
(Skewered sardines)

12 sardines

3 sprigs parsley

50 g pine kernels

5 tbsp olive oil

salt

freshly ground black pepper

wooden skewers

2 lemons

FASULYE PILAKI
(Beans with tomato sauce)

300 g dried haricot beans

1 onion

1 small carrot

6 tbsp olive oil

2 peppers

1 garlic clove

2 tomatoes

1 tbsp tomato puree

½ tsp sugar

salt

parsley and lemon to garnish

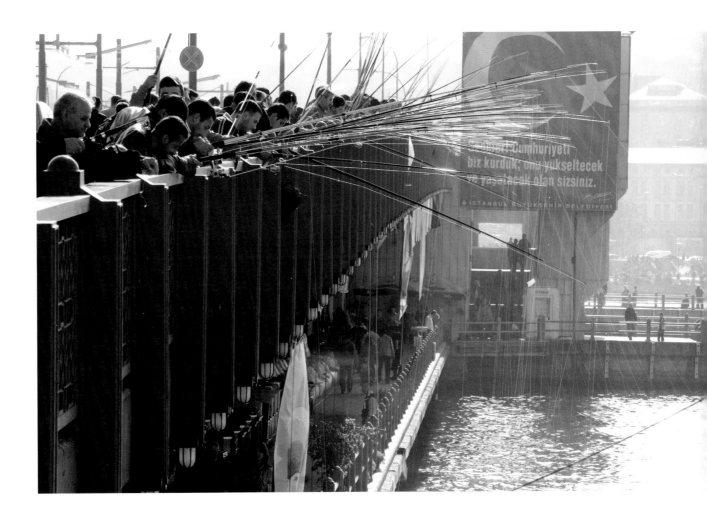

MUHAMARA
(Walnut dip)

200 g sheep's cheese

¼ tsp thyme

salt

¼ tsp hot paprika

¼ tsp freshly ground black
 pepper

¼ tsp ground cumin

200 g chopped walnuts

2 slices of white bread with
 crusts removed

2 tbsp tomato puree

1 garlic clove

6 tbsp olive oil

parsley to garnish

HAYDARI
(Yoghurt dip)

60 g sheep's cheese

250 g thick yoghurt

1 garlic clove

salt

freshly ground black pepper

2 tbsp olive oil

1 tbsp *pulbiber* (a paprika mix
 available from Turkish stores)

2 tbsp dried mint

fresh mint to garnish

FASULYE PILAKI *(Beans with tomato sauce)*

Soak the haricot beans overnight in cold water. The next day, strain and rinse them, put them in a saucepan, and boil them in fresh water until they are semi-soft. Peel the onion and carrot, dice them, and fry them lightly in oil.

De-seed the peppers and cut into small pieces. Dice the garlic. Add both to the pan and simmer. Pour boiling water over the tomatoes, peel and dice them, and place in the pan together with the beans and tomato puree. Cover with water, and simmer on a low heat until the beans are soft. Season with salt and sugar. Allow to cool, and garnish with parsley and lemon slices.

Tip: The cooking time for the beans will depend on how old they are.

MUHAMARA *(Walnut dip)*

Use a fork to crumble the sheep's cheese in a dish, and mix with the thyme, salt and spices. Stir in the walnuts. Soak the bread in water, squeeze it and mix it together with the tomato puree, crushed garlic and olive oil. Process the bread mixture together with the cheese and walnuts, and garnish with parsley. Serve with toasted Turkish bread.

HAYDARI *(Yoghurt dip)*

Put the sheep's cheese in a bowl and crumble with a fork. Mix with the yoghurt. Crush the garlic and stir into the yoghurt with salt, pepper, olive oil, *pulbiber* and mint. Garnish with fresh mint. Serve with flatbread.

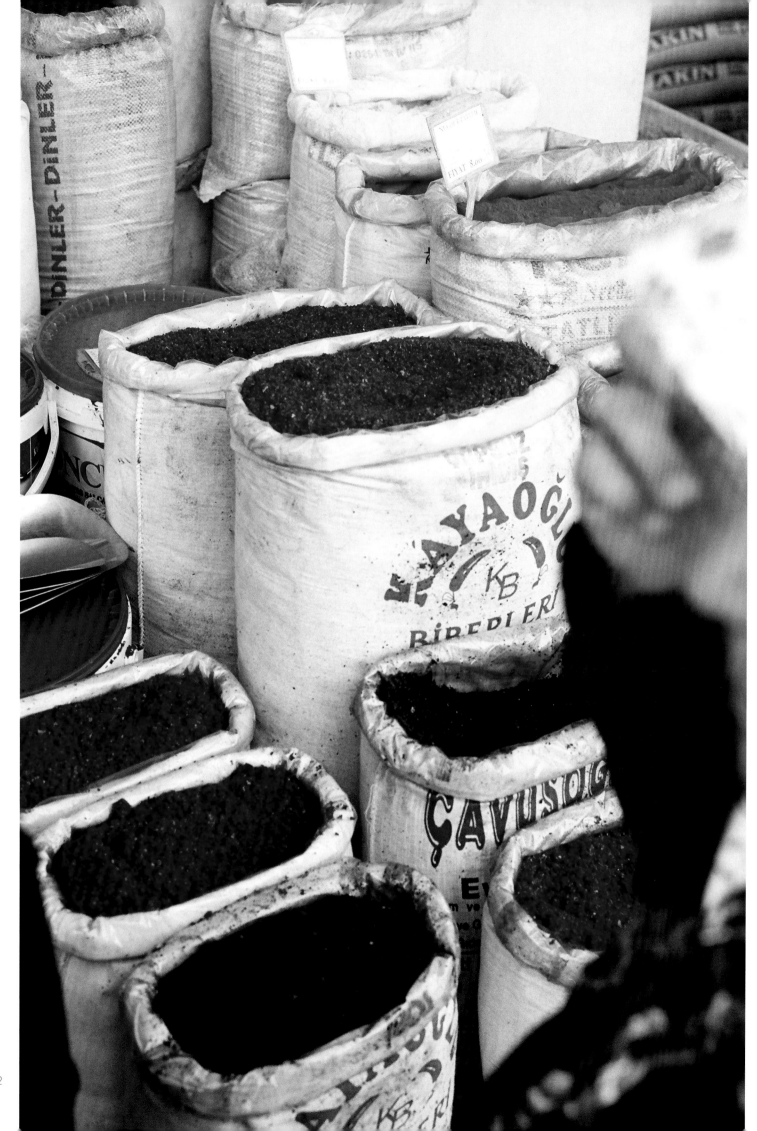

HAMSI BUĞULAMA
(Steamed Black Sea anchovies)

800 g fresh anchovies
(sardines may also be used)

2 tsp salt

3 tomatoes

1 lemon

4 potatoes

3 small onions

5 bay leaves

½ bunch flatleaf parsley

pepper

4 tbsp olive oil

ASMA YAPRAĞINDA SARDALYA
(Sardines in vine leaves)

20 vine leaves

20 sardines, approx. 800 g

salt

6 tbsp olive oil

1 tsp freshly ground black
pepper

½ tsp onion powder

1 garlic clove

juice of 1 lemon

parsley and black olives
to garnish

Main courses: more than just kebabs

Turkish cuisine has far more to offer than kebabs. In fact, the word 'kebab' simply means 'grilled'. On virtually every street corner you will find little fast-food restaurants selling mainly grilled beef, lamb, mutton, chicken or fish. There is hardly any pork because it is forbidden to Muslims. In addition to the many varieties of kebab, there are all kinds of stews: offal such as liver and entrails, and dishes of rice, fish and vegetables form an integral part of the cuisine. Main courses are always accompanied by white Turkish bread.

The remarkable number of dishes served at a circumcision feast for some princes at the palace was described by Helmuth von Moltke, Prussian military adviser to the Turkish army, early in the 19th century: 'As the ceremony is genuinely Turkish, they gave a genuinely Turkish dinner – of course without knives and forks, and without wine. The first course was a roast lamb, filled inside with rice and raisins. Everyone tore off a piece and dug in with his fingers; this was followed by halva, a sweet flummery made with honey, then another roast, and then another dessert, alternating hot and cold, sour and sweet. Each individual dish was excellent, but the overall combination was hard for a European stomach to digest, all of it without any wine. The ice was served in the middle of the meal; in the end, we were desperate for the pilau, which always signals the end of the meal.'

HAMSI BUĞULAMA
(Steamed Black Sea anchovies)

Cut the anchovies open, lay them flat, remove the heads and bones, but do not separate the fillets. Wash the fish, and salt both inside and outside. Pour boiling water over the tomatoes, peel and cut into thin slices. Peel the lemon, and also cut it into thin slices. Peel the potatoes and onions and cut into thick slices.

Line a baking tray with foil, lay the fish side by side, and place the slices of onion, potato and tomato on top. Then scatter the lemon slices and bay leaves around the tray. Finely chop the parsley, and sprinkle it over the fish, along with salt and pepper, followed by the olive oil and about 200 ml water.

Cover the baking tray with tin foil. Place the anchovies on a central shelf in the oven, and bake on a high heat (220 °C/gas mark 7) for about 40 minutes.

ASMA YAPRAĞINDA SARDALYA
(Sardines in vine leaves)

Soak the vine leaves in warm water, rinse and dab dry. Wash and salt the sardines. Mix the olive oil with the pepper, onion powder and crushed garlic clove, and coat the sardines with the mixture. Allow to marinate for two hours. Roll each sardine in a vine leaf. Lay the fish next to one another in an ovenproof dish, and sprinkle a few drops of oil on them. Bake in a hot oven (220 °C/gas mark 7) for about 20 minutes. Serve sprinkled with lemon juice, chopped parsley and black olives.

KAĞITTA LEVREK (Sea bass parcel)

Score the fish three or four times on both sides. Season inside and outside. Lay a large sheet of baking paper on an even larger sheet of tin foil.

Pour boiling water over the tomatoes to skin them, then slice. Cut the onions in half and slice. Spread half the onion and tomato slices out on the baking paper. Finely chop the parsley and garlic. Spread half of these over the tomato and onion slices, together with the bay leaf and 1 tbsp olive oil.

Lay the fish on the bed of vegetables. Place the rest of the onion and tomato slices, parsley and garlic on top, and add plenty of pepper. Pour over 1 tbsp olive oil and the white wine.

Wrap loosely with the baking paper and tin foil. Place the parcel under a preheated grill (not to close to the heat), or let it cook on a central shelf in the oven for about 40 minutes at 200 °C/gas mark 6. Place the baked parcel on a serving dish, and do not open it until you reach the table. Serve with green salad and flatbread.

BALIK PAPAZ YAHNISI (Fish ragout)

Halve the onions and cut them into slices. Peel the carrots and cut into thin strips. Chop the garlic. Heat the oil in a medium-sized saucepan, stir and sweat the onions until they are transparent, along with the garlic and strips of carrot.

Stir in the tomato puree, about 200 ml water, pepper, bay leaves, paprika and salt. Cover and allow to simmer for about 20 minutes on a medium heat.

Cut the fish fillets into strips around 3 cm wide, and add to the sauce, along with the white wine. Cover and cook for a further 10 to 15 minutes. Serve with bread or rice.

KAĞITTA LEVREK
(Sea bass parcel)

1 large sea bass (approx.
 800 g prepared weight)
salt
2 tomatoes
2 onions
1–2 garlic cloves
¼ bunch flatleaf parsley
1 bay leaf
2 tbsp olive oil
pepper
125 ml white wine

BALIK PAPAZ YAHNISI
(Fish ragout)

4 onions
2 carrots
4 garlic cloves
125 ml olive oil
3 tbsp tomato puree
7–8 crushed black peppercorns
2 bay leaves
2 tsp hot paprika
1 tsp salt
800 g bonito or mackerel fillets
 (or any similar firm fish)
125ml white wine

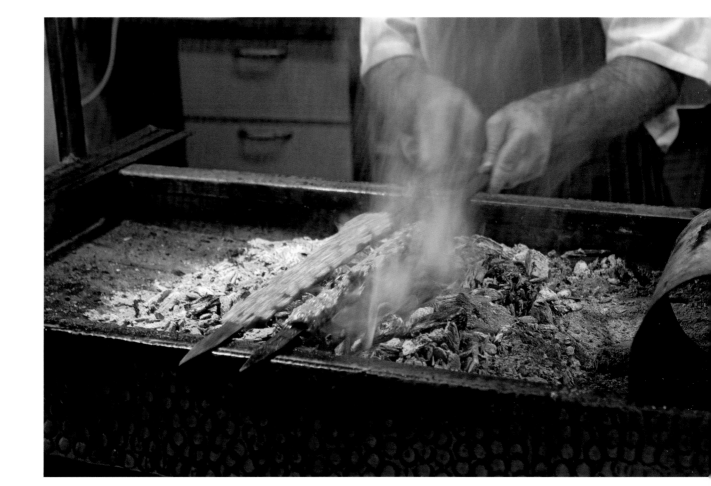

KUZU GÜVEÇ
(Lamb stew)

500 g shoulder of lamb

3 tbsp olive oil

2 onions

salt

2 aubergines

500 g potatoes

2 courgettes

250 g runner beans

5 mild chillis

250 g okra

3 tomatoes

freshly ground black pepper

2 garlic cloves

750 ml meat stock

2 bay leaves

SULTAN SARMA
(Minced meat and aubergine rolls)

1 kg tomatoes

2 garlic cloves

salt

4 tbsp olive oil

3 slices white bread

1 onion

1 bunch parsley

½ tsp freshly ground black
 pepper

500 g minced beef

2 large aubergines

KUZU GÜVEÇ *(Lamb stew)*

Dice the lamb, place in a large casserole dish, and brown on all sides in 2 tbsp olive oil. Finely chop the onions and add to the lamb. Season and add 1 tbsp olive oil. Cover and cook on a low heat for about 20 minutes.

Peel and dice the aubergines and potatoes. Cut the courgettes into slices, and discard the stalks. Cut the peppers in half lengthways and remove the seeds. Cut the beans into two or three pieces, depending on the length. Pour boiling water over the tomatoes, remove the seeds and cut into quarters.

Season the vegetables with salt and pepper, and add to the lamb, together with the crushed garlic. Pour in the stock and add the bay leaves. Cover, place on a low shelf in the oven, and cook for about 1 hour at a medium heat (180 °C/gas mark 4). Serve with rice and salad.

SULTAN SARMA
(Minced meat and aubergine rolls)

Pour boiling water over the tomatoes, peel and dice them, and place into a saucepan with chopped garlic, salt and 1 tbsp olive oil. Leave to simmer.

Dice the onion and finely chop the parsley. Soak the white bread in water, squeeze it dry and knead it together in a bowl with the minced meat, diced onions, parsley, salt and pepper. Make thumb-sized rolls out of the mixture, and lay them in a greased baking tray. Place on a low shelf in the oven and bake for about 10 minutes at 150 °C/gas mark 2.

Peel the aubergines, cut them lengthways in slices ½ cm thick, put them in a non-stick pan in 3 tbsp olive oil, and fry on both sides until they are golden brown. Take the slices out of the pan and let them cool on kitchen paper.

Wrap each minced meat roll in a slice of aubergine. Put the rolls in an ovenproof dish and pour over the tomato sauce. Place on a central shelf in the oven and bake for about 30 minutes at 160 °C/gas mark 3. Serve from the baking dish. Good with rice.

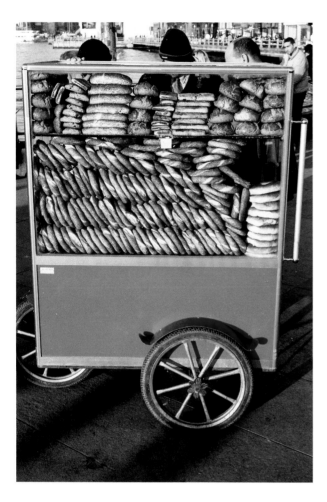

While New Yorkers devour their pretzels, the Turks love their *simit*. These sesame-seeded rings of bread, which you can buy anywhere in Istanbul, are generally eaten at breakfast time, with white cheese.

HÜNKAR BEĞENDI
(Lamb with aubergines)

Dice the onions. Pour boiling water over the tomatoes, peel and dice. Heat 2 tbsp butter in a casserole dish, and brown the meat on all sides. Add the diced onions, and fry lightly while stirring. Season with salt and pepper. Stir in the tomatoes and about 250 ml water. Cover and simmer for 1½ hours.

In the meantime, lay the aubergines on a baking tray, place on a central shelf in the oven, and roast at a very high heat (240 °C/gas mark 9) for about 40 minutes until they are soft inside and the skin has burst. Peel off the skin, put the aubergines in a dish and gently mash with a fork. Pour the lemon juice and a little water over them, and allow to marinate for 20 minutes. Drain well.

Put the flour and the remaining 3 tbsp butter in a saucepan and heat, stirring continuously until thickened, then remove from the heat. With a whisk or wooden spoon mix the aubergines with the white sauce. Add salt. Warm the milk in a different saucepan, and gradually pour in the aubergine mixture, stirring all the time. Reheat the mixture and continue to whisk. Stir in the cheese. Form a circle on the plate with the aubergine puree and lay the hot meat in the middle. Garnish with parsley.

Fact: The Turkish name of this dish can be translated as 'Sultan's Pleasure'.

TARÇINLI KÖFTE *(Meatballs with cinnamon)*

Dice the onion. Soak the bread for a few moments, then squeeze dry. Put the minced meat in a bowl with the bread, diced onion, egg, pepper, salt and cinnamon, mix together, and make into little balls. Grease a baking tray with butter. Lay the meatballs on the tray, place on a central shelf in the oven, and bake for about 20 minutes at 160 °C/gas mark 3 until brown. Serve with flatbread or rice.

HÜNKAR BEĞENDI
(Lamb with aubergines)

2 onions

2 tomatoes

5 tbsp butter

800 g cubed lamb

salt

freshly ground black pepper

2 large aubergines

juice of 1 lemon

2 tbsp flour

200 ml milk

20 g grated *kasar* (Turkish hard cheese) or parmesan

parsley to garnish

TARÇINLI KÖFTE
(Meatballs with cinnamon)

1 onion

2 slices white bread, crusts removed

500 g minced beef

1 egg

freshly ground black pepper

salt

1 tsp cinnamon

butter for greasing

ETLI YAPRAK DOMASI
(Vine leaves stuffed with minced meat)

300 g pickled vine leaves

1 large onion

1 tomato

1 bunch dill

1 bunch flatleaf parsley

2 sprigs mint

4 tbsp butter

400 g minced lamb or beef

80 g rice

½ tsp each of hot paprika and
sweet paprika

freshly ground black pepper

salt

250 g thick yoghurt

1 garlic clove

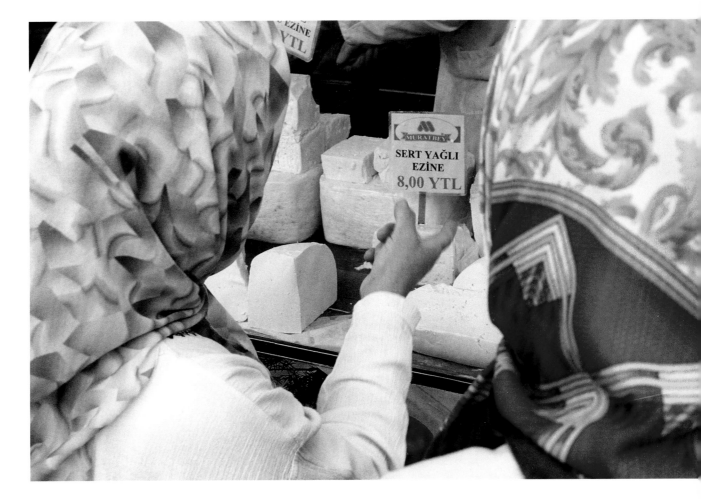

ETLI YAPRAK DOMASI
(Vine leaves stuffed with minced meat)

Soak the vine leaves in warm water for 20 minutes, drain, and dab dry with kitchen paper. Dice the onion. Pour boiling water over the tomatoes, peel, remove the seeds, and dice. Finely chop the herbs.

Sweat the onion cubes in a pan with 2 tbsp butter until they are transparent. Add the mince and brown it. Put the rice and tomatoes in the pan and cook for a few minutes. Pour on 125 ml water. Cover and simmer for about 10 minutes on a medium heat.

Take the pan off the stove and season the mixture with the paprika, pepper and salt. Stir in the herbs. Cut the stems off the vine leaves and lay the leaves on a work surface with the smooth side downwards. Put 1 to 2 tbsp of the mince filling on each leaf. Fold the right and left sides of each leaf over the filling, and then roll it up from the stem end to the tip to form a cigar shape.

Place the filled vine leaves close together in a wide sieve or steamer. Melt the rest of the butter and drizzle it over the leaves. Bring water to the boil in a wide saucepan, and place the sieve over it. Cover the stuffed vine leaves, and steam on a low heat.

Stir crushed garlic and salt into the yoghurt, and serve with the vine leaves.

Let us eat sweetly, let us speak sweetly.

Turkish saying

Sweets and desserts: sugar for the seraglio

Sultan Abdülhamid I was a peace-loving man who wanted everyone to be happy. He much preferred conquering beautiful women to conquering foreign countries and nations. But keeping all the ladies in the Topkapi harem happy was not the simplest of tasks. And so, late in the 18th century, he commissioned the finest sweet-makers in the land to create a sweet that would tame even the wildest among them. In the Sultan's Palace there was a kitchen devoted exclusively to *helvahaneler*. Hacı Bekir, a sweet-maker from Anatolia, is said to be the man who satisfied the sweet tooth of the Sultan and his harem: he did it with jelly-like cubes coated with icing sugar – Turkish Delight. How much of the story is fact and how much fiction we do not know, but what is established beyond a doubt is that in 1777 Hacı Bekir opened a sweetmaker's shop in the Istanbul district of Eminönü on the Golden Horn, and it has stood there ever since. In its windows are different sorts of Turkish Delight – nut-coated, creamy, fruit-flavoured or flower-scented – all beautifully displayed on silver trays.

Lokum, as the Turks call this sweet, was already known in Anatolia during the 14th century, but it was sweetened with honey or syrup of grapes, with flour for binding. When beet sugar came to Turkey from Europe in the 19th century, Hacı Bekir was the first to use sugar and cornflour instead of honey and flour, and thus give *lokum* a finer texture. The name itself derives from the Arabic *rahat-ul hulkum*, which means 'pleasant in the mouth'. Hacı Bekir's sweets were so pleasant in the mouth that the Sultan quickly appointed him chief confectioner to the court.

The fame of Turkish Delight beyond the borders of the Ottoman Empire is due to an unknown English traveller, who in the 19th century returned to London with a box of it, and gave it its English name. It is said to have been Napoleon's favourite sweet, and Winston Churchill was much in debt to it for his fullness of figure. Pablo Picasso is believed to have found increased inspiration after chewing his fill, and of course Western women especially were swift to fall for this, the sweetest of sweets. A Turkish journalist tried several times to get an interview with Rita Hayworth, but she kept refusing. Only when he sent her a box of *lokum* did she consent to a chat.

Turkish Delight is not just a treat for the taste-buds. Like many other Turkish sweets, it also serves a ritual function. At sunset on the last day of Ramadan, it is given to friends and relatives to celebrate the end of the fasting period and the beginning of Şeker Bayramı, the Candy Festival. Halva, a speciality made of sesame and honey, is given to mark a birth, death, call-up to the army, or the return from a pilgrimage.

The variety of sweet dishes in Turkey is huge: there are more than 200 forms of dessert, pastries and candies available. On virtually every street corner in Istanbul you will find a shop selling confectionery: baklava, halva, milk puddings and fruit compotes. Some dishes bear exotic names like 'Lips of the Beloved', 'Nightingale Nests' or 'Lady's Navels'. Almost all are irresistible.

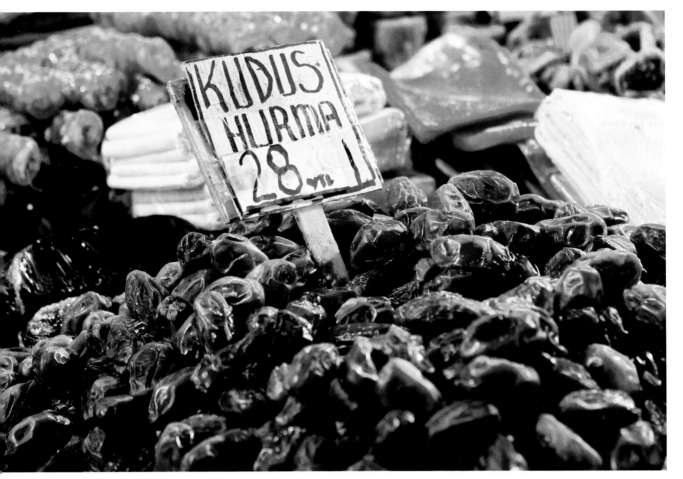

HANIM GÖBEĞI (Lady's Navels)

Put 500 ml water and sugar in a saucepan and allow to simmer for about 15 minutes. Stir in the lemon juice and let the syrup cool.

Put the butter, 250 ml water and a pinch of salt in another pan, and bring to the boil. Sieve the flour, pour it all into the second pan, and stir with a wooden spoon until it forms a thick dough. Stir the dough for a few more minutes until it can be taken from the bottom of the pan in a lump. Let the dough cool slightly in a dish, then work in one egg, then the other.

Heat the oil to 160 °C in a deep pan. Divide the dough into pieces the size of a tablespoon, oil your hands, and shape the dough into balls. Press them fairly flat and indent the middle – this forms the 'navel'. Deep-fry the balls in the hot oil until both sides are golden brown and let them drain on kitchen paper. Then dip them in the lemon syrup, and garnish by sprinking chopped pistachios in the 'navel'.

Tip: The oil is hot enough when you can hold a wooden skewer in it and there are no bubbles.

BALKABAĞI TATLISI (Pumpkin dessert)

Peel and de-seed the pumpkin. Cut the flesh into thin strips, place in a large saucepan and sprinkle with sugar. Pour in around 125 ml water. Add the lemon peel, cinnamon or cloves, cover, and allow to simmer for about 30 minutes on a low heat. Let the pumpkin cool in the syrup, then put on a plate and pour over some of the syrup. Serve with walnuts and *kaymak*.

Fact: The Prophet Muhammad ate pumpkin before his ascent into the heavens, and so this dish is traditionally eaten on the festival of Miraç Kandili, which celebrates this event.

HANIM GÖBEĞI
(Lady's Navels)

300 g sugar

juice of ½ a lemon

50 g butter

salt

150 g flour

2 medium eggs

500 ml vegetable oil (e.g.
 sunflower) for deep-frying

chopped pistachios to garnish

BALKABAĞI TATLISI
(Pumpkin dessert)

1 kg pumpkin

250 kg sugar

peel of ½ unwaxed lemon

1 cinnamon stick or 3–4 cloves

100 g chopped walnuts

kaymak (clotted cream,
 available from Turkish stores)
 or crème fraîche

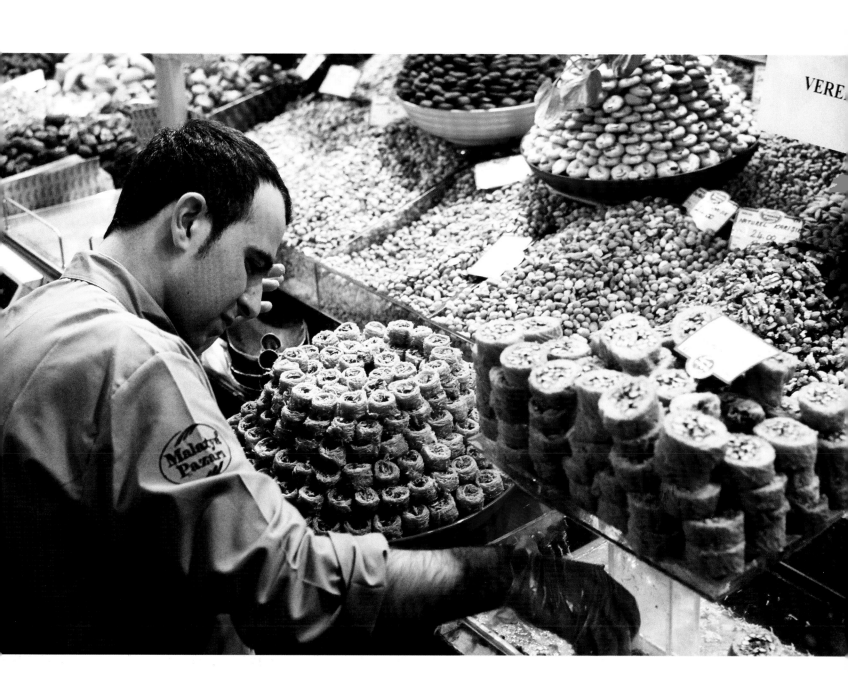

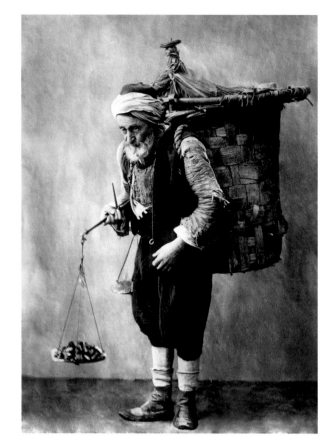

IRMIK HELVASI *(Sweet semolina)*

Melt the butter in a pan and brown the pine kernels. Pour the semolina into the pan and brown on a low heat, stirring all the time. Put 400 ml water and the icing sugar into a second pan and bring to the boil. Stir the semolina into the sugared water until it thickens. Cover and allow to stand for about 15 minutes on a very low heat, or on a hotplate that has just been switched off. Serve with chopped pistachio nuts and ice cream.

INCIR TATLISI *(Stuffed figs)*

Soak the dried figs for 10 minutes in hot water, let them drain, remove the stalks and scoop out the seeds. Stuff the figs with the walnuts and place in an ovenproof dish. Sprinkle with sugar and cinnamon, and drizzle with water. Place on a central shelf in the oven and bake for about 15 minutes at 180 °C/gas mark 4. At regular intervals, scoop the juice from the dish and pour it over the figs. Serve with whipped or pouring cream.

ARMUT TATLISI *(Baked pears)*

Put the sugar and 250 ml water into a saucepan and bring to the boil. Peel the pears, cut them in half lengthways and remove the cores. Put the halved pears and cloves in the sweetened water, cover, and allow to simmer for about 20 minutes until the pears are soft. Take them out of the syrup and lay them side by side in an ovenproof dish. Let the liquid boil for a short while longer, then pour it over the pears. Put the pears on the centre shelf of the oven and bake for about 15 minutes at 200 °C/gas mark 6. Let the pears cool in the syrup, then garnish with chopped pistachios and serve with pouring or whipped cream.

Tip: Quinces could be used in place of pears for this recipe.

IRMIK HELVASI
(Sweet semolina)

4 tbsp butter

2 tbsp pine kernels

200 g coarse-grain semolina

170 g icing sugar

chopped pistachio nuts

ice cream to serve

INCIR TATLISI
(Stuffed figs)

20 dried figs

200 g coarsely chopped
 walnuts

120 g sugar

½ tbsp cinnamon

whipped cream

ARMUT TATLISI
(Baked pears)

150 g sugar

4 firm pears

5 cloves

whipped cream

2 tbsp chopped pistachios

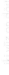

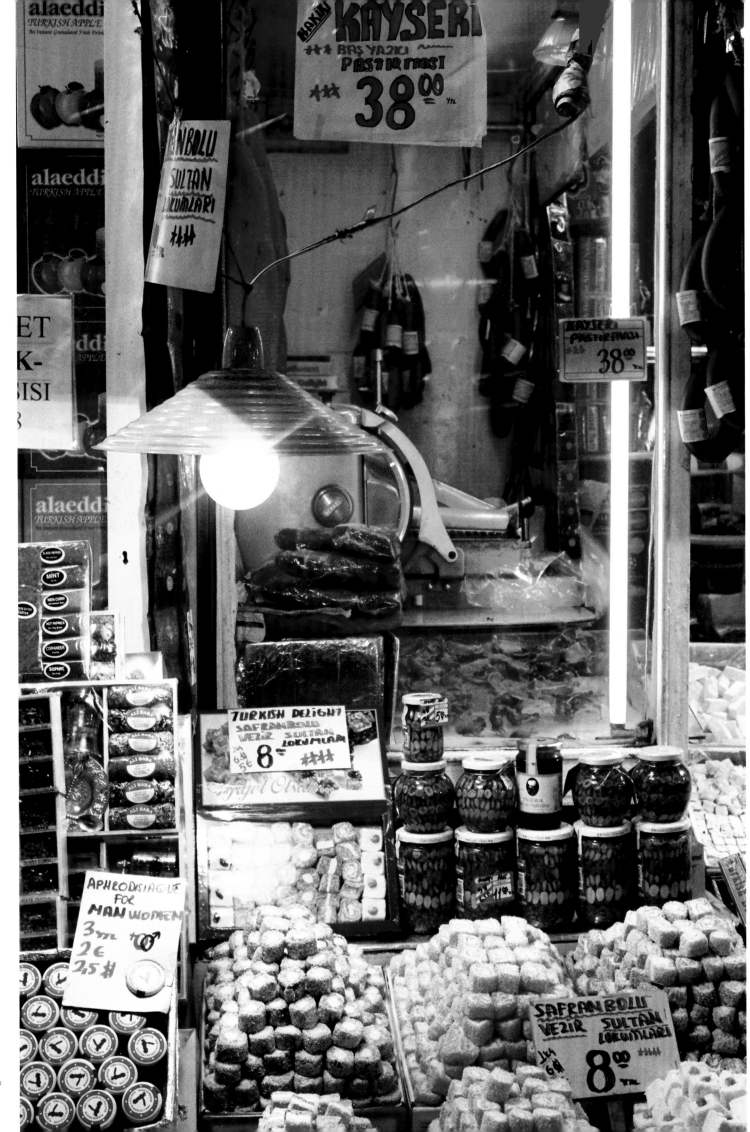

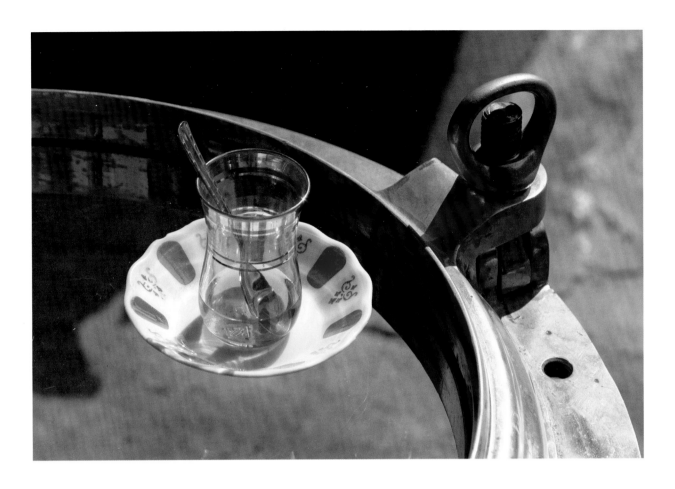

RECIPE INDEX (ENGLISH)

RECIPE INDEX (TURKISH)

ISTANBUL ADDRESS BOOK:
SHOPPING, SIGHTSEEING AND FINDING OUT MORE

GOLD
Goldsmiths at work:
Gold workshops
Çuhacı Han, 2nd floor
Nuruosmaniye Kapısı Sokak
Çemberlitaş

Gold jewelry with antique designs:
Hilat, jewelry
Şerifağa Sokak 3/4
Old Bedesten
Grand Bazaar
www.hilat.com

The right box for any ring:
Tahir-Özden Yücel, jewelry packaging and
display boxes
Tavukpazarı Sokak 60/62
Kurkcular Kapısı
Çemberlitaş
www.tahirozden.com

CERAMICS
Dishes and tiles with Iznik designs:
Selvi, ceramic dealers
Yağlıkçılar Caddesi 54
Grand Bazaar
www.selvicini.com

Authentic Iznik tiles:
Çinili Köşk / Tiled Pavilion
Between Gülhane Park and Topkapi Palace
Sultanahmet

A masterpiece of Iznik tilework:
Rüstem Pasha Mosque
Uzunçarşı Caddesi/Kutucular Caddesi Eminönü

CARPETS
For good advice:
Adnan & Hasan, carpet dealers
Halıcılar Caddesi 89/90/92
Grand Bazaar
www.adnanandhasan.com

Modern rug designs:
Dhoku, carpet dealers
Takkeciler Sokak 58/60
Grand Bazaar
www.dhoku.com

TEXTILES
Ottoman brocades:
Can Antik, Ottoman fabrics and antiques
Çadırcılar Caddesi/Lütfullah Sokak 34/36
Beyazıt

Beautiful fabrics by the metre:
Necdet Daniş, fabrics
Yağlıkçılar Caddesi 57
Grand Bazaar

Gold jewelry and Ottoman fabrics:
Antique Objet, jewelry designs
Terlikçiler Sokak 12
Grand Bazaar

A great selection of Oya scarves:
Şemo, textiles and rugs
Yağlıçılar Caddesi/Iç Cebeci Han 58
Grand Bazaar

One of the last of his kind:
Altan Örme, clothes-mending
Yağlıkcılar Caddesi 122
Grand Bazaar

Colourful scarves for grey days:
Anemira, cashmere and silk shawls
Sandal Bedesten 16
Grand Bazaar
www.anemiraconcept.com

CALLIGRAPHY
Real leaves, decorated with calligraphy:
Nick Merdenyan, calligrapher
Old Bedesten 24
Grand Bazaar
www.nickscalligraphy.com

A wide range of calligraphy and miniatures:
Omar Mustafa Erol, calligrapher
Yağlıçılar Caddesi/Iç Cebeci Han 45
Grand Bazaar
www.artofomar.com

Trading for four generations:
Elif Kitabevi, antique books
Book Bazaar 4
Beyazıt

Works by master calligraphers and their tools:
Sakıp Sabancı Museum
İstinye Caddesi 22
Emirgan

Majestic miniatures:
Miniature Collection
Topkapi Palace
Sultanahmet

ANTIQUES AND EPHEMERA
Every piece tells a story:
Gürtaş Koll, antiques and souvenirs
Halıcılar Caddesi 1/3/7/15
Grand Bazaar

Authentic Russian icons:
Burhan Ersay, antiques and souvenirs
Old Bedesten 101/102/103
Grand Bazaar

Keeping bad luck at bay:
Selim Odabaşi, blue-eye amulets, wholesale
Yağlıcılar Caddesi/Çukur Han 1
Grand Bazaar

Music like it used to be:
Mehmet Usta, gramophone dealer
Bakırcılar Caddesi/Lütfullah Sokak 16
Grand Bazaar

METALWORK
Objects from bygone days:
L'Orient, copper, bronze and brasswork
Şerif Ağa Sokak 22–23 / Old Bedesten
Grand Bazaar
www.muratbilir.com

Made-to-measure metalwork:
Güner Liman, coppersmith and antique
copper dealer
Çadırcılar Caddesi/Lütfullah Sokak 30
Beyazıt

Sensational silver:
Hüseyin Azmi Baykal, silversmith
Baykal Gümuş Elsanatlari
Tavukpazarı Sokak 55/Poyraz Han, 2nd floor
Çemberlitaş

LEATHER GOODS
Bespoke designs:
Paris Antilop, leather factory
Iskender Boğazı Geçim Han 31/3
Çarşıkapı

Leather puppets:
Karagöz Shadow Theatre
Sakıp Sabancı College
www.akbanksanat.com

Protection from the elements:
Leather dyeing and waterproofing
Imitat Deri Boyahanesi
Örücüler Caddesi/Cebeci Han 20/8
Grand Bazaar

DESIGNER FAKES
Imitation handbags:
Call +90-544-823 83 26, and Çetin Gökdemir
will meet callers on any corner in the Grand
Bazaar and take them to his stall.

Looking good:
Sunglasses and watches by 'Prada',
'Breitling' and more.
Dünya Saat
Feraceciler Caddesi 6
Grand Bazaar

A street full of bogus brands:
Çadırcılar Caddesi
Beyazıt

CENTRAL ASIAN CRAFTS
Turkmen silver jewelry and beads:
Nasip
Yorgancılar Caddesi 31
Grand Bazaar
www.nasipcollection.com

Textiles from Central Asia:
Semerkand
Yağlıçılar Caddesi/Astarcı Han 25/32
Grand Bazaar

Musical instruments and wooden objects:
Gallery Balkh
Perdahçılar Caddesi 28
Grand Bazaar
www.gallerybalkh.com

Felt figures from Kyrgyzstan:
Ak Gümuş
Gani Çelebi Sokak 8
Grand Bazaar
www.ak-gumus.com

THE ART OF RELAXATION
Bathtime luxury:
Eğin Tekstil, bath linens
Dr. Süleyman Ertaş
Yağlıkçılar Caddesi 1
Grand Bazaar
www.egintekstil.com

All you need for a visit to the hamam:
Azad Tekstil, bath linens
Yağlıkçılar Caddesi 16
Grand Bazaar

For bathing beauties:
Derviş, bath accessories
Halıcılar Caddesi 51
Grand Bazaar
www.dervis.com

For a brisk rubdown:
Cağaloğlu Hamam, Turkish baths
Prof. K. Ismail Gürkan Caddesi 34
Cağaloğlu

Scents of pleasure:
Fuar Pazarı, rose oil specialist
Egyptian Bazaar 40/B
Eminönü

Herbs for cooking and healing:
Nil Baharat, herb and spice merchant
Asmaaltı Büyükbaş Sokak 1
Eminönü
www.nilbaharat.com

Roast and ground coffee beans:
Kurukahveci Mehmet Efendi
Tahmis Sokak 66
Eminönü
www.mehmetefendi.com

Take a smoking break:
Ceramic water pipes with Iznik motifs
Efsane & Sahin
Yağlıkçılar Caddesi/Cebeci Han 55
Grand Bazaar

Games to play over coffee:
Dilek Gift Shop, backgammon dealer
Halıcılar Caddesi 26
Grand Bazaar

Something to mull over:
Yerliexport, meerschaum pipes
Şerifağa Sokak 59
Old Bedesten
Grand Bazaar

EATING AND DRINKING IN THE BAZAAR DISTRICT

For hungry bazaar browsers:
Brothers Restaurant
Yağlıkcılar Caddesi/Astarcı Han 23
Grand Bazaar

Where all the shopkeepers go:
Pendaliza, restaurant
Yağlıkçılar Caddesi/Cebeci Han 55
Grand Bazaar

A view of the Golden Horn:
Hamdi, restaurant
Tahmis Caddesi/Kalçın Sokak 17
Eminönü

Eating with history:
Pandeli, restaurant
Egyptian Bazaar
Eminönü

Sweet sensations:
Hacı Bekir, Turkish Delight
Hamidiye Caddesi 83
Eminönü
www.hacibekir.com

EATING AND DRINKING IN THE REST OF THE CITY

A feast from the sea:
Cibalikapı, fish restaurant
Abdülezel Paşa Cadesi 7
Cibali-Haliç
+90-212-533-28 46/27 89
www.cibalikapibalikcisi.com

A culinary tour of Asia:
Inciraltı, *meyhane*-style restaurant
Arabacılar Sokak 4
Beylerbeyi
+90-216-557 66-86/46
www.beylerbeyiinciralti.com

For quick lunches:
Sultanahmet Fish House
Prof. Ismail Gürkan Caddesi 14
Sultanahmet
+90-212-527 44 41
www.sultanahmetfishhouse.com

A great place to begin a night out:
Cezayir, restaurant & bar
Hayriye Caddesi 12
Galatasaray/Beyoğlu
+90-212-245 99 80
www.cezayir-istanbul.com

A cosy café in a trendy district:
Susam Cafe
Susam Sokak 11
Cihangir

A café with a view:
Pierre Loti Café
Gümüşsuyu Caddesi/Balmumcu Sokak
Eyüp

PLACES TO SLEEP

A home from home with a view:
Manzara Istanbul holiday apartments
Galatakulesi Sokak 3/2
Kuledibi/Beyoglu
+90-212-252 46 60
www.manzara-istanbul.com

Cosy and friendly:
Kybele Hotel
Yerebatan Caddesi 35
Sultanahmet
+90-212-511 77 66
www.kybelehotel.com

Old-fashioned luxury:
Büyük Londra Oteli/Grand Hotel de Londres
Meşrutiyet Caddesi 117
Tepebasi/Beyoğlu
+90-212-245 06 70
www.londrahotel.net

Staying in style:
Yeşil Ev Hotel
Kabasakal Caddesi 5
Sultanahmet
+90-212-517 67 85
www.istanbulyesilev.com

CHRONOLOGY OF ISTANBUL

1451–1481	Reign of Mehmed II, *Fatih* ('The Conqueror').
1453	Mehmed II conquers Constantinople and puts an end to the Byzantine Empire, of which only the capital had remained. Subsequently, the church of Hagia Sophia is transformed into a mosque.
1455–1461	Construction of the Cevahir Bedesteni (Old Bedesten).
1459–1478	Construction of Topkapi Palace.
1463–1470	Construction of the Fatih Mosque.
1481–1512	Reign of Bayezid II, *Veli* ('The Holy').
1492	The fall of Granada, the last Muslim stronghold in Andalusia. The Jews are driven out of Spain and flee to the Ottoman Empire.
1494	Jewish exiles open a printing press in Istanbul.
1501–1506	Construction of the Bayezid Mosque.
1509	A powerful earthquake devastates the city.
1512–1520	Reign of Selim I, *Yavuz* ('The Grim').
1514	Selim I defeats the Safavids at Chaldiran and brings artists and craftsmen from Tabriz to Istanbul.
1516–1517	Conquest of Syria and Egypt. The Turkish sultans now claimed the Caliphate for the region.
1520–1566	Reign of Süleyman I, *Kanuni* ('The Lawgiver'; known elsewhere in Europe as 'The Magnificent'). Golden Age of the Ottoman Empire.
1520	Death of the calligrapher Seyh Hamdullah.
1529	First Siege of Vienna.
1546	Fires destroy the market stalls around both Bedesten.
1554	Two Syrians open the first coffee house in Istanbul.
1557	Powerful earthquake in Istanbul.
1559	Completion of the Süleymaniye Mosque.
1561	Completion of the Rüstem Pasha Mosque.
1566–1574	Reign of Selim II.
1567	Printing of the first Armenian book in Istanbul.
1572	Completion of the Sokullu Mehmed Pasha Mosque.
1574–1595	Reign of Murad III.
1580	Trade agreement with England.
1584	Export ban on important goods such as cotton and grain.
1585	Monetary crisis.
1588	Death of the famous architect Mimar Sinan.
1589	Fire destroys parts of the bazaar district. Janissary revolt.
1595–1603	Reign of Mehmed III. On his accession to the throne, nineteen of his half-brothers are executed.
1603–1617	Reign of Ahmed I.
1603	Shah Abbas I of Iran reconquers Tabriz.
1611	Birth of the chronicler Evliya Celebi.
1616	Completion of the Sultan Ahmed Mosque, which because of its sumptuous interior of blue tiles is also known as the Blue Mosque.
1617–1618	Reign of Mustafa I.
1618–1622	Reign of Osman II.
1618	Fire in the bazaar district.
1622	Decree against smoking.
1622–1623	Reign of Mustafa I.
1623–1640	Reign of Murad IV.
1627	The first Greek books are printed in Istanbul.
1631	A fifth of Istanbul's houses are destroyed by the Cibali fire.
1633	Coffee houses are closed and coffee drinkers punished.
1640–1648	Reign of Ibrahim I, *Deli* ('The Mad').
1648–1687	Reign of Mehmed IV, *Avci* ('The Hunter').
1652	A large section of the bazaar is destroyed by fire.
1663	Completion of the New Mosque and the Egyptian Bazaar.
1678–1681	The first of ten Russo-Turkish wars.

1683	Second Siege of Vienna. Defeat signals the end of Ottoman expansion and the beginning of the Empire's slow decline. Death of the chronicler Evliya Celebi.
1687–1691	Reign of Süleyman II.
1691–1695	Reign of Ahmed II.
1695–1703	Reign of Mustafa II.
1695	Fire in the Old Bedesten.
1698	Death of the calligrapher Hafiz Osman.
1701	Fire in the bazaar district. Subsequently, the bazaar is roofed and becomes the Kapalı Çarşı (Covered Bazaar).
1703–1730	The reign of Ahmed III is known as the *Lale Devri* or 'Tulip Period'. In art this is characterized by the Turkish rococo style, and in politics by an initially tentative rapprochement towards Europe.
1727	Ibrahim Müteferrika opens the first Ottoman Turkish printing press.
1729	Ibrahim Müteferrika's press prints its first book.
1730–1754	Reign of Mahmud I.
1750	Fire in the bazaar, which is subsequently looted by the Janissaries.
1754–1757	Reign of Osman III.
1756	Completion of the Nuruosmaniye Mosque.
1757–1774	Reign of Mustafa III.
1766	Major earthquakes in Istanbul.
1768	War with Russia.
1774–1789	Reign of Abdülhamid I.
1789–1807	Reign of Selim III.
1791	Fire in the bazaar district.
1797	In Germany, Alois Senefelder prints the first book using his newly invented technique of lithography.
1807–1808	Reign of Mustafa IV.
1808–1839	Reign of Mahmud II.
1812	Plague in Istanbul.
1826	Mahmud II disbands the Janissaries. He forbids the wearing of turbans and introduces the fez. Fire in the bazaar district.
1828	The first lithographed Koran is printed in Tehran by Muslims for Muslims.
1831	Outbreak of cholera in Istanbul.
1835	The German general Helmuth von Moltke is appointed military adviser in Istanbul by Sultan Mahmud II.
1838	A free trade agreement is signed with Great Britain.
1839–1861	Reign of Abdülmecid.
1839	A proclamation called the Hatt-i Sharif of Gülhane heralds the beginning of a period of radical reforms, known as the *Tanzimat*.
1845	Construction of Galata Bridge, and opening of the first photographic studio in Istanbul.
1847	Abolition of the slave trade. First printed edition of the Koran.
1851	The Great Exhibition in London.
1854–1856	Crimean War.
1857	Abolition of poll tax for non-Muslims.
1861–1876	Reign of Abdülaziz.
1865	Devastating fires in Istanbul.
1867	World Fair in Paris.
1873	World Fair in Vienna.
1875	Britain and France withdraw credit. First Ottoman state bankruptcy.
1876	Abdülhamid II ascends the throne (until 1909) – first constitutional monarchy, and establishment of basic rights.
1877	War against Russia. Campaigns in the Balkans and Anatolia

	create a huge flood of refugees. Parliament dissolves after sitting for only a few months.
1881	Birth of Mustafa Kemal. Second Ottoman state bankruptcy.
1882	Foundation of Mimar Sinan University of Fine Arts in Istanbul.
1894	After a devastating earthquake, the bazaar is reduced to its present size. The book bazaar moves to its present site, the Sahaflar Çarşısı.
1909–1918	Reign of Mehmed V Reşad.
1912–1913	Balkan Wars. The Ottoman Empire loses most of its remaining European territories.
1913	Abolition of the guilds.
1915–1916	Hundreds of thousands of Armenians are killed during compulsory relocation.
1918–1922	Reign of Mehmed VI Vahıdeddın.
1920	Mustafa Kemal opens Turkey's Grand National Assembly in Ankara. The Treaty of Sèvres is signed by the sultanate.
1922	Abolition of the sultanate. Mehmed VI flees to Malta,

	and his successor Abdülmecid II is elected 'Caliph of the Ottomans' without the title of Sultan.
1923	Treaty of Lausanne. Ankara becomes the capital, and Mustafa Kemal is made President of the Republic of Turkey.
1924	Abolition of the caliphate. The new constitution comes into operation, and includes the separation of state and religion.
1925	Closure of Muslim monasteries and ban on the fez.
1928	Introduction of the Roman alphabet, and abolition of Islam as state religion.
1932	The Hagia Sophia becomes a museum.
1934	Mustafa Kemal is given the surname 'Atatürk'. A law is passed to introduce family names.
1938	Death of Kemal Atatürk.
1954	The last fire to date in the Grand Bazaar.
1980	Interior restoration of the Grand Bazaar.
1992	Construction of the new Galata Bridge.
1995	Opening of the Istanbul Gold Exchange.
1996	Opening of the Istanbul gold refinery.

GLOSSARY

akçe (meaning 'little white one') the asper, the first Ottoman silver coin, first minted in Bursa in 1326–27

arabesque a typical decoration in Islamic art, consisting of a forked or split leaf and a curved tendril

Atatürk Father of the Turks

Avcı 'the Hunter', title given to Mehmed IV

bazaar Persian name for a market; a centre of production and trade in Islamic towns

Bedesten the covered stone market buildings in the bazaar district, where the most valuable goods are sold

boza nourishing drink made from millet

cami mosque, the place in which Friday prayers are held

çarşı market or market building

çay tea

cebeci armourer

celadon type of pottery with a pale-green glaze

cevahir jewel, gemstone

cezve coffee pot with long handle, used for preparing Turkish coffee

çibuk pipe

çini tile

çinicilik ceramics (generally used to refer to old Iznik tiles or ceramics)

Deli 'the Mad', nickname given to Ibrahim I

dervish a member of a sect of Sufi Muslims, who are best known for their whirling dance of meditation. The term is derived from the Persian word *dar* – door or gate – an image referring to the fact that they went from door to door begging for alms

devşirme (Ottoman Turkish, meaning 'to collect') – the Ottoman system of recruiting boys to serve in the military or the civil service. In the conquered Christian lands, the most talented boys were selected, converted to Islam and trained to serve the Ottoman Empire.

Divan Yolu Constantinople's main thoroughfare in Ottoman times, which still serves as a major link between the Hagia Sophia and Bayezid Square

divit portable writing case in which calligraphers kept their pens and ink

dolap a wall niche used for displaying goods

ehl-i hıref (meaning 'community of the talented') a group of artists and craftsmen who were based at the sultan's palace

Fatih 'the Conqueror', a title given to Mehmed II

fatwah an Islamic legal proclamation

fez a hat widely used in the Middle East, made of red felt, generally with a black tassel

Golden Apple Ottoman term for an important target or a city to be conquered, like Constantinople or Vienna

gül rose

hacı title given to anyone who has been on a pilgrimage to Mecca

Hadith a collection of the Prophet Muhammad's deeds and sayings

Hafız 'the protector', title given to anyone who knows the Koran by heart

hamal porter

hamam Turkish baths

han inn for travellers and merchants; now used as business premises

harem (literal meaning: 'forbidden') women's section or chambers in Islamic houses or palaces

hisbah every Muslim's duty to do good and avoid wrongdoing

imam man who leads prayers in a mosque, or religious head of a community

janissary (literally, 'new soldier') a member of an elite infantry brigade in the Ottoman Empire

jinn spirits of smokeless fire, also mentioned in the Koran, according to which they are beings with free will and are therefore subject to Islamic law

kaftan long coat of silk or wool, buttoning at the front

Kanuni 'the Lawgiver', title given to Süleyman I

Kapalı Çarşı the Covered Bazaar (another name for the Grand Bazaar)

kapı gate

kerwansaray caravanserai, a roadside inn and resting place for caravans

kethüda president of the guilds, and also the name given to a variety of positions in the service of the palace or the army

kismet fate or destiny

Koran (or **Qur'an**) the holy book of Islam, written in Arabic, which is believed to be Allah's message to humankind, as revealed to the Prophet Muhammad. It consists of 114 suras (chapters).

külliye complex of religious buildings, generally centred around a mosque

lale tulip

Lale Devri (literally, the 'Tulip Period') historical period that coincides with the reign of Ahmed III (1703–30), which was marked by the rococo style in art and by early attempts at political rapprochement with Europe

macun (literally, 'paste') a type of Turkish sweet

madrasa (literally, 'place of education') school for the study of Islam

mescit small mosque

meyhane wine bar

mihrab prayer niche in a mosque, facing towards Mecca

mimar architect, master builder

minaret tower of a mosque from which the faithful are summoned to prayer

Mısır Çarşısı the Egyptian Bazaar, also known as the Spice Bazaar

mosque Islamic building where Muslims go to worship either collectively or privately

muezzin mosque official who summons the faithful to prayer

müteferrika privileged employee of the Sultan, a member of his immediate entourage who guarded him and during military campaigns looked after the public purse

nakkaşhane (literally, 'house of design') studio for artists and miniature painters at the Topkapi Palace

nargile water pipe or hookah

nazar boncuğu amulet that looks like a blue eye and guards against evil

Oghuz Turkic people of the steppes, ancestors of the Seljuks and Ottomans

oya needle lace

pabuç shoe

pamuk cotton

pasha title granted to a general or provincial governor in the Ottoman Empire

qadi a judge appointed by the ruler, one of whose duties was to oversee the administration of Islamic law

qalam reed pen

Ramadan Islamic month of fasting

sade lokum Turkish Delight

Sahaflar Çarşısı book market (also known as the Book Bazaar)

salaam a common greeting, meaning 'peace'

sandal special kind of silk from Bursa

saray palace

saz literally 'reed', the name for an ornate style of decoration

Şeker Bayramı (literally, 'sugar feast') three-day festival to mark the end of Ramadan

selamlık the parts of an Islamic house which guests, including males, are allowed to enter

Şeyh head of a religious order

sultan title of a Seljuk or Ottoman ruler

sultani first Ottoman gold coin

surname ceremonial book praising the Sultan's family

süryani people descended from the ancient Arameans, members of the Syriac Orthodox Church

Taksim place or building where water is divided to go in different directions; name of a square in Istanbul

tanzimat new order, reform

tespih Islamic prayer beads

tughra elaborately decorated monogram of a sultan

tütün tobacco

Valide Sultan Sultan's mother

veli 'the Holy', title given to Bayezıd II.

vizier high-ranking government official

waqf (plural **auqaf**) Islamic religious endowment that devotes a piece of land or a building to charitable or religious use

Yavuz 'the Grim', title given to Selim I

zulüm oppression

BIBLIOGRAPHY

Hans Christian Andersen, *A Poet's Bazaar*, London: Richard Bentley, 1846

Peter Bausback: *Kelim. Antike orientalische Flachgewebe*, Munich: Klinkhardt & Biermann, 1983

Bayerisches Armeemuseum Ingolstadt, *Osmanisch-Türkisches Kunsthandwerk aus süddeutschen Sammlungen*, Munich: Callwey, 1979

Burton Y. Berry, *Out of the Past: The Istanbul Grand Bazaar*, New York: Arco, 1977

Hans-Leo Bobber, Marie-Louise Hirschberger, Ralph Kersten, *Türkisches Schattentheater Karagöz. Eine Handreichung für lustvolles Lernen*, Frankfurt am Main: Puppen & Masken, 1983

Lady Annie Brassey, *Sunshine and Storm in the East, or Cruises to Cyprus and Constantinople* (1880), Piscataway, NJ: Gorgias Press, 2004

Burchard Brentjes, *Chane, Sultane, Emire. Der Islam vom Zusammen-bruch des Timuridenreiches bis zur europäischen Okkupation*, Leipzig: Koehler & Amelang, 1974

Evliya Çelebi, *Seyahatnamesi*, Istanbul: Engin Yayıncılık, 1999

Mustafa Cezar, *Typical Commercial Buildings of the Ottoman Classical Period and the Ottoman Construction System*, Istanbul: Türkiye İş Bankasi, 1983

Carla Coco, *Secrets of the Harem*, New York: Vendome Press, 1997

Edmondo de Amicis, *Constantinople*, New York and London: G.F. Putnam's Sons, 1878

Walter B. Denny, 'Dating Ottoman Turkish Works in the Saz Style', in *Muqarnas I. An Annual on Islamic Art and Architecture*, Oleg Grabar (ed.), New Haven: Yale University Press, 1983, pp. 103–122

Walter B. Denny, *Ipek, The Crescent and the Rose: Imperial Ottoman Silks and Velvets*, London: Azimuth Editions, 2001

Walter B. Denny, *Iznik: The Artistry of Ottoman Ceramics*, London: Thames & Hudson, 2004

M. Ugur Derman, *Letters in Gold: Ottoman Calligraphy from the Sakıp Sabancı Collection*, New York: Metropolitan Museum of Art, 1998

Christian Eber (ed.), *Reich an Samt und Seide. Osmanische Gewebe und Stickereien*, Bremen: Edition Temmen, 1993

Volkmar Enderlein, *Orientalische Kelims. Flachgewebe aus Anatolien, dem Iran und dem Kaukasus*, Berlin: Hensche, 1986

Kurt Erdmann, *Oriental Carpets: An Account of Their History*, London: Zwemmer, 1961

Suraiya Faroqhi, *Subjects of the Sultan: Culture and Daily Life in the Ottoman Empire*, London: I.B. Tauris, 2000

Alan W. Fisher and Carol Garrett Fisher, 'A Note on the Location of the Royal Ottoman Ateliers', in *Muqarnas III. An Annual on Islamic Art and Architecture*, Oleg Grabar (ed.), Leiden: E. J. Brill, 1985, pp. 118–120

John Freely, *Stamboul Sketches*, Istanbul: Redhouse Press, 1974

John Freely and Hilary Sumner-Boyd, *Strolling Through Istanbul: A Guide to the City,* Istanbul: Redhouse Press, 1974

Esther Gallwitz (ed.), *Istanbul,* Frankfurt am Main: Insel, 1981

John Gillow and Brian Sentance, *World Textiles: A Visual Guide to Traditional Techniques,* London: Thames & Hudson, 1999

Godfrey Goodwin, *A History of Ottoman Architecture,* London: Thames & Hudson, 1971

Godfrey Goodwin, *Topkapi Palace. An Illustrated Guide to its Life and Personalities,* London: Saqi, 1999

James Grehan, 'Smoking and "Early Modern" Sociability: The Great Tobacco Debate in the Ottoman Middle East (Seventeenth to Eighteenth Centuries)', in *The American Historical Review*, vol. 111, no. 5, December 2006

Anna Grosser-Rilke, *Nie verwehte Klänge. Lebenserinnerungen aus acht Jahrzehnten,* Leipzig: Otto Beyer, 1937

Çelik Gülersoy, *The Story of the Grand Bazaar,* Istanbul: Kitaplığı, 1990

Ulla Heise, *Coffee and Coffee-Houses,* West Chester, PA: Schiffer, 1987

Alastair Hull and José Luczyc-Wyhowska, *Kilim. The Complete Guide*, London: Thames & Hudson, 1993

Heinrich Jacoby, *ABC des echten Teppichs,* Tübingen: Ernst Wasmuth, 1949

Barbara Kellner-Heinkele and Ingeborg Hauenschild (eds.), *Türkei, Streifzüge im Osmanischen Reich nach Reiseberichten des 18. und 19. Jahrhunderts,* Frankfurt: Societäts-Verlag, 1990

Adel Theodor Khoury, Ludwig Hagemann and Peter Heine, *Islam-Lexikon A–Z,* Freiburg im Breisgau: Herder, 2006

Klaus Kreiser, 'Bedesten-Bauten im Osmanischen Reich. Ein vorläufiger Überblick auf Grund der Schriftquellen', in *Istanbuler Mitteilungen* 29, 1979

Klaus Kreiser, *Istanbul und das Osmanische Reich, Städte, Bauten, Inschriften, Derwische und ihre Konvente,* Istanbul: Isis, 1995

Klaus Kreiser, *Istanbul. Ein historisch-literarischer Stadtführer,* Munich: C. H. Beck, 2001

Klaus Kreiser, *The Beginnings of Printing in the Near and Middle East: Jews, Christians and Muslims,* Wiesbaden: Harrassowitz, 2001

Michael Levy, *The World of Ottoman Art,* London: Thames & Hudson, 1975

Friedrich Maritsch and Alfred Uhl, *Kaffee und Tee,* in *Droge und Drogenpolitik: Ein Handbuch*, by Sebastian Scheerer and Irmgard Vogt (eds.), Frankfurt am Main: Campus, 1989

Helmuth von Moltke, *Briefe und Zustände über Begebenheiten in der Türkei aus den Jahren 1835 bis 1839,* Nördlingen: Greno, 1987

Lady Mary Montagu, *Letters of the Right Honourable Lady Mary Wortley Montague,* London: Thomas Martin, 1790

Kenan Mortan and Önder Küçükerman, *Kapalıçarşı,* Ankara: Külür ve Turizm Bakanlığı Yayınları, 2007

Martina Müller-Wiener, *Türkisch-osmanische Keramik,* Traunstein: Städtische Galerie Traunstein, 2004

Wolfgang Müller-Wiener, *Bildlexikon zur Topographie Istanbuls: Byzantion, Konstantinopolis, Istanbul bis zu Beginn des 17. Jahrhunderts,* Tübingen: Ernst Wasmuth, 1977

Museum für Kunsthandwerk im Auftrag der Stadt Frankfurt, *Türkische Kunst und Kultur aus osmanischer Zeit, Teil I & II,* Recklinghausen: Aurel Bongers, 1985

Gülrü Necipoglu, 'From International Timurid to Ottoman: A Change of Taste in Sixteenth-Century Ceramic Tiles', in *Muqarnas VII. An Annual on Islamic Art and Architecture*, Oleg Grabar (ed.), Leiden: E.J. Brill, 1990, pp. 136–170

Müren Özçay, *Istanbul,* Istanbul: The Aga Khan Award for Architecture, 1983

Julia Pardoe, *The City of the Sultan; And Domestic Manners of the Turks in 1836,* London: Henry Colburn, 1837

Julia Pardoe, *The Beauties of the Bosphorus,* London: Henry Colburn, 1839

Anna Pavord, *The Tulip,* London: Bloomsbury, 1999

Yanni Petsopoulos (ed.), *Tulips, Arabesques & Turbans: Decorative Arts from the Ottoman Empire*, London: Alexandria Press, 1982

Hedda Reindl-Kiel, 'Wesirfinger und Frauenschenkel. Zur Sozialgeschichte der türkischen Küche', in *Archiv für Kulturgeschichte* 77, 1995, pp. 57–84

Marcell Restle, *Reclams Kunstführer Istanbul, Bursa, Edirne, Iznik, Baudenkmäler und Museen,* Ditzingen: Reclam, 1976

Carl Ritter, 'Die geografische Verbreitung des Kaffeebaums in der Alten Welt, nach seiner wilden wie Cultur-Heimat etc.', in *Die Erdkunde von Asien*, vol. 8, Berlin, 1847, pp. 535–608

Mohamed Scharabi, *Der Bazar. Das traditionelle Stadtzentrum im Nahen Osten und seine Handelseinrichtungen,* Tübingen: Ernst Wasmuth, 1985

Peter W. Schienerl (ed.), *Diplomaten und Wesire. Krieg und Frieden im Spiegel türkischen Kunsthandwerks,* Munich: Staatliches Museum für Völkerkunde, 1988

Friedrich Schrader, *Konstantinopel. Vergangenheit und Gegenwart,* Tübingen: Mohr, 1917

Rudolf Schröder, *Kaffee, Tee und Kardamom. Tropische Genussmittel und Gewürze. Geschichte, Verbreitung, Anbau, Aufbereitung,* Stuttgart: Ulmer, 1991

Heinrich Schurtz, 'Das Basarwesen als Wirtschaftsform', in *Zeitschrift für Socialwissenschaft* 4, 1901, pp. 145–167

Heinrich Schurtz, 'Türkische Basare und Zünfte', in *Zeitschrift für Socialwissenschaft* 6, 1903, pp. 683–706

Nedim Sönmez, *Ebru, Marmorpapiere,* Ravensburg: Otto Maier, 1992

Staatliche Kunstsammlung Dresden, *Im Licht des Halbmonds. Das Abendland und der türkische Orient,* Leipzig: Edition Leipzig, 1995

Heidi Stein (ed.), *Salomon Schweigger. Zum Hofe des türkischen Sultans,* Leipzig: Edition Leipzig, 1986

Karl Teply (ed.), *Kaiserliche Gesandtschaft ans Goldene Horn,* Stuttgart: Steingrüben, 1968

Karl Teply (ed.), *Die kaiserliche Großbotschaft an Sultan Murad IV. 1628. Des Freiherrn Hans Ludwig von Kuefsteins Fahrt zur Hohen Pforte,* Vienna: A. Schendl, 1975

Lucienne Thys-Senocak, 'The Yeni Valide Mosque Complex at Eminönü', in *Muqarnas XV. An Annual on the Visual Culture of the Islamic World*, Gülrü Necipoglu (ed.), Leiden: E.J. Brill, 1998, pp. 58–70

Mark Twain, *The Innocents Abroad, or the New Pilgrim's Progress,* Hartford, CT: American Publishing Company, 1884

Helga Venzlaff, *Der Islamische Rosenkranz. Abhandlungen für die Kunde des Morgenlandes,* Deutsche Morgenländische Gesellschaft, vol. XLVII, 2, Stuttgart: Franz Steiner, 1985

Martin Volkmann, *Die Nachfahren des Pazyzktepptichs. Geschichte und Geschichten um den Orientteppich,* Munich: Thiemig, 1982

Walter M. Weiss and Kurt-Michael Westermann, *The Bazaar: Markets and Merchants of the Islamic World,* London: Thames & Hudson, 1998

Charles White, *Three Years in Constantinople; or, Domestic Manners of the Turks in 1844,* London: Henry Colburn, 1846

Johann Wild, *Reysebeschreibung eines Gefangenen Christen Anno 1604,* Stuttgart: Steingrüben, 1964

Mark Wilson, *Thomas Allom's Constantinople and the Scenery of the Seven Churches of Asia Minor,* Piscataway, NJ: Gorgias Press, 2007

Banu Yalkut-Breddermann and Hanjo Breddermann, *Türkisch kochen. Gerichte und ihre Geschichte,* Göttingen: Die Werkstatt, 2003

Stefanos Yerasimos, *Constantinople: Istanbul's Historical Heritage,* Cologne: Könemann, 2005

ACKNOWLEDGMENTS

Our thanks to Christian Brandstätter Verlag – particularly Christian Brandstätter, Nikolaus Brandstätter and Elisabeth Hölzl – for all their cooperation and faith, Gerald Piffl from the Imagno picture agency, Brigitte Hilzensauer for proofreading, Dudu von Thielmann for the idea behind this book, our parents, Elisalex Clary, Anna Gerber, Carl Gierstorfer, Felix Grassmann, Ann-Katrin Ritz and Margarita Rukavina for their creative ideas for improvement, moral support and continuing inspiration, Valerie Loudon for technical support, the Zenübe Akay translation agency for their work, Marlies Klosterfelde-Wentzel for editing the recipe section, our recipe testers Hortense Boulart, Marie Hartig, Antonia Nordmann, Alexandra Senger, and all the many recipe tasters.

In Istanbul, our special thanks go to Kenan Mortan for the generosity with which he shared his immense knowledge and for his tireless help, Tarkan Şahin and Sıdıka Kara from the restaurants Cibalikapı and Inciraltı for the recipes they donated, Atilla Baltacı for translating and giving helpful information about Istanbul, Erdoğan Altindiş from Manzara-Istanbul for providing a home from home, Mike for the introduction to the bazaar and his great hospitality over the years, Mustafa Erol for introducing us to the secret world of calligraphy and for the beautiful samples included in this book, Erol Avci, Hüseyin Azmi Baykal, Murat Bilir, Sayat Bilir, Tania Chandler, Süleyman Ertaş, Çetin Gökdemir, Muommer Kiliç, Hayrullah Sagtan and Hasan Semerci for all their information, support and hospitality, and to all the shopkeepers and craftsmen of the bazaar district who helped us with our research.

STANDARD METRIC AND US (IMPERIAL) VOLUME/WEIGHT EQUIVALENTS

NOTE: American (Imperial) pint = 16 ounces;
British pint = 20 ounces;
American teaspoon = 5/6 British teaspoon.

3 teaspoons = 1 tablespoon = 1/2 ounce = 1/16 cup

Converting grams (g) to ounces (oz.)
1 ounce = 28.35 grams
1 gram = 0.0353 ounce

Converting kilograms (kg) to pounds (lb) or ounces (oz.)
1 kilogram = 2.204 lb = 35.273 ounces

Converting litres (l) and millilitres (ml) to cups and quarts (qts)
1 litre = 1000 ml = 4.226 cups = 1.0566 quart
100 ml = 0.422 cup

Temperature conversions and settings
ºC = 5/9 (ºF − 32)
ºF = 9/5 (ºC + 32)

PICTURE CREDITS

p. 2: Door of a house in Istanbul, c. 1895, Christian Brandstätter Verlag.
p. 8: The Galata Bridge, spanning the Golden Horn, 1890–1900, no. 00736468, IMAGNO/Ullstein.
p. 10: Market in front of the New Mosque, c. 1900, no. 00764429, IMAGNO/Ullstein.
p. 11: Sultan Ahmed Mosque, 1952, no. 7754-14, IMAGNO/Roger Viollet.
pp. 12, 48, 82: Owen Jones: *The Grammar of Ornament*, London: Quaritch, 1910; plates 36, 37 and 38, University of Wisconsin Digital Collections Center.
pp. 15, 49, 83, 122: Calligraphy by Mustafa Erol, www.artofomar.com
p. 24: Gentile Bellini, *Portrait of the Sultan Mehmed II*, 1480, National Gallery, London.
p. 26: Souvenir of Constantinople, AVQ-A-001826-0016, IMAGNO/Alinari.
p. 59: Miniature from the *Surname-i Hümayun*, Önder Küçükerman Archive.
p. 80: Street scene, 1890–1900, no. 00736467, IMAGNO/Ullstein.
p. 95: Sinan Bey, *Sultan Mehmed II Smelling a Rose*, late 15th century, Superstock.
p. 106: From a selection of motifs at www.fetitek.com
p. 124: *Surname-i Vehbi* A.3593, fol.49b and H.1609, fol.74a, Topkapi Palace Museum, Istanbul.
p. 155: Shoe market, Istanbul, no. AVQ-A-003909-0035, IMAGNO/Ullstein.
p. 175: Istanbul Hamam, Christian Brandstätter Verlag.
p. 214: Fig-seller in Constantinople, no. 00813643, IMAGNO/Ullstein.
Endpapers: Photography by Valerie Loudon.

Translated from the German *Die Basare Istanbuls* by David H. Wilson

First published in the United Kingdom in 2008 by
Thames & Hudson Ltd, 181A High Holborn, London WC1V 7QX

www.thamesandhudson.com

First published in 2009 in hardcover in the United States of America by
Thames & Hudson Inc., 500 Fifth Avenue, New York, New York 10110

thamesandhudsonusa.com

Original edition © 2008 Christian Brandstätter Verlag, Vienna
This edition © 2008 Thames & Hudson Ltd, London

British Library Cataloguing-in-Publication Data
A catalogue record for this book is available from the British Library

Library of Congress Catalog Card Number 2008905901

ISBN: 978-0-500-51447-4

Printed and bound in Austria